ANDREW WYETH

Richard Meryman

ANDREW WYETH

A SECRET LIFE

RICHARD MERYMAN

HarperCollins_Publishers_

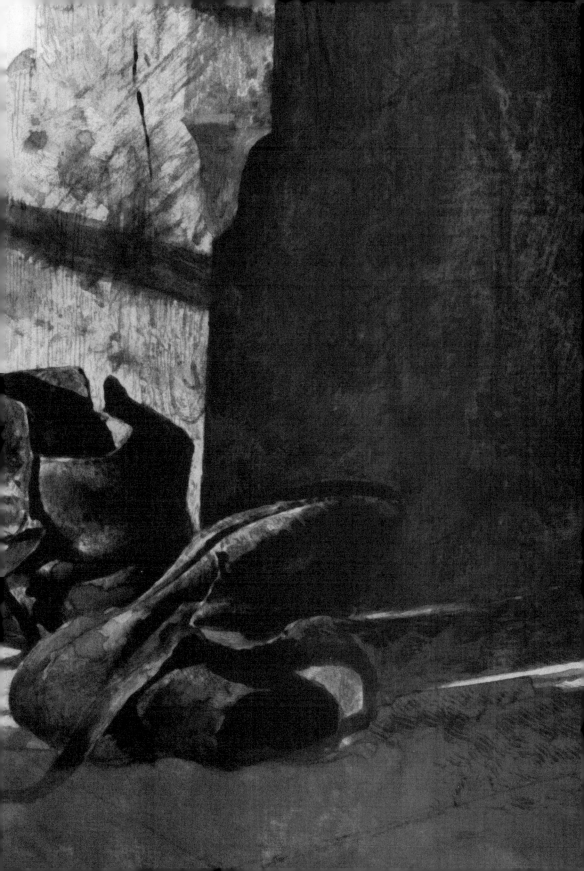

HarperCollins books may be purchased for educational, business, or sales
promotional use. For information please write: Special Markets Department,
HarperCollins Publishers, Inc., 10 East 53rd Street, New York, NY 10022.

FIRST EDITION

Designed by Joel Avirom

ISBN 0–06–017113–8

96 97 98 99 00 ❖/RRD 10 9 8 7 6 5 4 3 2 1

To my father

—

The dangers of life

are infinite

And safety is among them.

— G O E T H E

PROLOGUE

I met Andrew Wyeth in 1964 when I was an editor at *Life* magazine. I arrived at his house in Cushing, Maine, to write a major article, including extensive reproductions of his paintings. There were immediate bonds. We had both grown up in the homes of realist painters. The definitive force haunting his life and work was his father, the celebrated illustrator N. C. Wyeth, who coincidentally had served with my father on an art exhibition jury. My father—I am his namesake—was a landscape painter and portraitist who for nine years was the principal of the art school at the Corcoran Gallery of Art in Washington, D.C. In 1935, with abstract art dominating the art world, he moved the family year-round to the southern New Hampshire town of Dublin—which gave me rural New England roots to match Wyeth's association with Maine.

But most important, I identified with Wyeth's conviction that emotion is the bottom line of art. During three days in Maine and later in Pennsylvania, he explained his philosophy and creative process in hours of taped interviews. We talked informally as he took me to his painting territories, to Teels Island off the coast, to the Olson house where I met Christina, the subject of *Christina's World.* In Chadds Ford he introduced me to the Kuerner farm and Karl Kuerner. I joined the Wyeth family's Halloween costume extravaganza, and was the subject of a classic Andrew prank—and a test.

Wyeth had decided that I looked like a young Boris Pasternak, the Russian author he much admired. He had told everybody that Pasternak's son was coming to visit. All day I played that role, meeting the Wyeth clan, including the elderly Mrs. N. C. Wyeth. Sweet and thrilled, she appeared

with a book from her husband's library, written by Pasternak. While Andrew stood grinning weakly, I autographed it with a flourish.

I continued the connection with Andrew and his wife, Betsy, dazzlingly handsome, perceptive, fun. I was wowed, too, by the energy and imagination of his sisters, Carolyn, Ann McCoy, and Henriette Hurd. Later I was one of the group accompanying Andrew on his one visit to the Hurd ranch in New Mexico. In 1967 I took a leave of absence from *Life* to help produce and to write a lavish book of Wyeth's works published by Houghton Mifflin. I experienced Betsy as a guiding mentor, in the same way she had been a powerful influence on her husband's work.

Andrew and Betsy indicated that I was to be the future biographer of Andrew Wyeth. I took this as permission, even a request, to make notes of every encounter, to accumulate insights and information. I became the writer that editors called to do Wyeth articles, and was able to record hundreds of hours of interviews with all the Wyeths. I wrote a *Life* article on Wyeth's secret model, Helga Testorf; a *New York Times* interview with Carolyn Wyeth; a piece on the whole Wyeth clan for *National Geographic*; and a book on Wyeth for the Harry Abrams First Impressions series.

This biography became for me a map of Andrew's all-consuming obsession with painting: its ripple effects on his relationships, its roots in N. C. Wyeth's romanticized legacy, both dynamic and darkly distorting. The book is the story of how the complex pieces of his life—the inputs, the conscious choices, the compulsions, the angers and affections—have combined to transmit emotion onto his flat surfaces.

When we agreed that the time had come to write the book, Wyeth made several stipulations: He would not sit for interviews. He did not want the reproductions of his work reverentially placed on the page surrounded by white borders like a frame. He wanted the excitement of pictures bled off the edges and carried across the gutter between the pages. He also wanted a "tough book." It should be like his own work, treating truth as a form of honor. Once, explaining a pitiless portrait of his eccentric sister Carolyn, he said, "I love her too much to do it any other way."

He announced, too, that he would not read my manuscript, just as his own models have no say in a painting, though they have allowed him into their lives for decades, right to their deathbeds. Conceding no responsibility to any person, Wyeth considers himself as an eye hovering above his existence. As he says, "I am an illustrator of my own life." That is why a man so secretive has allowed a book in his lifetime. His own portrait/biography is one of the final elements of that life—and the impish child that is so much Andrew Wyeth loves an uproar. He sees no reason not to be around for the whole show.

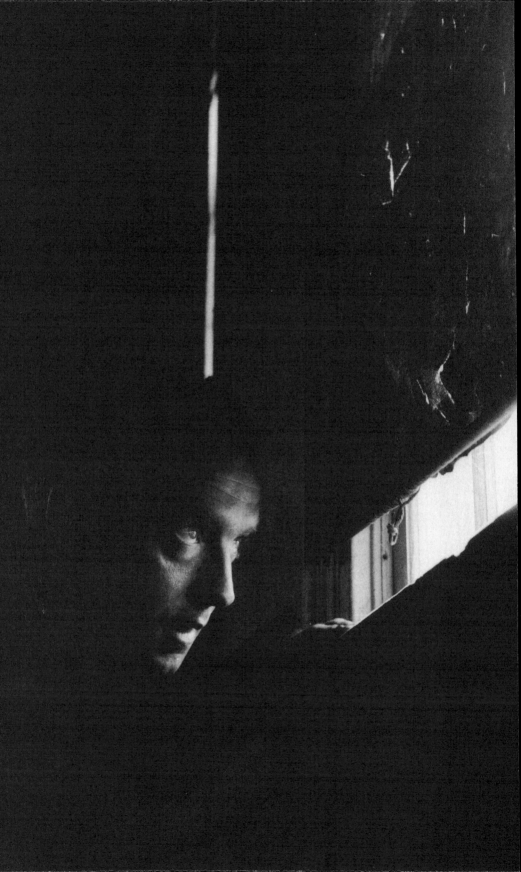

I

Christina's World *was painted in a rage.*
I was furious that Betsy wanted to build a
goddamn house in Cushing. I didn't want to be
rooted down. I was afraid I was getting in deep
like my father at Port Clyde with the big house
and dock. I'd go down there to Olson's every
day and put all my heat into that picture.
I felt the tragedy of Christina, and I decided,
"They're building that fucking house; I'm going
to make this picture as powerful as I can."
I have this hate within me—and you got to
take it out on the medium you're working in.
That makes you struggle to push a picture even
further, beyond the call of duty.

The Maine sky in *Christina's World* is a pale blue
ribbon. A billow of brown field rises toward it, at
once brief and vast, reaching at the left to the far-
thest edge of the earth. At center right, exactly on
the horizon, isolated in a tiny brown universe of
mowed grass, are a barn and a gaunt, looming
house, its dormer-windowed roof steeply pitched.
Lit by a slanting sun, weathered silver-gray, they are

In 1951 Andrew Wyeth peers from an upstairs window in
the disintegrating Olson house in Cushing, Maine, home of
Christina and her brother Alvaro. Wyeth's work often con-
tains fragments of the outdoors, framed by windows, ampli-
fying the mood and meaning of the interior. "The glimpse
you get of a landscape," he says, "whets my imagination—if
I don't see too much."

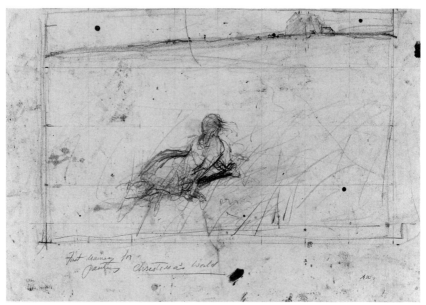

Study for *Christina's World,* 1948

exquisitely miniature. The brooding stillness is ruffled by a motion of gulls around the barn, by a minute, haunting black shirt on a clothesline, flying with outstretched arms. The buildings seem to breathe—alive, waiting, ominous.

In the foreground on the coarse grass a slender woman in a pink dress lies twisting back toward the house. Her upper body raised on emaciated arms, her elbow a swollen knob, her hands clenched and gnarled—she seems galvanized by yearning. Struggle and hope mix with malevolence. It is a disturbing picture, romantic at first glance, ultimately eerie.

It was the breakthrough painting that launched Andrew Wyeth toward a stratosphere of fame: an American household name who was also certified by elite museums and wealthy collectors. In 1959 and 1962 three museums paid record prices for his temperas. *Christina's World* (pages 16–17) became one of America's four most indelible images—along with Grant Wood's *American Gothic,* Gilbert Stuart's portrait of George Washington, and *Study in Grey and Black (Whistler's Mother)* by James McNeill Whistler.

In 1948 Wyeth looked out a window and saw crippled Christina Olson, dragging herself with her arms across the grass outside her kitchen door. That evening, during a dinner party, the concept for *Christina's World* was born fully formed in his mind's eye and in a few minutes Wyeth sketched what remained the final composition.

Indeed, *Christina's World* has suffered a fate of other icons—it has become the butt of the backhanded flattery of jokes. In cartoons Nixon crawls toward the White House, Patty Hearst cradles a gun in Christina's field, the Statue of Liberty yearns for a distant Manhattan skyline. A pink-clad fat lady longs for a layer cake. In a 1969 *New York Times Magazine*, an underwear model lay twisted at the bottom of a hill. Wyeth, laughing, drew a tiny house and barn on the hilltop. In 1994 John Baldessari used a square of Christina's field in his collage assembled from paintings in the permanent collection of New York's Museum of Modern Art.

Christina herself became famous. Tourists stalked the house, peering through the window at her, taking pictures, imitating the pose down in the field. One morning she awoke and found a stranger standing over her. "I'm a minister," he explained. When Wyeth told her the myriad symbolisms that are read into *Christina's World*, she said, "People are silly."

Wyeth spent the entire summer of 1948 painting this 32½-by-48-inch picture. The idea was triggered in May when he happened to look out a third-floor window of the Olson house and saw Christina, dragging herself across the grass. A gradual, never diagnosed muscular deterioration had left her lower body helpless. That day she was laboriously returning from the tiny garden where she cultivated the flowers that decked the lower rooms. Even the shed leading to the privy was lit by a bouquet.

Late that afternoon, Wyeth rowed his dory home from Hathorn Point, a half mile up the estuary called the St. George River that ends in Thomaston, Maine. The apparition of Christina, "crawling like a crab on a New England shore," stirred in his imagination. "Sometimes I think I'm not very artistic," explains Wyeth, "because people will say, 'Did you notice the amazing sulfur yellow in the sky, the way it . . .' That stuff never strikes me to paint. It's got to click with something I'm already thinking about. Then my hair rises on the back of my neck. I get goose pimples."

He landed at Bradford Point in Cushing where his wife, Betsy, was restoring an ancient colonial cottage moved onto acreage purchased from her parents' farm. To Andrew the house represented an anchor mooring him to this piece of earth. Now his summer months could not be simple, irrespon-

sible, organized solely by his painting impulses. He had been happy living in two converted horse stalls in the barn near her parents' farmhouse—able to pick up and row across to Port Clyde and move in with his own family, with his father, the famed illustrator N. C. Wyeth—able to work there in the little studio he had built. Now Andrew felt himself turning into a man of property, of burdens.

That evening he and Betsy joined a dinner party given by Betsy's parents, Bess and Merle James. During the meal Andrew suddenly put down his fork, left the house, and crossed to the bedroom in the barn. On the first piece of paper that came to hand, he indicated in a few swirling pencil strokes the composition of *Christina's World* (page 6)—placing her down in the field near the Olson burial plot. He once explained, "If you leave something nebulous in your mind . . . I hunt for it with purely an abstract line. I have to get the essence down as quickly as possible before it goes."

He showed nobody the drawing. Early each morning he returned to Hathorn Point. Dressed in dungarees, sweatshirt, and high-top sneakers, he walked briskly up a dirt road through blueberry fields, an arthritic hip defect splaying out his feet and making his thin body rock sideways, knees and elbows flailing, herky-jerky—like an off-kilter windmill.

Above him loomed the three-story Olson house, a vast, stark, gray ghost of Maine's tidy white frame houses, abandoned decades ago to soaking coastal storms and parching sun. Only traces of white remained on the warped clapboards and shingles. From the right end, like an afterthought, projected the one-story kitchen ell. Through the near window, past red darts of geranium blossoms, the head of Christina Olson was silhouetted against the opposite window—the long, ruined face with its hugely arching nose, and the oily strings of her lank hair.

Entering the kitchen, Wyeth was cordial but courtly—respectful of the dignity that clothed Christina's witchlike looks. Her right eye looked at Wyeth. Her left eye, a small brown pupil in a murky white ball, stared off toward some invisible spot. A single tooth stood like a post in her mouth. Her arms were skeletal, her hands contorted back at the wrists. She lived marooned on her straight-backed, cockeyed kitchen chair, its rear legs worn short from hitching

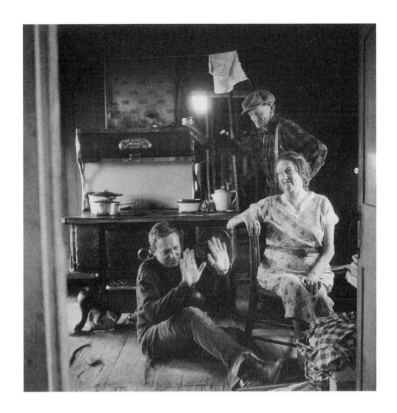

across the rutted linoleum floor between the table and the stove. On the seat of the chair were layers of newspaper to absorb the urine.

Within reach on the kitchen table lay her supply of plates and bowls, the jars of sugar and butter, all covered by a cloth. A big, black iron Glenwood stove, banded with chrome, stood against a center wall. Christina reached out with a poker to work its door. Beyond it, in a rocker, a pipe in his mouth, a cap on his head, sat her brother Alvaro, thin, small, weedy. With the same narrow face overwhelmed by the Olson nose, he looked to Wyeth "like all the crows of Maine." Behind him was the woodbox, which held the two cords they went through each winter, brought in by a wheelbarrow via the front door. Keeping Olson's warm was "like trying to heat a lobster trap," said Ralph Cline, another of Wyeth's Maine subjects.

From her station by the table Christina could watch the comings and goings on her horizons.

In the kitchen of the Olson house, Wyeth entertains Christina and her brother Alvaro. Christina did all the cooking in the household, hitching her chair across the ruined floor. Alvaro supplied the firewood.

Through the far window she kept track of the ships heading out to sea from Thomaston. She worried about storms and awaited the vessels' return. She could remember the last four-master heading out to sea. Through the opposite inland window she monitored the local traffic on the road that led to Cushing. The kitchen windows and doors were unprotected by screens. Cats and dogs came and went at will. For a time a porcupine took a shine to the pantry.

The kitchen ceiling and walls, impregnated with years of dirt, were a scabrous black. The grime was a lighter shade along the lower three feet of one wall, the height Christina could reach during a long-ago attempt at housecleaning. The overheated air was fetid with wood smoke, fuel oil, urine, musty cloth, cats, and tobacco. Some years later Wyeth brought the actor Robert Montgomery around to meet Christina. After a few minutes he fled outside and vomited.

Wyeth talked easily to Christina and Al about the minutiae of their circumscribed life: the virtues of good, dry hardwood, not pulp, compared to oil heat; the sails that lobstermen used on boats; how their several hundred hens were laying; which summer people were buying eggs and vegetables; the barge that passed by with a house built in the middle—"a rather queer looking article," said Christina. There was news of births, deaths, and people getting better from illnesses, and of the engagement of a relative's daughter to a young man described as "very quiet." With Maine terseness Christina remarked, "When her mother's around, I suppose he don't get a chance to say much." A woman gave her a dark green dress decorated with red fire engines. If she ever wore it, said Christina dryly, "People might consider me more of a freak than they do now."

From the kitchen Wyeth moved through the narrow pantry—like a ship's companionway—past the iron sink and the hand pump that lifted rainwater from the cistern beneath the house. Each morning and night Christina pulled herself along this floor to the former dining room, where she slept on a couch under an old quilt. In later years she and Al watched an ancient black-and-white TV set whose thin, seeping light glowed in the ground-floor windows, pale and ghostly. Sometimes Christina did her sewing. Her nephew, John Olson, says, "She could make pastry or a dress just like she was born to it."

Within the Olson house, life was suspended, time inexorable. During the decade Wyeth had known Christina and Al, he had gradually gained their trust and he was the one person allowed to roam freely through the rooms of this once grand house. "He won't hurt nothin'," Al said. "He ain't a foolish sort." More to the point, they trusted him not to judge them by what he saw.

Like peeling skin, crusts of paint hung from ceilings, tatters of paper from walls. Fallen plaster bared ribs of wooden lath. Desiccated into dry shreds, coated with the sediment of time, the accumulated clutter of Olson lives lay where it had been put down—one or fifty years ago. In the former dining room a picture hung draped with cobwebs matted by greasy soot, like black crepe hung in mourning. In the adjoining "shell room," gray with a scum of dust, was a table sheathed in shells, a collection of engraved shells from the Philippines, Australia, Panama, and Atlantic City, shell frames around tintypes, valentines, and a portrait of Abraham Lincoln. A ship model sat rigged with soot. Under a layer of dust, thick as a cozy, was a flowered teapot from the wedding china of Christina's mother, Katie Hathorn.

These were the artifacts of Christina and Al's heritage, the curios accumulated by Katie, who had sailed repeatedly to the Virgin Islands on a square-rigged bark with her sea-captain father, Capt. Samuel Hathorn—himself descended from a long line of seafarers. This lineage included, distantly, the nineteenth-century author Nathaniel Hawthorne, and John Hathorne, the main questioning magistrate at the 1692 witch trials in Salem, Massachusetts. Hathorns had settled this Cushing, Maine, acreage in 1743, building a log cabin. The land became a farm, and the cabin was replaced by a house. A third floor was added, and in the late 1800s, it became a popular boardinghouse called the Umbrella Roof Inn.

Katie married a tall young Swedish sailor, John Olson, a mate on a two-masted schooner stranded in 1892 by an early freeze of the St. George River. He beached himself permanently in the boardinghouse and farm. Anna Christina was born in 1893 and named after her Swedish grandmother. Katie died in 1929. John, crippled by arthritis, spent his last fifteen years in a wheelchair, tended by Christina and Al. When he died in 1935, they stayed on in the house.

Christina angrily rejected her father's wheelchair, a symbol of his arthritis. Al rolled it down the steep hill into the river. She refused to submit to her disability. Only Al was allowed to help her. She would rather live in squalor, beholden to nobody. When plaster fell off the dining room wall, a relative tells, "We went down and got some wallpaper and kind of plastered over the walls so that in the wintertime it wouldn't be so cold. She really didn't want us to do it, but we went in and done it just the same. But she didn't move out of the way. The funny part of it is, you *couldn't* move Christina out of the way. If she sat there, you got to walk over her."

The decay in the Olson house resonated with Wyeth's sense that time past and present are simultaneous. "Andy has very much to do with timelessness," Betsy Wyeth explains. "He can go back again and again to Olson's, and the thread is never broken. He knows there has been no other presence there. Christina and Al are part of the house, like a chair. They are in the present, but they are also their own past generations." Wyeth once said, "There's a haunting feeling there of people coming back to a place."

Where the world would see a recluse's ruin, to him the Olson house is "a monument" (whose portrait he painted in 1965 in *Weatherside*, page 145). He said, "The world of New England is in that house—spidery, like crackling skeletons rotting in the attic—dry bones. It's like a tombstone to sailors lost at sea, the Olson ancestor who fell from the yardarm of a square-rigger and was never found. It's the doorway of the sea to me, of mussels and clams and sea monsters and whales."

He explained: "The shadow of Christina's head against a door has a ghostly quality, eerie, fateful, serious, a symbol of New England people in the past—as they really were. There's *everything* about Christina—her hand pushing a pie plate toward you, or putting wood in the stove. There's a feeling that, yes, you're seeing something that's happening momentarily, but it's also a symbol of what always happened in Maine. The eternity of a moment.

"When you get next to something that's as mammoth as Christina, all the dirt and grime and slight things evaporate and you see before you the power of the queen of Sweden sitting there, looking at you. Our measly

minds pick up a speck of dirt on her leg or her bare thigh and we're clouded by that. She puts things in their proper position. All the feeling of ourselves and our little delicacies disappear. Knocks me right in the teeth. It's as though someone came up and said, 'Andy, your work is crap.'"

"I've seen Olson's from the air on the way back by plane to Pennsylvania—that little square of the house, dry, magical—and I think, My God, that fabulous person. There she is, sitting there. She's like a queen ruling all of Cushing. She's everybody's conscience. I honestly did *not* pick her out to do because she was a cripple. It was the dignity of Christina Olson. The dignity of this lady."

One winter night she sat on the floor of the old dining room near the oil heater, her lower body buried in a heap of rags. As she talked to a visitor, a yellow rivulet of urine flowed from under the pile, running across the linoleum and pooling next to his feet. With a grande dame's regal indifference to the unimportant, Christina ignored it.

Wyeth's personal relationship with Christina was a pristine romance. He explains, "There was a very strange connection. One of those odd collisions that happen. We were a little alike; I was an unhealthy child that was kept at home. So there was an unsaid feeling between us that was wonderful, an utter naturalness. We'd sit for hours and not say a word, and then she'd say something, and I'd answer her. A reporter once asked her what we talked about. She said, 'Nothing foolish.'"

Occasionally, they talked about her life—the launchings of large schooners built in Thomaston, what she had for lunch on those days, the sandwiches, coffee, and cakes. She told him about her one trip to Boston, describing every hour of the experience, how she took the train, who was on it, what they said.

Between the two was the trust that rises from respect. When Wyeth painted a portrait of Christina holding a kitten sick from eating too many mice, he would say, "I'd better wash your face." She would answer, "All right." As he moved a cloth into the folds of that heavy, wrinkled face, up around her ears, he once said, "Christina, you have the most marvelous end to your nose, a little delicate thing that happens." On her face was a smile close to rapture. Wyeth says, "Touching that head was a terrific experience

for me. I was really in awe of it." Then he adds, "She was just like blueberries to me."

This tenderness for unappreciated people reduced by life—his reverence for self-sufficiency and perseverance—is a fundamental energy in Wyeth's work. He has said, "I think one's art goes as far and as deep as one's love goes. I see no reason for painting but that. If I have anything to offer, it is my emotional contact with the place where I live and the people I do." He has also said, "Love is not nearly as useful as hate."

That opposite energy—"hate"—is a coadrenaline driving the intensity he pours into each painting. It is his word for the free-floating rage and fear—and the profound seriousness—he hides beneath a puckish irreverence. Ricocheting between love and hate, he is a thicket of opposites— kind, weak, tough, selfish, insecure, egotistical, poetic, wise, elegant, vulgar, naive, and ruthlessly determined. A mischievous anarchist, he is excitable to the point of wildness; his square, boyish face—below wiry, close-cropped light brown hair—is as rubbery as a clown's. Laughter puckers the corners of his bright blue, hooded, conspiratorial eyes into crow's-feet. He clicks his teeth as he cackles with delight.

Yet this intricate sprite is drawn to simplicity, to the understatement of winter, to white, to the restrictions of realism, and the driest, most lapidary of all mediums—egg tempera—a compound of powdered pigment, distilled water, and egg yolk that hardens on the panel almost instantly. He says, "I begin with emotion and am excited to the point where it affects my stomach. That's where I'm odd to paint the way I do, these immaculate pictures, closely done. You'd think you'd find a very calm mathematician."

Day after day in the Olson house Wyeth simply sat in a bare bedroom at the head of the decrepit stairs and gazed at the Masonite panel set on a cheap easel. On the gleaming white coating of gesso—a mixture of chalk and glue—were the swirling pencil strokes transferred from his first excited drawing. Wyeth once explained, "This time in a painting is terribly tiring, when you have nothing on the panel except a few strokes and you are filling in between the lines of what's not there. That's when I lose weight like mad, because I am seeing something that does not yet exist."

This is the state that Wyeth calls "dreaming," when his imagination sits open to a web of associations and recollections, each sensibility carrying its own lifetime of powerful feelings. "Dreaming" creates the mysteries beneath the surface reality, the implied metaphors. "Dreaming" transforms the picture into an independent object, with its own life, its own reality. "I have such a strong romantic fantasy about things," Wyeth says. "You can have the technique and can paint the object, but that doesn't mean you get down to the juice of it all. It's what's inside you, the *way* you translate the object—and that's *pure* emotion."

After a week of contemplation, Wyeth began covering the wildness of these lines with thousands of minute, finicky brushstrokes of tempera. Through the months of refining the realistic image, the challenge was to retain the excitement and abstraction in his initial inspiration. As a reminder, he drew on the room's wallpaper his original sketch of Christina in the field. On the panel he painted the house and barn, followed by the field, leaving Christina's figure to the very end so it would pop out of an *existing* landscape rather than a background blocked in later.

"I could easily have sketched in Christina's figure," Wyeth says, "but I liked the fact that it wasn't there. I often work on the distance, and try to think of it for a long time. In *Christina's World* I worked on that hill for a couple of months, that grass, building up the ground to make it come toward you, a surge of earth, like the whole planet."

Wyeth never went down into the field near the Olson family graveyard to draw his chosen perspective. He preferred an image filtered through imagination, through memory, embellished and simplified simultaneously. "My memory can be more of a reality than the thing itself," he explains. "I kept thinking about the day I would paint Christina in her pink dress, like a faded lobster shell I might find on a beach, crumpled. I kept building her in my mind—a living being there on a hill whose grass was really growing. Someday she was going to be buried under it. Soon

OVERLEAF: *Christina's World*, 1948, became Wyeth's signature painting and a hauntingly famous American image. Purchased by the Museum of Modern Art in New York City, it was Wyeth's breakthrough into major recognition. As he finished the tempera, he wrote his mother, "Nobody has seen it, but living with it as I work has made me feel certain that it goes way beyond my other work."

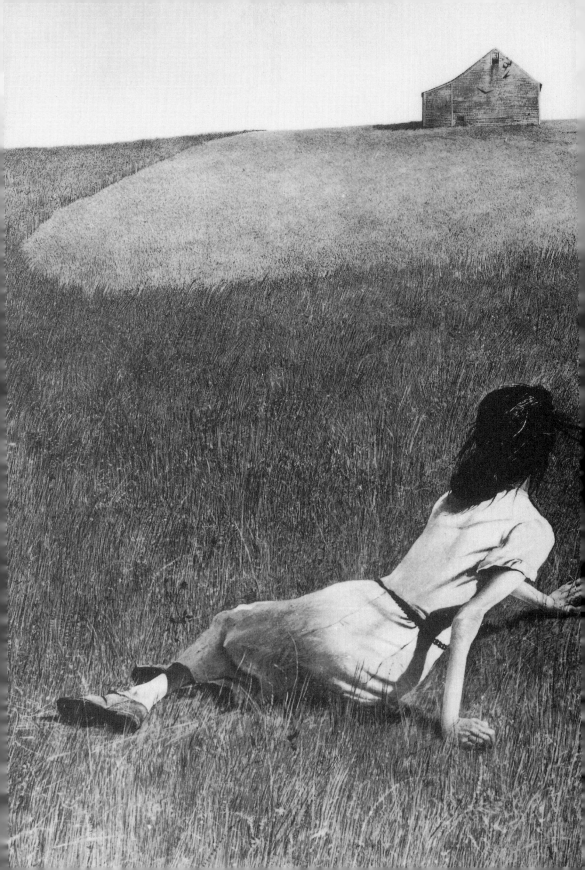

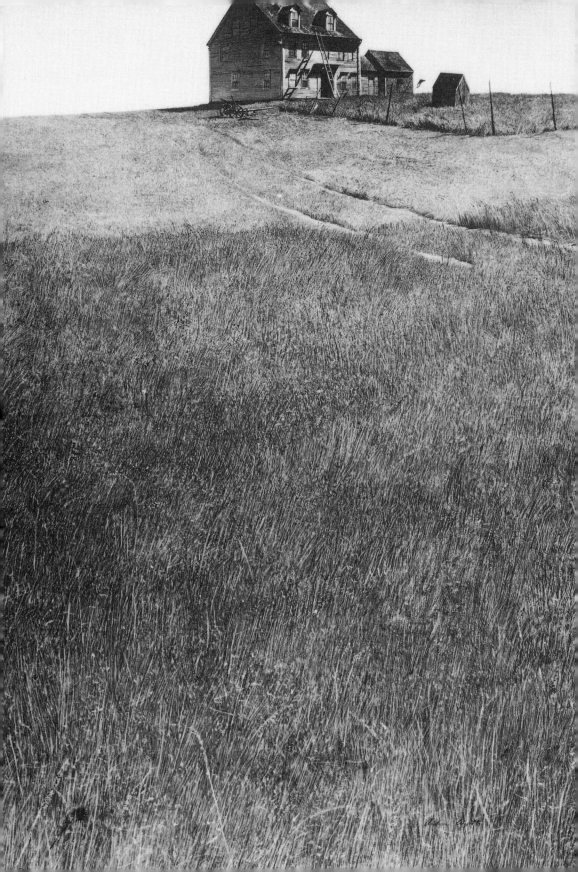

her figure was actually going to crawl across the hill in my picture toward that dry tinderbox of a house on top. I felt the loneliness of that figure—perhaps the same that I felt myself as a kid. It was as much my experience as hers.

"That's the excitement of tempera painting. Sometimes you get so totally involved that the world you're creating on that panel exists in reality. It isn't something concocted and made up. I don't spend four months on a painting just to be odd. I'm alone with a tempera for hours and hours. And the intensity builds and builds until it's not a flat surface to me, until the painting itself is a living object—and I live within the picture. I thought of Christina existing in that miniature house—not just Christina in small size—but a real one with an independent life of her own. I was building a real house—the clapboards and everything—each little sill on the window. I'd think, 'Well, I've sat there and drawn from that window—and here it is.'"

If Christina stood erect in her pink dress, if most of Wyeth's figures stepped out of their frames, they would be about twenty inches tall. He says, "I love the idea of putting all the people I've ever painted—in the size I painted them—little—together in a room. It would be marvelous. Get down and shake hands with them. Be terrific!"

Wyeth can be viewed as a primitive—every tiny element lovingly recorded. In fact that fascination with miniaturism is endemic to the Wyeth family, the sensation of hovering above a tiny, personal domain—an ant world—going about its business below. "Maybe that's one reason why I turned to the fine technique of tempera," Wyeth says.

His eldest sister, Henriette, for a time did mystical pictures of tiny, fairylike figures with wings in tremendous landscapes. Andrew's childhood toy soldiers are still arrayed in his studio. His brother, Nathaniel, made exquisite miniature furniture. But the family obsession is summed up by Ann Wyeth McCoy's walk-in, three-story dollhouse in Chadds Ford, a life's work. Ten of her childhood dolls dwell on its three floors. Nat made a Boston rocker, a mouse trap, a flip-top garbage can, a stepladder that works, and clothespins. Ann's painter husband, John McCoy, made a couch with two wingback chairs, a tilt-top table, and corner cupboard with a sink. Andrew gave her two little tempera reproductions in gold frames. The living room

fireplace is a replica of the hearth in her father's house. Over it hangs a teensy oil painting by Andrew's son, Jamie. At Christmastime stockings hang there and wreaths decorate the windows. One year Andrew lay on his stomach peering at the minute, trimmed tree with its lights and tiny wrapped presents. Whispering with excitement, he said, "Why don't you leave it here all winter like Christina and let the needles all drop off."

As Wyeth worked on *Christina's World* at the Olson house, the tempera, the house, the brother and sister all merged for him. Believing in the saturation powers of tone and odor and mood, he felt that "the panel began to inhale through its pores the quality of the room—just as Christina and Al smelled like the house. If you lifted them out bodily and set them down in a room in New York, it would be like looking at that house."

One day Wyeth heard Christina's nasal voice calling, "Andy, Andy." He went to the head of the stairs. Through a break in the banister her gnarled, twisted hand nudged a plate of fresh blueberry pie, which she had pushed ahead of her on the floor all the way from the kitchen. Al Olson regularly settled down on a cot in the studio room, scratching his matches on the wallpaper to light his pipe, watching, sleeping. When he woke and looked at the panel where Wyeth was painting the grass, Al would say, "Well, you're gainin'."

When Wyeth first began to visit Olson's, he had concentrated on Alvaro and painted outdoor watercolors of Al's vestigial farming—raising vegetables, harvesting blueberries, keeping a couple of horses and cows. In 1945 Wyeth painted Al in the kitchen in his rocking chair, lit by an embossed nickel oil lamp.

To Wyeth, Al was a beached relic of the sea. When his father, John Olson, was incapacitated by arthritis, Al quit the sea he loved and worked the farm—raising pigs, poultry, Green Mountain potatoes—cutting ice, and selling hay. "Couldn't take care of the land and the water at the same time," Al said, the twangy understatement tinged with contained grief. "Probably been better off if I'd stuck to the water."

Al stored his beloved dory in the haymow and turned his Friendship sloop upside down above high water. Sometimes on a hot day Al lay beneath

it, taking a nap. Betsy Wyeth sums up the harsh New England syndrome: "If you are tough enough, let the thing you love rot, go right by it every day, be tough enough, spit on it, call it the old woman—this thing that meant more to you than anything in the world, let it rot. 'Okay, I'm through with farming. Let the horse I loved, the cows I loved, let them rot.'"

Wyeth's first painting of Christina seated in the shed doorway, looking out to sea "like a wounded gull," won the second prize in 1948 at the Carnegie Institute Museum of Art in Pittsburgh. Al told Betsy, "You know what? You got the blue ribbon. You can put it on a pretty dress." Al's pride was hurt and he refused to pose again. "I got better use for my time," he explained from his rocker beside the stove, "than looking at *him* for two months." However, Wyeth later painted Al anyway—in the form of gnarled, dried-out seed corn hanging in a third-floor room, to Wyeth the very image of Christina's brother.

When the time arrived to fill in the figure of Christina, Wyeth summoned his courage. Though worried that he might humiliate her, he asked her to pose outdoors on the grass. Christina remembered that "at first I told him I didn't know. Of course, he kept talking and I agreed. When he wants to do a thing, it's pretty hard to refuse it."

Wyeth made detailed studies of her arms and hands. "When I put it on paper, my cold eye took in the deformity, and it shook me," Wyeth says. "I'd been so interested in her *being*, I hadn't thought about deformity. She was so much bigger than all the little idiosyncrasies." He abandoned the crippled contortions of Christina. "If you really are profound about a thing," he continues, "and really see its essence, you don't have to have a prop like deformity. It's like putting clouds in the sky, adding little jingles to make interest. That just covers your inadequacy."

For the figure, Wyeth used his sense of Christina's inner youthfulness. Christina chose the pink dress. He worked out the pose using Betsy's twenty-six-year-old body, but never took that drawing down to Olson's. For Christina's gray, tangled locks he used his memory of his aunt Elizabeth's brown hair. For the figure's shoes he copied a German shoe found in Betsy's Colonial house. Finally the planning, the anticipation became almost explo-

sive. Wyeth says, "When it came time to lay in Christina's figure against the planet I'd created for her all those weeks, I put this pink tone on her shoulder—and it almost blew me across the room."

When *Christina's World* was nearly finished, Wyeth took the panel into other rooms to see if the image was strong in different, harsh lights. One place was Christina's bare corner bedroom—papered with a pattern of pink flowers, put up originally by Christina herself. Another relic of her femininity was a powder puff ringed with lace and set on a dowel wrapped with pink ribbon. It was stuck in the chainhole in one window sash, perhaps to keep out the cold. She had not slept there since the early 1930s, when she became too crippled to climb the stairs.

Wyeth carried the painting to a stifling third-floor room, where the year before he had wrenched open the dormer window sash—an impulse that became *Wind from the Sea* (pages 240–41). A cool western breeze brought to life the ragged lace curtains that, Wyeth says, "had been lying there stale for years, God knows how long." The pattern of crocheted birds, dainty as the real Christina, fluttered, and awoke memories of his sickly childhood, lying in bed watching his own window curtains lift and fall. "My hair stood on end," Wyeth remembers.

Wyeth was apprehensive about showing the tempera to Christina. Would she feel embarrassed, exploited, her person violated, this innate lady? One morning Wyeth noticed a clean stripe wiped along the dusty floor. Christina had dragged herself up the stairs to satisfy her curiosity. Nothing was ever said. Wyeth finished in September. He kept the picture from Betsy's eyes until just before completion. It was she who named it, inspired by an oil painting by their friend Stephen Etnier titled *Stephanie's Ocean*, showing a young girl maneuvering a model sailboat in a tidal pool.

Wyeth hung *Christina's World* over the sofa. A few weeks later Christina and Al came to dinner. Al carried her in and set her down on the sofa, where she could not see the painting above her head. Betsy set up a small dinner table and placed Christina facing the tempera. It was ignored throughout the dinner. Later, for a moment, Wyeth and she were alone in

the room. He asked her how she liked it. With her crippled hand she drew his fingers to her lips.

Christina's World remained on the wall. Visitors hardly glanced at it. In October he shipped it to the Macbeth Gallery in New York. Depressed, he said to Betsy, "This picture is a complete flat tire." At the gallery the manager, Hazel Lewis, immediately telephoned Dorothy Miller, curator at the Museum of Modern Art. The procession began, including twenty-seven MoMA trustees, five honorary trustees, and the director, Alfred Barr, Jr., a ranking authority on Picasso and Matisse. There were Mrs. Vincent Astor, Mrs. Simon Guggenheim, and C. V. "Jock" Whitney's art adviser, who, according to Hazel Lewis, called him to say, "Boss, you gotta see this picture."

In December Wyeth received a check from the gallery for $1,400, his share of the sale price, "representing concrete, tangible and very real evidence," wrote Hazel, "that Christina has now taken up her new abode at 11 West 53rd Street! thereby enlarging her 'world!'" The total price was $1,800, in line with Wyeth's prices during that period—but considering the hundreds of thousands of dollars reaped through the years from reproductions, one of the great bargains of American art history. At the end of December 1948, MoMA hung the picture in its show titled *American Paintings from the Museum Collection.*

Through the years Wyeth painted four temperas of Christina. In her own no-nonsense Maine realism, she ended up preferring the later ones, searing in their truthfulness. Pressed to say what she thought of *Christina's World*, she answered, "I guess I looked better back to than I did face to . . . that's all."

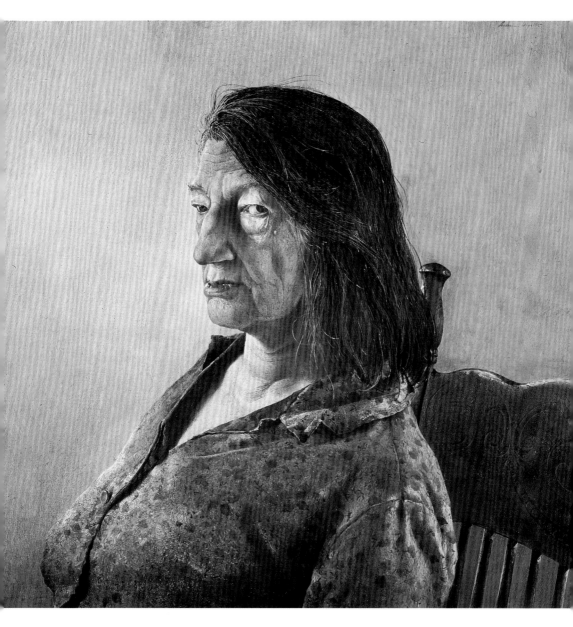

Anna Christina, 1967

A few months before she died, Wyeth painted Christina Olson in the kitchen chair where she spent her afternoons. The whiteout of foggy days seeped into the tones of her skin. The dress evoked the green sour apples she used in pies. Speaking of the power in her massive neck, the fortitude in her face, he once said, "There she was without affectation—the quality of a Medici head."

2

The wellspring of Andrew Wyeth's "love" and "hate" was N. C. Wyeth. No part of Andrew survived unaffected by a childhood at once idyllic and destructive. Those years, pervaded by the father, built the tumult—the "hate"—suppressed within the stillness of Andrew's temperas.

The greatest illustrator of his day, Newell Convers Wyeth, known as NC, is still famous for his blood-and-thunder pictures for *Kidnapped, Robin Hood, The Last of the Mohicans,* and *Robinson Crusoe.* His *Treasure Island* pictures brought a letter of thanks from Robert Louis Stevenson. Kept in print by a series of publishers, these classics have sold in the millions worldwide. During his prodigious career NC produced some 3,000 works for magazines, advertisements, and posters, and published 112 books.

Andrew worshipped and feared NC, made him his role model and swore never to be like him. Even in death NC's spirit still suffused Andrew's world. Painting after painting is a posthumous portrait. A hill swelling beneath Andrew's feet seemed to be his father's huge chest breathing in and out beneath the earth—a fantasy that underlies his 1953 tempera *Snow Flurries* (opposite page 38).

Even more than Andrew, NC was a daunting collision of opposites, like two men fighting in a sack. Family lore blames the two poles of his personality on heredity. His grandfather was a French Swiss named John Denys Zirngiebel, which means "decorating the gables." His grandmother, Henriette Zeller, was Swiss German.

They met and married in Neuchâtel, which is on the transition line between those two areas of Switzerland. A horticulturist, John Denys studied under the great Swiss-born botanist Louis Agassiz, and emigrated to America in 1855. He ended up in Needham, Massachusetts, where he had extensive greenhouses and invented a widely copied pressurized hot-water heating system. Known as "the pansy king," he developed the Giant

Swiss Pansy. He also started the commercial carnation business in America, importing seed from France and supplying the flowers to the White House. When asked what he thought of Thoreau, whom he doubtless met, John Denys shrugged and answered absently, "Oh — amateur naturalist."

Henriette Zirngiebel never adjusted to America, and as NC once wrote, "almost pined her heart away for her home and people in the Swiss mountains. During this pitiful condition of mind she gave birth to her only daughter — my mother." She, too, was named Henriette, and in 1881 she married Andrew Newell Wyeth, who weighed and inspected railroad hay shipments in Needham. A granite-solid, puritan New Englander, he was descended from Wyeths dating back to Nicholas Wyth [*sic*], a stonemason who emigrated from Wales in 1645, and helped construct an early building at Harvard College in Cambridge, Massachusetts. Wyeths were at the Deerfield massacre, at the Boston Tea Party, at Lexington; were privateers in the War of 1812; and died in the Civil War.

Robin Hood, published in 1917, is one of the timeless masterpieces illustrated by N. C. Wyeth. Read aloud to young Andrew, it became a drama he literally inhabited in his imagination.

24

Henriette was the vivid spirit in the family, a handsome woman, six feet tall with long hair piled on her head in a chignon. She moved gracefully, swaying slightly from side to side. Her hands with their long, tapered fingers were so beautiful that a Boston sculptor made plaster casts of them. Though gentle and sympathetic, with a quick humor, she did not tolerate vanity and recoiled from sentimentality.

She spoke both French and German, but her Germanic culture was primary in the household and NC grew up with German second cousins named Holzer. He later perpetuated Swiss-German traditions in his own household, and believed that this bloodline gave him a Teutonic toughness. His opposing traits, his sensitivity and artistic creativity, he attributed to the French-Swiss blood of his grandfather.

The conflict in NC's personality was symbolized by a body both awesome and delicate. As described by Andrew's brother-in-law, the artist Peter Hurd, NC "was built like a Brahma bull. A benevolent one—sometimes. Big!" NC stood six-foot-three, with broad shoulders. By the time Andrew was born, NC often weighed 260 pounds. His head was large, with long, curly hair, habitually topped by a broad-brimmed western hat. His gray-blue eyes—their upper lids hooded, the Wyeth trademark—were grippingly expressive behind glinting glasses. He could lift two ten-gallon cans full of milk, one in each hand, onto a train. He invited the fifteen-year-old Andrew to punch him in the stomach with all his strength. "He just stood there and laughed," remembers Andrew.

However, also like a Brahma bull, NC tapered down to fine legs and fine ankles—an oddity he often accentuated by wearing long, old-style knickers. His arms were slender, and his expressive hands were small. His massive body moved with grace, almost a dancer's bounce. His voice, coming from such imposing bulk, was surprisingly high, layered with a New England accent.

A former student of NC's, Francesco Delle Donne—who later married Andrew's sister Carolyn—remembers the excitement that quivered through the Delaware Art School in Wilmington when word went out that N. C. Wyeth was in town. "We would take off for Market Street and compete for his attention. We all wanted to be like him, out there and knowing

it all and doing it all and getting it all—with all that thunderous great talent. And we'd tell him we had left art class just to come and see him. And he'd say in that booming, knowing voice, 'Getting a lot of work done?' And we'd say, 'Oh, *yes!*' And he'd say, 'Then what are you doing here?' And he'd go off, and we used to stand there and watch him and say, 'God, he's great, isn't he?' But you'd never want to bump up against him. It was just like *High Noon.*"

In 1902, at age twenty, Newell Convers Wyeth traveled from Needham, Massachusetts, south of Boston, to join Howard Pyle's small two-year art school, run in Chadds Ford, Pennsylvania, during the summer and Wilmington, Delaware, in the winter. Considered the country's foremost teacher, Pyle was the dean of American illustrators in the era before the popularization of photography, when magazines and books depended on painters. In addition to painting, Pyle taught young NC to be a taskmaster. NC once wrote, "How Pyle did reach *in* and *down* and fairly [tear] at one's weak spots! It was like salt in an open sore, but it cleansed and healed."

Twenty-five miles southwest of Philadelphia, Chadds Ford was a dirt crossroads in a farming community: Gallagher's General Store, Green's Apothecary, a blacksmith shop, and the Chadds Ford Inn. Through this gentle valley flowed the Brandywine River—"all like wonderfully soft and liquid music," wrote NC. He rhapsodized about "the humble stone houses," the barnyards, the waving grain, the white farm buildings, "the great piles of corn in the fall with scattered pumpkins and little piles of golden ears." To him this was sublime nature sculpted by the hand of man. He wrote his mother, "I feel so moved sometimes toward nature that I could almost throw myself face down into a ploughed furrow—a *ploughed* furrow, understand! I love it so."

After graduation from the Pyle school, NC remained in Wilmington within his mentor's nimbus. On a sleigh ride in 1904 he met seven-

Loading his brush with pigment, his feet in high-top sneakers, N. C. Wyeth painted with an athlete's muscular energy, personifying the blood and thunder of his illustrations. The 1922 mural, depicting Abraham Lincoln and Secretary of the Treasury Salmon P. Chase, is in the Federal Reserve Bank of Boston.

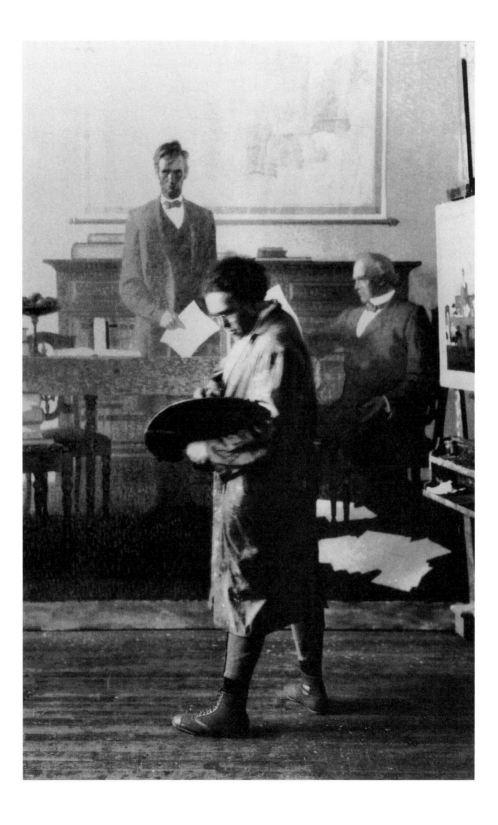

At age twenty-two N. C. Wyeth became engaged to Carolyn Bockius, one of ten children, whose father was in the leather business in Wilmington, Delaware. NC wrote his mother, "I am in love with Miss Bockius. . . . Here is a young lady of great sensibility—of inspiring thought, one strongly appreciative of art, of nature, and in many ways my mind."

teen-year-old Carolyn B. Bockius, semishy, flirtatious, very slender, very straight, five feet nine inches with a lovely neck and head, and large, dark, roguish eyes framed by masses of chestnut hair—an authentic beauty.

Unsophisticated, charming, she was one of ten children in a Wilmington family that had fallen on bad times. Her mother, Annie Brenneman Bockius, "was a difficult woman—absolutely a witch, a charmer," said Andrew's eldest sister, Henriette. "Rather a tiny person, utterly impractical, great taste, spent money as if it was air, and ruined her husband." Andrew thinks she also did a serious disservice by introducing NC to books and such authors as the transcendentalist Henry David Thoreau. Andrew says, "Pa became an intellectual and he was not that kind of man."

Carolyn's father, George Bockius, was in the leather business. A dashing, courtly, attractive man, known as a fine dancer, he drank and was caught forging a check, a sin hushed up by his friends. According to family history, when NC's parents came to meet the Bockiuses, George—dead drunk—fell down the stairs and landed at their feet. Fleeing his misfortunes, he lived most of his last years in England, where he ultimately killed himself.

"My mother," Henriette related, "was always worrying when they were going to have the next meal, whether her father was going to get drunk again or commit suicide or have a fit of asthma. Pa came along and he was the Prince Charming and the rescuer, wholesome, fine, remarkable. She was eternally grateful."

NC and Carolyn—he always called her Carol—were married in 1906 and, after a year, moved to a rented farm in Chadds Ford. In 1911 NC bought eighteen acres on a hillside south of town—"This little corner of the world wherein I shall work out my destiny." His down payment was the five-hundred-dollar advance on his first assignment from Charles Scribner's Sons—illustrations for *Treasure Island*. He built a small, squarish, two-story redbrick house with white wood trim. With its brick front porch and white wood columns and portico, it resembled a condensed mansion. Up the hill he built a spacious studio—which he once called "my church."

Full throttle in every way, a hyperidealist, NC planned to create the ultimate family. It would be a work of art, much like his 1931 sentimental mural titled *The Apotheosis of the Family*. At the center of a panoramic Eden, a heroic mother and father, nude with loins tastefully draped, stand tall, he with a hand on a pair of oxen, she with a baby nursing at her breast. Around them is their unclothed family at peaceful play. A boy—Andrew—shoots a bow and arrow. In a vast pageant, under billowing, whipped-cream clouds, happy natives bear provisions from the sea, woodsmen fell trees, men sow and reap, tend herds of sheep and cows, bees make honey, a seated Pan plays a flute.

In NC's head he was preserving a dynasty begun by his mother, to him the epitome of parenthood. She was his one intimate confidante, the umbilical cord extending by mail all the way back to Needham. The eldest

of four sons, he suffered a permanent homesickness, a sweet melancholy strummed by "searing thoughts of Home . . . the painfully searching and beautiful obbligato of my life. Its remote yet immediate strains persist like the sublimated rumble one hears from the bowels of Niagara."

Though her four sisters frequently visited, Carol Wyeth felt separated from home. Chadds Ford seemed an inaccessible, lonely place, and she looked forward to seeing her husband's new pictures. She would bring a little pail of milk to his studio away from home, and they would sit and talk about the painting. But ever so gradually he frightened her out of that ritual. "I felt inadequate," she told Andrew's wife, Betsy. Her daughter Henriette explained, "Pa had this built-in concept of women not understanding anything."

When Carol Wyeth was pregnant with the young couple's first baby in the fall of 1906, she found her bliss—and fulfilled NC's image of domesticity. NC wrote his mother in November of 1906, "I never saw a girl change so in my life . . . from a young fly-away girl into a *real* wife and mother. Every night, sure as clockwork, she carefully pulls out every little garment which she has made and talks about it and then carefully lays it back. My, how tender and sweet she is during those moments, almost spiritual."

The baby, a girl, was born prematurely just before Christmas—and died two days later. NC dug a grave in an ancient Quaker cemetery near the Brandywine River and lowered the small box into the rectangular pit. "That's the kind of man he was," Andrew says, admiringly. In NC's vision, Carol was now the kind of woman who "now seems to bathe in one perfect halo of beautiful thoughts and wonderful inspirations . . . how much akin to the beautiful is sorrow."

Beginning in 1907 Carol bore four children—Henriette, Carolyn, Nathaniel, Ann. The fifth, Andrew Newell Wyeth III, named after NC's great-grandfather, was born at 1:35 A.M. on July 12, 1917, the one-hundredth anniversary of the birth of Henry David Thoreau. Then in 1923, Carol Wyeth was forced to have a hysterectomy, and her daughter Henriette remembered her inconsolable, crying out, "I want another baby! Convers! I can never have another baby!"

From birth Andrew Wyeth was the prototype of the man he would become. Ten-year-old sister Henriette—named after her grandmother and great-grandmother—stared into the baby's face and said, "He looks as though he's going to be a great composer or artist." When Andrew was eight months old, NC wrote, "I think he's the most sensitive and spiritual little body I ever saw . . . even as young as he is, the power of reflection in his eyes is astonishing."

From the start he was a charming imp. "Lively as a cricket," said NC. Henriette, in charge of his toilet training, put Andrew on the potty. Nothing happened. The little imp walked a few feet, piddled, and pointed at the pool. He grew into an enchanting child with curly white-blond hair, sparkling blue eyes, and a roguish smile. The girls called him "Andy Pandy." His mother called him "my little snowdrop."

"Andy was born with a certain exquisite, almost painful sensitivity to life," Henriette once said. Every part was delicate—his nerves, his

ABOVE: **The N. C. Wyeth children, even when small, were in character:** (left to right) Ann at four the little mother, Nathaniel at seven the organized scientist, Andrew at two the charmer, Henriette at eleven the sophisticate in her French beret, and Carolyn, nine, the defiant eccentric. Decades later Wyeth painted two of his sisters: Ann McCoy in the tempera *Ann Wyeth* (OVERLEAF), still tenderly in touch with those early, idyllic days; and Carolyn in the dry brush *Up in the Studio*, still isolated but strong (PAGE 3 4).

Ann Wyeth, 1982

body, his health. Andrew had bouts of anemia, double hernias that required a truss, whooping cough, a chronic snuffling sinus condition, his nose regularly dripping with Argyrol. On orders from the family doctor, NC pushed wires tipped with medicine-soaked swabs up Andrew's nostrils. Food did not nourish him. Always spindly, with skinny legs and knobby knees, he was nicknamed "Soup Bone."

NC was a constant, warm, surrounding presence, protecting and nurturing (page 38). Morning after morning he sat on the bench outside the bathroom at the head of the stairs. In front of him four-year-old flaxen-haired Andrew stood happily naked on a towel. While NC soothingly

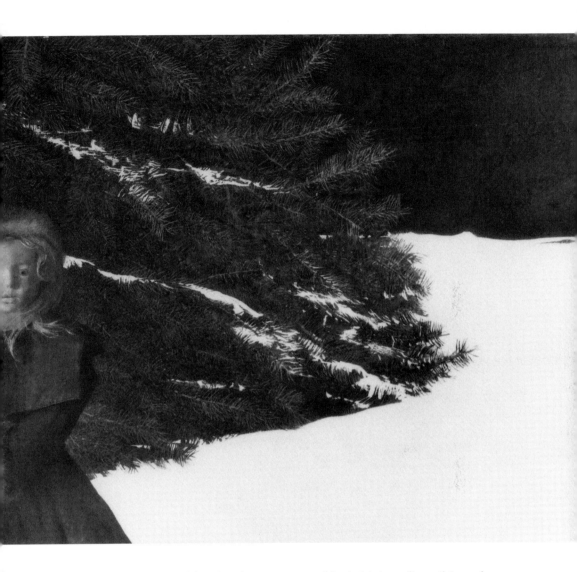

talked, those tapered hands, always warm, rubbed shining olive oil into the little boy's skin. When little Andrew had bouts of high fever, his father slept beside him—or sat beside the bed through the night, rattling the *New York Times*, which kept Andrew awake. When Andrew was racked by a nightmare, he would wake to find his father rubbing him down with cool alcohol.

Betsy Wyeth sees a link between NC and Andrew's choice to paint meticulously controlled temperas. "It's almost as though his father is speaking beside him, that calm presence quieting him down," she says. "If his father had been erratic, Andy would have been one of those helter-skelter people who go nuts."

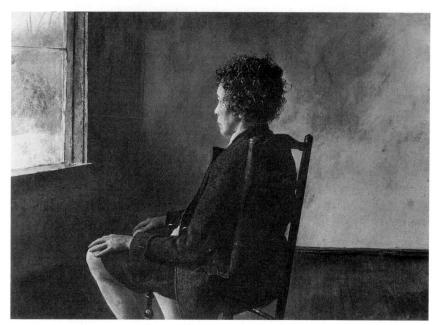

Up in the Studio, 1965

The death of that first baby girl left NC with a permanent agony, a helpless knowledge that the unthinkable *could* happen. His precious family seemed cursed with illness. Henriette was a blue baby and almost died; at age two she developed polio. A Quaker nurse prescribed boiling hot cloths and exercises, a precursor of the Sister Kenny treatment. Henriette's body straightened, but one leg was slightly short and her right hand misshapen. NC treated it daily for twenty minutes with an electrified sheepskin that painfully and futilely jerked the muscles.

During Nathaniel's first seven years he suffered stomach seizures, internal bleeding, and operations, including one to have tubercular glands removed from his neck. Ann almost died of peritonitis—with NC at the bedside entertaining her by drawing pictures. Every night at home, his nightshirt hanging just below the knees, NC went from room to room, checking each child. Henriette remembered: "We knew everything was going to be all right." Betsy Wyeth says: "Imagine never feeling alone or frightened."

But NC's strings of love were also reins. "There wasn't one phase of our lives he didn't enter," Henriette remembered. "He was the great big nanny of all time. Ma was always . . . well, he treated her almost like a daughter he had to take care of. Of course, she was generally pregnant. Pa was pleased that she stayed in bed. He was at his happiest when he was running everybody."

NC permeated the house. After reading much of the night, often manuscripts he had to illustrate, sometimes falling asleep with the book on his chest, he usually rose at dawn and went immediately up to his studio. With charcoal he drew on a fresh white canvas. Finishing his preliminary composition around seven A.M., he sprayed it with fixative. Then he roused the household, often improvised booming crashes and delicate trills on the grand piano in the big living room. Later, surprised pleasure on his face, he would say, "I thought that sounded pretty good this morning."

He made breakfast for the whole family, grinding the coffee and slamming and banging pots and pans—in case anybody was still asleep. Sometimes he would call upstairs to Ann, two years older than Andrew and considered father's pet by the other children: "Annie Rooney, come on down and have grapefruit with me!" She remembers grapefruits, the center filled with powdered sugar. Pancakes were covered with bananas and apples. "And, boy," Ann says, "if you didn't eat them, too bad. If you took something, then clean up your plate."

NC was temperamentally unable to return to the studio until the mood in the house felt right, everybody happy, constructively busy. To Peter Hurd he was "a very acute company commander. He had his mind not only on his immediate subordinates but on every trooper right on down the line." Andrew's sister Carolyn remembers, "He'd just look over his glasses, and I knew I ought to be painting, or Nat making a boat at his tool bench. Everybody knew that. You bet!"

Intensely, generously interested in everything the children did and said, NC constantly tooled their instincts, exploited the moment to teach a lesson, to give them the best of themselves. "He couldn't stop," Nat said. "He had to tell people, 'Now, you could have done it this way.'"

He installed a maple workbench for Nat in "the glassy," the glass-enclosed arboretum off the Big Room, which had become the children's play-room. NC explained how each tool was used, why each was designed as it was, the right way to sharpen the knives and chisels. Nat made a model of a ladder-back chair, working out the dimensions with his father, who drew sketches.

When Nat was finished NC looked it over. He said, "That's great, *but . . .*" and very quietly told Nat it was a lousy job. "He was going to make this count," Nat explained. "He left the room, and I remember tears running down my face." Nat smashed the chair under his feet, jumping till it was toothpicks. "After I regained my composure," Nat tells, "I began again. What a difference. The chair was beautiful. What a lesson he taught me."

Henriette remembered her father as a "kindly tyrant." She had learned to read fluently at age five. "It seemed quite easy," she remembered. At seven Henriette read her first Shakespeare play, *Henry VIII*, and was corresponding in French with her Swiss grandmother. But before each letter was mailed, it was checked and corrected by NC. "You had to do what you did with the utmost perfection or Pa's eyes would blanch," she said. "Nothing was to be stupid."

By fourteen, able to scan an entire page at a time, she had read *War and Peace* and the Bible. With a faraway look in her eyes, she would write on the air with her finger. Deciding that Henriette was *too* precocious, was accomplishing too much too fast, without the solid foundation he considered crucial to real accomplishment, NC stepped in. One day she found thumb-tacked to her drawing board a clipping from a magazine on the importance of reading slowly. That same year she submitted a historical essay to a contest. She showed it to her father, who said it was fine. She never heard about it again. Years later she discovered that she had won. Fearing that Henriette would get conceited, NC had never told her.

In this high-octane family, Carol Wyeth was a woman of homey virtues and sympathetic warmth, her pleasures simple—having picnics, sitting on the porch, putting up organdy curtains, keeping the house "like a polished old shoe," said Nat. She prized her lovingly polished silver—the silver candelabra and the bouquet in the silver bowl—and her rings and her drawers

full of linens and monogrammed napkins, the precious possessions she had missed in her genteelly impoverished childhood. She was not an intellectual companion to NC. The stimulation she provided was coffee and fresh rolls around three in the afternoon. "She was naturally intelligent," Henriette said, "and loved to read and wrote nice letters and could keep her checkbook balanced. But she had no education to speak of."

But in the family dynamics, Carol Wyeth was the all-important calming catalyst. She was the parent high-strung Andrew sought out when he needed peace, needed loving, needed the nerve medicine of her special lamb chops and baked potatoes. When NC went to New York, teenage Andrew would lie beside his mother in the quiet house and read aloud to her his semimemorized adventure books and stories and show her the illustrations. Andrew says, "Those are my warmest memories of my mother."

Henriette's daughter, Ann Carol, describes her grandfather, NC, as "qualified love." Her grandmother, she says, was "unqualified love—vital, fresh, infusing—like spring." Ann's daughter, Anna Brelsford, called Anna B., says that her grandmother "held the family together—sort of like gravitation." NC himself wrote that without her "we would all fall down." An antidote to his sternness, she was all childlike delight and playful gaiety. Years later when her granddaughters came for overnights, she would take baths with the little children, and afterward let them powder her, the talcum flying in clouds.

From his mother Andrew inherited a pacific nature and rarely required scolding. Even as a little boy Andrew was such a romancer, so puckishly beguiling, he received special indulgence. There was the sense of a unique being, fascinating, exciting, touched with magic, entitled to his own rules. "Everybody spoiled the devil out of him," Henriette said, "yet somehow he never got spoiled."

His father described Andrew at age five as keen, joyful, scintillating. A tutor remembered him as "such a dear boy. Obedient. As near perfect as they come." Carol Wyeth's sister, Elizabeth Sargent, remembered that "there never was

OVERLEAF: **Two-year-old Andrew was enveloped by the caretaking attentions of his father and was left with a lifelong sense of N. C. Wyeth as a massive, even overwhelming presence. In 1953 Andrew painted this feeling into the tempera** Snow Flurries **(opposite page 38). "It became more than a hill," he says. "It could have been my father's chest. I could feel the earth breathing."**

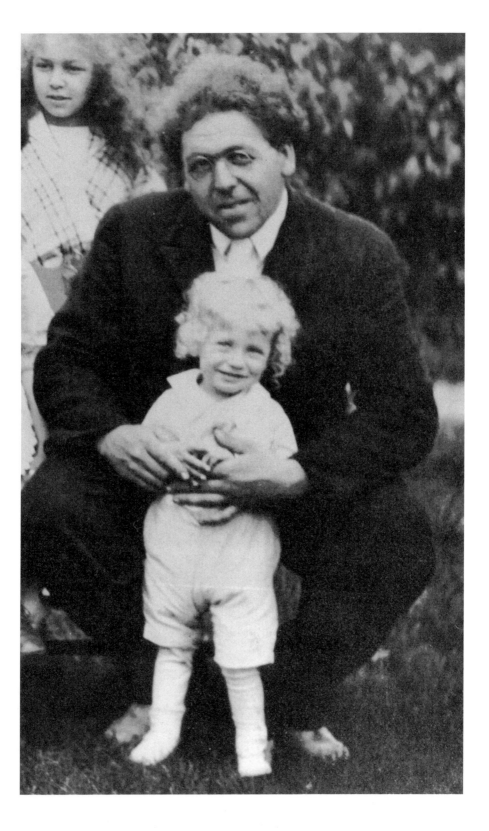

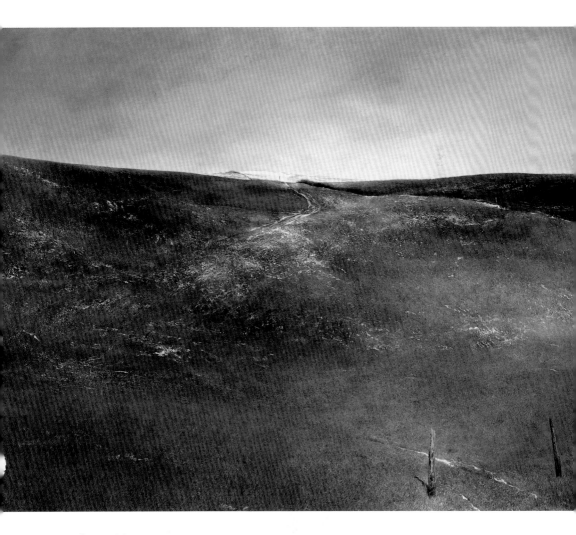

Snow Flurries, 1953

any ugliness. Andy was always so interested, gulping in all of life. His mind was open and receiving everything, every impression. You could see his imagination in his eyes—far away. With Andy you feel the earth is always new."

Despite his delicate health, Andrew's high-strung nerves gave him a feverish energy, which NC called an "incessant *aliveness*." For several years Andrew shared a bed in the small house with Ann—and kept her awake with the twitching of his legs and arms. Posing for his portrait, six-year-old Andrew's hands were so active they were unpaintable. NC had him hold a toy fire engine. The hands were still in constant motion. NC gave up and left them unfinished.

Hypersensitive, spindly Andrew needed all his wiles to cope with his huge, looming father, that towering personality like a children's book giant. "Andy was so attuned—but in such a fragile way that it could almost destroy him," says his sister Ann. "It's still that way, in his strange distant . . . he's so vulnerable. God! He's vulnerable to everything."

Henriette remembered her father's "Wagnerian bellow." She said, "We were all splendidly afraid of him in a very close and dear way. When that beautiful hand came down on your bottom or you were put in the bathroom to sit there weeping, I tell you, that was bad. And to be talked to seriously by Pa was like going up to interview God." Andrew was frightened of this omnipotent father who seemed able to read his thoughts, who must never be disappointed. Ann remembers, "We all belonged to him. We knew he was right. He was always right."

Andrew learned very early his lifelong ability to divert scrutiny and evade control. He once said, "There's something wrong with you if you don't figure out as a kid how to deal with grown-ups." Andrew's impishness helped deflect his father's discipline. In danger of a dark look from his father, Andrew would flash his roguish smile. NC, diverted, disarmed, would simply grunt, "Andy, stop being foolish."

Andrew could appeal to the Rabelaisian streak in his basically puritan father. Once, Andrew collapsed NC—and the whole family—by telling a "dirty" joke at the dinner table. "Who was the first carpenter in the Bible?" he asked. Answer: "Eve. She made Adam's banana stand."

According to his aunt Elizabeth, "Andy was a little rascal." At church in Chadds Ford he hid behind the curtain of the christening font. During the sermon, he made faces at the congregation. Stealing a candy bar at the drugstore, he made Aunt Elizabeth's daughter, Mary Sargent, be the lookout. When she protested, he slipped the candy into *her* pocket and ran out of the store laughing.

All his life Andrew has used his puckish nature to deliver him from both confrontation and capitulation. Nat Wyeth remembered Betsy at a restaurant badgering Andrew to eat his salad. Presently the plate was indeed empty. When the group stood up to leave, Nat noticed the salad dumped on the floor under the table.

This is the mischievous, restless Andrew Wyeth who has never grown up, just older, who has always needed constant excitement around him.

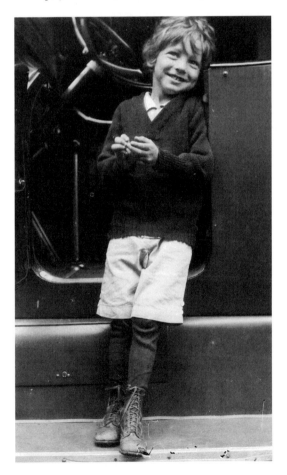

Roguish, bewitching, adored, five-year-old Andrew stands on the running board of the family's new 1923 model T Ford touring car. The same child is still wholly alive in the grown-up Andrew in 1966 (opposite). As one of his models said, "Andy's spellbinding—takes you places in his stories—and he's got that little bit of larceny in there. If you want to jump in the car and go do something bad, he'll jump in with you."

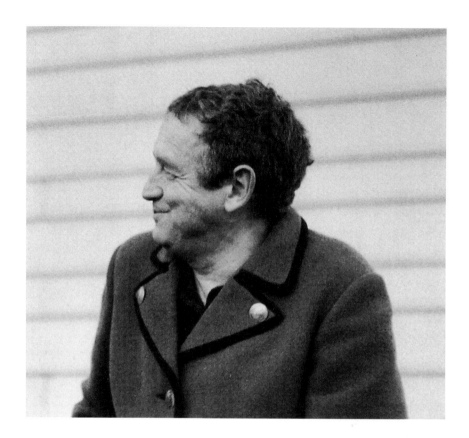

When it is not there he creates it. "He gets bored because of the strength of his nervous energy," Henriette said. "He can't dissipate it in things that don't feed him. You feel that Andy's continually being fed, stimulated, and he demands it. When anything interrupts that—when he isn't painting—then he's just going to be as foolish as he can be. He doesn't care."

Andrew sensed the combustibility in NC, the flash temper, the capacity for physical violence that flowered in the Scribner illustrations—the bloody hand holding a knife, the biceps bulging like rounds of beef, the teeth bared like a cornered rat, the cutlass splintering a doorjamb. "My God, you'd hear the skulls crack," said Henriette. "Apparently he had terrific fights in his youth."

A horrified fascination with violence that runs through Andrew Wyeth's paintings is rooted in his tug-of-war feelings about NC. Like the illustrations, the danger in his father was thrilling. Andrew's eyes gleam

when he says, "My father had a brutal side." There is a kind of admiration in his voice when he tells of a fight with a hired man who threw a hatchet at NC—or when he repeats a story his mother told about her courtship days. The carriage horse balked at a railroad crossing, and NC whipped the horse's head with the reins till the blood ran.

Such violence did not often erupt—but his daughter Carolyn watched as NC exploded at a rabbit hunter and took away his gun, tossing it away into the brambles. There was the day that the wrong plaster cast was delivered—a huge, hideous, curly-haired pseudo-classical head so heavy three men had to lift it. In a fury NC single-handedly heaved it down the stairs into the studio basement. Once there was a fight with what NC called "an ugly, drunken Irish family." He wrote his mother in Needham, "Somehow it gave me zest . . . for after all, to test one's ability and power to land a telling blow after a few years of artistic dissipation is damned stimulating."

Visitors were often invited to the studio to view NC's most recent picture. They sat on a long bench like a bleacher while he paced up and down in front of them, holding forth. Once a young man from the DuPont Company whispered to the person next to him. Grabbing him by the scruff of the neck, Wyeth threw him bodily out the door.

NC's tongue could also flail. Once in 1942 two young men, en route from Florida, stopped by to see Andrew. They were in NC's studio when an electrical storm hit "like some prearranged celestial blitz." The two youths were terrified; one of them was sick in the fireplace. "It angered me to see such a diabolical display of craven fear," NC wrote in a letter. "I gave them a tongue-lashing during most of the fireworks! The impression of their visit to my studio will remain in their minds for some time!"

NC loved going to the Friday-night wrestling matches in Philadelphia with Nat. If possible, they sat in the second row, NC jerking and grunting in his seat, reacting to the wrestlers' thumps and throws. Sometimes he yelled taunts at the huge men. Once a wrestler started climbing through the ropes to get at NC—who took off his glasses and stood up, ready to do battle.

There came the day when Andrew himself suffered the physical violence in NC. When Andrew was eight, one of his sisters told NC a lie— that Andy had boasted to their neighbors, the Kipes, that the Wyeths had more money than they did. Andrew says, "I was no more that type than the man in the moon." Out on the porch NC hit him across the side of the head, knocking him sprawling to the bricks. Andrew stood up, sobbing. NC said, "Don't tell anybody." But the hurt, the disillusion, was indelible.

3

NC set out to make his home a hothouse of the imagination, a creativity biosphere, untouched by outside influences. Each child would be individually shaped according to his or her particular bent. As much as possible NC would be the sole living influence, all rude reality kept well beyond the property line.

"Pa kept me almost in a jail," Wyeth says, "just kept me to himself in my own world, and he wouldn't let anybody in on it. I was almost *made* to stay in Sherwood Forest with Maid Marion and the rebels." Andrew was forbidden by NC to cross the road through town. "Even to this day I'm scared to cross it," he says. But on the other side of this great divide was the little girl of his dreams, Janet Miller, daughter of the postmaster. Once Andrew summoned the courage to invite Janet and a neighbor boy, Buddy Arment, to the house to play. Afterward, NC bawled out his smitten son, "That's a common girl, and I don't want her up here."

Andrew's heart was further crushed when, thrillingly, he was invited to Janet's twelfth birthday party. Wyeth remembers, "Ma wrote her saying I was coming and I was so proud of the letter that I wanted her to think I wrote it." Janet remembers, "The whole family brought him, hanging out the car windows. He came with a big bouquet of roses cut from the garden. He said, 'Am I going to sit beside you?' I said, 'I'm sorry. You're not.'"

By his early teens Janet was more receptive, and Andrew would look around and dart across the road and they would sit on the sofa in the living room behind the post office. Once while Andrew was waiting for Janet, NC appeared to get the mail. "I thought, My God, if he sees me, he's going to kill me," remembers Wyeth.

NC considered even school contaminating. The year Andrew was born, NC wrote: "The sheeplike tendency of human society soon makes inroads on a child's *uns*ophistications, and then popular education com-

pletes the dastardly work with its systematic formulas, and *away* goes the individual, hurtling through space into that hateful oblivion of mediocrity. We are pruned to stumps, one resembling the other, without character or grace."

NC himself had been a disinterested, mischievous student. His elementary education was a one-room, multiple-class school presided over by Miss Mary Glancy—who later taught the Wyeth children during their Needham period. His main interest was art. Dividing his room with a blanket hung from a rope, he created a tiny studio. He frequented a polo field in nearby Dedham, drawing the horses in violent action and selling the pictures to the owners. His father, a hard-nosed man of business, considered art a sissy interest, not a profession. Henriette said, "He thought it was insane and weak to think of just doing pictures."

In NC's first year in high school—the margins of his textbooks dark with drawings—he was such a hell-raiser his father decided to pound home some sense and responsibility and sentenced him to a year of hard labor on a Vermont farm. But his mother intervened. She showed his drawings to a knowledgeable source and, encouraged, worked out a compromise. NC went to a trade school in Boston to learn a true craft, mechanical drawing. After NC's graduation in 1899, his father relented and lent him money for art studies.

In Chadds Ford only one of NC's children received a conventional education—Nathaniel, who was ambitious to follow an uncle into engineering and graduated with a master's degree from the University of Pennsylvania. He and his sisters started out at a Friend's school in West Chester and one by one the girls ended up at home with tutors who took them through high school. "I would not say that I was educated," Henriette said. NC enjoyed announcing, "No top-notch artist ever graduated from college."

NC enrolled his youngest son in the first grade of the Chadds Ford public school. Andrew remembers, "The long days just about killed me." Too hypersensitive for that rough-and-tumble, he became thinner, more nervous, and could not sleep at night. After two weeks in the outside world, Betsy relates, "He talked his parents into saying he was going to die young, so he shouldn't have to go back to school. Imagine!"

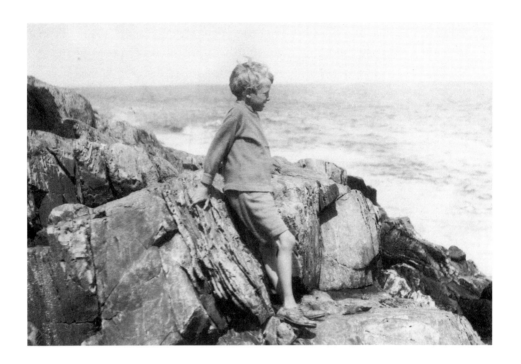

He was permanently returned to the safety of the family cocoon and the good intentions of a series of frustrated tutors. "My father didn't give a damn whether I got good marks," remembers Wyeth.

From the very beginning Andrew was a master of diversions. He turned the hands of the clock forward to trick one tutor into leaving early. When another asked what book he would like to read, Andrew went up to his mother's room, crawled deep under the bed, and returned with a much-perused copy of the unabridged edition of D. H. Lawrence's *Lady Chatterley's Lover*. It automatically fell open to the first sexual encounter with the gamekeeper. The young woman silently studied the pages. As Andrew tells the story, she looked up ten minutes later and said, "I don't think this is suitable." Then she continued reading.

When he was around eleven, his tutor was Lydia Betts, just graduated from college and the daughter of the country doctor who brought Andrew into the world. "Andy thought with his hands," Lydia recollected. "I'd be talking about the

Skinny, eight-year-old Andrew was already fascinated by the tumult of the sea foaming over the rocks of Mosquito Point, near his father's house at Port Clyde, Maine. He spent hours each day drawing his imagination—pictures of pirates and ships, soldiers and swordsmen.

cotton gin, and he'd say, 'You mean like this?' and he'd draw it. And it was right. He was no dumbbell. Just not too anxious to learn."

Lydia resorted to bribery. If Andrew paid attention during the prescribed two hours of teaching, he got a payoff. For an hour she read aloud stories about early American history, about George Washington. "He'd beg me," Lydia remembered, "and then listen so attentively, so appreciatively."

When Andrew was twelve, Henriette married NC's young student Peter Hurd, who was the first person in the family to notice or care that Andrew was not entirely literate. When Peter asked him to look up something in the encyclopedia under *F*, Andrew was helpless. Describing this, Andrew's voice is high with the timbre of outrage. "I didn't know how to read properly. It didn't bother my father. It bothered Pete terribly. I didn't even know my ABCs!" Andrew remembers gratefully, "Pete was very strict with me. He said, 'You've *got* to learn these fundamental things.'"

To this day he best absorbs the subtle tones and moods when a book is read aloud by Betsy Wyeth. His reading for himself is slow, but constant, choosing subjects in some way related to his work. Once on his bedside table were Françoise Gilot's *Life with Picasso*; *Thomas Jefferson: An Intimate History*; Edwin Way Teale's *Wandering Through Winter*; *Sergeant York and His People: A Fight in the Forest of the Argonne*, and an auction catalog from Christie's: *Impressionist and Modern Paintings, Drawings, and Sculpture*.

However, Andrew did grow up in a household orchestrated by NC as a constant Renaissance school. Only the best music, the best poetry, the best books were allowed into the house, only the best fairy tales, the best toys, the best paints and drawing paper—the best artwork. Books were revered to the point that, like edible food, they must never touch the floor. If they were on the floor, something was put under them. Funny papers were banned. When NC caught Ann reading a movie magazine, she blushed with shame. "Although we were raised simply," says Andrew, "we were raised to be little geniuses."

NC's library included full sets of Shakespeare, Goethe, and Tolstoy. He read the current "important" books, such as *The Decline of the West* by Oswald Spengler. He identified with the fated somberness of Thomas

Hardy. He read poetry aloud to the children—Robert Frost, Emily Dickinson, John Keats, Henry Wadsworth Longfellow's *The Song of Hiawatha*. Walt Whitman was "almost a Beethoven in writing." Henry David Thoreau was to NC "my springhead for almost every move I can make," and *Walden* was invoked like the family Bible: "The song sparrow is heard in fields and pastures, setting the mid-summer to music—as if it were the music of a mossy rail or fence-post."

Classical music was a routine part of family life. Henriette remembered that "Don't make Andy cry, why don't you put on clean socks" was mingled with a discussion of Beethoven.

Listening to music on the windup Victrola, NC held his head almost inside the little doors to the speaker. "Pa lowered himself into music," Henriette said, "as though he was going slowly into water." He liked muscular composers. A plaster bust of Beethoven stood on a windowsill of the Big Room. Stravinsky, Bach, Berg were other favorites; Mozart he dismissed as "just moozic." When a record was finished, NC would exclaim, "Dammit, that was splendid!"

By osmosis music became a current in Andrew's sensibilities. Wyeth's aunt Elizabeth, one of the few allowed to watch him at work, remembered thinking that "sometimes when Andy paints, he's hearing something." She added, "You can feel music in his intonations, his spacings."

The Wyeths went en masse to the swashbuckling movies of that time. One night in the 1930s they went to *Mutiny on the Bounty*. Nat remembers that "we were all just ecstatic about it. Coming out, Father, of course, towered above everybody. He sort of herded us to one side and said, 'Turn around now and look at these people. Did you ever see a duller bunch of faces? Look at those expressions. That's the trouble with movies, they don't leave anything for this'—and he tapped his head. "Your imagination goes to sleep.'"

NC was schooling the children to see through the eyes of imagination, which, he said, "inflames my love of life." Inspired by the scene framed by his studio window, he rhapsodized to his mother: "The lilac leaves shudder and fold themselves back into broken heart shapes of new-wet luster, then frantically restore themselves into position to be swept again and again and

again into bright-varnished and twisted shapes. The gray thin limbs of the spruce trees sway up and down in a ghostly slow dance. The deep gloom of the forest beyond remains still, like darkness."

No opportunity was lost to stimulate the children's powers of observation, so that "the background of memories will give them untold pleasure, and *perhaps* be the basis upon which they can build important life work." Driving home from the movies along the narrow, winding roads, NC would turn off the lights of the big Model T touring car. Seeing the familiar landscape metamorphosed by moonlight, he would cry out, "Look at it! Look at it!"

He led frequent family excursions—to a nearby dam in the Brandywine for swimming, or to the rocks in the woods above the house for a picnic, the boys gathering wood to build a fire, NC broiling the chicken or the shad roe. When the children were playing, he would stop and add his ideas. In the sand box on the front porch Henriette made a little railroad with a bridge. NC lit tobacco in the engine's smokestack to make it more realistic. Down at the brook, he made boats out of skunk cabbage leaves carrying spring beauty blossoms as tiny passengers. With a penknife he made a spinning waterwheel out of sticks and leaves, exclaiming, "Isn't that wonderful?"

On early spring mornings he herded his troop to boggy places, damp with leaf mold, where the first spring beauties blossomed white. "It was like the search for the Holy Grail," Henriette said. "The small stars were like the Virgin Mary as far as we were concerned. If Pa had taught us to drop to our knees and pray, we would have done it." She added, "Can't you see Andy's painting related to this?" But Andrew often resented the walks with his tour-guide father. He wanted to make his own discoveries, find his own exaltations.

Still, the very existence of this man and his explosive zest for life nourished Andrew's fantasy till the boundaries between figment and fact were blurred. "His father was a character out of Robert Louis Stevenson," Aunt Elizabeth said. "He captivated Andy every minute. He was everything that would excite a child with great imagination."

Sometimes in the evenings NC sat with the children around his chair and told fabulous stories and made drawings of pirates and Indians, or Old Kriss (Santa Claus by way of Kriss Kringle) sitting in a bathtub. A brownie sliding on his back down a bar of soap; elves swimming in the toilet; giants picking up little children, "doing everything but eat them," Nat remembered. "God only knew what was going to come out of his pencil with *his* mind behind it."

Excitement was Andrew's oxygen. His staff of life was the delicious, romantic horror, the hottest of thrills, that he painted all his life (*Little Evil*, opposite page 54). His thin body sometimes trembled from overstimulation. When NC read *Treasure Island* aloud, he acted the voices of Long John Silver, of Billy Bones. He *was* Quasimodo, the hunchback of Notre Dame. When he read *Dracula* he made all the faces, working the children into paroxysms of imagination. At a moment of agonizing suspense—just when Dr. Jekyll is turning into Mr. Hyde—NC would stop reading. "He scared us so much," Ann says, "Andy half the time didn't sleep that night."

NC found a macabre strain even in Saint Valentine's Day. Betsy Wyeth still shivers at the memory of her father-in-law at the family party: "He wore false teeth and dropped them in his mouth, changed his face into something . . . it was incredible! He *became* Dracula. The heavy man he was, coming toward you with this face—I was absolutely terrified of him. And I was supposed to take this Valentine in his hand."

Andrew's natural playing partner was Ann, only two years older. Her interest was dolls—playacting her mother's joy in domesticity. Sometimes they joined delights, Carol Wyeth happily sitting with Ann on little chairs, discussing the dolls' clothes and counting their knives and forks.

Andrew occasionally took part in Ann's homemaking make-believe. They built a shack of boards and bricks, and Ann made a mud pie in a pan, set it out to dry in a shaft of sun slanting through the crude window. Years later this reverberated in *Ground Hog Day* (page 289), a 1959 tempera of a sunlit plate and cup and saucer on the kitchen table at Karl Kuerner's farm.

But when Ann's girlish games palled on Andrew, he typically broke the boredom by creating consternation. Ann remembers, "Sometimes Andy got

to acting silly, and would do something nasty with a doll—pretend to be a doctor, pick up their skirts, laughing hysterically—and I'd have to chase him away."

Once at a stuffy party the adult Wyeth and his niece, Anna B., took off their clothes and streaked the living room. At another party, he was amazed by the host's collection of lotions, balms, and unguents in the bathroom. Then and there he took a shower and tried them out. Once he showed an X-rated film at his studio—his laughing eyes watching the young audience's reactions. The next day, at an ultraswank lunch, including one of the watchers, Wyeth said to the dignified hostess, "My friend here has just brought back a remarkable film from Paris." Grinning at the friend, he said, "Tell us about it."

The epicenter of the children's world was the basement playroom, part of the new wing added in 1926. The left side of the playroom was Ann's territory for her dolls and dollhouse. In the rear right was Nat's corner with his workbench and wood lathe. Andrew's area was along the right wall. Cutlasses with tarnished brass guards, crossbows, shelves of toy soldiers, trains, a hook and ladder that pumped real water, his Admiral Byrd setup—igloos, a plane, toy figures with fur-rimmed suits, and fake, glistening snow. "We had toys beyond belief," Henriette said. Whenever NC made a trip to New York, he arrived home carrying large boxes from FAO Schwarz, which Henriette remembered as "the cathedral of our lives."

For a time the playroom was infested with red ants. Andrew and Ann and their cousin Mary Sargent—Aunt Elizabeth's daughter—drew ferocious posters that they plastered on the door. Ann drew champagne glasses with devils inside, the bubbles floating up around the horns. Andrew painted red ants wearing German helmets, carrying guns with bayonets, shells exploding in the air. The pictures screamed: GET OUT RED ANTS. WE'RE GOING TO KILL YOU. KILL. KILL, KILL. To their delight and only semi-astonishment, the ants disappeared.

On the playroom floor Andrew and Ann laid out adjoining farms, populated with toy animals. Andrew used Nat's drill to bore holes in the wood floor and insert trees made from branches broken from the boxwood

bushes. Nat built Andrew a barn—"foreign looking," Ann says, "like Switzerland, like Kuerner's." Ann had a cow on rollers. Andrew's cow, given him by his sister Carolyn, was on a stand—reincarnated in 1960 in a painting of a young bull like a huge toy in the yard of the Kuerner farm.

When the farms were set up, Ann often lost interest in hers. This is still hard for Andrew to take. "I loved it that I *played* with the horses and the ducks and this miniature world. I wanted to create this thing and *use* it, let my imagination go. I've always gotten steamed up as I go along, get more and more intoxicated." In feverish motion, humming to himself, knocking pieces over, Andrew set up his soldiers marching down a tree-lined road. Once, with a touch of Grand Guignol, he laid a toy tractor-driver on the road— and made engine noises as he backed up a car and ran it over the body.

Even in play Andrew followed his father's principle that mood is everything. Too much fact constricts fantasy; imagination feasts on the hidden. Andrew and Ann set up model railroad tracks running into empty cardboard boxes. The dark, invisible interiors became mysterious and threatening, became railway terminals during World War I. On the old windup Victrola Ann played *The Victory Ball*, trap drums rustling in the distance, rattling louder and louder, rising to a heart-pounding crescendo of calamity.

Ann remembers, "Very little was said. We could just *see* the soldiers, their helmets approaching the scary dark place, and feel the confusion and terror of war, the station full of trains, the coldness, the dreariness of the curving tracks. It was horrible. I wouldn't even put my fingers on the tracks. Tremendous excitement out of nothing. We did it over and over again."

Both Wyeth the child and Wyeth the mature artist have been about melodrama—about death and danger tranquilized by romance, fantasy mutated from reality. "You don't have to paint tanks and guns to capture the war," Wyeth says. "You should be able to paint it in a dead leaf falling from a tree in the autumn."

Crucial to Wyeth has been the continuing, uncluttered clarity of his childhood emotions. He still keeps around him the objects of those years and they still awaken those fantasy realms, keep alive those excitements. While Lydia Betts was tutoring Andrew in the playroom, he kept glancing over his

shoulder at the rows of toy soldiers on his shelves—"as though afraid they might shoot at us," said Lydia. Those little figures—his silent companions—still stand in regiments on the shelves of the huge sideboard in his studio—and two army bands concertize on a windowsill. He has continued collecting soldiers, some two thousand marching, running with swords, kneeling and firing guns. He has buglers sounding the charge, drummers, flag bearers, horsemen carrying flags, soldiers in black hats and white pants. He has a horse-drawn Red Cross wagon, field kitchen, and cannons.

In his boyhood war games, a scratch on a painted face became a smirk; a worn spot, a mustache or a cruel wound. Ann, still annoyed, protests, "Andy always had the running soldiers, the shooting ones, the ones in olive drab he'd dragged around, that had red paint on them, bandages. I always had to play with the stiff West Point cadets."

Sometimes battles were waged outdoors in the soft earth between the house and studio, where Andrew dug trenches and erected ramparts. Rock bombs landed with huge explosions. When a soldier died Andrew entered that body, screaming and writhing in death throes. Indoors he deployed his soldiers in pictorial, decorative pageants that his mother allowed for days and days on tables or on the floor of the Big Room. Peter Hurd, who had spent two years at West Point, tried to instruct Andrew in actual military tactics, marches, and countermarches. Henriette said, laughing, "Of course, for Andy it's all swathed in glory and flags. He's another peace lover, like Peter, who adores the trappings and romance of war."

Wyeth explains, "The times I liked best were when I would work out my own little life with my toy soldiers. I built my own stories, and that is the way painting has been to me—a constant new experience that I want to carry through to the end. They were real little people to me. I'm not sure I can comprehend the big world. I'm not a big, powerful painter, doing great big forms. That isn't my interest."

Finished with tutoring by midday, Andrew was on his own all afternoon. "I was brought up by a father who believed in strong discipline," Wyeth says, "and yet freedom at the right moment." Often he went to his father's studio, the Vatican for his solitary imagination, filled with the source mate-

rial collected to stimulate NC's own fantasies. In the damp entry, cool as mountain air, hung a steel engraving of a steepled village, a lake, and a distant snowscape. It is the Swiss-German town of Thun, near Bern, and Andrew studied it by the hour, a window into the Swiss ancestry that would always race his imagination, make him feel special, give him a gloss of romance.

Beneath the Thun print was a cupboard of World War I lore. There were stereopticon slides that became three-dimensional in a special viewer, and stacks of wartime rotogravure sections showing World War I scenes. Off the foyer was the room where his father's greatest illustrations were stored. Sir Nigel fought a duel. Blind Pew tapped down the moonlit road. Robin Hood met Maid Marian. King Arthur received the sword Excalibur from the Lady of the Lake. Andrew, spellbound, steeped himself in his father's work. He lugged pictures almost his own height into the studio where NC stood painting, feet planted like a boxer's, the big, paint-piled palette as wide as a wing. On the canvas his brush moved rapidly, boldly— and then he wiped it on his plus-fours.

When Andrew leaned an old illustration against a table, NC stopped work and talked about the scenes and answered questions from his son, the only person in the family interested in these past pictures. "My relationship with my father was different from the rest of the children," Wyeth says. "It was through his illustrations. I fed on them and I think he felt this about me."

In the studio Andrew physically inhabited the long movie playing in his imagination, his world of gilded violence. In this era of showplace studios, NC had surrounded himself with a virtual museum of props. Andrew read and reread volumes on medieval armor. There were models of a Spanish galleon and a two-masted schooner, plaster casts of George Washington and the Marquis de Lafayette.

On one wall hung a World War I helmet, canteen, and gas mask, and a flintlock rifle that belonged to a companion of Daniel Boone. A birchbark canoe hung from the ceiling. There was a collection of antique pistols, a cupboard containing animal skins, a squaw dress, and a papoose carrier. The Indian drum was NC's desk chair. He still had his western chaps and, lying on the floor, his western saddle.

Little Evil, 1982

In Maine Betsy bought an antique black doll and paired it with a stuffed, arching black cat—a still life of Halloween horror. The props of Betsy's life have always been grist for paintings—her raspberry pie set out to cool, her berrypicking pail hung on a rocking chair, her fur hat on a stair's newel post.

These western artifacts were memorabilia of NC's young manhood. After he graduated from the Pyle school in 1904, the *Saturday Evening Post* and *Scribner's Magazine* invested in his future. They sent him West for three months to gather firsthand material on the Indians and cowboys. He worked a cattle roundup at a Colorado ranch and was a mail rider in New Mexico and Arizona.

NC wrote home that "the fascination of the life clutches me like some unseen animal." On a roundup he was in the saddle for twelve hours a day, sleeping on the ground, roping his saddle horse from the herd each morning, wearing a six-shooter and woolly buffalo-hide chaps. His mail route covered 75 miles of desert each way. He slept with Navajos in their hogans and ate horsemeat. Once he rode 120 miles through the high winds of a snowstorm. He experienced the death of another cowboy, kicked by a horse. When a horse died, NC cut it open with a knife to study its anatomy. At an informal rodeo he watched a black man who threw a wild steer with his teeth. "He succeeds in sinking his teeth in the poor steer's nostrils," wrote NC, "and with a powerful wrench, hurls the brute to the ground."

For Andrew the heart of the studio was the huge collection of costumes stored in chests. Dressed in these authentic uniforms—some inherited from Howard Pyle, whose pictures Andrew was also studying—Andrew could actually *be* the characters that excited him—a Revolutionary soldier, a musketeer. NC himself had worn Pyle's costumes and now shot home movies of Andrew as Robin Hood, as the monstrous Mr. Hyde. In later years Wyeth added to his father's costume collection. To *feel* military and German, he dons a uniform coat that belonged to Gen. Erwin Rommel.

Most of the other children in Chadds Ford cast Andrew as an outsider, strange, queer. With his odd hip condition that kept him from running normally, he felt like a cripple. Not athletic, never part of school life, sharing none of the ordinary concerns, eccentric in his interests, Andrew felt misunderstood, an oddity on the fringe, and is still embarrassed by his limited schooling, his uncertain spelling. He says, "I felt so left out from other kids! Paint was my only point, my only chance." On another occasion

he once said, "I don't fit in. I pick out models who are misfits and I'm a misfit. There's a stigma."

Wyeth identifies with the prehistoric men who made the drawings of bison and horses and deer on the wall of caves visited for no other purpose than art. He speculates that these first artists could have been men who were flawed, who were deformed or crippled or too weak to be hunters. Art was the one way they could have a position, could find recognition in their society.

As a boy he drew a few congenial, trusted cohorts into the circle of his excitement—a domain in which he was the fountainhead, the king. There were Buddy Arment and Brinton Kipe and especially David Lawrence—known far and wide as Doo-Doo—a boon companion who lived in the black community on the way to Kuerner's farm. Sometimes Ann joined them, and cousin Mary Sargent, who spent vacations with the family. On weekends and after school, in NC's costumes they acted out Andrew's fantasies of derring-do.

Mary Sargent remembers him "incandescent with ideas" as he organized his followers into the day's adventure—"like some robber baron," laughs Aunt Elizabeth. Sometimes the cohorts played World War I. Once eleven-year-old Andrew received a note from Buddy Arment. It read, "I hear the Muse [*sic*] river is in our way and if we try to swim it, we will be mowed down. Send boats and more food and ammunition at once." It was addressed to "Commander Andy."

Still fussed by sibling rivalry, Ann affectionately complains, "Andy was the smallest and he always took the best part and got the best costume. He was always Robin Hood, always D'Artagnan. He knew how to handle us. We all loomed over him. But he instilled something in us."

Andrew's D'Artagnan wore a wig of long black curls, a white plumed hat, painted mustache, leather jerkin, knee britches, tights, and a sword belt with a real rapier in a leather scabbard. "He was Errol Flynn," Ann says. "Still is." Later Wyeth purchased Flynn's pirate movies to run on NC's antique sixteen-millimeter projector, and when Wyeth was invited to Ronald Reagan's White House, he brought the receiving line to a halt for ten minutes while he and Reagan discussed Flynn in a film the two actors had starred in: *Santa Fe Trail.*

Andrew's favorite role was Robin Hood—wearing tights, a loose jacket, a longbow over his shoulder and quiver full of arrows on his back (page 58). David Lawrence played Friar Tuck. "Doo-Doo had great imagination; more imagination than any white boy I ever met," Wyeth says. "He dressed in black with that cowl—and his marvelous black face and whites of his eyes. Oh, God, it was wonderful."

Andrew's best friend and constant companion was Doo-Doo Lawrence, who introduced him to the black enclave over the ridge behind N. C. Wyeth's house in Chadds Ford. Another playmate was his red Irish setter, Sanco, who lived to the age of twenty-seven and, Wyeth says, "became like a human being to me."

The Merry Men wore peaked hats, jerkins, and hose. They carried scraped saplings, called quarterstaffs, and had wooden swords made by Nat. "The more we could carry," Wyeth says, "the more we looked like the figures out of Howard Pyle and N. C. Wyeth."

They spoke their version of Elizabethan English, filling the woods with cries of "Varlet!" "Knave!" and "Fie upon thee!" Mary Sargent remem-

bers Andrew and Doo-Doo "having swordplay with wild gesticulations, the small white and black arms and legs making a marvelous moving design." They made camps hidden from the mayor of Nottingham and roasted potatoes in a fire against the big rocks.

Once, taking from the rich to give to the poor, they swooped down on a wealthy squire—a boy delivering groceries. Distributing to the poor, they took the food into the woods and ate it. Once Janet Miller and a friend were riding to a nearby town in a horse-drawn sleigh. "This band of Robin Hoods," Janet says, "came tearing out of the woods, whooping and hollering and carrying on. Scared us half to death." Andrew laughs at the memory. "Of course, I wanted to be the gallant one and save this young girl."

Sometimes the other kids had trouble matching the intensity of Andrew, who *was* Robin Hood. He was frustrated when late in the afternoon they drifted off home. "They were doing these things just for the moment," Wyeth

For several years around 1930 Andrew assembled a willing band of "Merry Men" who acted out episodes from *Robin Hood.* From left are: Harry "Buddy" Arment as Little John, cousin Mary Sargent as Allan-a-Dale, sister Ann as Will Scarlet, Andrew as Robin Hood, Bill Seal as a bowman, Doo-Doo Lawrence as Friar Tuck, and Betty Seal as another bowman.

says, still annoyed. "They never knew we were doing something I'd been into all week. I never told them. To me it was sort of like building a painting. When I get an idea that means a lot to me, I just bury myself in it—a constant new experience I want to carry through to the end."

Robin Hood is still in Wyeth's bones, still part of his emotional vision, like an Indian's sense of magical spirits in objects and animals. Robin is a major part of the constantly unreeling movie that Andrew paints, transposing the small stage of his boyhood dramas into the framed theater of his pictures. On that miniature stage, his boyhood horrors, rages, tragedies still live like a visual subconscious, all the more intense because they are capped, compressed, concealed.

The core inspiration for a painting, the first trigger for the flow of metaphors, is deeply private. To explain those fragile fantasies would risk the very foundation of his excitement, of his work. But very late one night, his eyes gleaming, he did talk about *Spring Fed* (page 61), his 1967 tempera of the trough in the Kuerner barn, a steel bucket hanging on the wall beside it, a rivulet of water overflowing the stone edge into the lap of the viewer.

The water flows by gravity from the bowels of the Kuerner hill, "like life itself, endlessly moving," says Wyeth. There is a feeling that just off-stage, beyond bovine peacefulness through the windows, something terrifying has just happened, "as though the German army has just marched past." But at the core of Wyeth's imagination, the tempera is about the death of Robin Hood.

In Wyeth's version of the story, the wounded Robin is taken to a nunnery and locked in a room and bled. He bleeds for a day and a half. His followers hear a faint trumpet, which leads them to the nunnery. Little John breaks down the gates, heaving a huge boulder which to this day has not been moved. Inside, he flings himself against a door and there in a pure white room on a stone slab, covered by pure white sheets, is the dying Robin Hood, the blood running from his veins down the stone, his helmet by his head.

Andrew crystallized his fantasy dramas with little plays he put on in Ann's white-and-gold toy theater with its proscenium arch and red muslin curtain.

He towed across the grooved stage, in front of castles and gothic land-scapes, the cardboard bowmen, pikemen in helmets, knights on horseback, and friars and fair ladies he cut out and painted. He did all the voices. A family friend, Pultizer Prize–winning author Paul Horgan, made audience boxes filled with sixteenth-century Elizabethans. Ann played the back-ground music on the Victrola, Andrew sold tickets, and the whole family solemnly watched and applauded.

He put on *Treasure Island*: "Captain Bill Bones! Old Blind Pew, your shipmate. I have come to kill you for blinding me." He did *Robin Hood*: "Robin, I think you should go into the world alone in search of adventure. A week from today you will go." "Yes, my Lord."

Betsy Wyeth has said, "I always think of Andy as a little theater. He's the Globe Theater."

The annual, climactic orgy of imagination in the Wyeth household was Christmas, the culmination of NC's campaign to trace "a fascinating, mystic pattern on the minds of the children." The excitement, the exhila-rating terror of the supernatural brought to life, was almost traumatic. "Magic!" Wyeth says. "It's what makes things sublime. It's the difference between a picture that is profound art and just a painting of an object."

Each year Carol Wyeth took Andrew and Ann into Philadelphia by train—three in the seat, Ann and Andrew at the window, Carol on the out-side—to Wanamaker's department store. Wyeth still recalls the sensation of the train tilting slightly as it passed Ring Road and ran alongside Karl Kuerner's farm. He and Ann would imagine another child taking a later train, seeing these same things out the window, wondering what he or she would be thinking.

Both Ann and Andrew remember their mother's patience and enthu-siasm. At Wanamaker's they went first to the fabric department, where Carol fingered the cloth. Then they went to the toy department. Ann headed for the doll section. Andrew knew his mother watched to see which toy soldiers he most admired. They ate lunch in Wanamaker's Crystal Tea Room. Before going home, Carol sneaked back into the toy department and bought the children's Christmas presents—while they peeked to be sure she got the right things.

Spring Fed, 1967

The water trough in Karl Kuerner's
barn took on endless metaphoric sig-
nificance—which is Wyeth's way of
stirring the emotions he hopes will be
transmitted onto the flat surface. The
painting is about sounds, the clang of
the bucket, the crunch of hoofs of the
Brown Swiss cattle, the trickling
water, "nature pouring itself out,"
says Wyeth. It is about the possibility
of something dangerous just offstage.
But at the very core of Wyeth's imagi-
nation, the tempera is Robin Hood
bleeding to death in a nunnery, his
life's blood running from his veins, his
helmet by his head.

Andrew bought his father's present each year at Gallagher's General Store, spending the money he earned bringing water up to NC's studio, five cents a trip. Often the present was Limburger cheese, his father's favorite, and the fumes were a signal of approaching Christmas. In the Big Room Andrew and Ann practiced Christmas Day. They put small objects where the tree was going to be—an ashtray, a book, a pen, an old toy—and went upstairs. Then they raced down into the room, exclaiming, "Oh, look at this!" Wyeth says, "Even with the drab settings I paint, Christmas is under there. It's in my feeling for certain colors, the tans, the color of reindeer. It's in the strange mood of a landscape, that quality of Christmas Eve night."

On Christmas Eve the children hung their stockings on their bedposts and presents appeared mysteriously during the night. Sometimes Andrew awoke quivering with anticipation. He remembers lying there in the dark: "I could almost hear the sound of sleigh runners on the snow. Strange feeling." One night he reached down to the foot of the bed and ran his hand up from the toe of his Christmas stocking, feeling the different shapes. At the top he found a long, skinny elf with big feet and a head with a pointed hat. "I felt it," he remembers, "and wondered what it was and didn't want to turn on the light—I didn't want to spoil things, and my father would raise hell if we woke up too soon. I remember clutching this tiny figure to me in the dark. I could smell the new paint on its face. I felt the long nose."

Years later, in 1962, the elf was reincarnated in the long figure of old Tom Clark, one of Wyeth's black friends, lying asleep on a patchwork quilt, pointed nose and big feet aimed upright. Painting Tom in *Garret Room*, he thought about that moment in the pre-Christmas darkness, and the floppy, collapsible feel of the brownie as he carried it everywhere, till nothing was left but a wire stick figure and a small clay head.

NC Wyeth was re-creating his mother's Old World, Swiss-German Christmases in Needham, but he pumped up the rituals with the adrenaline of horror. Old Kriss became an awesome sorcerer, at once benign and terrifying—in fact, an exaggerated version of NC himself. "Old Kriss was always this marvelous merry spirit," Wyeth says, "and also a huge, terrifying

giant. I thought he was *evil*. I thought he was punishing me when I didn't get things I wanted for Christmas. I thought he knew more than he should have known about my intimate thoughts. I sensed that in my father, too."

During those nights before Christmas, overexcited and apprehensive, Andrew sometimes wet his bed—and just moved to the other side and let the sheet dry. Around 4:30 on Christmas mornings he heard above his head the stamping of heavy boots, the ringing of sleigh bells, a booming voice shouting to the reindeer to quiet down, the scraping of a huge bag dragged toward the chimney. Andrew's skin crawled with goose pimples. Up on the roof, living his role, NC was almost weeping with excitement.

Then Christmas coursed through the house like a burning fuse. Lights snapped on. NC often varied his make-believe. Sometimes, after his theatrics on the roof, he came up the stairs, his big boots thunderous, a slow tolling of doom. Huge in a padded Eskimo costume, a long beard, white eyebrows that sprouted straight out, he shook hands with every child—except Andrew, who crawled under the bedclothes and lay shaking, holding his breath till his eyes popped.

There came a time when the children might be old enough to doubt. On Christmas morning NC gathered the children at the living room doorway. In the gloom by the fireplace, Old Kriss slept in the big chair, chin on his chest. Suddenly the head—pulled by a string—jerked up. The children, remembers Ann, "scuttled up the stairs like mice, practically throwing up with terror and excitement."

To Andrew this was the quintessence of his father. "He made us sense Old Kriss, the light catching on the corner of his big bag full of toys. It's the way he finally painted Blind Pew coming down the road in *Treasure Island*. You look at the picture and there's no detail at all. Just a gleam of a tooth in the face, no costume at all, just one button showing. He based that on nothing."

Allowed into the Big Room, the children were exhorted by NC to take their time, look at the lights, make it all last, taste it. Holly and greens wreathed windows and paintings. Under the mantel was NC's oval watercolor of Old Kriss, surrounded by a wreath of silver paper. The only light came from the

fire in the fieldstone fireplace and the real candles burning on the Christmas tree, their tiny flames reflected on the tinsel like individual halos. The warmth spread the scent of balsam through the room.

Each child had a special present. For Carolyn one year there was a pair of grayish blue doves, caged in a box, its interior painted silver. Ann received a doll table, chairs, little candlesticks, and always a new doll from her mother, who sat with the latest doll on her lap counting on her fingers how many Ann now had, "One, two, three. . . ." Ann felt sorry for older Henriette, getting only silk stockings and books—"How pathetic."

One year under the tree there was an elaborate, medieval castle for Andrew. "When he gets excited," Ann says, "his face still does the same thing. He opens his eyes wide and there's a light . . . he almost . . . he's out of himself for a few minutes." The castle was built by Nat, who remembered NC painting the stonework with vines growing up into the crenellated towers: "His brush went so fast and he put a stain under one of the windows and said, 'That's where one of the lazy guards had to go to the bathroom; he just let it go out the window.'"

For the castle Nat later built a tiny torture cage that could be hauled to the top of a tower. Years later, describing it, Nat moved right into the Wyeth imagination, telling how Andrew locked an enemy knight into the cage. Nat said, "I don't know whether he let him die. But the fellow was almost bones by the time Andy took him out. And there was a big buzzard there, waiting for the remains." Nat added, "Andy would always make the most of something like that. He loved anything that was gruesome."

When the children were released by NC, Andrew remembers, "It was a mad shambles, shouts of enthusiasm, hills of wrapping paper, the dogs in it all, pulling. The place was a wreck." Carol Wyeth remembered "electric trains all over; you couldn't step for trains—and dollies and everything! It was a great big nursery."

Gradually the dusk of early dawn pushed away the darkness. A thin snow whitened the ground. In the silence a dog was barking. As lights snapped on in the distant houses, the little town sparkled like the tree. "I remember leaving the big room to get something," Andrew says, "and everything seemed so sad and cold and lonely and then you'd go back into

the Big Room with the fire going, and toys and things all over the place—I've always kept that deep impression."

Christmas filled the house for days afterward. Outdoors, Andrew and Ann released long ribbons of colored wrapping paper onto the snow and pretended they were wriggling paper dragons. After sledding in the cold, Andrew would come indoors and lie under the Christmas tree, smelling its pungent perfume, studying the galaxy of ornaments in the sky of spruce. Each year he searched out the pudgy-faced angel with little wings, one foot melted off as it twirled in the hot updraft from a candle. During the Indian summer of 1970, he painted young Siri Erickson standing nude on a granite outcropping in a Maine spruce woods. "I didn't paint Siri because she was a beauty," Wyeth says. "That had nothing to do with it. It was this husky little figure looking off with that pale blond hair. It was the figure of that little revolving angel against the Christmas tree. That's what a primitive painter does—takes memories and makes them into a reality."

At night Andrew and Ann felt sorry for their Christmas toys down in the chilly playroom. So they brought them back up and put them under the tree, even wrapping them in their boxes.

The tree was the talisman that kept the Christmas rituals alive. Finally, long after New Year's, the needles would begin to fall—and Andrew beneath the tree could hear the slight ping as a needle hit a glass ball. NC lit the candles one more time, and, slightly nervous that the house would go up in flames, the family sat around it, admiring, saying, "Terrific."

"Do you remember when you first fell in love?" Wyeth asks. "It's an amazing magic, isn't it? Through the years you're apt to lose it. But you don't miss it until you get it again sometime. That's the awful part. You don't know when you lose magic. But I'm *still* sad when Christmas is over and glad it's over. Yes, Old Kriss was horrifying. But magic. Anything that is good is horrifying . . . and sad."

The Andrew Wyeth who became famous was wholly formed by the age of fifteen, his certainties and strategies in place. From the time he first picked up a pencil, he followed an almost feral instinct for self-preservation. Wyeth has kept his interior, childlike sensibilities unchanged. "Andy has the belief and excitement of a six-year-old," Henriette said. "He has never lost the Christmas morning excitement." All his life Wyeth has been *thrilled* by a flick of morning light on a red apple.

From boyhood with clear eyes Andrew watched NC compromise the convictions he preached. His father's lofty idealism was inevitably disappointed. His need to be the total source made him vulnerable when the family—which he called his "shrine"—collapsed from within when the children asserted their independence and found their particular ways to slip his grip. "We were marvelous while we were still very small children," Wyeth says. "But as we matured, we were a drain and an unimportant drain."

Watching the disintegration of his father and the family, he instinctively understood that the *way* he lived could affect the *way* he painted. Determined not to repeat the mistakes of his father and siblings, Andrew managed to flourish in the force field of his father, benefiting from the positive and learning from the negative. He was untouched by the forces that gradually disintegrated the family biosphere: invasion by the sophistication of the outside world; Henriette and Carolyn's rebellion against the ambitions and standards projected by NC, which was impossible for all but Andrew.

The burden of NC's expectations has pervaded the family even to the third generation. "That's where my insecurity comes from," says his granddaughter, Robin McCoy, who never knew NC. "We grew up thinking how Grandpa would think and what *he* would do. And nobody could ever mea-

sure up to my grandfather's expectations because they were all bigger than life. That was at the bottom of our whole life and my mother's life. In some ways it has destroyed most of us."

Until 1921 when Andrew was four, NC had largely controlled the influences molding the Wyeth children. That year, commissioned to paint murals for the Federal Reserve and First National Bank of Boston, NC transplanted the family, lock, stock, and pony, to Needham, Massachusetts, ten miles southwest of Boston. Permanently lonely for his mother, his one "sympathetic, resourceful friend," he half-planned to settle permanently in Needham, where he bought his grandparents' white Colonial house next door to his parents.

During the Needham sojourn, Henriette at age fourteen began breaking loose from her father's spell, and Andrew believes that it was she who ended the family's innocence. Though she worked with her misshapen right hand, Henriette was the art prodigy in the family, not Andrew. When she was eleven, NC had begun her academic art instruction in his studio. He wrote to his mother, "Henriette's natural ability to draw is so astonishing that I hardly know what to do about it."

By the time the Wyeths moved to Needham, NC felt that Henriette was too brilliant to profit from his teaching, so he encouraged her to study in Boston. She traveled daily to the city to train with her father's former teacher at her father's former school, the Normal Art School. Now, too, Henriette could avidly pursue her interest in a wider world of the arts. Often she stayed in town and steeped herself in opera, ballet, and the Boston Symphony. To Wyeth, who believes that sophistication is devastating to pure emotional responses, this was a tragedy. "She would have been better off staying with her father," he says.

For Andrew, Needham was the early source of his complex, lifelong feelings for New England and his Swiss-German heritage. There were two Swiss great-uncles, Denys and the enchanting "Uncle Gig"—and visits to the Holzers, NC's second cousins. Andrew says, "I remember going over there and being horrified by the terror of these German people—enormous bowls of soup put in front of me—once I burst into tears because I wondered how I could eat it all." He continues, "Those early experiences

are what you feed on. It's fresh. It's open. Innocence is such a terrific thing. And knowledge ruins it. I got to know Maine through Needham. I've always felt I've had a real love for pines because of Needham."

In 1966 Wyeth painted the tempera *Far from Needham*, a huge boulder in a Maine field, backed by the spreading reach of a spruce tree. It is in part his memory of naps he took in the cupola of his grandparents' house, lying beside the calming presence of his beloved grandmother—known as "Aunt Ma"—who told him stories till he fell asleep. During the sleep he would hear the siren whistles of the fire department. "They haunted me," Wyeth says. When he woke, Aunt Ma was gone. In the quietness he could still sense the size, the space of her large, absent form as he listened to the soughing of the wind in the pines and watched the waving bows.

Aunt Ma was an influence teaching Andrew to see what was under his feet. His sister Henriette remembered, "She got us all so interested in how flowers grew—the way she would talk about bulbs sprouting through the brown leaves that covered them, protected them all winter."

The Needham episode ended after two years. According to his younger brother, Stimson, NC's tendency to dominate soured the whole Needham scene. Also, walking in the woods, NC discovered that Carolyn had built a tiny, secret replica of the Chadds Ford home, the house, the barn, her chicken coop and pony pasture. He realized that for everybody's sake, it was time to move back home.

In Pennsylvania, at age six and a dervish of activity, Andrew was a preter-natural watcher. He was well aware of the slow-motion collision between NC and Henriette, which shook NC to his very roots. Father and daughter were equally brilliant, searching minds—in a way, NC confronting himself. Nat Wyeth remembered, "Henriette couldn't stay in the same house with my father because they just opposed each other at every corner. She always had a reason why he was wrong, and he wasn't used to being told that."

"Pa taught us to think for ourselves," Henriette explained, "and I was going to go my own way. As I changed and became more knowledgeable and more . . . I was very happy, and, God, I could see all kinds of things ahead of me. But he didn't like that because he wasn't in charge."

At sixteen Henriette was small, reed thin, a knockout flapper with a boyish bob, sparkling, witty, brainy. Visitors to the house thought her fun and attentive, and she worked hard at household chores. But Henriette found Chadds Ford "rather prosaic and mundane, socially narrow and confined and rather stupid." She enrolled at the Pennsylvania Academy of the Fine Arts, and pursued the interests stimulated in Boston, often staying in Philadelphia for the theater and ballet. "I was a bright-eyed girl with absolute blazing interest," she said, "and I always managed to get backstage and tell the actors and dancers how marvelous they were—and then begin to cry with emotion and excitement and blow my nose."

She was offered an acting role in a local theater and, with her pure but small singing voice, had fantasies of an opera career. But she felt that her misshapen hand, which prevented her from playing the piano, was a fatal handicap. She hid it inside fashionable kid gloves and joined the social orbit in the Wilmington countryside, the seat of the French-American du Ponts and rich with landed gentry. Henriette foxhunted. Pursued by young and not-so-young beaus, she danced all night at coming-out parties at which real orchids were pinned to the walls. At one point she accepted marriage proposals from two men. "I felt detached from the family," she said. "Sort of elegant and very sophisticated."

In Henriette's memory her mother was "in perfect sympathy with me, quietly, with a wonderful gleam in her eye." NC was strongly disapproving. He kept criticizing her for being superficial and frivolous, "not as somber and real as great art required," Henriette said. She continued, "Then he would quote Thoreau. I loathe Thoreau. The man was a dope. Totally selfish. If I meet him in heaven or hell, I'm going to pull his great big nose."

But after a conflict Henriette would do something to make her father happy with her, would pick violets and bring them to him in a bouquet. "I loved Pa, and he knew it," Henriette said. "But he was wrong about me. I have never thought life is a joyous rosebud opening every morning. He wanted me to weigh 250 pounds, never marry, paint all the time. Be a kind of nun."

Soon, going on eighteen, Henriette found her escape. A friend of NC's who lived in nearby West Chester was Joseph Hergesheimer, a popular historical novelist and minor literary lion, who once wrote an essay

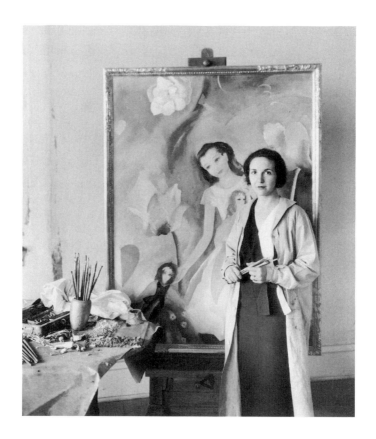

titled *The Feminine Nuisance in American Art*, saying that American literature was "being strangled with a petticoat."

Henriette was dazzled by Hergesheimer's silver tongue, the equal of her own. She once explained, "Pa said wholesome, classic, four-footed images. Joe wrote the way the best French impressionists painted, created tremendous romantic images." Hergesheimer commissioned her to paint a portrait of his wife, Dorothy, and, to that end, Henriette lived several weeks in their home. He supplanted NC as mentor. "You look at the good earth and grass and rocks and rippling brooks," Henriette said, "but then you never see gold and jewels and silver and polished wood."

The Hergesheimers invited her into their life. "He was crazy about Henriette," Wyeth says, "because she kept the table at a roar. She was some-

In 1931 Henriette, married to Peter Hurd, painted her own fantasies: fairy-tale rhapsodies that were her version of N. C. Wyeth's muscular flights of imagination. She went on to do flower paintings, exercises in pure beauty—along with developing a career as a commission portraitist.

thing else." In New York for play openings, they stayed at the Algonquin Hotel during the era of the celebrated wits of the Round Table. They went to *Twentieth Century* with its coauthor Charles MacArthur and his wife, Helen Hayes, who became lifelong friends. Backstage she met Gloria Swanson, coming offstage in a mink coat. In the dressing room Swanson let the coat fall—and under it she was stark naked. "Beautiful body," Henriette said. "Just like a twelve-year-old—everything firm and in place. There it was."

The actress Carlotta Monterey, later Eugene O'Neill's wife, taught Henriette how to drop her voice into her chest. The writer Carl Van Vechten was a friend. At parties George Gershwin played *Rhapsody in Blue*. "I sought out," Henriette said, "the very people that Pa and his great, very robust, handsome, solid, burning, passionate devotion to classical behavior and classic art could not understand. He thought I was eating sugar candies instead of orange juice and oatmeal."

Ultimately Hergesheimer told Henriette that he wanted to divorce his wife and marry her. She remembered, "He told me [about] the diamond bracelets he would give me. He was really after me."

When the portrait of Dorothy Hergesheimer was finished, Henriette left it in NC's studio. The next morning at 6:00 A.M. he came into her bedroom as she lay in her canopy bed. He said, "Henriette, I want to talk to you." He gave her hell for the portrait, said it was slick. She said nothing. After he left she dressed and went to the studio, put the portrait in the fireplace, and burned it up. Nothing was ever said.

The story of each of the Wyeth children is their individual strategy for self-preservation. By nature an unbridled eccentric, Carolyn was the family's lifelong rebel. "I wasn't the way my father wanted me to be," she once said. "I was the odd one."

Like a spoiled child, her feelings have always lived on the very surface of her skin. Achingly needy, defiant in her vulnerability, kind and manipulative, she could jerk from love to rage, belligerence to fear, laughter to tears in the space of a breath. In her uninhibited gusto she could be fascinating and fun. Henriette remembered, "By God, she had a power about her that if

people couldn't enjoy and feel, they were crazy. It was destructive in many ways, but remarkable and arresting. But my God, what a . . . whew!"

Carolyn was, in fact, the wild, dark side of N. C. Wyeth that he tapped for the explosive drama of his early illustrations. To him she was a living reproof acting out the qualities he knew in himself and disliked. "I'm too much like Pa," she once said. "He did everything in a big way; if he bought paint, he bought too much paint—which I do. Do everything in a big way. If I got drunk, I got drunk as hell. Eat too much. People say I'm too forceful. Certain members can't take me in this family. Andy can. They're conservative, I'm afraid. Ashamed of me."

Henriette's earliest memory of her sister was of Carolyn in a wicker high chair jamming food in her mouth with her hands, stuffing it till she vomited. NC had to clean the wicker with a hose. To contain his daughter, NC made a cage from a crib covered with chicken wire.

When she was four, NC described Carolyn's lifelong essence. "Sis Carol is as broad as she is long and her cheeks are like moons! She pounds through the days like a warhorse and seems never to weary. Her burly figure pushing an old doll coach retrieved from the dump, or dragging by one leg a disemboweled rag doll, is a common sight."

Called "the big noise" by NC, Carolyn lived indifferent to dirt and disorder, despite her father's attempts to tame her. Carolyn said, "From the time I was six, oh, he was hard on me. Andy says too hard. His big thing was 'Think clearly, Carolyn. Think clearly. Snap out of it. Do this, do that.' Gave me hell. I would get up late, not make my bed, all things like that . . . I just irritated him right down the line."

Fighting for her own soul—but not knowing what that was—Carolyn had only one way to rebel against NC. "What he told me to do, I did just the other way," she admitted. As Nat saw it, "Carolyn never missed a chance to defy Pa, and rubbed his nose in it." Being on time to meals was a rigid must. Carolyn would come in late from riding, breeze by the whole family assembled at the table, go up and take a bath in the bathroom at the head of the stairs, leaving the door open. "Father would just fume," Nat said. "I can still see him now with those glasses down on his nose, looking up at the stairs."

But the war of wills was even. "Pa was awfully hard on Carolyn," Henriette said. "She sort of fed on it, but the rest of us didn't. When two people are tearing at each other, it's awfully destructive to the family around them. Life is not pansies and violets—but all the same . . ."

Both Carolyn and NC, for all their thunder, looked to their mothers for total understanding. On winter mornings, Carol let her daughter warm the chilly chickens in the kitchen oven. According to Henriette, at Christmas "everything went to Carolyn," the most delicate French dolls, the best parasol, the best dollhouse. Carolyn remembered, "Ma backed me in everything—in my warmth, in my laziness, in wanting to get married when my father disapproved. She knew about the guy I was living with at my studio and she accepted it. Pretty good mother!" Once when Carolyn was found drunk and passed out beside the brick porch, Carol Wyeth explained, "Oh, Carolyn's tired."

Teenage Henriette once happened on her mother and father discussing the newest Carolyn crisis. NC looked defeated. Henriette suggested a psychiatrist. Carol's face went red with rage. She became hysterical, crying out, "That will *never* happen!" NC had to restrain her from physically lashing out at her daughter. According to Henriette, "She thought I meant that Carolyn would be put in an attic upstairs and fed through bars."

Like her father, Carolyn hungered for love and inclusion, but felt permanently isolated. She was cowed by Henriette's brilliance. She felt excluded by her sisters, who were "so slick in their clothes, clean and tidy," who recoiled from Carolyn putting dirty laundry away in the bureau with clean clothes, who gloried in old clothes worn till they were in tatters.

Sharing her father's pantheistic feeling for nature, Carolyn found loving relationships with plants and animals—though her mother once told her, "You love your dogs because they don't talk back to you." She would stretch out full length on her pony, Taboo, tickling his nose next to her face. She would carry her rooster against her cheek, crooning to it—and wrote touching, illustrated stories about her pets. "I get a warmth from animals," she said. "But from people I've never managed . . ." Her voice trailed off. When she planted a garden, with little paths and zinnias as high as her waist, it was in the most remote and secret corner of the woods.

But to her sisters, she was a loner by choice. "We had all kinds of projects," Henriette said, "and Carolyn was usually against them. Then she'd retire to the barn and draw pictures of rabbits." Sometimes she went drawing with her little brother, Andrew. Even as a boy, Andrew felt sorry for Carolyn in the family, and as a man he became her protector. In turn, eight years older, she became his safe confidante, the unshockable sibling, a prodigal pal, a dark, accessible father in tune with the angry misfit inside Andrew. She was the first of those persevering outcasts whose inner stature he recognized. "Carolyn prepared me for Christina Olson," says Wyeth.

As it was for Andrew, painting was the keel of Carolyn's existence. It was the source of her self-respect, the mitigation of her aloneness. NC took Carolyn into his studio for training in 1921 when she was twelve. She was late the very first day. She ended up working under her father's tutelage for nineteen years. "I wanted to take criticism to the end," Carolyn said. "I wasn't going to be like Henriette and run to the Academy." She worked very slowly, spending a week or ten days drawing one side of a cube—"Just the way I was in school. Still can't spell. I don't give a damn. I can't help it." Her pace drove NC wild with frustration. He himself painted with white-hot speed, doing in a single morning his great illustration of two train robbers fighting the crew between the train cars.

Typically, NC did everything in his power to back his daughter, even building her a studio. He kept her working in charcoal for four years, drawing cones and spheres, plaster busts. Carolyn remembered, "Pa would say, 'You do that and you work on it until it's the way *I* want it.'" Ultimately she achieved stunning charcoals, "some of the finest I've ever seen," says Wyeth. But beginning in the early 1930s, says Carolyn, "I painted what I goddamn wanted."

In a manner utterly her own, independent of any influence, almost primitive in the elemental simplicity of the shapes, primal in their power—she painted in oil her own constricted horizons. A dead tree in the woods where she once played. A corner of the house, seen from the darkness of the woods blazing white the way her mother loved it. Black-eyed Susans against a straight-backed chair. Andrew considers Carolyn one of America's preeminent women painters.

■ ■ ■

Andrew was not particularly close to his brother Nathaniel, six years older and "a different kettle of fish," says Ann. A sweet man with a harsh streak, ferociously funny, athletic, an excellent tennis player and boxer, adept with girls, he grew up on the perimeter of the family. He was beyond the reach of his father, who mainly watched with pleased bewilderment this family mutant.

The genetic strains that led the others into the arts made Nat a mechanical engineer who worked for forty years for the DuPont Company, designing machines and processes that solved manufacturing problems. In 1975 he was named the first senior engineering fellow, a topmost technical position at the corporation. He was the inventor and coinventor of twenty-five products and processes in plastics, textile fibers, electronics, and mechanical systems. One was the manufacturing technique that made possible the plastic bottle now used for virtually all carbonated drinks.

Expecting his first son to be a painter—and perhaps trying to load the dice—NC named this baby after himself, Newell Convers Wyeth. But while the Wyeth girls made imaginative, impulsive drawings, this boy did cramped little pictures inside confining squares. Noticing that after naps outdoors his little son's mittens were often greasy, NC watched him one day. The boy reached over the side of the carriage, released the brakes, pushed the wheels, and propelled himself along the brick porch.

NC presciently decided his son was in fact a born engineer, and gave up on him as an artist. That, said Henriette, "was kind of like saying he will never grow up. With the Wyeths, if you didn't draw, that was like turning down bread and butter and milk and not eating anything." NC renamed him something more suitable—Nathaniel—after NC's brother who was a "ride engineer," designing shock absorbers and springs for General Motors and Chrysler.

Submerged in science beyond his father's knowledge or even interest, Nat took apart countless alarm clocks and used the motors to drive model speedboats with propellers underwater or in the air, like tiny airplane engines. For driveshafts, he made universal joints out of soldered tin. Using

the coils from batteries, he built an arc searchlight, and, when Carolyn's pony escaped from its pasture, he located it in the dark by making its eyes glow—in the process burning the upstairs windowsills. Nat delighted in dinner-table stunts that disproved his father's skepticism—freezing water in a spoon held against ice cream.

But Nat did have his father's observant eye for the specifics of objects. "I had always been fascinated," he said, "by the curve of the runner on a Flexible Flyer where it came back to the straight section." He made a one-eighth-scale model that could actually be steered. Interested by the curve on the back of a Boston rocker, he made a minute reproduction, carving, steaming, and bending the tiny dowels. But it was not just a chair shrunk by using a micrometer. The thicknesses of the parts were adjusted to be optically correct. "The human eye does some tricks," Nat explained. "And you must feel the love that went into the original design of that chair. That's the art."

Ann was the satisfactory daughter, adoring, demonstrative, easily hurt, beautiful with her round face, sublime smile, curly blond hair, constantly clasping a doll. With a touch of bitterness she says, "My sister Carolyn always thought that Nat and I were the normal ones—which meant that we were absolutely blah."

She loved to please her father—and he her. She cut his hair. As he sat at the head of the dining room table, she would put her arms around him from behind. She says, "The smell of him, I can still remember it." She continues, "I remember going to exhibition openings with Pa as a young girl of fourteen or fifteen. He was always the center of a group, with his head above everybody's shoulders, and I would go up to him . . . I was so proud of him—and he would put his arm around me. He greeted me as if I was—well, somebody special in his eyes."

When she was only three, Ann hummed herself to sleep at night with melodies from Beethoven symphonies and sonatas. She was even nicknamed Beethoven because she had a certain facial resemblance to the composer. When she was sixteen NC bought her a parlor grand piano and hired the best teachers he could find—two years with pianist William Hatton Green, who had taught the composer Samuel Barber, and, for composition,

the concert pianist and composer Harl McDonald, who became manager of the Philadelphia Orchestra during the reign of Eugene Ormandy.

When she was eighteen, Ann's compositions were brought to the attention of Leopold Stokowski, when he was the Philadelphia Orchestra conductor. She went to his house to audition her piano composition called *A Christmas Fantasy*. Henriette kept her company. "Stokowski wouldn't let her in," remembers Ann with satisfaction. "She had to wait outside in another room. It really burned her up."

Stokowski was wearing red velvet pajamas. Ann played the piece on his piano. Because there was so much sheet music on the rack, he held up her score in front of her. He beamed when afterward she lit a Chesterfield, the sponsor of his radio show. He commissioned her to write the instrumental parts so the piece could be included in the Christmas program of the Concert for Youth series—along with Grieg, Tchaikovsky, and Wagner. In the program notes Ann included the information that "I was born of American parents in Chadds Ford, Pennsylvania," and "I am completing a second score for symphony orchestra which I call 'Autumnal Dirge.'"

On December 12, 1934, the entire Wyeth family sat in the front row of Philadelphia's Academy of Music. *A Christmas Fantasy* received a standing ovation, and Stokowski invited Ann to take a bow. She ran across her family's toes getting to the stage. He took both her hands in his. The orchestra stood. The violins tapped their bows against their instruments in applause. "I was queen for *that* night," says Ann.

In the audience was her fiancé, John McCoy, a student of her father's and the lone artist in a family of DuPont executives. A stipulation of NC's permission to marry his daughter was John's promise that he not interfere with Ann's music career—a commitment he kept. But the poet in McCoy was buried inside silence. Andrew says, "I was *very* fond of John, great warmth, very sweet and lovable, fine man, great qualities—but he was a quiet soul who'd sort of mumble, always tempered, not a man with enthusiasm—not 'God, Ann, that's terrific.'"

It was NC who fed Ann's ego almost daily. At her house, father and daughter listened to music together, to Sibelius, were excited together,

talked about the images they felt, the countryside, the snow, a flock of birds in the woods sounding like muted strings. Listening to her latest composition, NC sometimes wept. Once he said, "I wish Sibelius could hear that." She remembers, "He always made me feel the next one would be even better. 'Keep right on, now,' he would say. He never let you stop and think you were pretty good. Ever!"

But despite the transfusions of encouragement he gave all the children, NC transmitted an ambition for Andrew that his daughters never received. Henriette said, "Pa thought it pretty bad that I had any talent. I was the wrong sex. He had that idea that when a girl is born, we have another cook." In fact NC once wrote that the poet Emily Dickinson confirmed that "a woman's art, kept strictly and untarnishedly *feminine*, could rise to ecstatic heights." He added, "I am aware of no other woman's art, be it literature, music, or painting, that amounts to anything more than 'man's art drawn across her fan.'"

Describing Ann's relationship with NC, her daughter Robin says, "She was his lovey-dovey hoptoad. I don't know how he did it—he made her understand that she really couldn't do it alone." Ann's older daughter, Anna B., identifies with her mother. She says, "My sister and I were raised the way Grandpa raised Mom. Our father wouldn't send Robin and me to Bennington and Vassar, where we wanted to go. Education is not for women." She continues, "No wonder Mom has a low self-image. You just don't dare push yourself out there on that scary limb to be judged by the world. If you fail, maybe you won't want to do it anymore."

Ann kept her whole life miniature, a safe place to work things out—like the play farms that she set up and then stepped back and admired. She never pushed for technical training comparable to the artists' academic grounding—though she continued to see Harl McDonald once a week for coaching. But where Andrew could build size from the personal and specific, Ann remained a miniaturist: five- or ten-minute piano pieces, melodic, often emotionally powerful, capturing the mood of a moment, a fantasy, an excitement.

Her compositions are family portraits. *The Christmas Tree; The March of the Knights for Jamie* who loved knights; a portrait of her father; a graduation march for her son when he graduated from school; a suite on six of her

brother's temperas, including *Christina's World*. Playing the piano, she is a slight, hunched figure, with thunder issuing from her left hand.

"You use a tone on the piano like you use a brush," Ann explains. "You have the emotion first, then you put a line down. It's like making a drawing. You paint in music." She continues, "Writing something that moved the family or friends has been plenty for me. You see, I had my mother in me. I loved my house, my curtains, plain cooking, fixing things up—having a house just like my dollhouse."

Andrew, the youngest child, had the good fortune—and sly good sense—to avoid his father's full crushing impact. By the time he was born, NC's command of the family—and himself—had loosened. "Andy didn't have the same father," Henriette said. "When I was young Pa was sure of himself in the most utterly convinced and expansive great way. Then he began to doubt himself. Andy's father was beginning to be disillusioned, sad."

Andrew knew instinctively that NC had somehow lost his way, was breaking his own beliefs. And so did NC. As young as thirty, he complained of the din in his head from two warring factions. One was "the desire to live simply, serenely, morally, and to develop my talent to its highest state for its own sake." The other was "personal ambition and gain."

In the late 1920s NC began reaping and enjoying the perks of success—the attention of the celebrated and an ever higher level of living. Though he inveighed against "the disease of sophistication," he once shamefacedly admitted to a young artist, "Success in illustration brings merely financial success which in turn tends to lead one into destructive living."

The family had sporadically summered in Port Clyde, Maine, at a huge, gangling wooden hotel called the Wawenock. In 1920 NC bought an old sea captain's house fifty yards up from the rocky beach on a gentle slope with knee-high grass, daisies, buttercups, and hawkweed. Several years later he renovated the long, low, one- and two-story rectangular structure, and named it Eight Bells, after the famous Winslow Homer painting. Though he was ill-at-ease on the water, he purchased a twenty-eight-foot lobster boat and built a massive dock and a boathouse with a one-room studio attached.

At the Chadds Ford house there were now a cook and a butler in a white jacket—sister and brother—and laundry was sent out. NC was shaved by a barber in town. Through his brother Nathaniel, who worked for the company, he bought a secondhand, boxy, four-door Cadillac, and then a new Hudson Super Six. Carolyn had a horse and she foxhunted in jodhpurs and boots with the Brandywine Hunt Club.

NC sentenced himself to painting whatever brought in money, including considerable advertising work, pictures for Coca-Cola—two bottles in a snowdrift—and for Lucky Strike cigarettes—a series of bloodthirsty pictures under the slogan "Nature in the Raw Is Seldom Mild." Once when his assignment load kept him from turning out a painting a week for Lucky Strike, a delegation came to visit and asked, "Can't you put more men on the job?"

Though NC was outraged and disgusted, he was, in fact, compromising his work with shortcuts to speed production. Instead of physically working out his composition in charcoal on the canvas, he projected a small preliminary drawing onto the canvas and painted over the image. "My brothers and sisters loved him dearly," Wyeth says angrily, "but I don't think they realized how he bastardized his art to give them the life they wanted. We were wonderful until we got older. Then we ruined him."

Celebrities were attracted by this remarkable family. Carolyn said, "What happened to Pa—and Andy agrees with me—was Scott Fitzgerald time. My sister Henriette, terribly social-minded, gave a lot of parties here, cocktail parties—and insisted Ann have a coming-out party. My father built a tennis court—gave him a heart attack. That was the beginning of the whole mess. Party after party: Hugh Walpole, H. L. Mencken, Scott Fitzgerald. Got into that crap and it went on for eighteen, twenty-two years, and my father, of course, went right downhill. In fact, to be frank, the whole goddamn family went downhill. We all went together. I was fox-hunting at the time. Drunk. Nobody was doing anything. But Andy, of course, was a whole other thing. He knew something was wrong."

Scott and Zelda, wearing big straw hats, would arrive in a long touring car. "He wasn't too bad," Carolyn admitted grudgingly. They were brought

by NC's friend Judge Jack Biggs, later the executor of Fitzgerald's will. One night, after they left the house, Zelda said, "This car needs a washing," and drove it into the Brandywine. Richard Barthelmess came, and his costar Lillian Gish was enthralled by the dollhouse in "the glassy." Maxwell Perkins, the great Scribner's editor, pleaded with NC to write for him. Eric Knight, who wrote the best-selling-novel *This Above All*, was a friend of Henriette's. After movie actor John Gilbert, the great romantic lead, was introduced to Henriette, he announced, "I have just met my next wife."

Douglas Fairbanks and Mary Pickford begged NC to come to Hollywood to be the costume director on their next pirate picture—the whole family invited and given their own house and servants. Wyeth lore has it that Pickford clutched NC's lapel and gazed up imploringly with her famously huge eyes. NC refused for the family's sake.

In Andrew's memory "Henriette and Ann ate up all that stuff, being chased through the bushes by men. Nobody chased Carolyn because they were scared of her; she was like garlic." Andrew was not indifferent to the excitement. He would sneak gulps from his siblings' drinks. Once he and a friend,

Outside his Chadds Ford house, built in 1911 with the proceeds of his *Treasure Island* illustrations, N. C. Wyeth poses beside his new 1928 Cadillac. Torn between opposing sides of his unrestrained nature, NC assembled the trappings of his financial success and simultaneously cursed himself for violating his belief in simplicity.

Scootch Talley, got tight on hard cider. Hearing his father's footsteps, Andrew dived into bed fully dressed, his dog Lupe alongside. NC was much amused to find his son blamelessly asleep, with two big shoes sticking up from under the covers.

The influx of outsiders brought out the imp in Andrew, whom Hergesheimer called "that ominous child." When his sisters disappeared with young men into cars, Andrew crawled underneath and made vulgar mouth noises. Another time he put a laxative in the punch bowl and locked the bathroom door. Once he hid in the wicker hamper in the bathroom to watch a particular girl go to the bathroom. When Henriette found out, he disarmed her, saying, "I had a wonderful time. Several came in."

But Andrew's monkeyshines were often a signal of nervousness, of feeling foreign, misunderstood, and out of step even with his siblings—except for Carolyn. "Henriette," Wyeth remembers, "thought I was going to rack and ruin, running around with no real thought, no education, getting drunk at family parties. She would rip the hell out of me—'Where are your manners?'—'You've got to learn to dance properly.'"

Trying to join in, he imitated manly Nat and attempted tennis and boxing, but flopped at both. Peter Hurd taught him to shoot a gun and to fence, whacking him thoroughly with a saber. Wyeth is fiercely competitive and when Peter went back to New Mexico, he took fencing lessons from the University of Pennsylvania coach. When Hurd returned in the spring, Wyeth tells with satisfaction, "I fenced him right off the porch."

Except for Carolyn, Andrew felt that the other children were more favored by NC, who even bought Nat a car for the commute to college. A childhood resentment still feeds that undertow of anger. Wyeth says with passion, "It's a bunch of shit that I was the chosen child. I was just forgotten. Except for my mother, who bought me wonderful toy soldiers, they didn't spend any money on me. I had just a simple schoolteacher. They didn't buy me cars. They didn't send me places. I wasn't playing tennis and having music lessons. No, I just grew up with all this crap flying around me."

Andrew is still resentful that nobody seemed to care enough to find out what he was *truly* about. He says, "My sisters and brother didn't realize I

was painting and drawing. They couldn't have cared less. They didn't *know* me." Wyeth continues, "Henriette is the only one who said later, 'You were the one who was really doing something.' She is the only one in the family who had the guts to say that."

Andrew had made up his mind that he had something nobody else had. In this art family *he* was the one with the total commitment to painting, the one driven by a deep reason to be an artist, the one with secret sensations that *had* to be expressed in paint.

Carolyn remembers him, bored, gazing at a crowd of guests at a tennis game, then turning, and, soft as an Indian, disappearing into the orchard behind the house, Lupe beside him. He was going underground—or, as Henriette put it, "He was building an impregnable fortress of air."

He describes himself then as "just wandering over the hills looking at things, not particularly thinking about art, just perfectly to myself. I developed sort of unconsciously on the outskirts of the family without too much scrutinizing. I think my father had had it watching the other children so much. When I came along he sort of said, 'Oh, shit. Let him grow.'"

When he began to paint during his rambles, says Wyeth, "I put in more time than anybody in their right mind would do. I was going to do it *right*, or I was not going to do it at all. I was driven partly by self-protection. The only time I am happy is when I am painting and completely alone. Otherwise, people are picking at me, dragging at me."

5

In the Wyeth family the natural reaction to a strong emotion was to make a picture. As in medieval guild, art was an ordinary part of the children's lives—"Like coasting," said Carolyn. NC once boasted to his mother, "*Drawing!* That's the outstanding stunt in this house. To see the whole five around the lamp at night, bent over a tablet of paper, recording all sorts of facts and fictions of nature, one would at least guess it were an organized night art school—or that all were nutty in the same way."

Under their father's eye, the push was to get it right, get it better—be an embryo artist. NC was the benign but Olympian judge. When the children sometimes showed their drawings to their mother, "she had unerring taste," Henriette said. "We always knew if something was good or not. If a sweet distant look came on her face, you knew you'd failed. If you tried to get reasons, she would stride back and forth and say, 'Oh, I've always wished I could *do* something.'"

Although Henriette for a time drew fantasies of girls and angels and blossoms, even God, she never had a truly childish period. Carolyn was a skilled sketch artist in pencil, specializing in horses. In color she did astonishing Chagall-like paintings, dreamlike purple lakes and chartreuse women, black moons in pale lemon skies, castles, pink horses. Once she laid her pictures out on the floor of the Big Room, long lines of them, even under the grand piano, like pages from a book, everybody stepping over them. "Now watch out for Carolyn's paintings," her mother used to say.

Though the most obsessed, Wyeth considers himself the least gifted in the family. When he was five his pictures were much like any child's, pencil lines filled in with color. But he drew what was important to him. Violence became a volcano spewing red. Switzerland was crude mountains. When he drew the huge Victorian Wawenock Hotel in Port Clyde, where

he summered from the time he was three, Andrew carefully showed his father standing on the dock. "I always had a *reason* to draw," he says.

By age six Andrew was drawing obsessively, bubbling away, happier than anybody, sitting with a pad on his knees. Or he worked as late as 11:00 P.M. at his tiny studio setup in the "glassy," and then on the deep windowsill in the bedroom he shared with Nathaniel.

In a huge 1932 picture called *In a Dream I Meet General Washington*, NC painted his fanatical son at work. In NC's dream Washington turned in his saddle to talk to NC—while in the lower left foreground young Andrew stayed engrossed in the big sketchpad on his knees. With mock exasperation NC explained, "Here I am talking to Washington, a battle going on, and Andy was just interested in his drawing."

Into his early teens, soldiers, pirates, knights, Robin Hood, cowboys, airplanes, cars, trucks, Crusaders, Teddy Roosevelt, boxers, and musketeers battled and paraded in Andrew's unreeling paper pageant. Some pictures received titles: *Clang of Steel; In the Tavern, or The Lone Drinker; The Adventures of Dr. Jekyll*. One showed a musketeer roasting a weenie over an open fire.

A William S. Hart movie, *The Border Wireless*, sparked a spate of cowboys. Douglas Fairbanks's *The Black Pirate* in 1926 began a Spanish Main theme—a galleon fearsome with pirates, and refined by an instructional detail of the rigging by NC. Pirates dueled, and one ran with a cutlass in his mouth. The Battle of the Brandywine was an ever-present drama. The very ground on which Andrew played had been bloodied by the defeat of George Washington. Across the lines of Andrew's letter-writing pads marched ranks of uniformed British soldiers with their tall, peaked hats.

His father passed on the lore he had learned from Howard Pyle, including tales told by Pyle's great-grandmother, who remembered the retreating Continentals, trailing their muskets over the dry fields of September, their bare, bleeding feet wrapped in gunnysacks. As NC talked, his constantly moving pencil would illustrate his words.

A 1926 novel by John Thomason, Jr., *Fix Bayonets*, read aloud, brought World War I into the flow—precocious drawings of soldiers in battle, of German soldiers with packs and helmets (page 87). On the rakishly tilted

The German, 1975

helmet of an American soldier, his eyes cocked sideways, his bayoneted rifle behind him, sits a housefly. A soldier in profile with a pack on his back, gas mask on his chest, and bayoneted gun on his shoulder is captioned in a childish scrawl, "This is Andy as a soldier. Do you see him?"

Eras and epics swirled simultaneously in Andrew's head. On a single sheet are pencil studies of the cloth puttees of a World War I soldier, a doughboy at attention with pack and gun, a Mexican sombrero, the high-heeled boot of a pirate.

Andrew was clear by the time he was ten that painting was his life's work. "Art seemed to be inside me," he says. That same year NC wrote to his mother, "Andy is showing phenomenal ability in drawing, which is

ABOVE AND OPPOSITE: **In Wyeth's mind and imagination, past and present are simultaneous. His boyhood romance with toy soldiers, with war games, with the battle scenes he endlessly drew was transferred to Karl Kuerner, a neighbor who had been a German machine gunner in World War I. The climax of that theme is *The German*, painted when Karl was mortally ill with cancer. The helmet now sits in Wyeth's studio and holds some of Karl's ashes. Wyeth was painting cold eyes "that have looked down a machine-gun barrel, squinted great distances." He adds, "Those are my father's lips—cruel."**

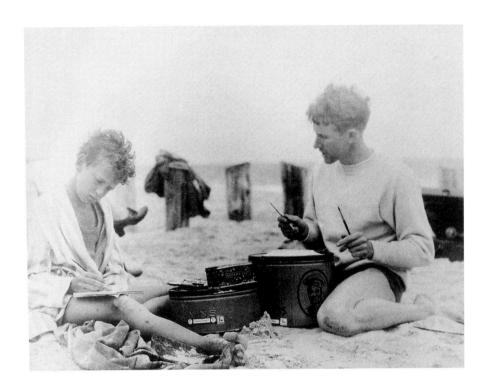

beyond a doubt more than a phase. I may establish a man Wyeth in my studio to carry on after all."

Now Arthur Conan Doyle's *The White Company* brought medieval knights into Andrew's stream of consciousness. NC occasionally took him to the Metropolitan Museum of Art in New York. While NC looked at paintings, Andrew explored the armor exhibits. He was particularly enraptured by Joan of Arc's helmet, bearing a dent from a crossbow bolt—"the most beautiful, simple object I've ever seen," says Wyeth. The department

At a family outing to Rehoboth Beach in Delaware, Peter Hurd gives watercolor instruction to an intent young Andrew. A beautiful, romantic young man raised in New Mexico, Hurd moved from being N. C. Wyeth's student to son-in-law, and became a brother/father to Andrew.

curator, impressed by the intensity and delight of this young man, took an interest and talked to Andrew about the exhibits, showed him behind the scenes, let him put on helmets and heft two-handed swords. "Beautifully balanced," Wyeth remembers with awe.

Andrew already had the idiosyncratic vision that has lasted his lifetime. Painting the stone house owned by ferryman John Chadd,

founder of Chadds Ford, he left out most of the windows—as he often does in his mature works. "I liked the simplicity of it," he explains. "The special feeling. You're not clouded with windows. I thought our house on the hill had too many windows."

Sometimes he tenaciously did four or five versions till he was satisfied with the action. Peter Hurd remembered, "You didn't see the broad, bright daubs of poster colors that most kids start out with. Right away he mixed colors into subtle grays and blues to get the effect he wanted." Pictures he liked Andrew importantly signed, "Andrew Wyeth."

He copied drawings from books, especially those of Howard Pyle. He repainted in watercolor the breakup of Oliver Wendell Holmes's one-hoss shay. He idolized Albrecht Dürer, and was awed particularly by Dürer's dead deer with an arrow through its eye. For a time Andrew signed his own pictures AW, the letters combined in imitation of Dürer's designed initials. "Andy would show a Dürer drawing to you," Aunt Elizabeth remembered, "and say, 'See that, the way the reeds come out of the water?'—discovering something utterly new. The world was a revelation to him."

From the beginning Andrew was a technician working to master his craft. Drawing his spouting volcano, he was thrilled to discover the shading effect possible with the side of the pencil lead. To imitate the detailed drawings of Dürer, Andrew used various pen points inserted in wooden penholders. "Even when I was little," Wyeth says, "I was very sensitive to the tools I used. I enjoyed the quality of that thick ink flowing out—a joy!" Oddly, his father never bought Andrew a good drawing pen. Peter Hurd had a fountain pen in a little case hanging at the ready around his neck—and gave a duplicate to Andrew, who wore it for years.

Beginning a lifelong pattern, Andrew hid or burned most of his pictures. Considering them experiments, done for pleasure, he did not want the burden of judgments. His father was virtually the only person who saw his work. NC treated the childhood pictures with utmost gravity, talking as though his son was a twenty-year-old art student. NC would tell him, "That's a good start," and then might say, "Now, Andy, he wouldn't hold a rifle that way," and correct it in a corner of the page. He taught the way a hand grips a cutlass, how the folds of a cloth would fall, how arms reach.

"It would hit me just clear as a bell," Wyeth remembers. "All I needed was an inkling of a drawing."

Interested in the French and Indian War, Andrew made a little painting of the British general Edward Braddock on his horse. NC said, "You've got to get the feeling of the Indians not seen, that silence of just the beat of the drums." He drew Braddock on his horse in full regalia, with a man-at-arms marching behind him in the deep woods. "You saw just the top of a feather in the bushes," Andrew says. "Just enough to excite me. He was teaching me to get the truth of it, understated, without overdetail, overemphasis."

N. C. Wyeth indicated violence with light glinting on a gun butt. A parrot's beak arcs cruel as a cutlass. Fierce eyes gleam in a red face. Light sparkles on a belt buckle. NC showed the instants just before the cataclysms. Swords and guns are raised to deliver death. The stagecoach drivers are poised for trouble. Captain Bill Bones stands still, draped in danger.

NC was already instilling the idea that power on the paper comes from powerful emotions, freely, even explosively released. When Andrew was thirteen, NC gave him a real watercolor set, a narrow tin box with rows of circular wafers. He was thrilled—though he hated the green. In the orchard next to NC's studio Andrew tried his first watercolor landscape. "I was being rather too careful," Wyeth tells, "and my father said, 'Andy, you want to explode on the thing'—and he did part of the sky very quickly, with great bravado. That's the way Pa was terrific. He got you to let go, showed you what a little sissy you were."

Subtly buried in NC's help was the expectation that Andrew would follow in his footsteps, though when Andrew abandoned pure fantasy and painted a storybook scene—somebody else's imagination—the pictures were stiff and tightly formal. "They were terrible," Wyeth says.

Beyond a nudge here and a hint there, NC left his son free to follow his own mind's eye. "Pa didn't want *anybody* to interfere with Andy's work," says his sister Ann. But it was a narrow, unsophisticated freedom. Andrew's lack of broad exposure to children outside the family, his geographic self-

confinement, his lack of reading skills, were a kind of quarantine, keeping him inoculated against any rebellious push for independence. As Wyeth says, "I was perfectly happy in my own little world."

But a few crucial mentors did penetrate that hermetic household, maturing influences so singular and dramatic they fit easily into Andrew's expanding imagination. The most important was Peter Hurd, from Roswell, New Mexico, who became a virtual Wyeth, adopting NC as a surrogate father. "Pete worshipped my father," Wyeth says. Many years later Betsy Wyeth read aloud an old letter to Peter from NC. The usually controlled Hurd broke down, tearfully hugging each member of the family.

When Peter arrived in Chadds Ford in the spring of 1924 at age twenty, he had just dropped out of West Point after two years to become an artist. He was determined to join NC's informal art school that repeated the Howard Pyle approach: a few students who once a week came to the studio for free critiques and inspiration. Impressed by Peter Hurd's commitment and the sparkle of his well-stocked mind, NC took him on.

From the first hour Peter wowed the Wyeths. He landed in Andrew's boyhood as though from the sky—a fallen angel in a black Stetson. Andrew was six and laughing hysterically at this fabulous man who talked about a ship's poop deck. Even Carolyn said, "He was like one of us. He just knew." Ann says, "I thought he was out of this world. I had a crush on him."

A slender, sinewy charmer, with bright blond hair, intense blue eyes, he was almost feminine in his handsomeness. A friend called him "Shelley in cowboy boots." He had the gift of being what anybody wanted at any moment. He was fun, a riveting raconteur. In his company people felt good about themselves. Bilingual in Spanish and English, he could mimic any accent—provincial French, Bostonian, Mexican, Texas American. Sometimes as a secret joke he talked to people in their own accents. He played the guitar, sang Mexican ranch songs, and twirled loops with a lariat—and did it standing upright on the back of Carolyn's pony. He could ride any horse, jumping on and off at full speed. Once he put on a one-man rodeo

beside the main road, bulldogging the Pyles' milk cows—from his horse lassoing and throwing them to the ground. Andrew and Brinton Kipe passed the hat among the cars that stopped. All the cows went dry.

Hurd was a dead shot with a pistol. Nat remembered him on a Brandywine bridge shooting the heads off snakes. But Peter's weapon of choice was a bullwhip. The family was swimming at a dam in the Brandywine River, and the owner of the property ordered them away, forcing Carol's elderly mother to climb over a gate. Whip in hand, Hurd found the fellow in Chadds Ford and gave him a thrashing around the legs. "Peter was a swashbuckling man if there was one," remembers Janet Miller, the postmaster's daughter. "When he hit Chadds Ford, we all stood up and looked."

After three months Henriette thought to herself, "I'm not in love with Peter Hurd, but he's going to be the father of my children." She explained, "Petie had a tender, curious delicacy about him. And there was his delight in the English language, and the sonnets he would write me in the Shakespearean mode. And his body. Women are like Indians, and I knew damn well he was my fate, willy-nilly."

Peter remained NC's student for five years, and as Andrew grew older, became an influence, taking him painting—to the squalor of the Wilmington town dump to break him loose from his romantic fantasy pictures. Peter was also an understanding mentor in Andrew's soft escape from a father who gave his son little or no guidance in the manly arts of adolescence. Peter progressed from swinging the little boy in circles by the hands to ushering the teenager into manhood. "At that time in my life," Wyeth says, "I wanted that swashbuckling cussedness and his showmanship. He just fit into what I dreamed up. I was very close to Pete."

Peter the severe West Pointer once told Betsy Wyeth, "When I arrived, Andy was getting the genius treatment." She explains, "Pete must have seen in Andy at that teenage level a wishy-washy direction he could have gone in. He had never done anything he didn't want to. He still hates to have things put in front of him that he *has* to do. Pete Hurd disciplined him."

Imposing some of the rigors of military school, Hurd helped Andrew control his sometimes erratic emotions. Andrew remembers Peter insisting,

"You're a young *man*. You've got to straighten yourself up." But the sternness was balanced by Peter's subversive side. He became Andrew's coconspirator, a fellow scalawag. The two once sat in a car parked in Philadelphia and drew explicit sex pictures—which they tossed onto the sidewalk. Wyeth reports, laughing, that people stopped, looked furtively around them, leaned down, looked around again, picked up the pictures, and shoved them into their pockets.

Young Andrew delighted in his father's Rabelaisian streak. NC actually used the shocking word "shit." He would hold out a finger and when Andy pulled it, NC laughed uproariously and farted. But more pervasive was NC's New England puritan prudery. He once told Henriette that she should never pose a woman with her legs apart.

Young Andrew's sources on sex were those secret times under his mother's bed, reading the racy books swiped from his parents' library—de Maupassant, *Lady Chatterley's Lover*, and *Meet Me in Samoa*. "That was a hot one," remembers Wyeth, laughing.

By age fourteen Andrew had romanced Janet Petty, the postman's daughter, into his first "girlfriend." Asked what that meant, she laughed warmly and said, "Not much." There were movies, concerts, kisses—and fiascoes. Andrew was sparring regularly with Nat, who was on the University of Pennsylvania boxing team. To impress Janet, Andrew entered a local boxing match. Before her very eyes he was knocked out cold.

In Janet's memory, "Andy wasn't like the rest of the kids. He had a poetic quality that made him different. Very sensitive. Very caring. Dramatic. I always thought he tried out a good line on me to see how I would swallow it." On her wedding day, Janet received from Wyeth a dozen white roses and a pen-and-ink landscape.

"From sixteen on," Henriette said, "Andy was a Beau Brummell, very handsome, looked just marvelous with this sort of conscious actor's expression—smooth as cream, suave, a great lover and all that—John Barrymore stuff." He and Nat went to Wilmington together to coming-out parties, returning at 2:00 A.M.

In Maine Nat had a beautiful, long-haired blond girlfriend, a minister's daughter some ten years older than seventeen-year-old Andrew.

When Nat had to leave a party early, Andrew drove her home. That night she gave him his first sexual experience. "I was kind of shook by it," confesses Wyeth. "I was a late developer."

The romance, conducted without NC's knowledge, lasted into Andrew's early twenties. She was secretary to the dean of a large woman's college, and when Andrew went to New York to see his dealer, Robert Macbeth, he secretly traveled north to sneak in and out of her room in the women's dormitory. Wyeth fondly remembers, "She used to laugh at the way I'd put money in all my pockets, and the dollar bills would keep falling out, sort of a whirlwind."

Once at Christmastime she visited in Chadds Ford. When Andrew took this older woman to a country club dance, John McCoy was so shocked he refused to dance with her. When NC sat up late talking with her about Tolstoy and Thoreau, Andrew went to bed. After she went to bed, he crawled across the rain gutter and into her room. Andrew says, laughing, "The gutter is still bent." When she wanted to get married, he fled.

His Svengali in this affair was Peter Hurd, the lady-killer, who encouraged him and explained what to buy at a drugstore to take precautions. Wyeth says, "Pa would have killed us both if he had known Pete was telling me what to do. But Pete thought I was being protected too much by Pa, physically. He gave me *edge* just when I needed it. And of course I adored him."

Contiguous with sex in Wyeth's work is death, the fear behind horror, the shock and thrill of the gruesome. Adolescent Andrew's tour director for the realm of death was a local eccentric named Christian Sanderson, who addressed him as "Sir Andrew." Chris was a schoolteacher dubbed mayor of Chadds Ford. He called square dances and was the caretaker at Washington's Headquarters, playing his violin for guests. He was active with the Boy Scouts. He was a fixture at parades, did an Indian club routine at high school football games, and in town pageants he played Rip Van Winkle, only semivisible behind long white hair.

His knowledge of local history, especially the Revolutionary battles, was encyclopedic. He gave talks at schools and had a weekly radio show called "Historic Rambles." A compulsive collector of lore and its residue,

he founded in his last home in Chadds Ford the Christian C. Sanderson Museum—a piece of Lincoln's bandage, a coronation plate, an Indian arrowhead, Revolutionary War cannonballs and officers' swords. "He was a high-level pack rat," Wyeth says.

Every scrap of life had to be commemorated and recorded. On the hundredth anniversary of Samuel Morse's first telegraph message, Chris went to a Western Union office and wrote on a blank, "100th anniversary of the first telegram." After scolding two boys for putting a dead cat in their teacher's desk, he took them outside and photographed them holding the corpse between them, each gripping a leg. He photographed Jack Dempsey the day after his fight with Gene Tunney. He photographed his mother at Charles Lindbergh's visit to Wilmington, the *Spirit of Saint Louis* in the background. He was present for Adm. Richard Byrd's visit to the nearby town of Kennett Square.

Chris did not drive a car. At sixteen Andrew got his license and a black Model A convertible with white sidewall tires and a rumble seat in which his easel and canvases sat up like passengers. Brinton Kipe remembers well the experience of riding with Andrew: "He'd go by a scene and get so engrossed, driving became secondary—a white-knuckle situation."

He became Sanderson's willing taxi, and they researched and Andrew illustrated a map of the Brandywine Valley's historic sights and landmarks. Chris steeped Andrew in the marches and countermarches, skirmishes and retreats in the Battle of the Brandywine, after which George Washington retired for the winter to Valley Forge. Asked years later what historical time he would most like to have witnessed, Wyeth chose that desperate time at Valley Forge.

One of Chris's favorite stops in his rounds of local life was the "viewing" of dead acquaintances—Andrew's earliest encounter with unromanticized death. Andrew describes Chris bending over the coffin and saying, "He certainly has changed." Ann says, "Andy treated it as a joke. But it wasn't."

Chris's mother, Hanna, a woman biblical in her patience and devotion, was herself a history buff. In her diary is the entry, "Twelve years ago tonight, Christie and myself camped out at Antietam battlefield." She sewed a Betsy Ross flag. Her son Christian was the heart of her life. In her

diary she wrote—"Christie will not be home tonight. Lord keep us till we meet." Andrew did several oil portraits of Chris, and gave one to him and Hanna. When Andrew borrowed it for a show, Hanna wept as it was removed from the wall.

On Christmas Eve 1943, Andrew dreamed that Hanna Sanderson was dead, floating in a cellar in a flood. Early Christmas morning, Christian Sanderson phoned Andrew to say that she had died in the night. He went to their tiny house, where she lay under her Betsy Ross flag, her head bandaged to keep her mouth from flopping open.

From his imagination Wyeth painted the tempera *Christmas Morning*. Viewed from behind Hanna's head, her lower body evaporates into streams of light, like ectoplasm, rushing across snowy hills into the particular eerie distance of Christmas dawn. Like the Star of Bethlehem, the morning star is still alive. It is Wyeth's vision of the moment of death, which he has painted with variations again and again.

Despite the often tranquil surfaces of Wyeth's images, his world of imagination is not a pretty place. It is filled with horror. This energy was first realized late one afternoon when fourteen-year-old Andrew had been drawing sheep at the farm of Spud Murphy, so named because he lived mainly on potatoes. Wearing a beaver hat with earflaps and a sheepskin coat, Spud walked behind the pigpens into a small grove of apple trees. "He turned his head a little," Wyeth says, "and I remember seeing his back and the light on his face. I remember I became terribly excited."

The revelation was seminal: He could fill an actual person or object with the same intense emotions he poured into his play dramas, into *Robin Hood*. Andrew's fantasy world and the real world could merge. "He wasn't *sure* it wasn't Dracula," Betsy Wyeth explains. "Or Jack the Ripper on his way home. It might be Mr. Hyde. I think it was absolutely grippingly horrific when it happened to him right in his own backyard. It was the first time it happened *not* in his imagination. He didn't have to go looking for it in books and games. He could mine his own surroundings. Nothing sentimental about it. There wasn't any beautiful light that came from heaven and struck him in the brow."

Dracula, Mr. Hyde, and Jack the Ripper were all men who were out-wardly ordinary but in fact bloodcurdlingly frightening. Now Andrew knew that anybody who walked into his life could spark the macabre in his imag-ination, his unholy Halloween dread, panic barely controlled. The thrilled emotion he purged through blood-and-thunder play and pictures could be kept charged and capped, and eventually exploded into paintings. "There's no end," Wyeth says, "if your emotion is strong."

Wyeth uses as an example his tempera *The Patriot* (page 167)—a World War I veteran from Maine. Wyeth says, "Spud Murphy was the beginning of when I—even to this day—like doing Ralph Cline . . . there was a strong quality of witchcraft and hidden meaning about him. I get a strange—my hair rises on the back of my head. Then nothing can stop me. I can't go anywhere else or do anything else. I have to grab that thing.

"Oftentimes people will like a picture I paint because it's maybe the sun hitting on the side of a window and they can enjoy it purely for itself. It reminds them of some afternoon. But for *me*, behind that picture could be a night of moonlight when I've been in some house in Maine, a night of some terrible tension, or I had this strange mood. Maybe it was Halloween. It's all there, hiding behind the realistic side."

In NC's house Halloween was not a major drama. The family was dis-tracted by four family birthdays in one late-October week. But Andrew indulged his taste for the eerie, honing his Halloween imagination on Oliver Wendell Holmes's *The Broomstick Train*. In the late fall he and Ann burrowed into corn shocks set up like tepees. Stripping kernels of corn off the dried cobs—tiny nuggets of gold—they buried their hoard of treasure in the dirt. Listening to the rustle of the wind through the stalks, they told each other it was witches and goblins.

As he grew a little older, his partner in pursuit of the macabre was his adoring and beloved Aunt Elizabeth, a large, wise, magical rapscallion, a gothic teller of horror stories, as much a witchophile as Andrew. Together they visited graveyards, entered crypts, broke into the empty stone house haunted by her maternal grandfather, a German named Herr.

Many years later Wyeth telephoned Aunt Elizabeth, asking her to come down from New Jersey for Halloween. She wrote in reply:

The Jersey Witch can't possibly ride that night. I loved hearing your voice and immediately felt like grabbing my broomstick and flying to you. What will you be that night? I often think of your beautiful exhibition in Rockland. How thankful I am that I saw it. It had all the youth and beauty of feeling that, if one carries it within them through life, one is truly blessed. A great big hug and tears to you, Andy dearest. When you are flying past the moon that night, throw me a kiss at midnight.

<div align="right">

Lovingly,
Elizabeth

</div>

Wyeth has made Halloween a personal Walpurgisnacht, an annual reconnection with the unearthly, with witchcraft and hidden meanings. On that day he is electric with fun. He picks the deformed pumpkins and carves them into jack-o'-lanterns, a long lineage of fantastic death masks summoned up from childhood by the remembered scent of candle-heated pumpkin flesh.

On Halloween night Wyeth sometimes throws open his studio to the Wyeth clan and cohorts. They raid the NC costume collection and disappear beneath Andrew's store of stage makeup, becoming a pack of ghouls touring the homes of close friends. Sometimes Wyeth in makeup and costume just walks alone in the night through a cornfield. "Marvelous," exclaims Wyeth. "Getting rid of myself—fifty years after I'm dead, I'll come walking back in disguise. I'd like nothing better."

Always he is transported by a sensation of invisibility, of seeing the world through other eyes—revisiting his boyhood orgies of delicious horror. "It's the eerie feeling of goblins," he explains, "of witches out riding their broomsticks, dark holes behind windows, the glint of metal, the

Each year, reliving the boyhood excitement of Halloween, Wyeth, in elaborate and sometimes horrifying guises, moves through the shivery night with a costumed gang of extended family, delighted by the playacting, the concealment, the chance to watch from behind a mask. Here in 1964 Wyeth is an American Indian while his wife, Betsy, plays a bawdy Restoration wench.

smell of damp rotting leaves and moisture, the smell of makeup, the feeling of your face under a mask, walking down a road in the moonlight as a child."

Wyeth longs to be an invisible witness, a receiver unaffected by consciousness of himself. At the same time that he fuses the subject with his fantasy, he also struggles to paint the object's fragile essence. He hates anything alien that intrudes, that changes. He hates the fact of his body, of his brushes and watercolor pads—everything that calls attention to itself, that distorts the fleeting impression caught from the corner of the eye.

"I don't want to be an *artist* strong in the picture," he says. "I wish I could obliterate the brushstrokes, the fact that it was done by human hands. I am an instrument trying to tune in on the thing that's already there. I wish I could be nothing, just float over the woods and fields—which is what I'm after in painting. My best work is strangely removed from people." Asked why his portraits gaze off into mysterious distances, he answered, "I don't like people looking at me. I want to be left alone with my thoughts."

Often on Halloween, he and Betsy and his two sons, Nicholas and Jamie, have dinner in costume. Once at Jamie's house a neighbor arrived with three little boys, trick-or-treating. They were ushered to the dinner table of demons. Jamie was a corpse with one eye hanging down on his cheek. Wyeth, surprisingly, wore only a black frock coat and a commercial gorilla mask.

One of the boys began shaking and crying. Wyeth stood up, saying gently, "Don't you see? It's only a mask." He pulled off the rubber head—revealing Dracula—long white fangs, bottom eyelids pulled down with tape hidden by grease paint, pointed ears and pointed powdered wig above a chalk-white face. The little boy wet his pants.

The stunt is a snapshot of Andrew Wyeth: ruthless to get an effect; not sweet; hooked on drama; loves to shock; watches the world from behind masks behind masks.

When Andrew was fifteen years old, there occurred at the core of his life a seismic shift, a central coming of age. It was the culmination of those years of romantic childhood fantasies, and the climax of the hundreds and hundreds of drawings.

In that year of 1932 Andrew spent months preparing a toy theater production of Arthur Conan Doyle's *The White Company*, a tale of romantic violence, death, and love that NC had illustrated. The hero of the book and play was Alleyne Edricson, a slender, blond young man "favored by all"—no doubt Andrew himself in his imagination. He rescues the heart-stoppingly beautiful, blond Lady Maude from the clutches of a ruffian. Though she is above his station, Alleyne wins her hand—"La-ty Maut I will love you forever."

Also in 1932 Andrew drew his last pure fantasy picture—a huge, closely done pen-and-ink of a gargantuan medieval castle looming on and on into the diminishing distance (pages 104–5). Under its stone ramparts, a seeming nation of knights lays siege. Wyeth is still annoyed that his father encouraged him to fill the sky with dramatic clouds, which he thinks somewhat spoil the picture.

In these two accomplished efforts NC saw the illustrator he expected Andrew to become, and he told his son to report to the studio every morning for serious academic art training.

In the big "lower studio"—a huge space built to accommodate the murals NC began painting in 1911—Andrew soldiered month after month through the discipline of drawing cubes, spheres, and pyramids. With charcoal he drew still lifes and plaster casts—Lincoln's death mask, the head of George Washington. "It was a terrible shock to me," Wyeth says, "because I wanted to express *myself*. Sitting down and drawing cubes

drove me up a tree. But my father believed in it. And I believed in it. You have to know the rules in order to break them."

In pencil Andrew drew male nudes, and for months a skeleton in all positions. Then purely from memory, he had to show it walking. NC promoted him to oil paint—still lifes of a coffeepot, apples, a cup and saucer in folds of drapery, an antique bakery table beneath a picture of Andrew by Henriette. NC hired local men to pose for portraits. "He was tough on me," Wyeth says, "but I think it was right. If severe training kills an artist's ability, then it ought to be killed. I certainly wouldn't want to be cut open by a surgeon who never had any training."

NC was nominally a Unitarian, and, in his universe, art offered something "akin to the compensations and demands of a religion." He took pride in being its fire-and-brimstone minister, insisting on absolute seriousness toward the work. Once NC described an encounter with "three young squirt art students who . . . silently sniffed and sneered . . . until I flew into a rage and lashed them with my tongue within an inch of their lives. My candid attack finally cracked them into making what amounted to the most naive confessions of their tiny, insectlike, art-student point of view. The next bowel-running art students that approach this studio will be shot down in cold blood—for they haven't any warm blood anyway."

In the memory of Peter Hurd, "Pa was a man of tremendous moods. He was double. If he was glowering, you braced yourself, and you accepted the fact that you'd be mowed down for some tiny thing. Maybe he'd begin on some puny characteristic in my nature, which I may not have been aware of, or hadn't done much about. In a few incisive words, he'd hit quick to the sore place. And you'd feel, Oh, God! and you'd know it was true.

"But I felt that tearing me down was painful to Pa because everything in the world that day pained him, and I was just the target. And being the target helped me like hell. He could put his finger on the sore spot right away—the bad, the false, the phony—the defects you tend to smooth over and not see, which is fatal.

"The next day Pa would come in and the clouds would have swept away. The sun would beam. He'd build me up so well. He'd point out the good things in my character, praise what I'd done. He had that marvelous

Flint, 1975

While concealing the Helga paintings, Wyeth produced
a full output of other work, including such major paintings
as *Flint*, expressing the infinite in terms of the common-
place. A huge boulder seemed a product of the primal
heavings of the earth and the slow power of glaciers.
Seagulls were present only in the grim relics of lobster
claws and crab shells and in their droppings that glowed
dead white in the fog. "It had a strange beacon quality,"
Wyeth says.

ability to communicate enthusiasm, zest. I can't conceive of anyone equaling him as a teacher."

Giving his critiques, NC walked up to the picture and then backed away, striding with the student at his side like two soldiers marching. When he saw a problem, he had no inhibition about fixing it himself. In 1934 Andrew was painting an oil of Bill Loper, who lived over the hill in the black community that NC called "Little Africa"—an area originally allotted to blacks by the early Quakers. Andrew was fascinated by the steel hook hitched to the stump of Loper's left arm, the sense of the leather harness and strap under his shirt. But NC reached out and scrubbed away the freshly painted hook, declaring, "You don't need it. It's a diversion. Simplify!" Andrew remembers, "My father said, 'Paint huge masses,' so I painted huge masses, and did other things on my own, went underground."

Arguing with NC was inconceivable. Henriette remembered standing quietly with tears running down her face while he reworked what she thought was the best background she'd ever painted. "But he was always right," she said.

NC never talked technique—how to handle the brush to get an effect; how to paint a tree, a head of hair; how to construct a composition. "There wasn't any of that formalizing," Wyeth says. "That's why I'm different, my whole outlook. My work happened naturally for me."

NC did pound home maxims: "Keep alive to everything. You must be like a sponge. Soak it all up. But be sure you squeeze it out once in a while. Don't let it get soggy." He talked mood, essences, tying the painting to life. NC told Carolyn, "Never paint the material of the sleeve. Become the arm." After painting a laughing face all morning, his own face ached. He once told his son, "If you want to paint a Negress, you should sleep with her first."

NC deified the subtleties of light, of nature. He preached the necessity of loving objects for their spiritual values. The factual knowledge of the shape and proportion of a jug should unlock a fascination with the object, a sense of its hollowness, its weight, its pressure on the ground, its smell, its displacement of air. He would dwell on the shadow cast by a plaster sphere,

Castle Siege, 1932

the gradations of dark like a black feather easing into a smoky dusk, into a starlit double edge. He talked about the "speed" of the sickle hanging in his studio, a shape that had not changed since biblical times. He talked about the importance of the dramatic as opposed to the merely theatrical. "Pa would intoxicate himself with his talk, along with the rest of us," Peter Hurd said. "He'd leave us trembling with excitement and exhaustion."

NC would show how an eye is held in the socket, the brilliance of the liquid inside the eye. He described the ear as the funnel for information from

the world feeding the brain, an instrument that has never been equaled. Henriette remembered, "I mean, God, you were fascinated forever. He made it almost unattainable, but worth trying because occasionally you'd get two square inches of good painting." Wyeth's voice fills with emotion as he says, "My father did everything in his power to make me see. He wanted you to really *do* something. Not just whisper."

In 1932, at age fifteen, Andrew summarized his years of illustrating his fantasies by drawing the pen-and-ink *Castle Siege*. NC was so impressed that he decided the time had come for his son to report daily to the studio for academic training.

Wyeth has always seized any technical device, any strategy, any insight—and help—that could bring him closer to putting down his vision. But even as he has opened the door to powerful influences, he has ducked their domination. In the afternoons Andrew disappeared away over the ridge. Uncoached, unmonitored, he painted the territory of Little Africa. He continued his friendship with Doo-Doo, who lived with his seventy-eight-year-old father, John Lawrence, who could still jump into the air and click his heels three times before hitting the ground. Doo-Doo took Andrew into the hidden, harsh lives of the blacks centered around Mother Archie's church, converted from a Quaker school, which was octagonal so the sun would shine inside all day.

Wyeth believes he evolved as an artist by trial and error, by trying out different styles and methods. Like his sisters and father, he used oil paint, and his renderings tended to be conventional. He did the graveyard, a dead chestnut tree, a field of looming corn shocks. In an oil of the Birmingham Quaker Meeting House, he used the impressionist style his father had tried for a time in easel paintings. A portrait of his sister Ann echoes Henriette, her purples and light blues.

The macabre, the mood of Spud Murphy, surfaced in a dark 1933 oil, *Burial at Archie's*—five ominous figures hunched around an open grave, pall-bearers of Halloween (opposite). In a 1934 oil Bill Loper saws a log surrounded by tall fox grass like twisting red flames, pulsing with unease. Searching for drama in the landscape, he experimented with color, firing off hot reds, intense blues, yellow, orange. In theatrical skies the clouds billowed black, blue. The monochromatic Wyeth of muted, winter browns and tans was years away.

Worrying that proficiency would breed overconfidence, NC decided that competition would benefit Andrew. In 1933 his sister Ann was seeing a great deal of John McCoy, who had studied art in France, been fired from a job in the DuPont advertising department, and was studying art at the Pennsylvania Academy in Philadelphia. One night at dinner in 1934 NC suggested he come work with Andrew in the studio. Often the two students painted the same subjects—still lifes and local models. When NC gave his critiques, he would say, "John, you win today," or "Andy beat you today."

Burial at Archie's, 1933

Sometimes NC would say to his sons, "Well, what did you accomplish today?" Andrew would feel inferior and think, Not very much.

But all the while, NC feared his son could not make a living as a fine artist and kept nudging him toward illustration. In 1932 Andrew received ten dollars from Charles Scribner's Sons for two drawings of Robin Hood. When NC was commissioned to do pen-and-inks for Howard Pyle's 1933 edition of *The Merry Adventures of Robin Hood,* he turned the job over to Andrew—although the work was published under NC's name. The same year he urged his son to illustrate Conan Doyle's *Sir Nigel,* but the drawings went unsold, despite NC's best efforts. "They were all terrible," Wyeth says. In 1934 Andrew illustrated *Around the Boundaries of Chester County,* a collection of historical stories. This time his pen-and-inks were published under his own name.

Studying under NC, Andrew took up oil painting. *Burial at Archie's,* painted in the black community over the ridge, is an early, theatrical product of his lifelong interest in death as the climactic drama of life.

In 1934 at age seventeen, when young men were conventionally moving from high school to college, Andrew "graduated" from NC's studio. By now every element of the future painter was present within him, but unmeshed, like the parts of an engine loose in a box. He had his little-boy excitement and hypervivid imagination. He had his library of personal myths—Robin Hood, Dracula, war as romance—that enriched reality with the drama of fantasy. He had his academic training in fundamental skills, and his steely compulsion to record his consciousness in paint.

But he was still tempted by illustration for the sake of the money. In 1936 NC again subcontracted a job, and Andrew's illustrations for Thoreau's *Men of Concord* again appeared under the name of his father. In the spring of 1936 Andrew had planned to go early to Maine and stay alone at Eight Bells, but accepted an illustration job from Little, Brown & Co.

"It was the dullest story," Wyeth remembers, "about a bunch of kids that bought a house in upper New York State, and in one room there was a stain on the wall and they began to think there was a serpent there. *Awful!* I read the galley proof sheets, long things—instead of going to Maine and letting go in watercolors. And I went to bed and I was fretfully sleeping, poring over this goddamn book in my mind and wondering, What the hell am I going to do with it?

"My father must have realized that illustration wasn't my ability. Early in the morning I was conscious of this big figure standing over the bed. It was Pa, and he said, 'Andy, it's ridiculous for you to do that book. Turn it down and go to Maine. I will support you. Go up there and paint like hell.'"

Maine was a milestone of intoxicating freedom, both personal and artistic. He wrote his father, "Every minute I am in bed asleep, I regret." In contrast to the stone houses and damp loam of Pennsylvania, Andrew found a new lyricism in the diamond clarity of the light, the histrionics of the weather, the gallantry of the white frame houses, frail as eggshells, perched on their thinly covered granite ledges. Most of all he was exhilarated by the infinite ocean of air and the surging, menacing depths of the sea, as restless and filled with hidden life as his own being.

He had the companionship of a Maine version of Doo-Doo Lawrence, an acolyte named Walter Anderson, a stunning boy with white-blond hair and a dark brown tan. His Danish and Swedish blood was mixed with American Indian, and his pale, thin face looked to Andrew like Robin Hood's. Walt's family had the dysfunctions dear to Andrew. The father, a fisherman, was an alcoholic. One of the five children, his beautiful blond sister Myrtle, ended up a hooker. A teenage brother, Doug, sometimes slept all night in NC's station wagon. Doug drowned near Eight Bells. His body was found the next spring partly eaten by crabs.

Attracted to those who have a passion, Andrew latched onto Walt's lust for the sea. Walt was a metaphor for Maine which, says Andrew, "is blond, dry, and cruel." Warily protecting their precious, solitary independence, both were defiantly on guard against the world. Betsy Wyeth says, "Andy has deep attachments, but doesn't want to be attached to anybody. The restlessness of his soul, his feeling for the sea is that. Strange man."

Though Walt was six years younger, the two boys became confederates in succeeding summers. Almost daily they rowed to the islands in Andrew's dory, Walt digging clams for lunch while Andrew did watercolors, his pants stiff with paint. They hauled the traps beneath the color-coded buoys and sometimes stole a dozen lobsters apiece, boiling them in Andrew's battered tin pot and eating only the succulent claws. Sometimes they stayed away for a week at a time. Walt knew the shallow reefs in the open sea, and they rode the combers that broke over the barely submerged rocks. Or they sat silently drifting, a chip on the palm of the sea. They rowed out to islands at night, through fields of phosphorescence. "The water was filled with fire," Wyeth once wrote in a letter, "and each dip of the blade of the oar made the water into a star light sky."

Andrew learned how to row standing up, facing forward, rhythmically pushing the oars. He learned how to read the impending weather, the spots to be safe in case of squalls, the out-of-the-way docks where they could get some soup and a swig from a pint. Walt took him to what he has always loved, the hidden-away places, the little-known river coves, uninvaded by other eyes, a gravel moraine marked by the print of a passing heron (opposite page 406).

He showed Andrew the Viking markings on Manana Island, next to Monhegan Island. In Wyeth's imagination Walt became a link to those astounding seafarers. "You can imagine the way they must have looked coming into Monhegan harbor," Wyeth says. "Jesus! God! It's fabulous to see people like Walt who are still rugged enough to live in that atmosphere."

Andrew carried his painting gear in a scarred metal tackle box, which he often used as a seat, resting his pad on his lap. Wishing that he "had ten hands to put all this down," he once ecstatically painted eight pictures in a day—and destroyed five. In Maine, watercolor was the medium totally in tune with Andrew's free excitement. "They were a portrait of how I felt at the time, the nervous excitement of my temperament," he says. "I can't go back now and recapture that. I think you paint what you are."

As resistant to control as the sea itself, always on the brink of chaos, every brushstroke unpredictable, watercolor focuses and channels the wild side of Wyeth, the boisterous, even violent area of his nature. "I don't stand there and placidly 'paint a picture,'" Wyeth says. "I can't stand those smooth things done in a studio with a hair dryer to dry your washes. My best watercolors are when there's scratches and spit and mud, gobs of paint and crap over them. I might as well be in an orgasm when I get going."

Every watercolor has been like a battle, the outcome constantly in doubt. His breath fast, talking to himself, the glasses he wears paint-spattered with color, he attacks the paper with a frenzy, scratching it with the end of his brush, scraping it with a razor blade, dabbing at it with Kleenex. In 1993 Wyeth painted his artist son Jamie, who describes the process: "It's absolute control that looks like a mess. Chaos. But he has absolute knowledge of what's going to happen without thinking about it. He was using like a two-quart saucepan filled with water. He had a wide brush with a long handle and he dipped it in and splashed it into the color and dragged it down across the paper in an absolutely straight line. As he pulled it away, there'd be just this tiny, tiny hairline.

"Then he'd work back into it with the corner of that brush. He'd squeeze some color in there that looked like it didn't even belong there. Then he'd take the whole bucket of water and throw it on the paper and throw the thing across the room and get up and walk over and look at it and kick it, and then pick it up and work some more in a true frenzy. Forgets you're there. His breathing is heavy and he's exclaiming, 'Yes, that's it! Oh, boy, this is it!' Completely carried away." Betsy Wyeth says, "You know when he's zeroing in on something because he touches the end of your nose and looks right at you—and has this marvelous smile."

Helped by lessons from his father's friend and fellow Howard Pyle student, Sid Chase, Andrew achieved fluency in watercolor in a sudden rush in 1936, when he was nineteen. His Maine pictures took on a distance, an atmosphere. Exulting in his freedom, thrilled by the blue of water and sky, he was painting the sea and its fishermen pictorially, at face value—Rose Teel gathering driftwood into her dory; Ralph Teel rowing his dory; a man

digging clams; Charlie Stone by the bow of his beached, wood-filled dory. "I was sort of flexing my muscles," Wyeth says, "just soaking up the country. I wasn't ready to express anything. I just let myself go completely. I didn't know any better."

The bravura handling, strong pigmentation, and decorative impact were the imprint of his idol, Winslow Homer. In 1936 Andrew paid homage with a trip to Homer's studio in Prout's Neck, Maine, driving over with his sister Carolyn to see a small exhibition of watercolors marking the hundredth anniversary of the artist's birth. Homer's nephew, Charles, had kept "Uncle Winnie's" studio perfectly preserved. "It was a terrific experience," Wyeth recalls. "There were his casting rods and his net that he would use to pick the fish out of the water. A small canoe in one corner. The easel. Charlie Homer showed me the things Homer had written on the wall. I remember the dampness of that air."

Years later Wyeth returned to the studio and to his disgust found a young painter violating the shrine. "It was very depressing," Wyeth remembers. "There was an awful painter there painting these terrible oils. Looked like whipped cream sea coming in. And on Homer's easel! His wife had had a baby four months before and it was crawling around crying on this floor. They had gotten in a cleaning woman and she'd washed the walls, taken off all Homer's writing."

The relationship between father and son was changing. Andrew was independent in painting. NC wrote of his astonishment at Andrew's progress, at the "rapidly maturing grasp of matter and mood," and forecast "big work ahead." NC made himself his son's protector. Sherwood Cook, who later married Betsy's sister Gwen, once stopped by to see Andrew in Maine. "NC came out," Sherwood says, "and said, 'Andy's busy. Here, take this cigar,' and he gave me one of those green cigars and sent me on my way."

When Andrew's beloved Aunt Elizabeth visited in Maine, NC was delighted, welcoming her as a healthy buffer between his son and the distracting interest of local girls. Andrew would knock on Elizabeth's window at first light and they would go off all day painting together. Sometimes father and son made companionable expeditions, once for two

days on Teel's Island. Sharing full-moon nights at nearby Cannibal shore, they watched the great green breakers smashing against the granite shelf, white spume spraying high in the palely gleaming light.

In the fall of 1936 the Philadelphia Art Alliance hung some twenty of Andrew's watercolors. Using an introduction from one of NC's New York associates, Andrew then dropped these off at the Macbeth Gallery. The first to specialize in American painting, they had exhibited Frederic Remington, George Luks, and Winslow Homer. Back came a letter from Robert Macbeth saying, "Our first reaction is, you being desirous and willing, we must give you a one-man show next year. I think you've got something quite new to offer and we would like to help you make your New York debut."

The next June, Andrew drove his father's car to Maine determined to lift the level of his work for the Macbeth show. Now his hand was surer. More and more space entered the work, forceful foregrounds and limitless distances, vast caverns of air. Skies resounded with billowing clouds; bright color moved into the pictures; undertones enriched the surfaces; the stark watercolor paper itself became the gleaming whites.

He painted a storm approaching from Caldwell's Island—a detonation of blue. He painted Milton Teel hauling traps in a white dory. He painted the blueness of the bay at Port Clyde, the shimmering white of the church of the fishermen in Martinsville, and the silver of sunrise on a dory. Executed with headlong speed, the images are fresh and spontaneous. There were no preliminary studies, only abandoned false starts.

Wholly released into freedom, Andrew happily allowed his father to remain the "big nanny" managing the details of his infant career. NC was thrilled. That fall Andrew simply sent his summer's work down to NC, who selected the pictures for the Macbeth show. He numbered them on the back for a future list of titles, had them matted and shipped them to New York.

NC wrote his son a letter that Andrew can still recite from memory: "They look *magnificent*, and with no reservations whatsoever, they represent the *very best* watercolors I ever saw! This remark from your old dad may not mean much to you, but I believe what I say and I'm certain I'm right. . . .

You are headed in the direction that should finally reach the pinnacle in American Art."

NC assigned himself some of the credit. He continued, "For the first time in my life I am beginning to feel secure in the belief that certain fundamentals which I have always stressed, to those who would listen and absorb, were sound and potential. You had the good sense to accept and apply them."

Andrew gratefully answered his father: "What you had to say about my watercolors means more to me than you know. You are the only person that really understands what I am after. I feel very certain in what I want to do, and I only hope that in the future I can really make you feel happy."

In the shipment of watercolors to Macbeth, NC enclosed a letter saying, "The boy was really aflame! Your interest has, of course, given him solid satisfaction and stimulation—as it has to me, too." Macbeth replied that opening the bundles of pictures was "a faith-justifying experience" and called them "spurts of youth." He asked NC to write the introduction in the show's catalog. It was to NC, not Andrew, that Macbeth explained by letter the prices of the pictures—$38 minimum for drawings, $100 maximum for watercolors—the plan for hanging the pictures, the decision in those Depression times to spend money on frames, the costs of the show that Andrew would bear—framing, advertising, and invitations—and Andrew's share of the sales—a 50-50 split. "They really took me for a ride," says Wyeth. "My father and I were gullible."

On October 19, 1937, the whole Wyeth family, except Peter and Henriette Hurd, who were in New Mexico, went to the opening at the Macbeth Gallery. Andrew arrived directly from Maine and was so nervous that he lacked the courage to sign the paintings. The Depression had deflated the art market, and Andrew expected the worst—confirmed when just one picture sold that night, a watercolor of the house where he saw Spud Murphy. The rest of the family returned home to Chadds Ford, while Andrew remained in New York.

The next morning he went to see a Peter Hurd landscape at the Association of American Artists gallery. Around noon, embarrassed by the lack

of sales, Andrew dropped by the Macbeth Gallery to see if anybody had visited the show. Both rooms were packed. "I almost fainted," Wyeth remembers. Before the end of that second day, the entire stock of twenty-three watercolors had been sold. Andrew cleared approximately $500 and his mother took over his bookkeeping.

He took a train back to Wilmington and was met by NC. "What a welcome that was!" Wyeth exclaims. NC reveled in his son's success. In a letter to Henriette and Peter Hurd he quoted art dealers: "first watercolors since Homer"; "at last a man who has the guts to present nature honestly, powerfully and beautifully"; "a much-needed spirit in a New York sick with unmeaningful, unsightly and unsalable moderns."

7

"If somehow, before I leave this earth, I can combine my excitement and absolutely mad freedom with truth, then I will have done something." Wyeth's "truth" is the essence of objects and people, everlastingly elusive, teasing him forward. He says, "I want to get down to the real substance of life itself." The route to his goal is realism, because "the object is the art, not what I make of it."

He has chosen two mediums to fulfill this credo, expressions of the two diametrically opposing sides of his personality. One medium is spontaneous watercolor. The other is meticulous egg tempera, used by such Renaissance masters as Jan van Eyck and Roger van der Weyden, Simone Martini, and Fra Angelico.

Watercolor is the wild, only semicontrolled Wyeth. Turning the corner into his twenties, his "truth" was "the smell and taste and color of Maine"—man melded with nature. Painting pure emotion, his watercolors explored the farthest margins of realism, half slipping into abstract expressionism. "You come on something in nature," he describes, "and you have a red-hot impression, and if you can catch a moment before you begin to think, then you get something. You construct a mood into something as solid as the object itself." In those early days he often abandoned formal composition and was interested primarily in the play of light, in motion. Just shapes. Swaths of color; intense blues, ochers, black browns, red, orange—liquid—what Betsy Wyeth calls "spikes and whoosh."

Andrew usually went to Maine early to escape his father's omnipresence. In the spring of 1938, he rushed north to "be like Winslow Homer." Wyeth says, "I never wanted to copy the work of other people, but I wanted to find the truth in nature that they were expressing—and then find my own truth. So Homer led me on to something else. I got a direction that was authentic to me and to what I felt."

He arrived in Maine in early May. Snow still lay in drifts in the woods behind Eight Bells. Walt was away working on a fishing dragger. Always wrenched by change, Andrew felt distanced from the Maine ethos he wanted to express. Moreover, he had been suffering secret misgivings about "the glib stroke of watercolor." It now felt too facile, too flippant for his ambitions, too impressionistic to express "the real substance of life." A visitor to Andrew's studio, seeing those early, wild stabs of color, exclaimed, "You make nature look dull!" Wyeth remembers, "That really shocked me. I said to myself, 'There must be something wrong somewhere.' I kept thinking, The object is so great, why lose it in paint! I used to get so depressed."

In the frigid solitude of that 1938 Maine spring he briefly became what he really was: a sheltered, obsessed boy, both fleeing and needing his father, overcome by longing for his roots, for the safety of family. Andrew wept as he wrote his parents a uniquely self-revealing letter:

Dear Ma and Pa,

> I have never felt worse than I have today. I don't know what came over me. I never felt so homesick and lonely in all of life. If this keeps up, I will go nuts. God, I just feel lost up here. I never knew how much Chadds Ford means to me until now. I look at these islands and think that I know them, and then I realize that I only know them on the outside. I am quite sure and know that I can paint Maine and probably make quite an income for myself. I try to make myself believe that I will live here some day, but am beginning to change my mind.
>
> Please don't show this letter to any of the family because it's none of their business and some of them may think I am just soft. I tell you the truth it takes a lot of courage to write and tell you this. I hope you will forgive me for being so stupid about the Chadds Ford landscape. I certainly will never be that way again.
>
> For two cents I would pack up now and return to Chadds Ford. But, of course, that is impossible because I do want to make some money out of this summer's work. But next summer I won't come up here unless you are with me, and I mean it, too.

Here's one way I know that Chadds Ford is the place for me. When I try to make a tempera wash, dreaming up here, I find I can't get any feeling into it. The reason is, I don't know it well enough. In watercolor I can handle it because I don't get into any details and watercolor makes it very exciting to do.

I don't know whether I should send this letter to you or not because it may make you think I have lost hold on myself, but I have been feeling this way for several months, and that is the reason I kept talking about Maine all the time, just to keep up my courage, because I know you were always right when you said the place where you are born is the place for an artist to paint.

I am not going to read this letter over myself because I probably wouldn't send it.

Always there when needed, NC sent a long, loving answer by return mail. He told Andrew, "Anyone as sensitive as you is bound to run into just such mental and emotional upset sooner or later. Intense nostalgia constitutes a very definite form of growing pains and is the truest barometer in the world of your spiritual and emotional potentialities. . . . As one swings into mature years, the reactions are more intense, more glorious—and more difficult." NC ended with the reassurance, "Give no thought to money-making, you can always do that."

Like the rest of his family, Andrew had used oil paint for his "important" pictures. But that medium felt greasy to him, even wet and slimy. He disliked the thick buildup of pigment, the heaviness that called attention to itself. He once explained, "Oil is hot and fiery, almost like a summer night, where tempera is a cool breeze, dry, crackling like winter branches blowing in the wind. I'm a dry person, really. I'm not a juicy painter. There's no fight in oil. It doesn't have the austere in it. The difference is like the difference between Beethoven and Bach."

Egg tempera appealed to Wyeth's fastidious, meticulous side, the searcher for "truth" and "essences." Perhaps tempera would allow him to keep the violent quality of a watercolor done in twenty minutes, but have all the solidity and texture of a painting. Betsy explains that tempera is the

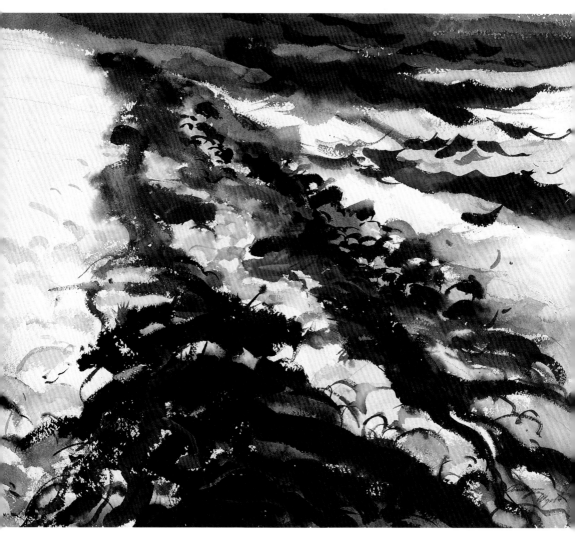

Shoreline, 1938

In his early twenties in Maine, liberated from his father's scrutiny, Andrew exploded onto watercolor paper his unfettered emotions, his passion for the abstract patterns and color qualities of the sea and its shores—the kelp and barnacled rocks and mussel shoals. Exhilarated by controlling the uncontrolled, he was painting less what subjects looked like and more how they felt. "I never knew exactly what was going to happen," he says.

medium for suppression, like a New England church compared to a European cathedral: "He's said that the Pilgrims were just as violent in their appreciation of God as the people who worship in a cathedral, but the passions were contained within the structure of a very simple building."

Later, in 1941, Wyeth began a technique halfway between tempera and watercolor, called drybrush. He dips a small brush into the watercolor pigment and with his fingers squeezes out most of the color and moisture and splays out the bristles. Stroked on top of a liquid, watercolor wash, the brush leaves separate, distinct marks, which can be layered and cross-hatched and woven and built not unlike tempera.

Wyeth was introduced to tempera by Peter Hurd, who had been studying the writings of the Renaissance painter Cennino Cennini, and had used the technique while learning to paint frescoes in Mexico. Describing a Renaissance tempera of the Virgin Mary, Hurd whetted Andrew's interest. "It is absolutely miraculous to me," Peter said. "The belly above the pubic hair . . . there is a tone in there that only tempera can give you. It's not the pink flesh of an Ingres or a Renoir. It becomes almost a memory of the form in the body."

Peter showed Andrew and NC a sample tempera. In lock step, three abreast, they did the familiar ballet, marching close to the painting and then back away from it, then close again, Peter the teacher this time. Andrew was sold. Using Peter's mineral pigments, some from the earth in New Mexico, Andrew learned to mix egg tempera colors.

First the yolk of the egg is separated from the white. In its fragile skin the yolk is gently rolled from palm to palm to remove the last of the still-clinging albumen. Held like a teardrop at the edge of the palm, the yolk is stabbed with a knife, and the orange fluid pours into a white cup containing distilled water. This egg liquor is combined with colors that have been ground to powder and mixed with distilled water to form a paste. Depending on the ratios of the ingredients, the paint can be watery and transparent, or thick and opaque.

Andrew and Peter went together to the Philadelphia Museum of Art to study the early-fifteenth-century techniques. They experimented with various surfaces for panels—not always successfully. An early Hurd tem-

pera was being considered for purchase by the Whitney Museum of Art in New York, and before the eyes of the acquisition committee the sky in the painting flaked away and fell to the floor. Ultimately, Wyeth and Hurd settled on fiberboard coated with the smooth, porous mixture of chalk and glue called gesso.

Andrew liked the feel of tempera—its thin, smooth surface, its capacity for detail. Its translucency created a subtle glow of light. Fast-drying, it forced him away from the slick manipulation possible in oil, the easy blending from color to color. Andrew explained to NC, "I think it's possible to paint a pair of oarlocks with the cord that's tied to the thwarts, and really make you feel the truth, the absolute quality of a worn piece of metal, make it really as it is, to express all of Maine."

In 1936, the year before his Macbeth show, Andrew painted his first tempera, a portrait of his Boston Bull terrier. In the fall of 1937, after the watercolors for the first Macbeth show had been shipped to NC, Andrew stayed on in Maine to try landscapes in tempera—brushing out the pigment much as he did watercolor, a treatment echoing Peter Hurd's swift fresco technique on wet plaster. He painted a fisherman, Charlie Ervine, posed in front of his house in Martinsville. This tempera was sent at the last minute to Macbeth for inclusion in the show, but it was kept in the storage room.

While working on the picture, Andrew went to the county fair with Charlie and two other men. Andrew wrote his parents, "Mr. Ervine, of course, got very drunk, and then we spent most of the day having fights which he started. We would have to help him out. My little training in boxing helped me very much, I'll tell you."

In addition to using tempera to become more specific and detailed, become deeper, Andrew decided he needed additional technical training. He spent the winter of 1938 back in NC's studio, studying anatomy and continued to experiment with tempera, painting his most direct and revealing self-portrait (page 122). The pose is startling, confrontive. At a three-quarters angle, the head seems suddenly turned, the eyes defiant, challenging the viewer. The full mouth is tight—privacy interrupted.

In the summer of 1938 he painted five temperas, one of them an intense head and shoulders of Walt Anderson, titled *Young Swede* (page 123). In the picture fifteen-year-old Walt is also challengingly watchful, like a palomino colt sensing danger. The portrait is virtually a duplicate of Andrew's self-portrait—two outsiders, two fugitives wary of confinement. "Nobody but Carolyn saw anything in it," Wyeth says. "Nobody liked my temperas then. They thought I was crazy." Walt remembered, "NC looked at this painting and said, 'I don't know, Andy'—which was to say he didn't think Andy was ever going to do much with tempera."

In their brotherly compact, Walt Anderson was the archetype of the Wyeth-model relationship. For Andrew, painting and friendship are spun together in a thread that extends for decades, severed only by death. "I'm *involved* with the people I paint," Wyeth says. "They become my friends. They're not people I paint and send home."

Walt meshed almost perfectly with Andrew. He came from the harsh, subsistence heritage indigenous to the Maine coast. Describing his boyhood and the little Maine world that Andrew first painted, Walt said in his soft, reflective voice, "When I grew up at Port Clyde, wasn't nothin' here. No jobs. Weren't many cars. Couldn't afford them. So everybody had their own little business. Few cows. Others had an ax or a saw to cut wood. Some like my father went lobstering, and in the wintertime go dig clams. And he cut wood sometimes. Had to be good at about anything you could do to get by. Man and wife and six kids—wasn't too much money to live on. You get a pretty good idea about what's important—and what isn't important."

Though he could speak with a native eloquence, Walt had that Maine gift for silence. It was a New England privacy unlike the hyperbole that filled NC's house. "It's what we didn't need to say to each other," Wyeth explains about Walt. "That's the thing." NC once said about his son, "Behind Andy's very free badinage and raillery and almost swaggering carelessness is a remoteness of spirit that is very moving."

Walt was a soulmate, too, in his rootlessness. One of Wyeth's later models, Pam Cowe, says, "Andy is drawn to freedom like a butterfly drawn

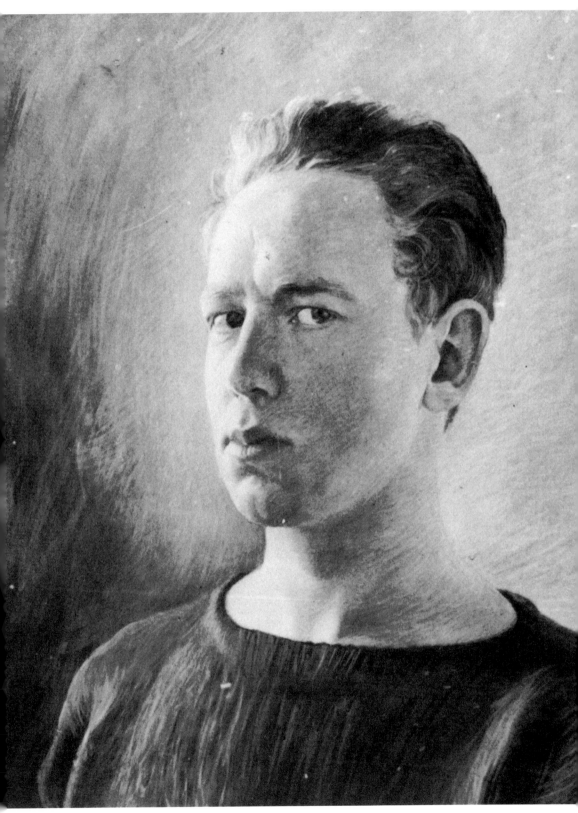

Self-Portrait, 1938

Young Swede, 1938

to flame. Not a moth, a butterfly." Walt himself admitted, "For some reason we seemed to get along pretty good. Andy was about like I was. Didn't have much to care about."

Walt never had ambitions beyond Port Clyde. "When the tide goes down, I go clamming," Walt said. "All I need is a three-fifty clam hoe and that old rowboat I got. I can quit and come home any-time. They say that the less you have in life, the tougher it is. I don't have very much, but I don't see where it's so tough. When you live off the land, you become self-sufficient. In the city you're dependent on so many people. Don't need the land other than to walk on."

In Maine Andrew found a soulmate, Walt Anderson (above), a boy of the sea six years younger, like Andrew a renegade against the estab-lished order, suspicious and defensive toward any inva-sion or control. The 1938 self-portrait (opposite) shows the severe Andrew Wyeth ordinarily covered up by captious charm.

Adding luster was NC's disapproval of Walt as an influence and as a painting subject. NC claimed that Walt was atypical of Maine fishermen because he was Scandinavian with his blond hair. "Pa was painting the old salts," Wyeth says, "and here was this young man who had not even fished yet, but I did not want to follow my father into *his* viewpoint of Maine." NC decried Walt's inferior mind, called him Andrew's "Man Friday." He wondered whether there was something queer about his son's constant companionship with this beautiful younger boy. "He thought maybe we were homosexuals," Wyeth says, adding "I think sometimes fathers get to be maybe a little mean, a little jealous."

The upright citizens of Port Clyde considered the adult Walt Anderson a no-good buccaneer. Jimmy Lynch, another model and a second apostate, relates, "The only thing Walt ever did to conform was to make sure that he got home to bring food and milk to his mother while she was alive." Walt had a reputation for selling "short" lobsters and poaching from other men's traps. One resident described him as "a poor, sad drunk who ran up against a wall all his life." Another said with classic Maine understatement, "I guess I'd have to say he wasn't a responsible person." Another said, "That man, he'd steal the gold teeth out of his own grandmother. But Andy brought out the best in him."

In words that apply particularly to Walt Anderson, Betsy Wyeth says, "Andy likes people he can discover himself. He likes pirates. He likes robbers. He likes people that have to go about their business, people who are rejected or passed over by others." Explaining Wyeth's tolerance for malefactors, Henriette said, "There was never a great distinction in Andy between right and wrong. It either existed or it didn't exist. I think honesty is his one moral judgment. Not whether you're a devil."

Talking about his friend, Wyeth says, "Walt was a renegade everybody looked down on. But he was a very fine person." Then Wyeth adds what from him is a great compliment: "He was a strange person to me." Then the renegade in Wyeth speaks: "I think he and I got along because we were never tied in. And I think that's what bothered a lot of the fishermen and Port Clyde people—just as I've bothered a lot of people in my free spirit. They're even still bothered."

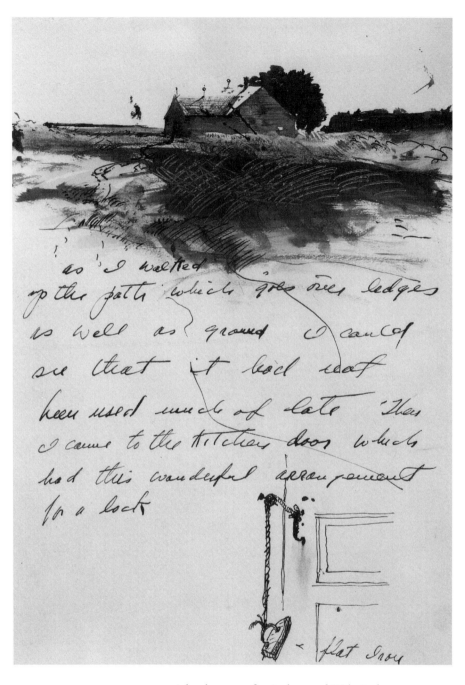

as I walked up the path which goes over ledges as well as ground I could see that it had not been used much of late. Then I came to the kitchen door which had this wonderful arrangement for a lock

← *flat iron*

A headquarters for Andrew and Walt Anderson was Teel's Island and the house of Henry Teel, a quintessential Maine lobsterman. In 1954, shortly after Henry died, Wyeth visited the deserted island and wrote his friend William Phelps a letter. He included a drawing, which he trusts more than words.

Just as Wyeth does in his paintings, he describes Walt Anderson with metaphors: "I can only tie him up with a person like my hound Rattler. Rattler's the most complex dog. Underneath the surface he does a lot of thinking. There's all sorts of little channels and passageways. Rattler's like the St. George River. It looks perfectly flat—calm—and yet underneath there's terrific currents. Well, that's Walt. Not a simple man by any means. Thinks a lot. Yes, he's close to nature, but . . ."

Walt with his American Indian blood inherited the romance of the redskins and pirates that Wyeth still doodled on drawing pads. Convinced that blood determines behavior, Andrew relished the animal instincts he considered Native American heritage. Walt, watching the way a man walked, would conjure up a personality profile. He himself in his habitual sneakers trod the shores with a stealthy, almost eerie silence. When trapped on the water in a white-out fog, he could put ashore anywhere and recognize the particular bit of rock and woods.

Walt in his own way understood Wyeth, the artist. To Andy, he says "a shell on a beach is just the same as somebody who lives there. Has the same value. He realizes that some time it had a life, even though it's an old shell now, all whitened out from surf and sand and sun. I step on 'em and keep walking. But he sees something in 'em. Sees something in everything and remembers it, too." Walt the pirate had an affection for Wyeth that he reserved, perhaps, for nobody else. He once said, haltingly, "People . . . a few that you really care for . . . I don't know why . . . it's like falling in love. You don't know why you do. He's one of the few."

Wyeth offers his models the intoxication of his full and all-forgiving attention, his appreciation of their most private self-respect, the value that perhaps only they see in themselves. He offers his Peter Pan energy, the excitement he projects, the feeling that this hypnotic man is in touch with regions beyond ordinary sensibilities. He offers, too, the aura he commands as an artist.

Pam Cowe explains, "Andy is the spark of freedom that's in all of us, but we don't let go of our control enough to be that free and real. It takes somebody like Andy to make the spark burst out, and once it does, you can't stuff it back in."

· · ·

Walt Anderson introduced Andrew to the 26½-acre Teel's Island, named after seven generations of Teels who preferred that isolated, self-sufficient life. The white frame pre-Revolutionary house sat for protection in a hollow on the northern end of the island, hull down like a ship half over the horizon. The kitchen ell was built from the wreckage of a British man o'war that went aground in the 1740s. The two vagabonds spent nights there, sleeping in the attic, listening to the roof creak in the wind.

"Hen" Teel and his island became for Wyeth an epitome of seacoast Maine. "I see a man like this," Wyeth wrote his parents, "and it makes me see how little I really know this country. God, just to paint one piece of kelp and make it real and alive, I would be happy."

Born on the island, Henry was one of fourteen children, taught by a woman assigned to run a family school there. He was a good cook, even made ice cream. A tall, lean man usually in overalls that gaped at the sides, he could play his fiddle and dance a jig at the same time. He wore his clothes till they were rags. The kitchen gleamed. On winter mornings the water would be frozen in the kettle on the cold wood stove. To preserve the wet-cell battery, the only electricity on the island, he listened to only half the news program on his radio. He came to "the main" only to deliver lobsters and buy provisions, and sometimes to go to the socials at the Cushing Grange Hall. Keeping time with the music, he nervously tapped one of his huge feet in its saddle shoe. A friend said of Henry, "His feet are so big, he has to pull his pants on over his head."

After posing for a tempera in 1945, Henry decided that sitting a second time would be too confining. Like the sea, he was a man in per-petual, restless motion—repairing his lobster traps, whittling plugs for lobster claws, seining sardines for bait. When other lobstermen stopped by bringing gossip from the mainland, they were invited to the house "for a mug up." Walt said, "Henry wasn't a man cared much for paintings. If they'd owned a picture, it'd be a portrait of a great grandmother, finished right up." When Wyeth showed him a watercolor, Hen said, "Gawd—some slippery with that brush, but ain't it a mess."

Wyeth once started a painting of the kitchen ell and stashed the paper in the attic of the house. A week later he came back and the picture had disappeared. Henry's sister Rose Teel said she'd never seen it. Wyeth mentioned it to Carolyn. She discovered, much to Wyeth's amusement, that Rose and Henry had decided the heavy watercolor paper, carefully folded, was just the thing to patch a broken windowpane.

In Wyeth's imagination, Henry's island world became a portrait of the lobsterman. "You'd see Hen on the mainland," Wyeth says, "and he looked just like Teel's Island walking along. He was the color of the barnacle-covered granite ledges. An amazing gray. I painted the ledges thinking of his face." As Peter Hurd once said, "Andy makes people out of things, and that person is also himself, and vice versa. It's a curious, mysterious, wonderful thing."

One of those ledges was the arm embracing a small cove just below the house. Wyeth painted that in the 1950 tempera called *Northern Point,* done from the roof of Henry's house. Stuck in the gray grass field under the house is one of the poles that Henry lined up like beacons to guide him to a set of traps. On the ridge of the roof is a lightning rod, a needle as thin and sharp and storm-resistant as the man himself, with his sly cunning, his tiny eyes, and the bright flash of his quick grin. Embellishing the midpoint of the rod, the ocher color of Henry's vest, is a glass globe that seems to spin in midair.

Like most lobstermen, Henry once had a powerboat but preferred to row his dory tending his 150 traps. He liked the quietness. With rubber boots rolled down below the knee, he stood erect, his lean shoulders moving sparingly back and forth, his dog, Ted, sitting in the bow. When he returned to the island, the dory crunching onto the coarse beach, he would ship the oars and step from the boat in a single elegant and graceful motion. When he came into the house, he immediately went to the window and looked back out to the sea.

In 1950 Wyeth painted Henry's dory in *Spindrift* (pages 130–31). Keyed in that island gray, the tempera is essentially a full-length picture of Henry amid the ambience of his island. Pulled up on the beach, the dory rests in the hot silence of a summer noon broken by the feathery swish of the water sliding up and back on the shells and gravel, by the speed of one of hundreds

of barn swallows that swoop and swerve and feed on the sea fleas and bugs. Flattened under the bow is a swatch of the seaweed that odorizes the air.

The rugged and refined dory—"like a child to him," says Wyeth—is a braille record of Henry's labors and the sea's weather. Around the bait bucket the curving interior is spattered with the silver dots of fish scales. On the outside planks of the dory is the ripply reflection of the water, the same that Wyeth sees on the ceiling of the main room when he lies on the floor, sensing the entire island from the subtly vibrating light.

Laid across the seats of the dory are Henry's oars, long and spindly and sea-worn like their owner. They evoke the small bones Wyeth senses within the callused hands bloated by saltwater. The blades, Wyeth describes, are gradually eroded by the constant dipping into the sea, and grow "thinner and thinner over time, like a piece of ice cream licked by a child." The leather nailed around their midsections is the economical way to reinforce the perishable wood, like Henry's own stringy hide that protects against a life that has worn him to his essence.

Sometimes, long before dawn, Wyeth would row across alone from Eight Bells to Teel's Island. Excited by clues that tell a whole way of life, he would hear across the water the barking of Henry's dog in the darkness. Soon he could see the pale, tiny square of light marking Henry's kitchen, the lamp blinking on and off like a miniature lighthouse as Hen passed in front of it. Wyeth could imagine him lifting logs from the blue wood box, building the fire in the shiny black stove, making coffee. Presently, there came the squeak of Henry's oarlocks, followed by the swoosh and thump of traps hauled up, then falling back into the water.

Andrew called Henry "the Baron of Teel's Island" and found his Maine eloquence almost Elizabethan. He once told Wyeth, "You know that girl, Andy, the one with them air-cooled teeth? Saw her over to port. She had on one slim rig. Went by me with everything humming taut." Many of the lobstermen cannot swim. One fell overboard and drowned off Teel's Island. Wyeth asked Henry the next spring, "Have they found his body?" Henry answered, "God, I guess not. He's had some soft walkin'." Wyeth says, "I saw a ghostly moving figure barely touching the bottom of the ocean."

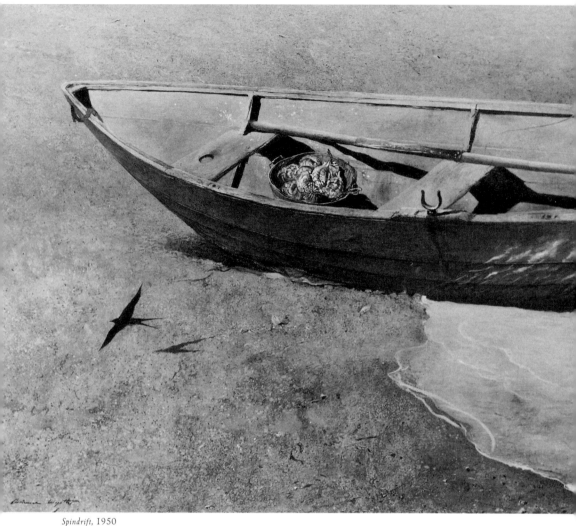

Spindrift, 1950

He abhors the picturesque element in Maine, loves the terse truthful-
ness of subsistence Maine natives, their ability to cauterize the sentimental,
to cut past their folksiness to the core of their lives. Wyeth once visited an
old man at Spruce Head, Maine, the home of Ralph Cline, his subject in
The Patriot. Wyeth tells, "The fellow was sort of grimy, the whites of his
eyes very white. I said, 'Did you know Ralph Cline?' 'Yup.' I said, 'Wasn't he
wonderful?' 'No, he warn't. He was just Ralph Cline.'" Wyeth laughs
appreciatively. "That settled that!"

In his late seventies Henry was unequal to another winter on the
island and stayed in Port Clyde—impatient to return to Teel's Island as

soon as weather allowed. The next year he went
into the hospital in the fall, was operated on, and
died that spring of 1954. Wyeth and Walt
Anderson independently visited the island. Hauled
up into the high grass in front of the house was
Henry's little punt, face up. "When he'd leave for
any length of time," Walt said, "he'd always turn it
over. Gives you a funny feeling. Andy mentioned to
me about Henry leaving his things laying around as
though he was through with them. He saw it, too."

Wyeth believes that people
shape and wear their inti-
mate possessions into sur-
rogate self-portraits. After
Henry Teel's predawn tour
of his lobster pots, Wyeth
painted the dory with its
worn oars, and the sea, lap-
ping on the gravel and
shells, patterning its side
with rippling reflections.

Wyeth has always had a strong feeling for the poignancy of objects cast up by the sea, by life—the flotsam of time. He did a watercolor of the abandoned skiff, and a picture of the violation of Henry's rocker, painted blue by the island's new owner and kept outside. Wyeth found torn and rotting, half buried in the sand, one of Henry's rubber boots—"some soft walking"—and he painted it in tempera. "These subtle things that go by," Wyeth says, "things that mean a lot to me, people I care about—I record them to get my feelings out."

Wyeth is painting the drama within the commonplace, the remote, peculiar side of nature hidden from most eyes. He says, "The hardest thing for a young person is to see romance in the surroundings of the commonplace. We cease to see the quality of an electric stove against a window. If you believe in it, have a love for it, this specific thing will become a universal. Of course, the mundane has got to have a lift, but it all depends on how strong your imagination is. I could see myself doing airplanes in airports, the planes taking off, landing—the oil dripping from motors; feel the storms and clouds the plane has passed through—like the days of ships coming in. It's the ability to see beyond."

8

On July 12, 1939, his twenty-second birthday, Andrew casually, impulsively took his first day off from painting that summer—and permanently altered the course of his life and work. The previous day a Merle James had come with the artist Roy Mason to see NC. Andrew was impressed by James's easy flow of humor and information. "He knew about everything," Wyeth remembers. James lived in Cushing, and he talked intriguingly about "our side" of the St. George River.

Though Andrew never, ever looked up people, he set out from Port Clyde in his father's station wagon and drove the fifteen miles down the long finger of land on the north side of the river to Thomaston. Then he turned back south along the next peninsula toward Cushing—hardly a town at all with its white houses and plainspoken farms strung along three miles of road. "I thrive on nothingness," Wyeth says. "And Cushing is one of those things that almost isn't."

Till then he had been focused almost entirely on the islands and edges of the sea. He was intrigued to explore this bit of inland Maine. It touched memories of the two childhood years in Needham, Massachusetts, the sensations that meant New England. Open barn doors with swings hanging from lintels gave glimpses of barns like his grandparents' in Needham. In the quiet of the fields he could hear the wind in the pine trees, the soughing that had charmed him waking from naps.

Where Port Clyde was a threshold to the moods and violence of the sea, the inland calm of Cushing, sedate, removed, was another essence of Maine. "I began to feel the personal side, the inner, introspective side," Wyeth says. "I had been trying to feel the bigness of Maine, the swish and swirl of the sea, but that didn't really click."

Here the drama of the sea was only sensed. On white doorsteps were conch shells brought from the Caribbean by sea captains. Newly painted

lobster buoys hung beside barns. Victorian scrollwork under porch roofs evoked the filigree on the sterns of British men-o'-war. A foghorn on a far island signaled distant danger. In Andrew's imagination the silence was suffused with foreboding. Beyond the horizon of this pool of timeless quiet, terrible events could be happening. As Wyeth once put it, "Jack Kennedy is getting shot at the same time as the delicacy of a woman's hand picking berries."

In these guileless houses, beside their potato patches, might be brutal seamen retired from dangerous, violent lives—New England Spud Murphys. Perhaps pirates had hidden away here. Perhaps witches concealed themselves in this quiet—along with the citizens capable of burning them at the stake. "Until that time," Wyeth says, "I hadn't known the real intensity of Maine. It was like finding in some lonely room dry dead flies and a newspaper twenty years old."

Before calling on Merle James, Andrew paused to make a drawing of the white, boxlike Acorn Grange No. 418. Arriving at Broad Cove Farm at Bradford Point, he was struck by the tan field unfolding before him, rolling up the hump of a far ridge. On the crest was a shingled barn and a white clapboard farmhouse, stark with no flowers, shrubs, or trees. It seemed perched there. A high wind might blow it away. Turning up the long driveway, he headed toward two women who, more than his own family, would share and mesh with his intense, singular sensibilities.

His knock on the door was answered by seventeen-year-old Betsy James, wearing a halter, high heels, and very tight short shorts. She had lustrous brown eyes, and her brown hair was in bangs and a pageboy down to her shoulders. In Andrew's memory the door was opened by "this brown, healthy girl with this dark hair."

Betsy was startled. She had expected a man coming to cut wood. This dressed-up, tallish, slightly gangling young man was subtly different from anybody she had ever seen. "I liked his type," she remembers. "Not drop dead, but very interesting looking. I liked the color of his hair."

Having seen "M. D. James" on the mailbox, Andrew asked, "Is Doctor James at home?" Betsy said no, but invited him inside—where

Lime Banks, 1962

His future wife, Betsy James, expanded Andrew's horizons into the territory around Cushing and Thomaston, Maine. There in 1962 he saw, luminous in the moonlight, a white bank of lime that a century earlier had fed local kilns and was carried by clipper ships up and down the coast. In Wyeth's imagination seamen's families watched for their return from garret rooms. White has always fired Wyeth's excitement. He hurried to his studio and drew its outline on a studio wall. "Just the curve of a pencil line can give you a mood," he says.

Andrew said that he was a medical student at the University of Pennsylvania. Betsy was impressed, even as she explained that her father was not a doctor. She told Andrew that she planned to go to the University of Chicago and study archaeology, but wanted to ski for a year, so she was going to Colby Junior College in New Hampshire and would transfer later.

They sat in the small, sparsely furnished parlor and were immediately absorbed in each other. She found she liked his slight air of theatricality and felt a strong physical attraction. Andrew was fascinated by this beauty who so clearly understood his feelings about the open quality of Cushing and its houses, the quality of the light falling on her floor.

He was enthralled by the house surrounding this remarkable girl. The woodwork and wide board flooring were painted, as was everything except the delicately carved mantel. On the floors were hooked rugs. Victorian wallpaper covered the walls. A melodeon was well used. There was a back scratcher made from shark's teeth wired to a cane. A chair was upholstered with red roses on a black background. No rare antiques. "They didn't care about that kind of beauty," Wyeth says.

There were no curtains. Light saturated the immaculate rooms. In the kitchen was a wood-burning iron stove, an iron sink, gray-white walls, a basket of new peas. In lieu of electric lights, glass oil lamps were lined up, waiting for evening. "It looked like what Maine was *really* like, just as they found it," Wyeth remembers. He was reminded of the atmosphere during his boyhood stays in the old Wawenock Hotel. "To feel something," Wyeth says, "you have to half know it already."

This casual home was in contrast with NC's expensive renovation of Eight Bells, the ostentation of a servant and the dock big enough for a steamship. "He always spoiled things," Wyeth says. "I even regretted electricity. Pa was too intellectual, had too big a mind to get close to nature. He always treated Maine as a place to go for a short time."

Even the N. C. Wyeth migration between Pennsylvania and Maine seemed to Andrew overproduced, overorganized. Lists were written out—huge wardrobe trunks of clothes, the silver service, picnic baskets, paints and canvases brought and often hardly used. For Andrew, the fuss was one

more clue that his father had been corrupted by sophistication. "I'd been alone with Walt on the water," he says, "while the family was having this tennis court stuff."

The utilitarian simplicity of the James house, its feel of early New England, was the hallmark of Betsy's mother, who joined Andrew and Betsy and invited him to lunch. Named Elizabeth Browning—a distant relative of the poet Elizabeth Barrett Browning—she was called both Bess and her daughters' childhood nickname, Maga. She was a tall woman, five-foot-nine, lean, with a full bust and a long, corded neck. Her face was square, swarthy, muscular; her long, dark brown hair wound in a bun on her head. Her demeanor was quiet, reserved, even stern—that of a person hard to know well—an air of American aristocracy, of puritan fiber. A Bible-studying Unitarian, she meditated behind her closed bedroom door. She was a woman to whom posture was important. She corrected her daughters with code letters, "S.U." meaning "Sit up!" She valued chastity and punctuality, graciousness and diction. When Betsy on a date missed her curfew by ten minutes, Merle James was dispatched to the boy's house. When Merle—who liked to be called Jim—started a slightly off-color joke at dinner, Bess at the other end of the table would shush him, saying, "Jim, Jim. The girls."

But as Betsy describes, "All of a sudden the sternness would break up. That was the shock of it. Like bells ringing." Bess's smile literally flashed. A gold tooth was like a roguish exclamation point, usually echoed by a gold choker necklace. Her fingers restlessly twisted gold rings.

She was game for anything, rode horses, danced like a young girl, loved to play Monopoly. She and Jim read aloud to each other, and she had a reading circle. Though using a wood stove, she was a superb cook—driving miles for the freshest eggs, the newest corn. She was constantly busy. She made her own soap. When writing letters to "dear sweeties," she impatiently used abbreviations. She walked fast and drove fast, hitting puddles at full speed, spattering the windshield with mud.

"She was a finely bred racehorse," Betsy says. "You never knew what to expect next. She'd have a basketful of things to mend and never get to the bottom of it. Sweaters half finished. You always knew when she was in the house." Wyeth remembers that "she had that New England fragility, and

yet the spark that keeps them going. Very alive. Edgy. Had a light touch. Didn't go too far. But there was a strange gleam in her eye."

However, the New England granite would suddenly resurface. A friend said, "Maga was sweet but, boy, with a piece of iron in her back." She disciplined Betsy by withdrawing. "Distant, not moody," Betsy says. "The personality would leave and you'd miss it terribly." In later years Betsy lived in psychological terror of losing her mother, her one source of love in the family. Her friend Doctor Margaret Handy told her, "You have to separate yourself from your mother. You've got to cut that tie." Betsy tells, "So I did it." She slapped her mother's face during a disagreement.

The iron had been annealed by a life shadowed by mortality. Born to a wealthy family in Montville, near New London, Connecticut, Bess was a twin whose brother died at birth. In her early teens her father died of Hodgkin's disease and her mother committed suicide. Bess and her younger brother were raised by her mother's sister in Belmont, in western New York. From childhood Bess suffered digestive problems. Soon after she was orphaned, she contracted rheumatic fever—and the lifelong peril of a rheumatic heart. Doctors forbade her to go to college and to marry; motherhood was absolutely out.

But Bess wrote off the medical profession's pronouncements. She went to Wells College in Aurora, New York, and then to graduate school at Cornell to study animal husbandry. For a time she taught high school Latin. Five times she was engaged to be married. Then, at the age of thirty-one, she married Merle James, with whom she had three daughters, Louise, Gwendolyn, and Betsy. The fragility of Bess's health was never mentioned in the family. That was how Bess dealt with misfortune and what she taught Betsy. The disagreeable and the disastrous must be handled without remark.

In 1946 Jim took early retirement and the family moved to the Cushing farmhouse full-time—far from temptation, but also far from the conviviality of East Aurora, where he belonged to an arts club called the Hammer & Tongs and was chairman of the board of education. In Cushing the plan was that he would paint full-time and Bess would support the family. A studio was built onto the farmhouse. Financially he was now dependent on Bess, who kept a tight hand on the pursestrings.

Jim James came from a lower-middle-class family in the small town of Franklinville Station, New York, where his father had a piano store. Blessed with a beautiful tenor voice, he earned money by singing at funerals. He studied art at Syracuse University—he was elected president of the senior class—and became a painter of considerable competence in watercolor and oil. In 1952 he had a one-man show at the Currier Gallery of Art in Manchester, New Hampshire. He settled in East Aurora, where his first job was designing illuminations for a leather shop. He then worked for the Roycroft Press in Buffalo, and in 1924 became editor of the rotogravure section at the *Buffalo Courier-Express.* Though Bess was independently wealthy, she insisted on living frugally on her husband's income.

In Cushing, Merle James was absent when Andrew arrived. But his wife, Bess, was there and their handsome seventeen-year-old daughter, Betsy. Bess combined a New England austerity with a warm heart, and was later adored by Wyeth. Merle—called Jim—was a beguiling Welshman, a newspaper rotogravure editor, and an accomplished oil painter.

Jim James—or Pom Pom, as his children called him—was a tall, slender man, an impeccable dresser with a broad, high-domed brow and narrow jaw. His eyes were convivial, eyebrows bushy, his laugh and manner relaxed, a cigarette

dangling in his mouth. He was Welsh, a teller of jokes who loved language, read avidly, and had an inquisitive mind. He pursued interests to the nth degree and was a major conversationalist, happy to listen but able to hold an audience with stories and light humor. A connoisseur of the outrageous in life and fascinated by Arctic history, Jim knew Frederick Albert Cook, whose claims of having discovered the North Pole in 1908 and reaching the summit of Mount McKinley in Alaska were judged false. In 1923 Cook was imprisoned for fraudulent use of the mails.

Betsy, as a little girl, worked for Jim's attention. She helped him empty the ashes from the furnace. When he farted, she tried to fart too. They shared the same irreverent humor, the same zest for the out-of-doors, for skiing. Still she did not feel close to her father. Once, when Bess was absent on a steamship cruise of the Great Lakes, Betsy had a minor illness. Her mother immediately left the ship and rushed home. "She was there," says Betsy, tersely. "He wasn't."

The grown-up Betsy judges that her father was incapable of real contact, was a magnetic personality who floated charmingly on the surface of circumstance. "My mother did not marry the right man," Betsy says. "He was not like her, not a blithe spirit. He appeared to be, and would charm women. Everybody fell in love with my father. But it was a surface thing. He was kind of stuffy underneath. I caught on to that very early. He was two different men—the father at home and the father with people. At home the warmth wasn't there. I don't remember him ever saying 'I love you.' Maybe he said it to my sisters. Maybe he didn't like me."

Betsy's albums are full of pictures of sun-warmed family excursions on Jim's boat, named the *Semaj*—James spelled backwards—and scenes of family trips, idyllic fun. But in the family dynamics, Betsy grew up feeling on the fringes, feeling uninteresting to her sisters.

Louise, five years older, says, "I didn't pay much attention to Betsy. I was the extrovert. Buzzed in, buzzed out. I was president of my class, in the honor society, in the dramatics club, on the soccer team. So the other kids were sort of in the background. I didn't mean to run roughshod over them, but I demanded a lot of attention. I was horrible."

Neither James parent was demonstrative. Praise was in short supply. For all her achieving, Louise felt she had never wholly satisfied her parents. She says, "Nobody told me I had done a good job. Ever!" When elected president of her school class, she did not tell her parents. "I felt my family just sort of took everything for granted."

The middle sister, Gwen, fifteen months ahead of Betsy, was an extremely pretty, impulsive, mentally quick girl who, like Louise, paid little attention to her quiet younger sister. She remembers that "Betsy took more time at things. She was the one . . . when we had an ice cream cone, she worked on it for an hour. Mine would be gone in five minutes." Like Louise, Gwen went to Syracuse University, where she studied art and ultimately became a wallpaper designer. She connected well with her father by talking about his work—which Betsy refused to do. "Bored me to death," she says.

On some level Betsy felt unworthy. "I was the flawed child," she says. "Everything was wrong. I always felt I was kind of a . . . you know, the other girls were okay, but I was different." Perhaps because her mother's parents were third cousins—Brownings, whose lineage stretched back eleven generations—Betsy was born with deformed bones and spine, potentially a hunchback. Bess massaged the little body and irradiated it with optimism. She oversaw the corrective exercises that continued till Betsy was fourteen. Bess's attitude was, "We will get through this one. You're perfect." And she would impress on Betsy: "There is nothing you can't do if you really want to do it. Don't aim so high that you can't make it, but if you really want to do it, do it."

Betsy also had a stammer and a serious reading problem. "I was very slow," Betsy says. "The plodder with lots of books going home at night and being sure my homework was done and very conscientious." At the dinner table Bess did crossword puzzles out loud to increase Betsy's word knowledge. So small that her parents worried she might never grow, Betsy was a stick even when she did reach normal height. She did not menstruate until age fourteen. "I was a strange child," Betsy says.

To the world she was quiet and submissive, "always a goody-goody little girl," Louise says. "Always did what she was supposed to. If somebody

wanted her to sit on their lap, she'd sit on their lap." But within herself, Betsy had a rawhide will. There is a photograph of a little-girl Betsy, her face rigid with anger as she gripped a half-dead Christmas tree, defying the world to burn it.

Even before she was in first grade, Betsy was constructing a secret life in hideaways—a piece of burlap laid out like a rug in a field of thistles that kept the world away. She took her treasures there, her gleanings from the objects put out for pickup on the neighborhood "junk day."

Needing friends, Betsy created a pal, Mary Lane, and a place for her was set at the dinner table. Betsy had an eerie rapport with animals. When she lay totally still on the grass, curious chipmunks would jump up on her body. She made friends with a crow who would come through the window into her bedroom. Years later at her house in Chadds Ford she was adopted by one of the geese wintering there by the Brandywine River.

By the time she was eight, excluding herself from the usual organized sports and girlish interests, Betsy was a watcher who made odd corners of eccentric lives into another kind of secret place. She visited older people, often those who lived alone, who gave her intimacy, talked about their lives, their pasts—a man who sat alone in a cabin talking to the world over a shortwave radio.

"I wasn't doing something social," Betsy explains. "I was walking directly into their lives. I was understood and they understood me. They needed me. I brought joy to them; just the fact that I would appear. It was the kind of thing Andy does. Everyone Andy paints . . . they need him. There isn't a model who doesn't enjoy him. My sisters knew nothing about this side of me."

In 1931, when Betsy was ten, the James family began their annual summers in Maine with Bess's old friend Ruth Rockwell. The dirt road to her house on Bird Point in Cushing passed within a few feet of the Olson house. Each spring as their car went by, Christina's thin arm waved a welcome through the dirty kitchen window.

Christina was a natural for Betsy, who washed her dishes, hung her laundry on the line. "Christina needed attention," Betsy says. "No one was

taking care of her. And I got tremendous warmth. It was a place I could go and be understood and adored and given total freedom. I never discussed it with anyone. While I was roaming Olson's, Gwen was involved with boys."

Almost daily Betsy and little Marianna Rockwell arrived with a white enameled pail to get milk and sweet peas from Al Olson. On hot days Betsy and Marianna played in Alvaro's cool ice-house, the blocks covered with damp sawdust. They played in the hay barn, where each summer there was a litter of kittens whose tails were often cut off by the hay mower. Betsy picked nasturtiums in Christina's garden. Christina's father, John Olson, was still alive, and Betsy took a perverse pleasure in doing cartwheels while the old man watched from his wheelchair in the morning sun just inside the shed door.

Always fascinated by contrasts, by "things appearing to be other than what they really are," Betsy saw the ultrafeminine woman trapped inside the contorted shell of Christina's body, saw her essential daintiness, the delicacy behind the deterioration. When Betsy came into her life, Christina could still walk, swinging her feet forward, leaning on Betsy. Christina gave evening "socials" for her sewing group. Sometimes Betsy helped serve the ladies fruit punch and the light cakes and crisp cookies Christina baked with skill and pain. These occasions were held in the front parlor with the flowered rug, where Betsy liked to comb and braid Christina's long hair to the accompaniment of stories of seafaring forebears.

Gradually, Christina confided the outlines of her story, memories of the days when she could walk the mile and a half to the village school where she completed the eighth grade, an exellent student with an impressive memory. As her "lameness" progressed, her mother made knee pads to protect her when she stumbled and fell. She went to Grange dances and watched from the sidelines. Once, walking home in her white dress, she fell in the muddy road and lay there wailing, "Why does everything happen to me?" It was the only time anybody remembers Christina crying.

At home she did the wash, became an expert seamstress, helped her mother can and cook, paint and paper the walls, make their own soap. With her friends there were picnics and lobster feasts out on the islands. She fell in love with a Harvard boy who summered in Cushing, and he wrote her

affectionate letters: "Every night I look up at the great square in the southeast and name the stars in it—Broad Cove, Four Corners, East Friendship. I wish I was driving around it with you. Well, anyhow the gossips will have a rest and you'll have a chance to get to bed earlier." After three years his attentions and the letters petered out.

Betsy explains, "I'm a listener. I want to understand. Probably it was the situation at Olson's that first attracted me. I knew what it was to be *not* right—like Christina. At that time I was trying to straighten out my own body."

At Olson's and the other households she visited, there was what Betsy calls "a touch of the voyeur"—just as Wyeth wants to participate deeply, but without true involvement. Betsy says, "I wanted to be part of it, smell, touch, feel, and then walk away. I wanted my freedom. The minute it became a responsibility, I was gone. Except for my own life."

Just as Wyeth has always been simultaneously attracted and repelled by potential violence, Betsy was drawn to the chaos of Olson's but frightened by a wild streak within her. "That's why I am so organized," Betsy says. "I've liked to come home to orderliness because I am so chaotic underneath, so *really* wild that I *really* have to keep things in order. I've always done that."

The vital seventeen-year-old who opened the door to Andrew on his birthday had blossomed only two years earlier. Her contained gusto had virtually exploded through the self-restraints—along with her womanhood. Suddenly her figure was head-turning. Her brown eyes flashed; she loved to dance. Suddenly Bess was objecting to boyfriends too old for her daughter. Gwen remembers, "My God, she took off. Had all the boys around her. I thought, my goodness, my little sister has grown up—without my permission."

Now she was a powerhouse at school. In May of 1938, the year before she met Andrew, the principal of East Aurora High School wrote to Mr. and Mrs. Merle James: "Betsy has undoubtedly told you of her selection into the National Honor Society of Secondary Schools. Selection for membership in this society means that the faculty of this school considered the

candidate outstanding in character, leadership, scholarship and service. The National Honor Society is nationwide in its scope and holds a place where membership in it is recognized as a mark of outstanding personal worth."

After lunch Andrew told "Miss James" that he had never seen Cushing and asked her to show him the countryside. When they got into his car, Betsy noticed on the backseat a yellow pad with an ink drawing of the Grange Hall. She thought, "Someone knows how to draw." She realized that he had already seen Cushing and was not a medical student. He must be the son of N. C. Wyeth, whom Roy Mason's wife had met the day before. She thought, "I'll show him a real building. This will be fun. I'll take him down to Christina's."

Searching her memory, Betsy elaborates, "Maybe I wanted to compare him. He was kind of glittery—almost movie star—a little flashy. I could take him to the door at Olson's—I wanted to see if he would go in. A lot of people wouldn't—the smell, the odor—and this was a summer day. I wanted to see how he would get along. From the time I was ten years old I had known that Olson's was difficult for people. Without saying anything, I judged them by what they did." Here was a trait Andrew and Betsy shared from the beginning: They are both watchers who delight in putting people in difficult situations and seeing how they react.

Andrew drove four miles south from Broad Cove Farm, turning left onto the dirt road at Hathorn Point. Years later Christina remembered the day she met Andrew Wyeth. "This station wagon drove in and down the field," she said. "When they got out, we saw Betsy and she came in and told me it was N. C. Wyeth's son. Didn't mean a thing to me. I never heard tell of Wyeths. She wanted some water. He was going to do a watercolor. I didn't know anything about painting to articulate at that time."

To Andrew, the matchstick-dry, disintegrating Olson house where Betsy introduced Andrew to Christina Olson felt ephemeral, as though built of fragile boards instead of hefty timbers. In *Weatherside*, 1965, it was "an accumulation of centuries"—"an elemental monument." He says, "The whole history of New England was in that house."

Andrew sat on the roof of the car and checked his position in relation to the islands that were his habitat. He realized he had been to this point years earlier, when he came by boat with a fisherman named Crow Morris to pick up herring

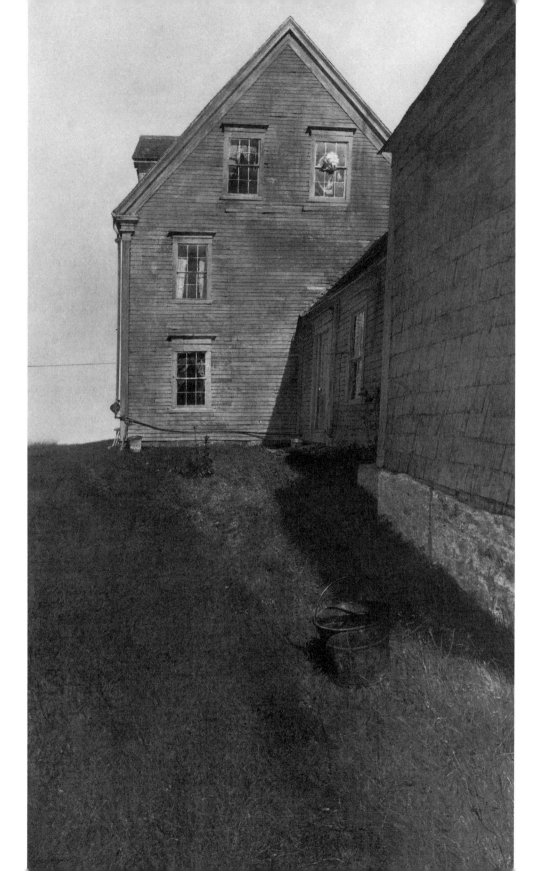

from Al Olson's weir. Then, from the car roof, he did his first watercolor of the Olson house.

Andrew marched straight into the kitchen to meet Christina. Betsy was amazed at his immediate warmth. "Right away he was terrific," she remembers. "So natural." She laughs. "Here was this seventeen-year-old playing a trick on him! And he's not knowing it! He got by the first hurdle."

Remembering that day, Wyeth says, "I was more interested in Betsy than I was in Christina, that first meeting. I'd known Negro houses and pretty run-down situations in Pennsylvania and even in Maine, so that didn't shock me. It wasn't any new thought. I wasn't walking in there and thinking, Oh, God, where's my paint? No, no. I thought the house was wonderful-looking from the outside. But it didn't knock me out. I was knocked out by Betsy."

The next day Betsy and Gwen were sunbathing nude behind a stone wall, a favorite indulgence. Bess kept a tin horn to signal the arrival of visitors. The horn sounded and they popped their heads above the wall. Coming up through the field from the river was Andrew. The girls scrambled into their clothes. He had arrived by dory to invite "Miss James" to come to Port Clyde to meet his parents. She insisted that Gwen come with her: "I wasn't going alone!" says Betsy.

When they came ashore in Port Clyde at Eight Bells, the family was gathered on the long porch. Before he could introduce the two girls, NC said to Andrew, "Well, I thought you were going off painting and now you're bringing back two covers from the *Saturday Evening Post.*"

"I could have slapped his face," Betsy says. "I just didn't like him." She felt even more like a dangerous interloper when they were not invited to lunch, though it was clearly imminent. Andrew quickly ushered the sisters to the studio he had built in the nearby woods.

Leaning against the walls were his brilliantly colored watercolors. To Betsy's chagrin Gwen took over, showing off her art training at Syracuse, getting down on her hands and knees to see the pictures close up, expounding on the application of washes, the kind of paper, the compositions, and so on. Betsy hung back, silent, disliking art talk.

Off to one side, unframed, not included in the display, was a portrait of a blond young man whose eyes kept looking at Betsy, fixing her attention no matter where she moved. "I wasn't terribly interested in prettily done work," she remembers, "but this picture was strange, something I'd never experienced before. I loved the way he had handled the spruce trees in the background. I thought, This blond young man and I understand each other."

After a while Andrew said, "Betsy, you haven't said anything. What do you like?"

She answered, "I like this the best," and pointed to *Young Swede,* the tempera of Walt Anderson. "I knew the other things were pretty surefire," Wyeth says, "but tempera was new to me. It was what I was really interested in—and nobody was encouraging me. So Betsy really hit the note. That meant everything to me."

9

Nothing has ever *truly* mattered to Wyeth except his work—not family, friends, money, sex, pain, or pride. On the very few occasions when he has sought an intimate relationship, he has intuitively known that it would support and advance his painting. Wyeth once explained, "I've never been interested in women that say, 'Andy, I think you're darling.' I think that's a bunch of shit, and I don't want it. I think it's saccharine. Nonsense. Weakening. They want you to take care of them. I find it terribly aggravating. Betsy doesn't have to give a shit about me. I want her to love my work, not me. That's the important thing. I'm a very queer man."

When Andrew returned Betsy to Broad Cove Farm on July 13, he asked permission to call on her in a week. She made him get an okay from her mother. Bess James told Andrew, "She has to be in by ten-thirty absolutely, and I have to know where you're taking her."

On Saturday the seventeenth of July, Andrew took Betsy—dressed in a white sharkskin dress—to Rockland. They went dancing at a crowded pavilion with huge blinds raised like eyelids over windows that looked out on a wide porch facing the pale sea. Betsy, who loved to dance, found Andrew a little awkward—but fine. After an hour, she excused herself to "powder her nose." Betsy remembers that "when I came out, Andy was sitting on the rail of the porch with the most *intense* look I've ever seen on a man's face, nobody even close to his intensity—absolutely *consuming* me. I was a little frightened. He completely enters your whole understanding, this most secret part of yourself, tunes into it instantly."

They returned to dancing, and Betsy remembers, "He was a *completely* different man. *Totally* different. It was the greatest dance I've ever had. A sweeping . . . it was like I was a rag doll. Absolutely extraordinary." When the song was finished, he led her down to the shore. The tide was coming

in. Moonlight was on the water. Andrew kissed her. He said, "Let's get out of here." She agreed that the time was getting close to her mother's curfew.

Wyeth says, "I'd been a loner all my life, actually, until I met Betsy. I was smitten with her." Driving back to Cushing, Andrew pulled the car to the side of the road below the General Knox mansion in Thomaston. He told Betsy, "If you come with me, you will continue what you are for the rest of your life. Nothing will change." He asked her to marry him.

She answered yes. At home that night, she told her sister Gwen, "You won't believe this, but . . ." In fact, Betsy herself did not entirely believe. For her at seventeen this was still a thrilling, summer love affair. She remembers, "He absolutely put a net around me. I wasn't taking the romance seriously. I was playing with it. And a little scared. I'd never had anything quite this intense before."

Andrew's painting virtually stopped. Together they went on walks along the shore, picnics in the blueberry fields and on the islands. Though he saw her almost daily, a stream of letters arrived at the James farm from Port Clyde— "I could not sleep until I told you how swell it was seeing you this afternoon. I do love you, my sweet." "My dearest darling, I can't live without you."

Bess had never told her daughter the facts of life, but she now instructed Betsy, "Your virginity is your most precious possession at this point in your life. Just remember that." From the Port Clyde side of the St. George River, NC wrote Henriette and Peter Hurd that Andrew "went starry-eyed over a *very* attractive young lady." He added tepidly, "As long as an event must happen, it is deeply gratifying not to have to worry about *what is a girl's background.*"

In September Betsy returned to Colby Junior College in New London, New Hampshire. The love letters continued. September 15: "My darling one, I've been alone so much of the time in my young life, that now when I have at last found someone who loves and understands me completely, it's hard for me to let you go away. . . . You mean more to me than my father and mother." September 19: "My most dearest Betsy, I've read your letter over and over. I certainly hope I can live up to all you said."

September 20: "My beautifully divine darling, I want you to know that I think you are the most beautiful person I've ever known." October 4:

"My dearest, dearest darling Betsy. You've made me see so clearly that an artist's life must be rigorously governed by spiritual rectitude and purity of conduct."

Andrew would tell his father he was going to New York to see Robert Macbeth, and then secretly continued on up to Colby. The college had strict rules, so Betsy sneaked off campus to see her swain. But his attraction had little to do with his art. "I really forgot he was a painter," Betsy says. "He came to New Hampshire and followed me around and all that, and did watercolors. I guess I saw them. I mean it was just wonderful— Oh, God, I have a boyfriend in Pennsylvania."

October 10: "My dearest darling one. To tell you the truth, I don't like people in any way to get close with me. In fact, I hate it. That's why when I met you I knew I was in love because I wanted you right from the start to know me completely. You know me as no one else does, darling. That's why I do the foolish thing of lying to people about myself when they ask me personal questions. I want people only to see my pictures and I always want to stay in the background. I want my life with you to be just that way."

That fall in mid-October Betsy, now eighteen, visited Andrew in Chadds Ford. They sat on the rocks above NC's house and Andrew talked about his boyhood there, his feeling for the Pennsylvania countryside, so fueled by adventure, by fantasy play, by Robin Hood. His fabulous but pained inner world resonated with her own secret life. "I realized how much we had in common," she says. "It was almost a language. Andy and I both grew up as solitary, out-of-the-mainstream children with a powerful parent. I had a removed childhood. He had a sickly childhood. I was the youngest. He was the youngest. They left me alone. They left him alone. He was a slow developer. I was very slow."

They share a sense of terror beneath the ordinary. Betsy had had her own Spud Murphy. In her early teens she often skied alone along a secret route beside Tanners Creek to her own secret ski hill she called Mt. Olympus. Once as she rounded a big, solitary barn, Betsy was enveloped by unearthly screams like a child's agony. In the barnyard a man gripped a bloody knife, his fierce eyes fixed upon her. A pig, blood pumping from its

neck, careened across the yard, spraying scarlet on the white snow. Other men stood there, laughing.

"It was the turning point in my life," Betsy says. "I realized everything had better have *that* in it. I was about fourteen. Same age that Andy saw Spud Murphy." In addition, her girlhood upstairs bedroom faced the house next door. In the nighttime darkness, an epileptic convulsed in seizures, screams piercing the quiet. To this day, says Betsy, "a still night drives me nuts."

During that visit to Chadds Ford, Betsy fell in love. She remembers, "I always knew at some point that somebody was going to find me and know what I was all about. And it happened. Just like that. Boom!" She continues, "I had a terrible premonition that he would die before I married him. He asked, 'Should we announce our engagement?' 'Absolutely!' 'Will you leave college?' 'Absolutely!'"

Now Betsy, age eighteen, began writing her own passionate letters—which she has burned—and confessed that only now was she truly in love. Andrew was startled and troubled. He wrote on October 23, "My only dearest darling, you tell me that you did not really love me at that time. I thank God that I've never been false to you about my love for you. . . . I want you to know you are my one and only one forever. Oh, *God,* how can I ever thank you enough for making this person finally love me as I love her.

"Darling, you've given me my first hard blow. I can see that I am to blame for the whole thing, and you, Betsy dearest, I love you so completely that I can never play the game, making you fall for me. When I am with you I'm lost, just as I am when I'm painting well. Darling, you've learned to love me with no help. It's really great when you think about it. But now to hell with the past, we have each other.

"We love each other completely, and, darling, I swear, I'll really beat you if you ever again doubt my love for you. You have only seen me when I am nice. But when I get mad, watch out. And darling, if you ever again tell me things which you don't really believe, I will do something you will *never* forget. We are one from now on."

With the exception of Ann, NC fought the marriages of all his children. After the weddings, while genuinely wishing them happiness, he exerted his

force of gravity to keep them in orbit around him. When Peter Hurd proposed to Henriette in 1926, she was also "very fond" of a young man in Philadelphia and engaged to a much-married Wilmington socialite—against NC's wishes. She accepted Peter Hurd—also against the wishes of NC, who till then had made a son of young Hurd.

NC argued that Peter was not ready to marry and support a family, and offered Henriette the standard solution of that era: she should go to Europe for a year. She refused. "Pa thought I was lost," Henriette said. "But I wanted to give myself and I did and Petie was very selfish and very charming and I absolutely adored him."

They were married in June 1929, when Henriette was twenty-one and Peter Hurd twenty-five. Andrew was turning twelve. But the pull of NC and Chadds Ford was so strong on Henriette, the rebel, that she and Peter rented a house ten minutes from the Big House. Then NC bought the former schoolhouse at the foot of the driveway and enlarged it with living quarters. The first two Hurd children were born there. Peter and Henriette maintained a horse and a high-octane social life, becoming in Hurd's self-contemptuous phrase, "the little friends of the rich." Peter spent an increasing amount of time in New Mexico, establishing an independent life and painting style. In 1934 he bought property in San Patricio, fifty miles west of Roswell, and named it the Sentinel Ranch after the overlooking mountain. Only after a full decade of marriage was Henriette able to make the break and move West.

When thirty-one-year-old Carolyn wanted her try at marriage, NC was determined that she was "unsuited." He was probably correct. Diagnosing her problem with men, she once said, "It's either fuck or fight." Her man was twenty-four-year-old Francesco Delle Donne—usually called Frank—a sometime student under NC. Classically handsome, very Italian, he was distinguished by a sweet kindness and voluble enthusiasm. His father had been an immigrant success story, building a grocery store into multiple businesses. Frank met Carolyn when he came to NC's studio as part of mural-painting class. He remembers, "In burst Caroline from outdoors in

her riding hat, really handsomely attractive with that great Wyeth smile, and we struck it real strong."

Carolyn began seeing Frank, and, he says, "I just loved when she would gush with laughter; it brushed off on me like crazy. Everything was funny. She was a great joy. Colorful as hell. With all the 'Goddamning' and 'crap,' she was basically a very kind, overgrown kid. She meant well. The very thing that stirred a little trouble between us was the very thing I just loved her for—that wonderful way of just being herself."

After about four months, defying NC, Carolyn and Frank eloped and were married in Arlington, Virginia, in 1941. They settled into an apartment in Wilmington, and were occasionally invited to the Big House for family gatherings, where Frank felt hazed as an outsider. He sensed that in NC's head "there was always this undercurrent about this young man of Italian descent: 'I don't understand his language, his attitude, the whole makeup of what he stems from.' Everything was American one hundred percent, and I wasn't American here long enough to be one hundred percent."

At Thanksgiving dinner NC pointedly offered "the Pope's nose" to Roman Catholic Frank. "He was always driving it straight to me," Frank says, "like an arrow in a very clever way. But he never fooled me." When Frank complained to Carolyn, there were fierce arguments, Carolyn defending her father.

In Wilmington Frank hustled to make a living as an artist, painting portraits, doing signs for Coca-Cola. Carolyn, unable to paint there in alien corn, pined for Chadds Ford and home. There were immediate problems in the marriage. "She was insatiable for the money thing," Frank says. "Like having spent on something else the money I had given her toward our keep in the household—and needing more money. I was always broke. I'd say, 'Now where did that go?' She'd say, 'Goddamn it, I did do the wrong thing, and I won't do it again.' And before you knew it . . . it kept repeating because she couldn't help it."

They separated and then reconciled, moving into a tiny house at Painters Crossing, just a couple of miles along the Baltimore Pike from Chadds Ford. Ann McCoy helped them furnish it. Carolyn was subject to

nightmares and walked in her sleep. One night Frank woke to see her going toward the open window. As she plunged out, Frank was able to grasp her leg, but her weight dragged her from his hand and she fell two stories to the ground. Her ankle was shattered and she walked with a limp for the rest of her life. NC blamed Frank for not taking care of his daughter, for being an inadequate husband.

For Frank this was an insupportable hurt. "I was close to a breakdown," Frank remembers. "I found myself crying irreversibly. Almost shattered." Carolyn went home to the Big House and Frank fled into the air force, ending up in the Special Services Art Department at Lubbock Air Base in Texas, where he made a little extra income painting portraits of officers. When he was due to be released, Carolyn began writing pleading letters and Andrew wrote "in his wonderful way" to say they might have a chance of making it work. "That's the way the Wyeths were," Frank says. "There's always that chance of things working out, and they usually did. But not in my case."

Frank returned at the end of 1945 and moved into the Big House with Carolyn and the widowed Carol Wyeth, who, he says, "was the dearest lady who sprinkled everything with sunshine. Always saw the good side." But at the end of 1946 Frank left to visit his parents in Wilmington and never came back. "I'd always be in debt," he explains. "That's what she was, and nothing would change her." The divorce was uncontested.

Ann was refused permission to marry until she was twenty, so NC's student John McCoy courted her for two years. Raised by an understanding mother, John was the artist in a business family. His father was a vice president of E. I. du Pont de Nemours & Co.; his brother later became the president and chairman of the board. During World War II, John was 4-F and did his war effort working at DuPont, where he became a "stainless steel engineer." Unknowingly, he was keeping track of all the steel destined for the building of the atomic bomb.

With NC's full blessing, the marriage of John and Ann took place in 1935 in the studio—before a triptych that is now in the Chapel of the Holy Spirit in the Washington National Cathedral. NC knew he was not

losing his favorite daughter. Dependent and accessible, she was settling permanently in Chadds Ford, only minutes away. She was forever his. When Ann and John were returning from their honeymoon at Eight Bells in Maine, they drove past the turnoff to the Big House. Its lights were visible through the trees. Reflexively, Ann said, "Aren't you going to turn?" She explains, "I felt a stab in the heart. I felt that body of warmth there, the love, safety."

NC knew that John would be no obstacle, was not a man who would push him away or act threatened and possessive. Leanly handsome, he was a thorough gentleman, sweet and sincere. He was also a loner, low on passion, taciturn, a man who never entirely believed in himself, who felt his capabilities unfulfilled. "My family always just overrode John," Ann says. "I can see them coming over here now, and he would sit in the corner chair there with his Scotch. He'd make some remarks; once in a while get something said. He just didn't push that hard. But he had his own ideas."

In Henriette's view, John was underappreciated as a person and an artist. In 1932 he studied theater set designing, but gave up that serious interest when he began studying under NC. A realist, painting in the shadow of Andrew Wyeth, he worked in oil and a technique he devised himself, combining oil and watercolor. His work was handled by a New York gallery where everything sold. He had one-man shows at the Farnsworth Museum in Rockland, Maine, and the Delaware Art Museum in Wilmington. He taught for twenty-five years at the Pennsylvania Academy of the Fine Arts.

His primary subject was Maine, where each year he spent four summer months. In the Chadds Ford winters he continued to paint Maine from sketches and memory. These pictures of the sea and its swooping birds, the barnacled rocks, the spruce woods and wildflowers expressed a poet buried beneath the heavy exterior, a lyrical connection to nature. "My father was a mystic," says his daughter Robin, "a real flight, the sky, up, going somewhere."

In 1936 when Nat wanted to marry Caroline Pyle, NC fought the union, even though she was the niece of the deified Howard Pyle. Her father was

Walter Pyle, who owned the Westbury Farm spring water company. After he died, her mother, Ellen, ran the company, raised her three daughters, and painted covers for the *Saturday Evening Post.* Caroline was extremely pretty and intelligent, and had ambitions as a poet. NC was negative because initially the romance between Nat and Caroline had cooled. Then Caroline's interest in Nat rekindled when Ellen died and the Westbury Farm company had to be sold to raise money. NC thought she saw Nat not as her lover but as her salvation. They were married in January of 1937.

When he announced his intention to marry Betsy James, says Andrew, "Pa was kinder to me than he was to a young artist in Rockland. One day Pa was looking at the fellow's work and all of a sudden a car horn began to blow. Pa said, 'Who the hell is that?' The young man said, 'Oh, that's my girlfriend. She's getting impatient.' Pa said, "You better get rid of that little bitch or you will never paint again!' The fellow married the girl and she made him go into the fish business. My father told him the truth."

NC did his damnedest to dissuade his own son from marrying. If Andrew would stay single and just paint, NC offered to build him a studio and support him financially. "My father tried to bribe me," Wyeth says. "If I'd been weaker, I probably would have done it—and I wouldn't have found myself so quickly, my *own* thing."

Andrew and Betsy went ahead with their plans for a big wedding in the fall of 1940. Soon the size was reduced, and it was moved up to May 25, then to the fifteenth. Andrew explained the reason in an April letter: "I know by the 25th I will be painting pretty heavy and it would be hard for me to drop it." Betsy wrote her girlhood friend Marianna Rockwell, "I'm just about the most excited girl alive."

In May, before the wedding, Andrew wrote a consoling letter to her parents, but aimed at NC:

> What a pure and rich life you have given me. The thing now is for
> me to show the world what a life like I have had does with a wife
> like Betsy behind me, and she is *really* behind me. There is no
> fooling about that. I should prove your ideas of what the right life

is for an artist to lead. It may interest you to know that Betsy was going to be made student president of Colby College if she went back next year. This is the highest honor a girl can get. Betsy was very happy to know this, but said that it seems stupid now that her aim in life was to build my work as high as possible and to give me the rich life I need to build.

The ceremony was held in the Jameses house in East Aurora, New York, Andrew in a white tie and tails, Betsy with gardenias in her hair. There were no bridesmaids. The *Buffalo Courier-Express* described the setting: "Ferns and blossoms banked the mantelpiece which formed the background for the altar, flanked on each side by tall ivory tapers twined with similax. A harpist named Martha Gomph played the wedding music. The bride was radiant." The instant the minister pronounced Andrew and Betsy man and wife, the groom and his father fell into each other's arms, sobbing. The profound interlinking of their lives had been broken.

Betsy was embarrassed in front of all her friends. "I'm standing there," she laughs, "and the bride isn't being kissed by her husband. I thought, 'My God, the reverend is going to think he's in love with his father, not me.' But it was a tremendous change in their lives. He was *Pa!* Andy was leaving. It was sort of like saying goodbye to Santa Claus."

The couple honeymooned at Eight Bells in Port Clyde. On the fourth day they were invited to a wedding in southern Canada. Betsy said, "Oh, this would be wonderful." Twenty-two-year-old Andrew said to eighteen-year-old Betsy, "We can't go. I've got to get back to work." "So soon?" "Betsy, everything else is going to be secondary." That was the bride's reality shock. "It happened that fast," she says. "Straight from the shoulder. Couldn't have been clearer. I had taken him away from his work for a week."

As much as she could, Betsy joined his Maine life. They woke at dawn, hearing the scrape and click of the clam diggers in the tidal flats. Their days were spent out on the islands, sometimes hauling lobster traps with Walt Anderson, Betsy bailing amidships, Andrew in the stern, drawing. They picnicked on Little Caldwell's Island, Andrew painting while

she sunbathed or searched for Indian relics—and then they rowed across to Teel's Island for a visit with Henry. While her husband painted she made her own clothes on an old Singer sewing machine the Teels had used for stitching sails. Coming home in the dusk, they hoisted the sail in the dinghy.

Betsy wrote NC and Carol, "Most of our evenings are spent alone talking about some incident during the day that has only proved more right those ideas and ideals that we both believe in." In a journal she wrote, "He is so stimulating that I feel my whole soul just a surging wave of ideas, impressions and thoughts. . . . How thrilling it is to know that my own Andy sees things as I do. . . . Yesterday, I picked six quarts of cranberries up in back of Andy's studio."

After a passionate courtship, Andrew, age twenty-two, and Betsy, eighteen, married in 1940 in Maine at the Jameses' house in East Aurora, New York. During the reception Henriette's son Peter looked rapturously at his beautiful new aunt. Now forced to share his precious son, N. C. Wyeth showed mixed feelings.

Betsy wrote her parents, "Gee, we're the happiest couple alive." And in another letter: "It will always be just as perfect as it is right now." Andrew wrote his parents, "I can't keep myself from painting. I must be at work on my painting before I can get the most out of anything."

Their marriage began the eight-year formative era that delivered this boy in his mid-twenties to status as an American icon, an evolution from exuberant watercolorist to *Christina's World*. By the time Andrew married Betsy, he had committed himself unswervingly to tempera. "I wanted something," he says, "that I could chew on for months at a time and pour myself into."

By 1941 Andrew was mastering a personal technique that exploited tempera's capacity for detail. With teensy strokes using tiny brushes, he patiently built color upon color, tones on tones, layer on layer—"the way the earth itself was built," he says. The process was summed up by an old Maine couple who once paused behind Wyeth when he was painting. "There he is again," the woman said, "daubin' away, daubin' away, a little to a time."

In later temperas, the finicky strokes were increasingly undergirded by the same wild underpainting Wyeth uses in his watercolors. His conservator Timothy Jayne explains that "these are very savage paintings, scraped and beaten. I see the anger under there."

Except for Betsy and his sister Carolyn, the people important to Andrew were discouraging about tempera. "I'd made my name with watercolors and a great fluency," Wyeth says, "and they thought I was retreating into stupidity by wanting to do every feather on a buzzard's wing." Robert Macbeth was indifferent to the temperas. In 1942 NC sent Henriette some photographs, and, according to Wyeth, she wrote back a scathing letter. "These are hard-edged, ugly paintings," he quotes. "When are you really going to start painting again?" NC said to Andrew, "Why the hell do you bother with tempera? You've lost your quality."

NC would look at a tempera and say, "Andy, can't you add some color to it?" Andrew would answer, "That isn't what I'm after, Pa." NC would warn him, "No one is going to buy these pictures." In fact, NC's early, great work on the Scribner Classics had been in muted color. But he went along when printers and publishers pressured him to brighten up. "They loved him when he would do sunset pictures and rainbows," Wyeth says.

Though well aware that NC had sacrificed his quality to be commercial—and had little feeling for tempera—Andrew was forever vulnerable

to his father. In 1942 NC steered him away from a tempera which was, in fact, a major work. Painted from a bird's-eye view, the picture looks down on three turkey buzzards, wheeling and gliding, riding the updrafts as they survey the Pennsylvania hills that lap one another to the farthest rim of the world. When NC saw *Soaring,* semifinished, he told his son, "Andy, that doesn't work. That's not a painting."

Deflated, Andrew put it away and later his sons nailed onto its back their model railroad tracks. It ended up against a wall in Wyeth's studio. Eight years later the Macbeth Gallery was planning a show, and Andrew showed *Soaring* (pages 188–89) to their friend Lincoln Kirstein, the cofounder (with George Balanchine) of the New York City Ballet Company. Kirstein insisted that he finish it. In New York it sold immediately and today hangs in the Shelburne Museum near Burlington, Vermont, the track marks invisible against the wall.

Like a round peg in a round hole, Betsy filled the vacancy left by NC's loss of influence—and filled Andrew's loneliness in his work. She became a potent voice, helping to steer Andrew's painting, and he in turn was open to her ideas. Wyeth has always been humble in his struggle to communicate on a flat surface a fleeting impression, like shaping a handful of smoke. Inevitably, the picture feels to him less than his original vision. Showing a new tempera, he radiates the excitement of the inspiration, but at the end will often murmur, "It's a strange one." Then, as he turns away: "I wouldn't know."

A by-product of Andrew's nervous sensitivity is a concealed vulnerability—one of the reasons he has allowed so few people into his life. "You can rule Andy with a look or a comment," says his friend Helen Sipala, "much more than you could if you hit him with a two-by-four. Because he really does value the opinions of the people he loves. If you said, 'You're disappointing,' that would wound him to the point where he would never recover from it. I think that is because of his father."

Describing her role in Wyeth's work, Betsy says, "It's like I'm a director and I had the greatest actor in the world. I mean, what's a director without an actor? So my role is *unimportant.* It's the most elegant, wonderful position in the world to be in. I had these strange viewpoints, and he would right away catch on."

Discussing the dynamic his marriage brought into his painting, Wyeth says, "Betsy started out with nothing. When I married her, she didn't know how to boil water. But she's made me into a painter that I would not have been otherwise. She didn't paint the pictures. She didn't get the ideas. But she made me see more clearly what I wanted. She's a terrific taskmaster. Sharp. A genius in this kind of thing. Jesus, I had a severe training with my father, but I had a more severe training with Betsy." He continues, "A lot of artists' wives have brains like a turnip. Wouldn't know a good picture if they fell through it. Might as well be showing the work to a gnome."

He continues, "I think there's always a danger of rigor mortis. An artist like me needs someone tough to keep him on the button. It makes me fight all the harder. I knew what my drive was, and I wanted like hell to paint. Betsy galvanized me at the time I needed it. Later on it became a little hard to take."

In the schoolhouse in Chadds Ford—rented to them by NC—Andrew's studio was just off the huge former classroom, and an integral part of the tiny household. Drifting in and out, Betsy saw all paintings at all stages. In the evening they discussed the day's work. "It was perfectly normal," Betsy says. "Never a second thought about what I was doing. It was a way of life. I was not this *thing* that arrived from upper New York and changed the world. It was very subtle."

"We developed together," Wyeth says. In Betsy's memory, "It was all so natural. The slow emerging of a me that had always been there." Since girlhood, Betsy had had an intuition for drama, an almost preternatural visual sensibility. Perhaps it was inherited from her father, the rotogravure editor. As a girl she would go to Jim's office and submerge herself in his picture files, and he would hand her fifty photographs and quickly tell her the stories they contained. Bess often took Betsy to Buffalo, a pre-Broadway tryout town, to see every play of importance. Nothing daunted Bess, not the bus trip, not blizzards requiring ropes strung for pedestrians along the sidewalks.

Andrew taught his teenage bride to see in a different way, to find the cosmos in a detail—the weeds she would ski over, the flowers she cut down

without a thought. She says, "I love the theater, and he showed it to me in the drama of real life. It wasn't the great choruses I'd heard, the Christmas pageantry, Shakespeare—the great voices, Katharine Cornell, Maurice Evans. It wasn't the presses in my father's newspaper, the editing room. It was the enormity of Henry Teel in his kitchen, turning to look out to sea."

Betsy was fearless. On their long walks over the countryside she asked questions that were searching in their innocence. She would say, "Why do you see so many colors? Why do you paint the sky lavender when I see it's blue?" Remembering, she laughs. "I guess he learned quickly that I was a person who wasn't very artistic."

The year 1941 began two years of seminal evolution in Andrew's work, strongly influenced by Betsy's visual palette. Andrew painted a large, winter tempera called *Dil Huey Farm*—a symmetrical composition divided at its center by the lower half of a huge buttonwood tree, its limbs, branches, and twigs spread against the sky like veins and capillaries, bare except for one poignant spray of leaves. Behind the tree flows the Brandywine River. Tiny in the left distance are the wood barns and stone house of the farm. Betsy watched the picture evolve.

The finished tempera was high in key, with touches of impressionist broken color, slightly shimmering passages of blues and lavenders, and a pinkish sky—faint reverberations of the wild Maine watercolors. The picture was hung in 1941 in a joint Andrew Wyeth–Peter Hurd show at the Corcoran Gallery of Art in Washington, D.C. Alfred Barr, Jr., director of the Museum of Modern Art in New York City, saw it and wrote to say he was "much impressed," and inquired the price of the picture. Though there were "no funds for purchases at the present time," *Dil Huey Farm* was hung in a 1943 show of *American Realists and Magic Realists* at MoMA.

Betsy, however, was not impressed by the picture. In her view the early temperas were too close to studio adaptations of watercolors. "In my temperas," Wyeth says, "Betsy helped me get rid of all this goddamn French impressionism that I had very strongly in my watercolors. She really let go on me. She said, 'Andy, you've got to get rid of all this corny color. Everything is exaggerated. That's no more this valley—it might have been painted along the Nile. You're going down the wrong road. You've got to

get to the truth.' I was jolted. But it was an overhauling I needed terribly. I'd been using color for color's sake."

Betsy talked about the shock that lay in lack of color. "I brought white into his life, the snow," she says. "How people look in that atmosphere—I always loved snow. I think blood on snow is more shocking than blood on brown earth." She encouraged Andrew to express his macabre streak—Spud Murphy—*her* stuck pig—their shared sense of disturbing unease. "I was taking out the softness," she says, "sharpening his edges, going after the real meaning. I had a simplicity that wasn't cluttered with art theory, and I translated his ideas into metaphor. His language had to be understood somehow."

She campaigned against Andrew's urge toward meticulous realism. The year after *Dil Huey Farm* he perched for two weeks on a stool teetering in the Brandywine River and painted the tempera *Summer Freshet*, an early experiment in the odd and dramatic perspectives that became part of his painting arsenal. Seen from above, a huge, foreshortened trunk leans out into flooding, curling water. Big green leaves rise dramatically in the foreground; the blotchy, mottled bark of the tree is microscopically painted.

Betsy told him, "I'm so caught up in all the bark you're doing, I'm losing the whole impact of the painting." She told him the detail was like anatomical drawings that show every muscle. "If that's the kind of artist you want to be," she said, "go ahead and be that. But it doesn't interest me." Repeating his version of Betsy's dictum, Wyeth quotes, "Don't show your cards, not every fucking leaf. Suppress it."

She was casting herself as a counterforce against what she saw as Andrew's safe, conservative approach to painting. She urged him to be utterly austere, and concentrate totally on the reason for the painting. She objected strongly to her young husband's method of making a preliminary pen-and-ink drawing on the tempera panel. She told him, "How the hell can you do that? You don't know what's going to happen during the long period you'll be painting it. Don't shut your mind to an accident happening."

Betsy also influenced Andrew's watercolors. "I had a sort of clarity of vision of what I would love to have happen if it would be possible," Betsy

says. "That's what we used to discuss at great length: 'Why haven't you painted Walt Anderson the way he *really* is?' I was changing the outlook on the familiar. I'd always been someone who'd done that. That to me is absolutely riveting."

In the summer of 1941 Andrew painted a milestone watercolor called *Coot Hunter*—Walt Anderson shooting birds—carrying a shotgun and a clutch of dead birds away from his beached dory. Until then the "swishy watercolors," as Betsy calls them, had generalized Andrew's exhilaration in the vastness of the air and water and the fragility of man in this amphitheater.

But this time Andrew was striving for more substance, more completeness, the uniqueness, the difference of objects. Betsy says, "The whole thing was beginning to take place, the emerging of something *more*. Everything was now there." Andrew tried one version after another, but none expressed the elusive something he felt. Interested at first in the blond hair, he tried several poses against dark spruces. He tried the picture, surprisingly, in oil with no sky, then tried it splashy with lavenders—one, two, three, four, five variations.

Andrew showed each picture to Betsy. "I took him deadly seriously," Betsy says. "*Deadly* seriously. I wasn't Carol Wyeth bursting into tears and saying, 'Oh, Convers, it's so wonderful; you're such a marvelous painter.' "

She voiced her feelings about Walt, what quality the picture should have: "Walt larger than life, monumental, not just anybody. He's *heavy*. Huge. Just crunching the hell across the mussel shoals." Betsy stood up and demonstrated the walk. "It's *this*." Finally, she says, "He got mad enough at me, and, *whoosh*, he did it."

Coot Hunter hung in his 1941 show at the Macbeth Gallery, and was reproduced in the *New York Times* art section. Gertrude Vanderbilt Whitney, founder of the Whitney Museum of American Art, was interested in it, until she heard the price, $350. She asked if Andrew would settle for less. He refused. Robert Macbeth called Andrew to say that a sportsman wanted to buy the picture, but could Andrew paint in a face on the hunter. Wyeth likes to tell how Betsy raged, "If you do that, I'll leave you." He ends, "So I didn't do it."

It was included among eighteen watercolors shown in a separate room at the *Twentieth International Exhibition of Water Colors* at the Art Institute of

Coot Hunter, 1941

Chicago. A friend wrote Andrew that his pictures "showed up like dia-monds in a bucket of sawdust."

Coot Hunter was one of the earliest examples of Betsy's power to delineate drama, to grasp and verbalize the subjective, abstract quality in an idea, give a thread that another can follow to express the more than meets the eye. But she likes to keep her hand almost invisible, waiting till a person's guard is down.

She would say one oblique sentence, ask an unanswered question, just as Andrew was preparing for bed. "Betsy gets to the core of the thing," Wyeth says. "A hint is all an artist needs—a little glimmer of truth. It's funny how it smooths the whole thing out."

Sometimes Betsy gives an entire vision. Typical was her impression of the Hurd

On Blubber Butt next to Teel's Island, Walt Anderson carries a dead coot and his shotgun away from Andrew's dory. This was a key shift from atmospheric abstractions of Maine sea life to a figure with more weight, articulation, and par-ticularity. *Coot Hunter* was bought by the Art Institute of Chicago.

ranch after her only visit. She remembers: "It belonged to nomads. Brilliant jewelry. Silver and deep purples. People with glistening teeth, the dark skin and black, black hair. The alien quality of the Anglo, and even the Spanish. A working farm. I woke up one morning and heard the horses outside hitting the sides of boards. Henriette was an amazing little thing that goes chugging along, like a tiny little Singer sewing machine."

In 1957 Wyeth was painting an almost panoramic tempera of Karl Kuerner's house and pond, eventually titled *Brown Swiss*. Betsy described a moment in Tolstoy's *War and Peace* when an army marched across an earthen dam while a man and his grandson sat fishing in the pond. "The picture should be as if you're one of those soldiers and you don't even see the sky," she told Andrew. "You just remember that incident. If you went back, you'd be surprised at how the hill isn't that big."

She recalls, "He was off. Boom!" She had given Wyeth an abstract underpinning, had supplied him with a story that crystallized the atmosphere that inspired the painting, that summed up the complex of emotions that had come in a rush, but had to be kept alive during the months of "daubin'."

Tuned to the same visual reverberations, speaking in their own shorthand language—their reactions resonate in each other. Betsy's enthusiasm has been both an exhilarating stimulation and reassurance. Her judgment has always been the one secure handhold he totally trusts. She can see a drawing and, she says, know in a flash "when Andy has hit and whether it can lead to months of sustained concentration and excitement. It will change, but he's going to be able to refer back to the romance, the excitement, the composition of the drawing—the shapes that excite him."

The beginning of *The Patriot* (opposite), the portrait of Ralph Cline, is classic. Wyeth saw him at a Memorial Day parade in Cushing, and Ralph agreed to pose. For the next five days the image of him built in Wyeth's imagination—the bald head, the World War I uniform. On Sunday morning in the attic of Ralph's sawmill, Wyeth tells, "I sat there and talked to him and looked at him in different positions. He was terribly nervous. He's not used to being looked at—and it was something for me, too. I was

The Patriot, 1964

Ralph Cline, a sawmill operator, was "back-country Maine," a down-east humorist with shrewd eyes and a core of sweat, stain, and cussedness. While posing, Ralph told his tales of fighting Pancho Villa on the Mexican border, his battles in the Meuse-Argonne during World War I, and said, "I don't think it's too much to ask a man to risk his life if the country's in peril."

nervous. Finally, I started one sketch. It sort of struck dull. Then I moved to the left, and he looked out, and I don't think it was fifteen minutes—I did this thing.

"Then I came home with it. Didn't show it to Betsy. Just stuck it behind the refrigerator. I was so excited about it, I wasn't even going to show it. We had supper. I said, 'I've got something. I'm probably nuts, but this thing really thrills me.' And I hauled it out. That's a very nervous, tense moment because Betsy is so much a part of my life. Showed it for just a second. I wanted it left in my imagination. Betsy *right* away caught it. She's marvelous. If somebody had been dull and said, 'Oh, well,' the whole thing wouldn't have meant anything to me."

In those moments Betsy's voice vibrates with excitement: "Oh, my God, Andy. Just *terrific!* It's *unbelievable!*"

IO

During those early years of marriage, in parallel with her influence on her husband's painting life, Betsy deeply altered the dynamics of Andrew and NC. Virtually all those who experience Wyeth's full attention, each in their own way, want to possess that magnetic, elfin spirit. His bride and his father were no exception. But Betsy held most of the cards.

In October, while she stayed behind with her parents in Cushing, the twenty-three-year-old groom came down to Pennsylvania to give the inside of the schoolhouse a coat of paint. Young Andrew wrote his bride, "The only satisfaction I get is that I am fixing up our house, the place where you, my precious love, will live with me. It is hard for me to believe that you are mine. Darling, it seems so long since I last saw you and I keep looking at your photo and it really doesn't look like you. Good night, sweetheart."

Nineteen-year-old Betsy answered, "Darling, I will come out this Saturday and until then I will be thinking of you most of the time. Thinking of your lips, your arms around me. For two cents, I would drop everything and come right out. I thank God I have so much to do, or I could not stand being so far from you. My own darling, you will be *with me* every minute this week. We are too much one in feeling and in our soul."

The sales of watercolors were flat in 1941. Watercolors sold for as little as $38. Temperas were priced at $400. One show netted $1.37 after paying for the catalog. Another brought $3.00 after the costs of framing and the opening party. At one point their cash flow amounted to $92. That year Andrew wrote his parents, "I wish I could get *Life* magazine interested in coming up here and getting some photos of Walt and I in his dory around Teels Island so I can get some of these pictures sold."

In answer to a tough letter from Andrew—probably coached by Betsy—complaining about the lack of income, gallery owner Robert Mac-

beth wrote a kind but firm letter in return, pointing out that Andrew had been remarkably fortunate, that two sellout shows for such a young artist had been "something new in the annals of American art." But he had saturated the market of buyers interested in his watercolors, and the world war in Europe had deflated all sales of art.

Wyeth remembers, "We were absolutely broke. Best thing for us. We'd go to a movie and spend twenty-five cents for dinner. We started out with an empty living room, a stove, icebox, and a lot of toy soldiers." Betsy took sewing lessons; bought fabrics at the Everfast Mills and made her own clothes, curtains, and bedspreads. Her ancient washing machine was run by a gasoline engine. They had no bank account. Once Betsy bought a fur piece, then felt so guilty about the expense she took it back to the store.

She set about designing her new home, a form of self-expression that ultimately became as compelling as Andrew's need to paint. In the schoolhouse she painted the floor of the big room burgundy and the walls white. Her coffee table was a wire screen stretched over the cast-iron base of a pot-bellied stove. She made a

In the first years of their marriage, reveling in each other, Andrew and Betsy lived near the foot of N. C. Wyeth's driveway in the converted schoolhouse vacated by Henriette and Peter Hurd. NC considered Betsy a giddy lightweight, and began competing with her for possession of his son— who spent most of his days away painting.

second coffee table by mounting a large round mirror on a cloth-covered orange crate. They had a lemon yellow couch, and Bess James bought her a wing-back chair. With the first money she had, Betsy purchased in Maine an enormous carved English lion's head, which still hangs high at one end of the schoolroom. A large hutch held Andrew's toy soldiers and books illustrated by his father and Howard Pyle.

Betsy wrote her friend Marianna Rockwell, "I made some cute curtains for the kitchen—sewed red-checkered sailboats on them. My bathroom is my pride and joy. I painted the walls a colonial yellow and floor a royal blue. My curtains I made out of yellow corduroy lined with royal blue cloth. The rug is light blue with royal blue stars, yellow wastebasket, yellow hamper, and my towels are royal blue with my initials in yellow—and yellow with my initials in royal blue. How's it sound?"

When NC stood in the schoolhouse, surveying Betsy's decorating efforts, he said to her, "I wish you could have seen this house when Henriette had it; it was beautiful."

The Wyeth family, bewitching, churning, judgmental, drew Andrew back to its bosom, the cherished son and brother. Betsy, handsome, vivacious, came along as part of the package—the very young and inexperienced bow on top of the box. She had only lived one year away from home, attending Colby Junior College, where she "danced to a vic until twelve," thought "the boys were all so smooth to me," went to a big-band prom with a boy who had "a marvelous, super, smoothy, nifty, perfect personality." Betsy knew that "Artie Shaw is more popular than Goodman or Dorsey now."

Remembering those early days, Wyeth says, "She was overcome by—well—everyone in our family had been doing things, and here she was a young girl from a small town in New York State with certainly a fine background, but not what they . . ."

On her side Betsy remembers, "I adored them, found them *fascinating* people. But I kept my distance. I mean . . . cook good meals, be attractive, wear the right clothes. They didn't know me. They didn't want to. I guess it wasn't necessary." Her trait of watching became a kind of self-protection. "I wanted to be a little removed so I could have a position to observe.

All five of them had a very strong trait from N. C. Wyeth. I decided the word for it wasn't 'devious.' It was 'cunning.'"

A couple of times when Betsy picked up her phone on the party line with the main house, she heard members of the family discussing her. "It was very interesting," she says. "Very interesting." Once Betsy had her palm read, though she is terrified of fortune-telling. The palmist said, "You've got a very strong sister-in-law and her name is Carolyn. Watch out for treachery." Betsy listened to the advice. "I watched," she says, "and saw what he meant. I never crossed any of them because I never trusted what they would do."

N. C. Wyeth genuinely wished for a loving relationship with his daughter-in-law—but on *his* terms. As he had attempted with his own children, he wanted to mold her. Betsy remembers, "I knew what he thought of me—that I was a lightweight, that I liked too many things, that I thought the world was too wooooonnnnderful, that I was too quick to judge people, that I really didn't deserve his son. I thought he was a horse's ass."

Betsy found her father-in-law dictatorial and overbearing—stamping his foot for emphasis as he made a point. "If people weren't paying enough attention to him," she says, "he would sit down at the piano and thunder out his chords. If he in any way suspected that your mind was straying from the point he was trying to put across, he would almost come up and rap you with a ruler and say, 'I demand your attention!' So you had to learn to scoot around that."

Andrew watched the submerged struggle with puckish amusement—though his loyalties were torn between his totally supportive wife and his hallowed father, whom he blamed for not understanding Betsy. The issue between Betsy and NC was joined immediately after the honeymoon at Eight Bells. In August 1940 NC wrote Henriette from Port Clyde, "We noticed a sharp recoil from Ma and me right at first, and it worried us sick. I had almost planned to return to C.F. immediately, rather than destroy a summer for them. It's as though someone had embittered her against us." The letter continued, "Through association and many pleasant and revealing conversations, everything promises well. They certainly are a happy pair!"

However, NC tried to bring his daughter-in-law to heel at the county fair. Betsy jumped on a giddy ride of chairs whirling high in the air at the

ends of long chains. NC kept buying tickets for every chair to keep the contraption running continuously, hoping, Betsy still thinks, that she would panic and ask for mercy. "Of course," she says, "I loved the freedom of it." Eventually NC gave up.

In Chadds Ford the young couple were constantly invited to dinner at the Big House, NC presiding. He kept trying to put weight on Betsy, and insisted that she eat bread pudding, which she detested. While Andrew, Carolyn, and Carol Wyeth collaborated in distracting NC, she whisked the pudding under the table for the dogs to eat, then returned her clean plate to her place. "I wasn't one of his children," she sums up. "I wasn't one of the people he approved of. He gave me no love. So it was all just discipline."

Being alone with her father-in-law, Betsy says, "was very, very uncomfortable; he didn't know what to talk about." NC, the compulsive teacher, felt no potential in his daughter-in-law worth training. He thought that Betsy—who operated by instinct and intuition—had nothing to say about literature or music or art. His attitude was doubtless fueled by her low opinion of his work. "He was fooling around with tempera," Betsy says, "and it wasn't his medium, and I was pretty ruthless—this is why I wasn't close to him in his work." During this time, when NC scorned his illustrations, Betsy once announced that *Treasure Island* was his finest work. NC shot back, "Well, that shows how limited you are."

Living in the schoolhouse, Betsy felt penned up and isolated. Her husband was absent virtually all day, every day. Henriette remembered, "Betsy was in a terrible state during the first years of her marriage. I think she was totally unprepared for the intensity Andy had to give his work. She thought it was idiotic. A lot of people did. A young woman in love has a hard time understanding."

Moreover, they lived essentially in NC's front yard. He continued treating his son as both his property and his responsibility. "I thought marriage would be the freest thing in the world," she says, "but I was too close to the domineering personality of Andy's father, who visited every day. Every day! I felt this terrific pressure."

"Some mornings," Wyeth tells, "we'd stay in bed later—a young couple, didn't have any children—lying there talking, sometimes making

love. Suddenly, we'd hear the snapping sound of the boardwalk outside. Oh, God, it was Pa bringing the *Times* to us; he always felt I should read the newspaper. He'd pound on the door, and, Oh, Jesus, I'd be putting on my clothes a mile a minute."

Frequently NC brought their mail—and then disappeared into the small studio off the huge schoolroom to discuss Andrew's work with his son. He would hector him with reminders: "Andy, how long since you've put gas in the car?"; "Andy, for God's sake, will you remember to pay your bills!"; "I hope you dropped a note to Henriette for her birthday next Tuesday." Betsy says, "He just didn't feel that Andy was capable of doing anything, like going to get the mail, or crossing the street properly. If I was ever ill, right away I would be taken up to the Big House to be cared for. They felt Andy was incapable of taking care of such a difficult wife, and certainly he wasn't going to be able to support her."

To stay undistracted from his painting, Andrew has always arranged buffers, people who have kept his own life uncomplicated, kept his mind free for the flow of impressions and imagination. When NC worried about Betsy's "sharp recoil," about "the someone who had embittered her against us," he was unwittingly writing in part about his son. Andrew planned Betsy to be a counterforce to NC. "Pa would practically lay out my palette," Andrew says, "and then if I had any business letters to write, he would write them for me. You begin to depend on that—and that's what happened to me and my father. I realized, 'Jesus, where am *I*?' I finally broke that. I married Betsy." He adds ruefully, "Who then became really much stronger than my father."

When Andrew married Betsy, he had long since built his secret life, keeping himself safe from his father's officiousness, from his spell. "I think he was afraid of his father until he married me," she says. "I was the escape, I was his secret from his father—as though I was a model and his father was me now."

"Andy was very careful to shield his emotions from his father," Betsy says. "He told me things he would never reveal to his father—all these strange feelings that we'd had together—what was underneath the surface

of things, what the person could actually be. He would say to me about paintings, 'I don't want my father to see this.' And I was the one seeing everything. It was a very scary position to be in."

But for the rest of their life together, Betsy would live with concealment, a central trait that has configured Wyeth's life and art. Secrecy saved him from his father's saturating presence. It has diverted the intrusions of money, adulation, fame, fashion, friends, models, wife, and family. It has protected the raw and delicate sensations Wyeth works to express on the flat surface. It has preserved his blend of imagination and memory, and masked his violent emotions. Racked by the present, unspared by forgetfulness, Wyeth describes his dilemma: "I'm very sensitive, really supersensitive. But I've *got* to be vulnerable, keep my spirit open. Otherwise, you're no good."

Secrecy is his key to freedom. Knowledge of his thoughts and movements gave people power over him. Constitutionally unable to endure confrontation—except when intoxicated with rage—Wyeth explains, "I can't have fences built around me, *ever.* I can't be held in by 'You should do this, you can't do that.' If you don't keep your secrets, you've got to be hard and bull-headed. So it's easier to be secret."

Wyeth also talks about "the power of secrecy." Subterfuge stimulates and inspires. Ann explains, "A secret is *yours!* It adds a fantasy. A magic." Henriette said, "The great things are created secretly. Like the impregnation in the womb. The start of things that grow in the black earth. The dreams in your head are secret and dark and magical and they ought never be blasted with light."

Throughout his life, when Wyeth leaves home in the morning, no one knows his movements. There is much Wyeth family laughter at the childhood time when Andrew was sharing a bed with Ann and he fell out onto the floor. As he landed, he called out to her, "I'll be right back." His niece Robin McCoy says, "That's Uncle Andy. He'll look you in the eye and say, 'I'll be right back,' and you won't see him for two weeks."

Wyeth has always had special people who welcomed unexpected drop-ins: for instance, Helen and George Sipala, who own the former Howard Pyle mansion, have given Wyeth a key. One day, early in the

morning, he stealthily let himself in through the kitchen door. He felt invisible in this secrecy, a ghost moving through the rooms among the ghosts of Pyle and NC, no consciousness of himself to cloy his impressions. He found the man and wife asleep. Entering their zone of intimacy, he watched the two figures, vulnerable, unaware, eerily still.

He painted the tempera *Marriage* (opposite page 182)—the couple laid out like human shells. It is another painting of death, of Christmas morning, the bed about to sail through the window toward the morning star. It is a painting of childhood associations—his parents in bed, the pillows he used to play with, the dolls that Ann put to bed, the death masks hanging in NC's studio, the days of sickness when he was brought to the doctor who lived in that mansion—and dozens of other secret sensations reincarnated.

During his months of work, the Sipalas often posed in the bed. Wyeth would tell them, "You can get up now and rest." But he concealed the picture even from them. Henriette explained, "It's a private thing that goes onto that canvas, a clear, pure stream that mustn't be touched by light or noise or anything else. You've got to keep it pure beyond belief, just as the stars are in a certain kind of gas."

Wyeth dreads a watcher in the same way that a person may prefer to weep in private, free from inhibiting eyes. Very, very few have ever seen him paint—only those so intimate that they do not break the self-hypnotic state of communion. To him the act of painting is as personal as the sex act. He resists even talking about it. He would like the brushing on of pigment to be a secret even from himself. "I hate being caught with my watercolors under my arm," he says. "I wish I could do this thing without me existing."

Only such a compulsive need for privacy can afford shelter through months of painting the fragile, fleeting emotion he felt in a wink. An outside, misunderstanding eye might judge his vision; qualify it, turn that first, elusive impression into something regular and normal. "I'm so damned hypersensitive, I might kill somebody," Wyeth says. "That's how tense I get. Isn't that awful?"

The secret relationship with the model is an essential slice of his life. "Some little thing can ruin a whole day," Wyeth says, "so I have to have

something secret that I'm doing, that's just mine." When the world began visiting Christina Olson, taking pictures, getting autographs, "Well, that almost ruined the whole thing," Wyeth says. "But I had had my little say."

Even the surface realism of Wyeth's work is part of the secrecy, a form of concealment creating drama. In all areas of his life his interest is in atmospheres and tones, not the accuracy of facts. His real subjects are the secrets that only he has sensed and plumbed, personal meanings within metaphors and unearthly moods—mute allegories—hidden myths.

In his work Wyeth is profoundly honest, working to paint the slippery substance of life itself. As Betsy says, "Andy's work is the only place he tells the truth." Otherwise he is a prodigy of wiles and disinformation. "I think he's quite carefully a weirdo," Henriette said, "with fantastic statements to keep people puzzled and wondering. It amuses him a great deal to tell fantasies about what he does, the most exquisitely built-up lies. They're always so interesting and dastardly that you're privileged to hear these incredible things from one of the great painters of the period."

Virtually every aspect of Wyeth's daily life is related to his painting. The quality of the work and the purity of his goals has informed all sentiments and excused all stratagems. Marriage—the minutiae of living—must never be allowed to compromise his physical and emotional freedom, the childlike irresponsibility he believes his work requires.

In December of 1940, Betsy became pregnant. "It wasn't my happiest period," she remembers. "It was a lonely time. Andy's dislike of my pregnancy was violent. He can be—he dared to say things to me that he never dared to say to his father. In other words, with me he could vent his fury."

Fatherhood would confine Andrew—the same reason he gives for not wearing a wedding ring, the same reason he never fastens a seat belt. Fatherhood would bring change, would dilute his relationship with Betsy. He once told her, "When you first got pregnant, I hated the thought that somebody else was going to interfere."

In fact, on one level, despite his passion, the marriage to Betsy violated a life-long attitude. Wyeth has always believed that NC's art ambitions were sabotaged by his children. "I think we all took from my father,"

Wyeth says. "Myself, Carolyn, Peter Hurd, Nat, Ann, Henriette—and I don't know what we've given in return. Pa felt so strongly about family life, he made everything else unimportant. You've got to be selfish to paint. I'm much more selfish than my father."

Wyeth's niece Robin McCoy remembers his repeated warnings: "Never fall in love. Never have children. Never get tied down to one person." When John McCoy died of Alzheimer's in 1989, Wyeth told his sister Ann, "Oh, God, it must be great to be on your own." Robin says by way of explanation, "He is so afraid that this seed in him, this brilliance, will be killed. If you go to Uncle Andy for help, he simply can't help you— 'I don't want to get involved.' However, if he allows himself that opening to feel for you, it's all there. He's been there for me every major time I've needed him, but I've never asked him to be."

When Betsy suffered a miscarriage later that winter, Andrew was relieved. In 1942 Betsy had another miscarriage, and then in the winter of 1943 she was pregnant again. When the baby began to show, Andrew walked several steps apart from her on the street. "He felt it stamped him," Betsy says, "and took something away from his individuality." In September 1943 their son was born and named Nicholas, after Nicholas Wyeth who came from Wales to Massachusetts in 1645.

Only rarely did Andrew take part in child care. Once he was asked to give Nicky his bottle. When Betsy came downstairs, she found the baby on his lap, the bottle waving in the air, while Andrew with his bare toes turned the pages of an art book on the floor. On another occasion Ann's husband, John, came by the schoolhouse and discovered Andrew painting, oblivious to Nicky upstairs soaking wet and screaming.

Even as he fled intrusion by NC and Betsy, Andrew courted their care-taking with beguiling helplessness. Increasingly, Betsy stood between the inward Andrew and the outside world. "He's afraid of people," Betsy explains. "That's why he uses all kinds of disguises. He's not afraid of children and dogs. Andy isn't capable of distributing his warmth to two people at the same time." Betsy described one of her roles in a letter to their friend

William Phelps: "As usual 'Little ole Andy's' good nature prevails, and the only one who he sounds off his personal feelings to is me. And as you most certainly know by now, he dislikes scenes and is prone to get me worked up to fever pitch, knowing my red Welsh blood will voice his opinions while he goes on about his painting quietly."

Taking on another role, Betsy began keeping records of Andrew's paintings. In 1942 they met Edward Hopper, an American realist he greatly admired. Andrew felt that Hopper's atmospheric studies of urban loneliness made him the Wyeth of the cities. Josephine Hopper, called Jo, taught Betsy "all about being an artist's wife." Jo told her to keep records of Andrew's work, but not to use a camera. He should do little pencil sketches of each work. Andrew complied, but only briefly.

Bess James had taught her daughter the rudiments of money management, and Betsy enthusiastically took over the checkbook. The job of paymaster grew into a permanent function as business manager. In October 1942 Betsy wrote the Macbeth Gallery that "Andy threw up his arms and gave me full charge of business. I'm delighted because it's just the sort of thing I love and only hope I can do a fairly decent job of it." She went on to say that they were both "dumbfounded" that he received only $180 from a $300 sale made by Andrew in his studio. She quoted the contract, and went on to question the fifty-fifty division of expenses. Macbeth sent another twenty dollars.

By this time the Wyeths had discovered the iron, adamant core within Betsy's charm and gusto. Except for Henriette and Carol Wyeth, they were all a bit afraid of Andrew's new wife. Carolyn's husband, Frank Delle Donne, remembers her in 1941. "She had a New England quality about her," he says, "like a Katharine Hepburn or a Bette Davis—the same way of telling you what she thinks in no uncertain terms, very cold and removed: 'I don't give one damn what you think, and this is what I think and this is the way I feel and this is the way it's going to be.'"

Betsy's sister Louise, explaining her sister, says, "I think Betsy had to fight for her life in the Wyeth family. She hadn't had any experience dealing with people outside of a small town. She was either going to survive or not

survive. She could easily have been submerged by that crowd of complete extroverts—loud and vibrant—and never found her own personality. If she hadn't risen to the occasion, she would have become a mouse and been dropped by the wayside.

"But I think she got from her mother a stick-to-itiveness that has carried her through a lot of situations—'I'm going to tough this one out any way I can.' She *can* be tough. She's very, very sure of where she stands and what she wants. She has her own space and nobody, but nobody comes into it unless she lets them. She's had to develop that herself. I admire her for what she's done, because as a little kid she really was very meek and quiet."

In 1942, the year Betsy turned twenty-one and old enough to vote, her rivalry with NC came to a climax. Her unswerving conviction about her husband's painting—a bond of steel that has always bound the two together—was an advantage against her father-in-law. She almost welcomed NC's dismay at Andrew's austere temperas, at his "unimportant" subject matter.

The climactic collision between the two had its roots in Andrew's occasional commercial work to meet their bills—some of which NC was paying. "It would infuriate me that Andy would do these few illustrations to make money," she says. "I tried to make him realize that he really, truly didn't have to go along. He really had so much to give us in this strange world that he believed in and let me see, and he shared mine, too."

In 1942 he accepted a commission from Farrar & Rinehart to do the jacket for Hervey Allen's *The Forest and the Fort.* The fee was $175, and Andrew exulted, "This money will save the day." The subject he picked was an Indian in native dress, and he painted the book jacket that fall in Chadds Ford. One morning after dropping off the mail, NC went into the studio where Andrew was at work. After a while Betsy opened the door. There stood NC, brushes in hand, repainting the Indian's face. Andrew was behind him. She thought, Is *anybody* allowed to touch Andrew Wyeth's paintings? Who does he think he is? She turned on her heel and thunderously slammed the door with all her strength.

NC put down the brush, saying, "Well, I think I've done enough." Andrew was horrified. "Here was this great man working on this picture, and he had transformed this innocuous face I had drawn into this marvelous type, with the high cheekbones and wonderful slit eyes. I just gasped. He knew Indians. Had lived with 'em. I thought she was being a stupid young kid."

While Andrew stayed safely inside, NC came into the schoolroom where Betsy waited. According to her memory, she asked him, "Pa, who ever worked on your paintings?" He said, "Howard Pyle." Betsy said, "How many years ago was that?" He answered, "You're absolutely right. The stage is yours." He left. Betsy says, "He knew he had lost Andy." When Wyeth tells that story his eyes shine, and he relishes the detail that Betsy slammed the door so hard that plaster fell from the ceiling.

The next year Betsy took an equally strong stand with Andrew. For five hundred dollars he painted a cover for the *Saturday Evening Post*, which offered him a contract for ten more. He was tempted. "I was absolutely up against the wall. I knew I couldn't do anything else but paint. Oh, I might be able to dig ditches." But Betsy was adamant. "You will be nothing but Norman Rockwell for the rest of your life," she said. "If you do it, I'm going to walk out of this house." He turned down the offer, and says, "That was a real changing point for me. Ten temperas a year would have been devastating. I give Betsy full credit."

Nevertheless, needing income, Andrew persisted on other commercial fronts. He gave a full-page testimonial for Grumbacher watercolor pigments: "I have found that your Hookers Green II watercolor is the richest made." He painted a cover for *Progressive Farmer*. He contributed illustrations, frontispieces, and dust jackets to twenty-three books. They included *Captain Horatio Hornblower* in 1939 and *Lord Hornblower* in 1946, both by British author C. S. Forester; *The Brandywine*, by Henry Seidel Canby in 1941; and Hervey Allen's *Bedford Village* in 1944.

Decades later Betsy made internal peace with her father-in-law. Andrew's uncle Stimson had planned to do a book of NC's letters, which had been

saved by their mother. Betsy took over the project and was astonished to find a sympathetic, layered N. C. Wyeth whom she had never suspected—the poet, the idealist, the dark self-doubter. She also rediscovered the books he had given her with little notes on the flyleaf—the only way he knew to approach her. "I was quite surprised," she says.

Betsy assembled NC's lifetime of letters into a remarkable 1971 book called *The Wyeths.* Now she could understand the inputs that had produced her husband, could understand her father-in-law. "It's the closest I can ever come to NC," she says ruefully. "We could have had a good time." She pauses and then adds, "I wish I'd known him."

She continues, "Now I really understand. I was part of a conspiracy to dethrone the king—the usurper of the throne. And I did. I put Andrew on the throne."

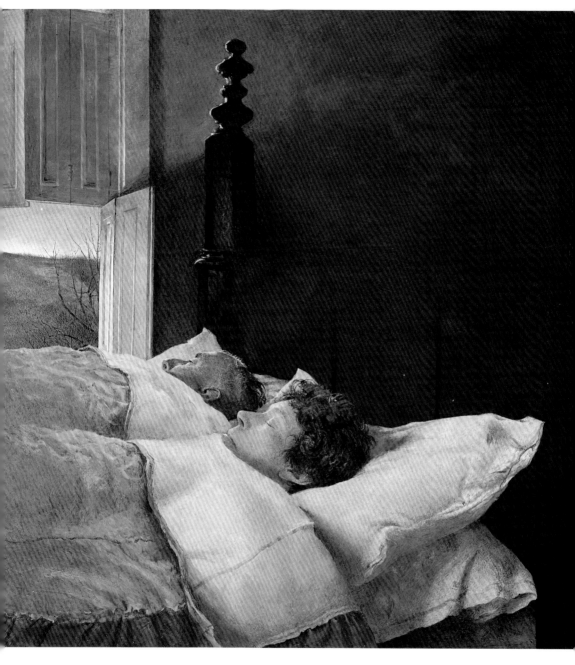

Marriage, 1993

Given a key and permission to prowl the former summer
mansion of Howard Pyle, N. C. Wyeth's teacher, Andrew
saw his friends, Helen and George Sipala, asleep in bed.
It is a picture, too, of Wyeth's vision of death, the bed
poised to wheel out the window and over the horizon
toward the morning star.

II

In that first year of marriage Andrew wrote Betsy, "I took a walk over the hills to feel again the pulse of the earth. Thank God you will soon be walking over the snow and ice covered hills breathing this pure air. I do want you to love this country and know it as I do."

Wyeth explains, "I don't love the Brandywine Valley because it's scenic, or because it's beautiful. I love it the way you love your mother. I love it because I was born here, because I live here. I don't think a country makes an artist. I think an artist makes the country. It's what you bring to it— what's inside you that's really important."

If Maine to Andrew is a cathedral of air, his few square miles of Pennsylvania feel like its foundation—heavy—its footings sunk deep into the rich earth. The inhabitants—the people, the objects, the growing things—are equally expressions of its nature. "I can do an awful lot of thinking here," Wyeth says, "about the past and the future—the timeless-ness of these rocks and these hills—about all the people who have lived here."

The spine of Wyeth's Pennsylvania life has been the walk he has taken thousands of times, always the same during boyhood flights from his father's eye, during the first years of his marriage, then during the 1950s— during all his life and recalled in his imagination. Always there has been a sense of sneaked solitude, the feel of a double life. Nothing is arranged. His feelings are uncontaminated by another's reactions.

Wyeth sometimes refers to "loneliness," but he really means "alone-ness," a free space where imagination and excitement, sadness and poignancy—all the fragile responses—can rise and mix. "When I paint an open field or the inside of a building with loneliness implied," Wyeth says, "it's not concocted. Perhaps I dream of more loneliness in a thing than is

actually there. But I'm not trying to be dramatic; it's natural for me." He pauses, and then asks, "Have we lost the art of being alone? I think we have."

The walk begins with a slow passage through the steeply rising woods above NC's house, past the huge, bedrock outcroppings like enormous, half-covered fossil bones—his Sherwood Forest in the years of Robin Hood reenactments. He moves delicately through the trees, thinking only of what he feels, all senses tuned to textures, tones, and glints of light, to particulars and panoramas. He says, "I wish I could vanish into my hound as he goes through these woods, looking up at the branches in the sunlight, the leaves falling down on him. When I'm alone, I want to forget all about myself. I don't want to exist."

Among the trees, in the hay and cornfields up on the ridge, he some-times sits motionless, relishing the quiet, absorbing the minutest details, loosening his imagination. He tells a story about the great nineteenth-cen-tury English landscape painter John Constable, another artist who found complexity in the commonplace, in the countryside of Suffolk, England. Constable came home one day and hung up his coat. His wife heard a squeaking, and out of his pocket crawled a field mouse. "It expressed how quietly that man would sit in a landscape," says Wyeth appreciatively.

Wyeth is not looking for prettiness of scenery. He is not a "nature lover" who knows the names of plants. "Nature comes in to me by the back door," Wyeth says. "I'm just interested in objects; pure curiosity. Once I'm interested I'll study it endlessly. If you start putting names to things, it gets to be a business. For me all imagination disappears."

Andrew wrote a friend, "I can think of nothing more exciting than just sitting in a cornfield on a windy fall day and listening to the dry rustle. When I walk through the rows of blowing corn, I am reminded always of the way a king must have felt walking down the long line of knights on horseback with banners blowing. I love to study the many things that grow below the corn-stalks, and bring them back to the studio to study the color. If one could only catch the true color of nature. The very thought drives me mad."

The top of the ridge opens out onto farm fields, onto the winter stubble of cornstalks. With its rip of wind and scudding clouds, it feels to Wyeth like the top of the world. Here he lay on his back watching the buz-

Winter Corn, 1948

zards ride the wind—the origin of the tempera called *Soaring* (pages 188–89). They are looking down on Bullock Road to the south, and Ring Road to the east. The one landmark in the painting is a stone house, home of John Andress, whose wife—her head bald, a pipe and curses in her mouth—fascinated the young Andrew.

At the Andress house Andrew' often slanted right and headed downhill into a small community of blacks, living in one of the small enclaves set aside by the Quakers after the Civil War. From the 1940s to the late 1960s they were major painting subjects. Staying close to their plots of land, usually available

On a walk across his familiar territory, Wyeth sat in the quiet of an abandoned cornfield. Two ears of corn seemed like old men, one still with a mouthful of teeth, the other with empty gums.

and amenable, they were another of Andrew's hidden-away realms—impoverished survivors with their own special dignity, but ignored and misunderstood in his white world. Sometimes NC helped them out, buying coal and oil, paying rent, even paying off Adam Johnson's mortgage. But he considered them unsuitable for art, a servant class who should call him "Mr. Wyeth," who cleaned his house and mowed his lawns, who were colorful primitives—an attitude summed up by NC's nickname for their area: Little Africa.

Andrew approached them with the fixed attention of a grown-up child, free of superiority and sociology. Growing up with Doo-Doo, accepted as "Lil Andy," he had been allowed access to this culture so foreign to his own, allowed to study the minutiae of their lives. Wyeth remembers looking closely at Doo-Doo: "I could see the sleep still in his eyes, and the corner of his mouth was still filled with food that would sort of stick when he'd talk, and it interested me. It's also interesting to be struck with the shape of a spruce tree. If you really look at them, there are amazing little things about a spruce tree. They're like thousand leggers."

During their war games, Doo-Doo built tiny huts of crisscrossed, intertwined sticks woven with leaves—"like something out of Africa"—and billeted toy soldiers inside them. "It just fascinated me," Wyeth remembers. "I would get spellbound watching. He had more imagination than anybody I've ever known."

The U.S. State Department wanted Wyeth to send his paintings of blacks to Russia for an exhibit. He refused. "I'm not a painter of Negroes," he explains. "I'm a painter of people. They're friends of mine who are the most subtle to understand. To me they are really part of the earth—more in contact with what I'm interested in than a lot of white people. Great dignity."

Wyeth elaborates: "People are a marvelous mystery to me. I often see them in color; some are ruddy and some are silver gray. They're moods in themselves. To me everyone is as important as everyone else; everything is as important as everything else. In some way a tree is just as important as a person, in its own life."

No matter what or who his subject may be, Wyeth sees himself as a painter of natural objects, catching subjects in their native habitat. "If

you're going to paint nature," he says, "you've got to let it dictate your quality. The very odors of a scene must seep into the picture. Otherwise you concoct your moods. If I throw myself into a mood in Olson's, compared to working in Karl Kuerner's house, I'm going to get a completely different emotion—and that breaks down any formula.

"If you paint constantly in the studio, you get into a formula. Audubon's pictures are all wrong to me. They look concocted. Most artists always seem so strong in front of the paintings—give you *their* concept of, say, what a Negro looks like, the same eyes over and over again. They get a method of doing things—a way to do a man's head—or they distort reality to 'express themselves.' They're actually saying, 'To hell with the object.' I feel the subjects I paint are far bigger than I am."

However, the finicky process of tempera demands that it is usually done indoors. So Wyeth transports the mood to his studio, spreading out artifacts of the scene—pots of huge green skunk weeds brought from a swamp during a 1941 tempera of two black frog hunters. Pine boughs for a Maine tempera. The wooden stake that was beside a boulder. "If you were doing President Kennedy's nose," Wyeth says, "you'd be very careful, wouldn't you? Well, isn't that stake just as important as President Kennedy's nose?"

In 1941 Andrew described to Jim and Bess James one of the walks over his route. "Last week we had a small snow storm, about six inches. The snow was very wet so it stuck on every limb and weed. I got up around 3:30 A.M. and took a long walk in the moonlight, the full moon shining on the snow. In the stillness now and then was the sound of a dog barking in the distance. A low hanging mist from the Brandywine River covered the lower half of the moon and when the dawn began to shine in the East, the two effects became one. Lamps gleamed in the Negro houses, the feeling of life beginning to stir. I could hear the pigs in the outer sheds of a farmer."

The farmer was Adam Johnson, a beloved man, hard of hearing, with deep pride and religion, who raised hogs and chickens, grew hay for feed, and mowed grass and did odd jobs for NC. Canny about commerce, he had a sideline as a town money-lender. One of Andrew's very first temperas, painted in 1940, shows Adam gripping a gleaming ax. Behind Adam is his

Soaring, 1950

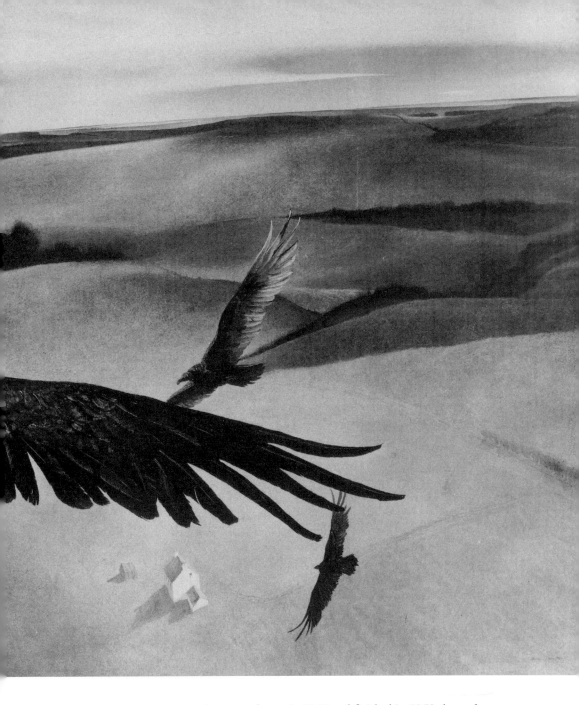

A tempera begun in 1942 and finished in 1950 shows three
turkey buzzards looking down on Andrew's habitual route
along the ridge and down into his two worlds in that little
valley. Below was the John Andress house and to the right was
the black community centered around Mother Archie's church.
To the left and down the hill was the Kuerner farm.

estate: the mowing machine, chicken coop and haystack, the outhouse, and the tiny, two-story, four-room frame house that previously had been the home of Doo-Doo Lawrence. Everything was a masterpiece of make-do, built from trash boards, broomsticks, bits of burlap and tin, lengths of wire—a great beyond in which other people's discards found an afterlife.

This picture was exhibited at the Carnegie Institute in Pittsburgh. When it did not sell, Wyeth gave it to Adam. Soon it was hanging framed on the wall of Adam's immaculate living room. Wyeth saw the picture and asked, "Isn't it smaller?" Adam explained with his slight stutter, "Oh, Andy, I . . . I . . . I found a frame over in the dump. Looked so good. So I just sawed it off and it fit in fine." Telling the story, Wyeth exclaims, "The left side was gone!" Then he laughs uproariously and affectionately. A part of him does not want his pictures treated as holy objects; and Wyeth was gratified when Adam refused an offer of six hundred dollars for the painting.

One day when Andrew passed by on a walk, Adam called out, "You out sighting, are ya?" Gesturing to an upstairs room, he said, "I've been up there sighting the Bible. You want to come sight *me*?" On the windowsill of that little room Adam kept a stone tablet inscribed with a verse from the Bible. On a table was his own huge Bible, festooned with colored paper markers, indicating passages that illuminated issues in each day's news. Adam was a student of the nobility and limitations of God's children. He once said, "Andy got one power and he won't get nothin' else. Andy got a glory of painting. I got a glory of cuttin' grass and I won't get nothin' else."

Painting out of his mature vision in 1963, Wyeth did a tempera titled *Adam.* Posed in front of the pigpen, Adam's huge barrel of a body was clad against the cold in a fur-lined hat with earflaps like a helmet, and layer upon layer of clothes—bib overalls, sweaters, big coat, all held closed by buttons and pins and prayer (see study, pages 248–49). His domain seems pitched at the very pinnacle of Wyeth's world, the pigpen barely clinging to the hill. A flight of grackles shoots up like arrowheads.

"I never think a primitive quality is a bucolic thing," Wyeth said later. "They try to tie me up as a painter of the American scene like Grant Wood. I'm not that. To me Adam was a fantastic figure. He could have

been a Mongol prince. Or Old Kriss coming toward me, with all those jingles and the safety pins and things on him."

The picture was sold to Mr. and Mrs. David Rockefeller for $60,000. Years later Wyeth sat next to her at a dinner party. Impishly he bemoaned to her the fact that more of his top paintings were owned by Japanese than by Americans. "That's *terrible*," she said—much to his amusement. He knew she had recently sold *Adam* to a Japanese collector for a seven-figure sum.

Proceeding downward past Adam Johnson's, the walk takes Wyeth to Archie's Corner, where Bullock hits Ring Road. At the corner was Mother Archie's church. Its name was a mispronunciation of its founder, Mary Archer, a stocky, quiet woman of mixed blood who wore a black bonnet and preached in a black dress with white lace around the neck. She is buried somewhere in the adjoining graveyard, with its few remaining cement markers tilted haphazardly, the names scratched into the wet mortar with a nail.

In the winter of 1945 Andrew painted the dilapidated interior of Archie's, his eye tilted up to study the ceiling. A jagged hole shows black in the battered plaster. Beyond an ancient oil-lamp chandelier a white dove flutters. Talking about *Mother Archie's Church*, he tells of an Easter service when the climax was to be the Holy Ghost released in the form of a dove. The cue was sounded, nothing happened; a long pause. Then a voice called through the trap door, "The cat ate the Holy Ghost. Shall I throw down the cat?"

Behind the church was a wood-frame house, the home of Evelyn Smith, who posed for Andrew and remembers him in those days: "He had a hat with flaps on the ears, flopping around like dog ears, and a sheepskin coat. He was far from what you'd call articulate looking. He wasn't all that into familiarizing. He was like a country boy."

Across Bullock Road from Archie's Corner was the former stone blacksmith shop and home of Bill Loper, the handyman whom Andrew had painted in 1934, when NC, during a critique, scrubbed out the hook on the stump of the left arm. That moment and the image of the hook stayed alive in Andrew's consciousness, this reincarnation of Captain

Hook, the menace of it, the oddity, the brutality—the neighborhood children screaming in an ecstasy of fear when Bill playfully waved the hook.

Andrew wished that the oil paint had dried before NC rubbed away the hook. "Then I could have seen what I had done," he says. Bill Loper died and was buried in the church's grassy little graveyard. Wyeth still imagines his skeleton in the stygian darkness of its rotted wood casket, the hook, rusted red-brown, hitched to his arm bone—horror beneath the picturesque.

But Bill Loper's hook was not laid to rest. It became one of the extended dramas that evolve in Wyeth's imagination. One image flows from another, bringing new meanings to objects, new extensions of fantasy—sometimes through decades of total recall. His actors, alive and dead, remain eternally in the wings, dressed in their costumes of associations, ready to take their places in his daydreams.

"I dream a lot," Wyeth says. "When I'm doing nothing is when I'm doing the most. Sometimes when there is great tension, or lots taking place, I may get an idea or an emotion, and it hits me strong. I let it build in my mind before I ever put it down on the panel. Sometimes I do my best work after the models have gone away, purely from memory."

In 1983 Wyeth visited a sawmill in Maine, curious about a deeply depressed young man who had lost his hand. "He told me he was embarrassed by it," Wyeth says, "that it was sort of like losing his testicles." At the mill Wyeth found the man's hook and harness lying on a huge log. Wyeth rapidly painted the watercolor *Buzz Saw*, the hook in a shaft of sunlight, bright against a mysterious, menacing darkness of spruces.

Wyeth was still thinking about Bill Loper and his hook, "the way he'd take it off and lay it on things, and he'd eat his lunch and the food would stick to it. The way the leather band went around his arm, the way it hooked in." In 1984 Wyeth painted from memory the hook and harness, strange and frightful, lying alone on a huge chestnut log dating back to his boyhood, Mother Archie's church in the distance. Its title is *Little Africa*. But Wyeth's feelings were still not satisfied. In 1985, fifty-one years after NC rubbed out Loper's hook, he painted *Field Hand*, the hook resting on the same log at the summit of a hill beyond Ring Road. This time Bill Loper sits leaning against it, gazing out over the valley.

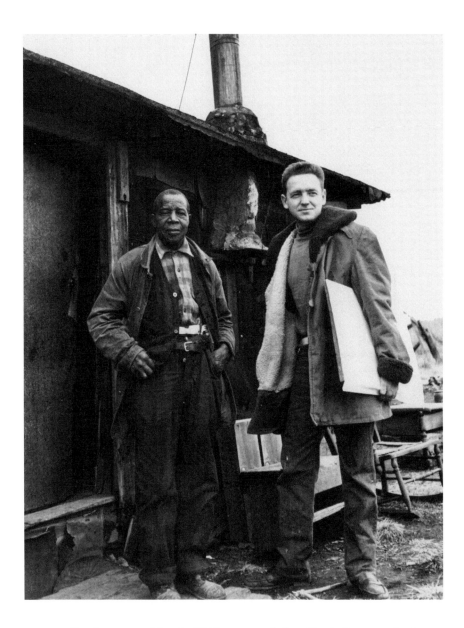

ABOVE: Ben Loper posed for the 1950 tempera *A Crow Flew By*. Ben was a local handyman, what was called "a farm-about," who adopted a retarded boy, James, painted by Wyeth in the drybrush *James Loper* in 1951 and *April Wind* in 1952.

OVERLEAF: Over a hill, beyond the Kuerner farm, was the shack home of Ben Loper. The detritus and make-do of Ben's unencumbered, natural life delighted Andrew. Drawing *Chicken Wire* in 1952, he marveled at the delicate lines of the horse-drawn wagon, pragmatically converted to a chicken coop, the disintegrating corncrib and chicken house blown by the winds of time.

On the other side of that hill lived Bill Loper's brother, Ben, and a retarded boy named James, who was subject to "moon madness"—sleeping out in the cornfields on the nights of the full moon. Insanity fascinates Wyeth. It reveals the dark underworld of the soul, the spookiness of possession, of eerie otherness, of Halloween and Spud Murphy.

One Easter, Wyeth gave some hard-boiled eggs to James, who left one of them on that chestnut log. The next day Wyeth and James came upon the egg, now covered with ants. James sat on the log, picking off the ants and eating them, one by one, with the delicate relish of an aesthete tasting a delicious almond. Seeing him "like a figurehead" moving across the landscape, Wyeth painted James in this moment in the 1952 tempera *April Wind*—but from behind, his madness hidden, a secret in the picture that informs the visible. Amid the stillness, the weight of the huge log and the smoothness of the hill curved like the edge of the moon, a frozen wind lifts the tails of James's worn coat.

In the 1950s Andrew extended his radius northeast to include a cluster of blacks in nearby Dilworthtown, and west, where Tom Clark lived by the railroad track. He was a tall, attenuated, austere man, whose Moorish blood gave him blue eyes and aquiline features. Andrew marveled at his spidery hand lying relaxed on a table or lifting the lid off a pot of pork and cabbage as though revealing a glorious gift. Each moment was whole in itself. Peeling a potato became an art, the skin coiling like a ribbon off his paring knife.

One subject, Willard Snowden, a former merchant seaman, destined to take an important place in Wyeth's cast of models, literally came knocking at his door in 1964, asking for odd jobs. Electrified, Wyeth saw him as an elegantly speaking drifter, passing through like a modern Wise Man cloaked in mystery. From that moment came *The Drifter.* Wyeth painted the life-size head as "a map of the world of all the Negroes at Mother Archie's, nostrils like one of the hills he walked over."

By then Andrew and Betsy were living a mile away in the old Brinton's Mill, bought and rebuilt by Betsy. So Wyeth let Willard move into the schoolhouse. Painting him during that time (opposite page 198), Wyeth

thought of himself as part of Willard's daily environment—"a rare experience, as natural as breathing, like doing a picture of the corner of the studio."

Willard would lounge in an easy chair and in mellifluous, professorial tones expound on life and grape wine, ignoring his problems in the first caused by the second. When Willard shook and hallucinated with delirium tremens, Wyeth held him till he quieted. When Willard dropped and broke his Easter bottle, he was devastated but philosophized, "They should be kind to the human race. They should have the package stores open on Easter. Wine's good for the system, for the body, your blood. But it must be the deuce for somebody who doesn't control that stuff." Wyeth did a watercolor of Willard's jug sitting on a windowsill and titled it *Lunch*. In Willard's vision, Wyeth was "all youth and laughter—but he puts me in mind of a country schoolteacher with a paintbrush in one hand and hickory stick in the other—with all due respect."

On the walk, instead of visiting the black community, Andrew sometimes headed to the left of the Andress house, along the ridge to the top of what was known as Kuerner's Hill. At its summit to this day are three little pines like a tufted topknot. "I love to sit under them and hear the soughing of the wind," Wyeth says. "It's an amazing sound under the pines." It reconnects him with those years in Needham, Massachusetts, listening to the soughing after naps—and with those ecstatic moments under the Christmas tree at home, looking up into the branches.

Grazed smooth as a front lawn by Karl Kuerner's Brown Swiss cows, the hill leads steeply down to Ring Road and the Kuerner farm, the terminus of the walk. Directly across from the foot of the hill is the entrance to the farm, marked by two stumpy pillars, built during World War II by German soldiers from a prisoner-of-war camp near Philadelphia. The stones are pale green serpentine stone that came from the burned-out mansion called Windtryst, where NC and his new bride rented rooms till they could move into their house—the place, too, where Chris Sanderson picked his Christmas holly.

The driveway is bordered by pines planted by Karl—like those he remembered from Germany's Black Forest. To the right of the drive is a little

pond, the water flowing over the dam like silk threads. From the bottom of the hill Andrew could see on its surface the reflection of the Kuerner house. Dating back to the American Revolution, the building is three stories tall, a white, stuccoed stone cube—like a block of snow ice or a castle keep, its tiny attic windows through the thick fieldstone like ports for archers.

Beyond the house is the huge red wooden barn. Below the barn to the left is a meadow that butts against the railroad embankment. Beyond the embankment, on the opposite slope of the valley, is Lafayette Hall, the mansion house where Howard Pyle summered while teaching N. C. Wyeth—and near the track is a stone house where the students worked and the spring where they went for water.

This farm became the heart of Wyeth's imaginary world in Pennsylvania, the rich, gutsy counterpoise to the dry fragility of Olson's. Miraculously concentrated in that small cup of a valley are Wyeth's most compelling inspirations, his themes of war, death, brutality, and Christmas. The farm connected Andrew's fantasy to the miniature barn that waited for Carolyn under the Christmas tree—and the toy farms that Andrew and Ann constructed in the dirt, the layouts he sometimes populated with his toy German soldiers. The farm was also a walk-in version of that steel engraving of the Swiss town of Thun, with its distant snowscape, like Kuerner's Hill.

For decades Wyeth had prowled those premises. "It's a strange thing when you go back to a place you know very well," he says. "It adds another dimension. I'm actually bored by fresh things to paint. I love to see what different changes time brings about. Nature does amazing things to life." As at Olson's and the old Pyle mansion, he has permission to roam through the Kuerner house, turning his imagination to the lives within those massive walls—noticing burned matches beside an oil lamp, wondering what nighttime errand had left this evidence. The coolness of the entry room, the utilitarian plainness of the high-ceilinged rooms, with their scrubbed linoleum floors, painted furniture, iron beds, all felt like Switzerland to Andrew. They revived the sensations of the Swiss Christmases in Needham, continued by NC in Chadds Ford. Wyeth's Germanic strain, inherited from his father's

The Black, 1966

Willard Snowden lived in the schoolhouse for several years, his life examined and painted by Wyeth. One snowy day Wyeth was electrified by the sight of African American Willard in a shroud of white snow. Quickly Wyeth tacked a huge piece of leftover brown wrapping paper onto a big sheet of cardboard—"the tone seemed to fit the day, grays and tans"—and painted rapidly with tempera.

Swiss grandmother and his mother's Pennsylvania German forebears, allies him in his imagination with everything Teutonic. "Kuerner's is Germany to me," Wyeth says. "The German race has a strange fascination. It's very hard for me to put it into words. But I think it's in the paintings—in some of them."

From the day Andrew discovered Kuerner's, coming over the hill when he was about thirteen, he was impressed by Karl, a short, stocky man, powerful, his face heavy, with defined cheekbones, red veined from the sun. He treated young Andrew almost as an equal. Standing in the barn door in the late afternoon after work, he talked in his soft, thick German accent about "the old country" where he was born in 1898 in the tiny village of Neuffen in southern Germany. He was a sheepherder there, and during World War I a machine gunner in the kaiser's army. He fought in the carnage of Verdun and received the Iron Cross from the crown prince, Friedrich Wilhelm, eldest son of Wilhelm II. Karl was wounded in the right arm. On cold days, with no feeling in his fingers, he would pull a knife from his pocket, only to find his hand empty.

Here in front of Andrew was a talking, breathing German soldier, like the ones who garrisoned his fantasies, the rotogravure pages and stereopticon slides in his father's anteroom, the World War I movie *The Big Parade*. Here was a man who had worn a helmet like the one Andrew wore in his father's studio, who had fought in battles like those he staged with his toy soldiers.

After World War I, Karl returned to sheepherding. He was sometimes joined in the mountain meadows by a tiny young girl named Anna Faulhaber, who was the third youngest, the prettiest, the cosseted favorite in a clannish family of twelve children. Karl and Anna were married in 1921. During the next two years, she bore a daughter, Louise, and a son who died as an infant.

In 1923, to escape Germany's postwar inflation, Karl emigrated to the United States. The sale of all his possessions brought just $125 for the passage, and $25 to show at Ellis Island. In Philadelphia an uncle arranged a job in a slaughterhouse. In 1925 he was able to send for Anna and Louise, and the family lived in Philadelphia. Karl moved on to a brickyard, and then

was trained as a machinist at the Baldwin locomotive works, a well-paid job he expected to be permanent.

Anna hated the city and America. A country girl unable to adapt, she was homesick for Germany and the embrace of her family in Göllsdorf. She spoke only German and disliked Karl's German relatives in America, her one social circle. She begged Karl to move to the country. Karl found a job as the horse groom on the Chadds Ford farm of George H. Earle, the governor of Pennsylvania. The next year he rented the present farm from Dr. Arthur Cleveland and worked off the fifty-dollar-a-month rent by caring for the horses and sheering the sheep. Karl explained, "You see, I was a shepherd and that was my decide—to be my own boss as much as possible."

As a teenager Andrew arrived one day at the farm in his father's wooden-sided station wagon, all dressed up to ask permission to paint on Karl's property. The eldest daughter, Louise, remembers, "He was very mannerly. Very handsome. I kinda had a crush on him." Karl had known local artists in Germany, and told him to paint anywhere—and told the children: "The artist doesn't need any bothering."

In the first half of the 1940s Andrew was barely beginning to mine his world for metaphors. His attention was primarily on the Pennsylvania countryside, and he painted relatively little at the farm—"None of it very good." He ripped his failures from his pad and left them around the farm. Karl lit fires with them, and in poker games sold them for fifty cents' worth of chips.

Discovering a young buck, frozen stiff, hanging in the barn door at the Kuerner farm, Wyeth's reactions were typically mixed. He grieved for the brutal death of this delicate, free creature, like the imagined reindeer of his boyhood Christmases. But he was fascinated by the brutality in the hunter who shot it—Karl Kuerner.

In 1945, during one of his walks, shortly before Christmas, he came upon a dead buck, hanging by its hind legs in the open door of Karl's barn. He stood looking at it for a long time, deeply affected, associating it with Christmas, watching the snow sift onto its frozen body, seeing the sadness in the dead eyes, the grace of the legs that once carried it across fields and bounding over fences.

Young Buck, 1945

A thoughtful Wyeth in 1957 heads home from Kuerner's with his miniature black poodle, Eloise. Behind Wyeth is the white stucco cube of the Kuerner house, the huge red barn, the driveway with its two stone entrance posts, and a corner of the pond. To the right of Wyeth is Kuerner's Hill. To the left in the distance, parallel to the line of fence posts, is the railroad embankment leading to the road crossing where N. C. Wyeth died.

Almost every day after work, Karl walked the perimeter of his property with his Winchester 70 and shot groundhogs, possums, skunks, and crows. In 1944 Andrew painted his first Kuerner tempera, *Woodshed.* Nailed by their legs to the shed wall, two dead crows are silhouetted against a slash of sun, their shadows creating a double image. Black as evil, they are killers, too, with their cruel, curving beaks.

Keeping count of his kill, Karl also nailed groundhog tails to the woodshed. He boiled up their bodies for generations of German shepherd dogs. Or he sold the groundhogs for food to the neighborhood blacks, charging fifty and seventy-five cents, depending

on the size. Bill Loper had a taste for skunks, and his house was scented accordingly. In 1942 when Andrew wanted to draw a detailed study of a buzzard, he brought the problem to Karl, who baited several traps with the afterbirth of a calf, and then killed the huge bird so Andrew could draw it in his studio.

Wyeth was fascinated by the utilitarian self-sufficiency of the farm. "Nothing was ever allowed to go to waste," he says. Everything was used. A splendid tree would suddenly disappear, chopped down for firewood. No sentiment. Hams and bacon hung in the chimney to be smoked by hickory wood burned in the stove. The ashes were used as fertilizer. Cornmeal was made by milling kernels dried on the stove. Machinery was used to the limits of its lifetime. The iron wheels of the manure spreader left scars on Kuerner's Hill. Proud that he was the first farmer in town to have rubber tires on his tractor, Karl says, "Bought a Fordson tractor in 1939. I seen it at the New York World's Fair. Henry Ford himself rode around on the thing, and that tractor did anything I wanted."

Karl and Wyeth would sit together in the living room—under a wall clock that was a gargantuan pocket watch—and swap stories and drink hard cider brewed by Karl. Sometimes Betsy in the early years of her marriage would come alone, seeking companionship with the Kuerner girls. She felt foreign to the Junior League girls she met at Wilmington parties. She felt alien in the Wyeth family—though Ann regarded her as virtually a sister and each morning there was a ritual phone call while they enjoyed a coffee and cigarette. Betsy made gentle gestures toward Anna, whose mind had been affected by her loneliness. On Betsy's first Easter in Chadds Ford, Anna somehow found her way to the schoolhouse to deliver an Easter basket of flowers, moss, and eggs. The image stuck in Wyeth's imagination, and in 1984 he painted *Lost Her Shoe*, just the legs and hips of a slender model, Ann Call, striding across Kuerner's Hill, with Anna Kuerner's hand clutching the Easter basket.

Sometimes Andrew and Betsy arrived together and stayed for dinner, eating German onion pie. Sometimes Carolyn rode her horse over to the Kuerners', bringing champagne and her big laugh. They tied sleds on ropes

behind a car and towed each other at night along the snowy back roads. Sometimes at dusk or in the moonlight they all went coasting and tobogganing on Kuerner's Hill. Once the toboggan headed for a low barbed-wire fence. Karl junior yelled, "Duck!" Everybody ducked—except Betsy, whose face was severely torn. But that has always been her way: make up your *own* mind; hold your head high.

Lydia Kuerner remembers that when the Wyeths arrived, "it was sunshine coming into the house. We didn't have a lot to smile about, and when they came it was nice because they were such happy people. You know Andy with that big smile."

12

Even as a little boy, Wyeth had a crystalline, child-man certainty about the kind of artist he felt growing inside him. All his life that fragile being has been protected by a deep fear of the intellectual and an abiding faith in the instinctual. Great art, he believes, is bred in the bone, not the brain; artists must paint out of their own nature. From his boyhood he had watched his father churning with philosophic introspection and rejecting the innate gifts that gave his art its power—his mastery of drama, his fierce sense of romance, his counterpoint of violence and sentiment. "He tried to get serious and do other things," Wyeth says sadly. "But they didn't have his quality. That's the tragedy of my father's life."

NC was a self-educated, self-anointed authority with an opinion on everything. But by nature he was hounded by doubts, and beneath the egotism he sometimes felt lost. In times of uncertainty and melancholia he looked to his reading for peace and answers—in Goethe, Emerson, Tolstoy, in Thoreau's "high consciousness between two eternities." But often such books only fed his mental turmoil. Henriette said, "Pa was like Blind Pew. He felt half blind a lot of the time, feeling ahead."

Suffering from a pattern of alternating melancholy and exhilaration, he wrote in 1913, "Never in my life have I suffered such a total eclipse of optimism." Two months later he was euphoric, declaring, "That's all I want! To keep flexible! . . . To feel the irresistible march of progress within, that is heaven—all the heaven I ever want."

In 1909, at age twenty-six, NC was in demand to paint advertisements, magazine covers, and book jackets, but already he was convinced that illustration was a lowly craft, a roadblock to the standard of achievement he had set for himself. He wrote: "the very source of my livelihood (and a good one it is, too) is standing in my way. . . . It is my purpose to create pictures

that will last, like the works of men like Michelangelo, Raphael, Millet." He was dreaming that "every stroke of my brush will become charged with a *cosmic* truth—the *universal message of the ages!*"

Art to him was "a tangible form of reverence and love for the blessings of existence." Therefore, his own art should encompass all of existence. "The universe towers in my mind a great overpowering mystery," he wrote. "The significance of the tiniest speck of bark on the pine tree assumes the proportions of the infinite sky. My brain almost bursts with the effort to really appreciate the meaning of life."

These were the impossible ambitions he set for himself in his "easel paintings." In 1909 he thought the answer might lie in the new style of American impressionism. He painted a few landscapes in broken color, a technique that introduced a radiance of light by breaking a color into many individual hues. Simultaneously NC was reaching his full powers as an illustrator, and in 1911 he began *Treasure Island,* the first of his great Scribner Illustrated Classics.

These became the two tracks of his life. One was a career that he scorned but that exactly fit his talents and temperament. The other was his search for an artistic style to carry him to his dream of feeling like a *painter.* Looking for answers—while illustrating *Kidnapped*—he visited the watershed 1913 Armory Show in Manhattan, where he saw the works of such postimpressionists as Paul Cézanne, Vincent van Gogh, and Paul Gauguin; the fauve Henri Matisse; the cubists Pablo Picasso, Georges Braque, and Marcel Duchamp, whose *Nude Descending a Staircase* was a hit of the show— dubbed "an explosion in a shingle factory." Painters Edvard Munch and Wassily Kandinsky; sculptors Aristide Maillol and Constantin Brancusi; and the "primitive" Henri Rousseau were represented. The exhibition was a superb survey of everything that was *not* happening in American art.

NC and his sturdy Americanism must have been rocked by the show. But, writing later, he was simply disgusted: They are entirely without aim or principle—a motley lot of charlatans with no head nor tail to their endeavors unless it is to be *different.*" On another trip to New York he was equally scornful of the famous illustrators he joined at lunch, pronouncing them no better than clerks and bookkeepers. He could be equally scathing

about the success of his own illustrations, his "skin-deep picture-pictures"—playing "jack straws with an author's work" instead of "recording the heart-tearing, soul-moving phase of the dear life at your own table." He bewailed his own inability to voice his passion on canvas: "I can't do it . . . I seem to be fitted neither by training or professional habit to satisfy these Religious Cravings."

A central influence in NC's search—and a prime source of confusion—was Christian Brinton, a wealthy art writer and collector, described by Henriette as "a rather superficial show-off." Andrew remembers, "My father knew a lot of pseudoartistic people that really undermined him terribly. My mother used to say there were certain people she hated to have at the house because 'your father would be in such a state for weeks.'"

Brinton once brought two abstract painters to NC's studio, a Frenchman and a Russian. Brinton repeated to NC what one said afterward: "The trouble with that man is too much good illustration to make good paintings, and too much good painting to make good illustrations." Andrew says, "That was a tragic thing to have done. Pa went absolutely crazy."

Brinton spoke persuasively about the large collection of modern Russian painters, including many by Marc Chagall, in his West Chester, Pennsylvania, home. NC was impressed by their high-key color, their quality of fantasy and folklore. In later years Andrew visited Brinton with NC and saw the Chagalls as a warning to himself, and a metaphor for his father. He says, "There were paintings of Russia where Chagall grew up, towns full of snow, black spruce trees. Very fine. Then he went to France, and the French impressionists took him away from his soul."

In 1915 Brinton introduced NC to William Lathrop, one of a pocket of American impressionists in the Delaware Valley led by Edward Redfield, whose work was described as "masculine," "virile," and "thoroughly American." NC valued him, too, as a source of stimulation and new possibilities. Andrew's sister Carolyn remembered that throughout her father's life, "Anybody who came along, Pa would all of a sudden get under their spell, as bold as he was. He would be swayed by this man, by that man. Bad. Nobody can influence Andy or me. Oh, boy, we had the lesson with him, what it did."

Lathrop in 1915 presented NC with a book on Giovanni Segantini (1858–1899), a Swiss painter of peasant, mountain scenes, often religiously symbolic, distinguished for impressionist light effects mingled with firm realism. He was extravagantly admired by NC, who saw in the pictures lessons "not technical but *moral* and *spiritual.*" That same year NC began in earnest his serious "easel paintings," his lifelong struggle to be a fine artist. He did *The Fence Builders*—men putting up a split-rail fence, the handling of the valley and hills influenced by impressionism.

In 1916, while illustrating *Black Arrow,* NC traveled all the way to Pittsburgh to see another exhibition of modern European painters. He came home flushed with praise for the "indefatigable energy and sustained integrity" of the French painters. To him they were "a severe commentary on the transient, puerile efforts that are masquerading as art in *our* annual shows (made up mostly of grotesque, sensational stuff flashing mere whims of shallow brains and shallower emotions)." That year he declared: "I am most ardent to come abreast of the modernistic spirit and *will do so* if my *caliber* is equal to it."

In 1917, the year of Andrew's birth, NC included impressionist broken color in his illustrations for *Robin Hood* and *The Boy's King Arthur*—and continued to feel trapped in his success as an illustrator. NC rhapsodized to his brother Stimson about their feelings for *home,* their "experiences of the spirit"—and cursed himself for "using the divine fragrance of these inspired moments to garnish a pirate picture, an Indian scene, or some meaningless fantasy. Ah! I've had long drilling in thus diverting the golden stream into the gutter. Can I stop the leak? I *must!!*"

World War I was aflame in Europe, and NC declined lucrative offers to cover the war as an artist-correspondent. Instead he painted an inspirational mural for the navy to use as a poster and did illustrations for *Red Cross Magazine.* By 1918, ever restless, NC had become contemptuous of his impressionist friends, describing their pictures as emphemeral "whispering sweetness." He wrote that "Redfield works at his art like a carpenter, and when exchanging thoughts with him one is constantly distracted by his sawing and nailing."

Hoping to combine illustration with real painting, NC in 1920 increasingly accepted commissions for murals. Many of them Andrew dis-

likes, saying, "Look at them! A man who was so robust—and they're just tinted with almost crayons and pastel colors."

In 1921, as he often was in his life, NC was lonely for "a sympathetic, resourceful friend" and "deadly tired of introspection." In a letter that year NC lamented, "If only I could find a *man* to whom I could write, or to whom I could talk and discuss. One who is in perfect sympathy with *Nature*. . . . Then I feel my soul will be filled . . . and I could accomplish so much more."

By the mid-1920s most of NC's great illustrations were behind him: *The Last of the Mohicans* in 1919, *Robinson Crusoe* in 1920, *The Scottish Chiefs* in 1921, *The White Company* in 1922, *The Deerslayer* in 1925. His illustrations gradually lost the muscular power that made them great, sliding into a pantheistic idealism intended as poetry. "He started to make those banners too flamboyant, his skies got too flamboyant," says Andrew. "In the beginning of your career, you reach a point where it's exactly balanced. But if you get carried away, then you become a caricature of your original self."

In his easel paintings, NC's feeling for the countryside had always been fundamentally sentimental, and more than ever his vision lacked the concealed teeth that grew in Andrew's later work. Betsy says, "He only had about fifteen painting years. Then something happened. He didn't believe in himself. He put up this big front—a very sensitive man."

In that pivotal year of 1925, when Andrew was eight, Henriette was another confusing force. Andrew has always blamed her for helping to derail NC, for making him feel insular, for introducing him to a sophisticated social world, for bringing modernism into the very heart of the family. Studying at the Pennsylvania Academy of the Fine Arts, Henriette was inevitably exposed to the modern movement. She said, "I simply liked contemporary art, as if I was picking a big bouquet of flowers and putting them in water and looking at them." She was interested in Braque, Picasso, Modigliani, Manet, van Gogh, and brought home books of their works. NC paid attention. He was vulnerable to Henriette, respecting her brilliance to the point that he asked her to critique his work—which she did with withering honesty.

In that same year of 1925—the year he struck Andrew and knocked him down—NC's world was profoundly shaken: his mother died. He lost

the sounding board of his deepest feelings, the keel of his life, the woman who backed his youthful desire to be a painter against his father's wishes. In his grief he resolved "to carry on for her sake into a more important field." Starting in earnest a program of experimentation and imitation, he began what he called "an important epoch."

It lasted more than a decade. Beginning in 1925, he tried out color, abstraction, and flat painting—and impressed these elements on his daughter Carolyn. He tried the styles of modernists, expressionists, and Russian folk artists. "You can see they lack the juice of conviction," Wyeth says. "In those pictures, everything he talked to me about, the strength of how you build a building and the massive quality, just crumbles into nothing. He was so down to earth, but these pictures are full of rainbows. Sculpted clouds! That's the worst." Though NC never lost what Henriette called "his elemental blow of design," his images at their most extreme almost disappear into prismatic, overlapping planes of light and color. "He went just nuts," Wyeth says. "He soaked up too much. He wasted himself trying to be modern."

Andrew remembers his father in 1925 at Port Clyde out behind the Wawenock Hotel painting *The Harbor at Herring Gut* in the manner of the Russian folk artists. Eight-year-old Andrew, seeing the brilliant colors, stylized treatment, distorted scale, wondered, "What's he trying to do?" Today Wyeth says of the picture, "It sort of looks like it ought to be a rug, a paisley shawl or something. Then you look at *Treasure Island* or *Kidnapped!* The way he turned his back on Pyle; I can't believe it."

With anger in his voice, Wyeth continues, "I grew up with Cézanne and all that shit floating around. I just thought it was putrid stuff. I couldn't bear it. I liked all the people my father *had* liked—Winslow Homer—but had dropped because they weren't in the modern stream." His voice softens. "For some reason he didn't do anything to deter me, didn't try to force this other crap down my throat. I guess I was too young. He didn't bother too much about me."

When NC's experimental period tapered off in the mid-1930s, his work did earn him recognition as a fine artist—though nothing close to his rep-

utation as an illustrator. In 1940 he was elected to the National Academy of Design, and his work appeared in its annual exhibitions. It hung in exhibitions at the Corcoran Gallery of Art in Washington, D.C., from 1930 through 1945. In 1932 a non-experimental canvas, *In a Dream I Meet George Washington*, won a prize at the Corcoran Biennial. He was included in the Carnegie Institute's exhibitions in the 1940s. But at a fundamental level, NC believed himself a failure. In the 1945 biennial at the Corcoran, *The Spring House* was voted "most popular" by the viewing public. Hearing the news, NC wept with joy and gratitude.

Andrew's wild and spontaneous watercolors, the sell-out show in 1937 at the Macbeth Gallery, faced NC with a wrenching truth: The son was fulfilling the father's lofty aspirations. NC was boundlessly proud of his son, this product of his teaching and ideals who was standing on his artistic shoulders. But NC's feelings of inadequacy were also stirred. After the superiority and contempt NC had showered on other artists, he himself had fallen short of his own standards.

He wailed, "Andy is carrying on the fundamental study and discipline I *should* have followed, and is so acutely building toward important expression. I cannot modify my bitter disappointment by argument or philosophy." During a trip to New York, NC met a young engraver and watercolorist who asked excitedly, "By God, are you the father of Andrew Wyeth?" With equal parts of amusement and disgust, NC wrote Henriette, "At last he knew who I was, and I had difficulty shaking loose from him."

In 1938, the year Andrew had a show at the Currier Gallery of Art in Manchester, New Hampshire, NC wrote Henriette, "The bulwark of my stay here this summer will be Andy's accomplishments. His watercolors have so definitely advanced into impressive maturity . . . their impact on any one whose sensitiveness lies beyond romance and dreams makes it hard to hold back tears. What magical power that boy has! I am at once stimulated beyond words to new, purer effort, and plunged into black despair."

NC did not understand the crucial difference in their two natures. He had taught Andrew that art begins with emotion. But NC's emotions were distorted by the static of cerebral abstractions, of cosmic contemplations:

"To express through the medium of sadness the exquisiteness of life is my great desire, because I feel Nature in her *glory* that way. The more beautiful an aspect of nature, the more I turn in upon myself and live deep in sober reflections. The brilliant sparkle of a sunpath across water does not make me jubilant and happily excited, but creates an intensely reverse feeling of solemnity, almost austerity."

Andrew was painting direct unadorned passion. After a walk along the ridge in Pennsylvania, Andrew in 1942 wrote his father: "The sky made the ground move. Even the crows and other birds seemed to be blowing instead of flying through the air, everything was moving. Some day to put this in painting is what I hope to do—such pure color which seemed to blow all dull things out of my mind."

NC sensed too late Andrew's core gift of finding complexity within simplicity—as in *Ice Pool* (opposite page 214). Andrew says, "My father really floundered, and then at the end of his life he saw what I was trying to do. Simple things—like using just a dead crow in a field. When he saw *Winter Fields*, he said, 'If only I was twenty years younger.'"

But perhaps language, not pure painting, was ultimately NC's primary form of expression. Though Andrew admired his father's flights of complex eloquence, he came to believe that NC ultimately talked away the emotions essential to painting. Terrified of being emotionally empty, Andrew has adamantly avoided self-dissection of feelings. His responses are visceral, not cerebral, tuned to tones and moods. He believes that feelings, voiced into chilling air, will congeal and die.

"I think we all talk too much," Wyeth says. "I know I do. One thing, you'll never hear me talking about a painting I'm doing. You can talk it out, build fences around it. I even hate to put it down on paper. I hate to paint it, because then it becomes set. It's awful when it's set."

During the 1940s NC felt that his idealistic faith in the power of preeminent truths was utterly betrayed by World War II, by what he called "the lurid threads of the world's dementia." In 1941 he wrote, "All sense of serenity and security has crumbled away, and all I can do, when I think about it all, is to gawk stupidly at the retreating pageant of my dreams and hopes."

AMERICAN ARTIST

35¢ *September 1942*

ANDREW WYETH

Photo by Robert McAfee

With his watercolor shows selling out at the Macbeth Gallery in New York, Andrew, at age twenty-five, was so successful he rated a cover on a major art magazine. Above his head is his drawing of a turkey buzzard with a five-foot wingspread, a study for his tempera *Soaring.* Around his neck is the special Waterman drawing fountain pen given him as a teenager by Peter Hurd.

Even in the idyllic cocoons of Maine and Chadds Ford, the Wyeth family could not escape the horror of war. In Port Clyde the salvos from navy gunnery practice shook Eight Bells and lifted the floor of NC's studio. To NC's Chadds Ford studio came a Guadalcanal marine veteran, bringing background research for blood donation posters that NC agreed to paint. He watched three hours of film on the battle for Tarawa in the Pacific, in color, uncut, with sound. Nat Wyeth remembers, "He saw people with limbs blown off. People burned to a crisp by flame throwers." What NC called "Fuzzy-Wuzzy" brought in five Japanese heads, holding them by their hair. He collected his bounty of five sticks of candy and rolled the heads on the ground like so many coconuts. NC wrote: "I was near the breaking point several times and within an ace of losing my lunch several other times."

Compounding NC's distress, Andrew was in danger of being drafted into the army. Just as Andrew had been deemed too fragile for school, all the Wyeths agonized over the effect of battle on this prized, hypersensitive young man. Betsy wrote about "that awful shadow that ends all other thoughts." NC gathered influential names and contacts to pull strings. Nat Wyeth actually tried to take his brother's place in the draft. Perhaps still romanticizing war, Andrew was primarily worried about the interruption of his work. Though he hoped that his marriage might exempt him, he wangled a job as an artist-correspondent. But, poised to leave for the Solomon Islands, he was rejected because of his arthritic hip condition.

At the end of 1943 Andrew was drafted and reported for his physical. This time he was rejected for "third degree *pes planus* symptomatic"—flat feet. In addition to the twisted condition of his right leg, affecting his hip, one lung was suspect. Relieved that he could continue his painting, he wrote his father: "I have certainly been given every chance in the world to make something of my ability and, by heavens, I will."

The atomic bombs dropped in 1945 were to NC a final, overwhelming evil. Within him was still the boy who was devastated by remorse when he threw a rock into a pond, shattering the tranquil surface. Now, said Henriette, "He felt responsible for the war in some dreadful way he couldn't help." His children would come upon their father in the studio, sit-

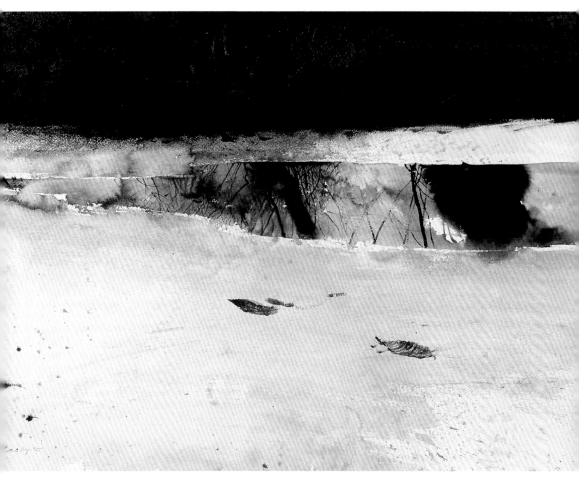

Ice Pool, 1969

With a sense of abstraction that eluded his father's
search for a modernist style, Andrew painted a window
to the sky—a reflection of the wooded Brandywine
riverbank filling the glassy open water in a white plane
of snow ice.

ting in the dark at his desk or on the steps between the two studios, staring in despair at the dim floor.

In those years Andrew and NC were experiencing a role reversal. Now influenced by his son, NC switched to the medium of tempera. He even used one of Andrew's models, painting the scorned Walt Anderson rowing a dory. In 1942 NC repainted in tempera an exact copy of his stylized, romanticized 1932 oil of Henry David Thoreau standing above his little cabin on Walden Pond. "This often happens to an artist late in life," Andrew says. "It's really tragic because it means you're hanging on to something. Very sad. My father was a creative genius, wonderful man and believed in so many things, but boy, oh boy! When I start doing that, I hope somebody takes a pistol and blows my fucking brains out."

Betsy Wyeth says, "I think Andy felt his father was such a tragic figure. Andy was forming his own ideas about what direction he was going to take, and he wasn't going to take *that* direction. It's finding your parents aren't the dream world that you thought. Their weaknesses are glaringly real to you. It's understanding what made it all happen and resolving that by the grace of God it will never happen to you. And Andy has *never* swerved. But he was kind to his father. He never fought with him. Never said a cruel word. He encouraged his father. He was most grateful for what had been given him."

In Pennsylvania Andrew routinely ended each day at his father's studio. "It was a very sad period for me," Wyeth says. "I knew Pa wasn't doing his best work, and I felt the need of bucking up his spirits. I hoped that it helped him, but I don't think it did." When Andrew and Betsy left for Maine in 1944, NC wrote: "I do not remain unscathed when Andy pulls out—his companionship and stimulation are enormously important to me these days. And especially since Tuesday I have had every urge to pack up and go immediately."

In 1945, at the end of NC's summer sojourn in Maine, father and son sat up talking until 3:00 A.M. NC lapsed into pessimism, saying, "I'm just old hat"—and told his son to forget about realism: "You'll never make a living at it. Nobody understands it or has any interest in it."

Knowing that NC was flagellating himself for failing to become a distinguished painter—a disappointment highlighted by his son's accomplishments—Andrew was especially solicitous. He tried to see his father daily, and sometimes picnicked with him at the rocks above the house.

That day Andrew had been out on Teel's Island and returned with a watercolor of Henry's trousers hanging from a hook, the suspenders dangling down. NC was expansively complimentary, Wyeth remembers, "So I told him what I really thought of *his* work. I told him, 'This watercolor is nothing compared to what you can do. You've created the greatest paintings of the most absolute romantic vitality. Whether they're illustrations doesn't matter. You don't realize what you've done. You've made a landmark. You've done it. There's no one that can touch you.'"

The next day Andrew took his father to the train in Rockland. As the train pulled out, NC called, "Watch your driving going home. Be careful."

In addition to his son, NC had another source of solace—and it was not Carol Wyeth. According to Andrew, "My mother was a wonderful com-

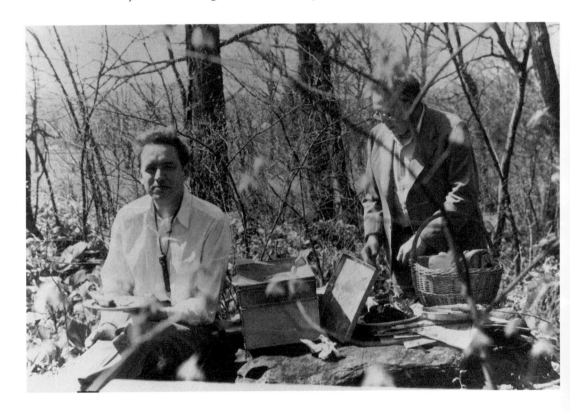

panion for my father. She let him have the life that he wanted, but I don't think she had the slightest idea of what he was doing." By the 1940s she had entered menopause and was sickly and, says Wyeth, "lazy and heavy and whiney," complaining about the capabilities of the cook and butler. She had little patience for her husband's despondency. "Ma thought it was absolute nonsense," Henriette remembered. "All Pa's questioning and self-criticism and changes of philosophy had gone on year after year, and Ma finally became very, very bored with his constant nibbling and chewing at what is the meaning of life. She would not listen to it anymore. She put on weight and read stories in the *Saturday Evening Post.*"

NC in his early sixties found refuge from himself in a woman who gave him back his youth—and perhaps revived abandoned dreams. She was young, pretty, physically magnetic, with an intellectual, creative bent. She fed his ego with admiration, was a fresh ear for his torrential feelings and ideas, perhaps the understanding listener he had needed all his life. Once again he felt able to school and foster an expectant mind. He had a reason to live. Unfortunately, she was Caroline Wyeth, the wife of his son Nathaniel.

Caroline was an embryonic poet with a love of language, literature, and music. Nat read little, was an engineer who analyzed not ideas but how things worked. She was a charmer who could be devastatingly brusque and had not been warmly welcomed into the Wyeth clan. Early in their marriage Nat was transferred by DuPont to their explosives plant in Pompton Lakes, New Jersey. She was lonely and felt uprooted from friends and relatives, deprived of intellectual stimulation.

Betsy explains, "N. C. Wyeth wasn't getting a lot of flattery at that time in his life, in his work, in anything, and she was giving him all that flattery, and doing it deliberately to pay everybody back that hadn't loved her. She was going to take him away from his children, distract him. '*You* can't have him because you don't deserve it. *I* deserve that mind.'"

NC went to Pompton Lakes for visits and they corresponded. His letters were sometimes boyish with confession. He told her that she held "a growing and unique place in my heart and mind," and in 1944 wrote, "Perhaps never before have I felt the craving so intensely to either talk with you, or by letters, to communicate some of the sharp delineations of feelings

that rise and fall these days with such excruciating force. . . . Doubtless you have at times reflected upon the character of some of the letters I have written to you and have subtly wondered at some of the personal sentiments expressed in them."

Typically, NC set about encouraging and developing Caroline as a poet, praising the "astonishing power and beauty" of her poems, mobilizing for her his connections at publishers and magazines, asking Stephen Vincent Benét to suggest texts on poetry. "Pa finally found somebody he could train," Andrew says. "I saw what it must have been like when he spotted ability and real talent. And of course there was the fascination that she was Howard Pyle's niece. It was total obsession on his part."

Not the least of Caroline's allure was her first son, born in November of 1941 after she and Nat had had difficulty conceiving. He was named Newell Convers after NC. He was a fascinating, precocious child, who at the age of three was listening to Rachmaninoff concertos and Beethoven and Tchaikovsky. NC adored him, "that gleaming child of color and spirit," and exclaimed over the boy's expressions, "haunting in their warmth and alive charm." Nat said, "I remember Pa telling us, 'You must be awfully careful of that little boy in the automobile because there are so many wild people on the road.' Over and over again, to the point where I could hardly take it."

In the spring of 1945 Nat and Caroline resettled in Chadds Ford. They rented a small house near the schoolhouse and Andrew and Betsy. With Nat absent much of the time in Pompton Lakes, Caroline was alone in the small house with Newell and their second child, Howard Pyle, born in 1944. From the schoolhouse, Andrew and Betsy could see NC drop off the mail in the morning and emerge hours later. Carol Wyeth never showed any jealousy. When he sometimes came home wih his collar smudged with red, she laughed and said, "Where'd you get that lipstick? You're a bad boy."

Later that spring of 1945 Carol Wyeth went to Maine with Ann and John McCoy. NC stayed behind. Dressing before lunches with Caroline, he would ask his daughter, "Do you think this is the right tie for this suit? Do I have the right color shirt on?" Carolyn Wyeth remembered, "Oh, God,

when your own father does that! And he was such a strong person! He was a puritanical New Englander."

One evening in the early summer of 1945 Nat went up to the house to ask his father about the relationship with Caroline. "Pa brought up all these other things," Nat recollected, "and just snowed me with them, just talked about the terrible storms they were having in Maine."

Nobody in the Wyeth family feels certain what actually took place between NC and Caroline. Decades later, the speculations are primarily self-portraits of the Wyeth children. As a whole, the family has felt no censure, just sadness. In the Wyeth ethos, understanding vindicates behavior. Wives should tolerate the behavior of men—in particular male artists. Couples stick together no matter what.

Nat's reverence for his father remained: "It was all understandable. I think Pa lost control." Carolyn said, "I don't hold it against Pa. I just pitied him like hell." Ann says the relationship was no more than "a meeting of the minds." Henriette said, "He had one hell of a terrible time, which I think reduced him to the final nubbin in his own mind. He hated himself for that lapse." Andrew admiringly remarks that his father was a full-blooded man, and says, "I'm sorry it had to be my brother's wife. But I didn't really blame Pa. I hope he enjoyed every bit of it."

The family curator of NC's memorabilia, Betsy Wyeth, is adamant that the infatuation was unconsummated and has been overblown in the family history. "I just owe it to my father-in-law to put the record straight," she says. "It's not fair to Caroline. It's not fair to Grandma."

In the Wyeth family calendar, October 19 is a charged date. On October 19, 1902, N. C. Wyeth arrived in Wilmington to begin studying with Howard Pyle. On October 19, 1932, Andrew entered his father's studio for academic training. On October 19, 1937, Andrew's first one-man show opened at the Macbeth Gallery.

On October 19, 1945, NC was preparing for the return of Andrew and Betsy from Maine. To clean the schoolhouse, he had hired Evelyn Smith, a woman Andrew had painted. On this sunny, warmish morning he

set out in his 1943, maroon, wood-sided Ford station wagon to fetch Evelyn from the house next to Mother Archie's church. He stopped at Nat's house at the foot of the road, and Caroline brought Newell out to join his grandfather for the outing. He decided not to include Newell's frequent companion, Steve Petty, son of Janet Petty, the postman's daughter and Andrew's teenage crush. Carolyn Wyeth did come and was dropped off at Painters Crossing to catch a bus to West Chester.

Now alone with Newell, NC turned up Ring Road toward the railroad crossing just before the Kuerner farm and Mother Archie's. Part of the ambience of the valley was the train at the crossings—as NC had written Caroline in 1944: "Just at this instant, I hear the distant sound of a Reading train whistle. It is an especially eerie and poignant voice—a call from great distances in space *and* time. . . . It also speaks of the future; it punctuates the moment between the two eternities."

On that day, before reaching the railroad crossing, NC stopped the car to show Newell a couple in the cornfield shocking corn—bundling the dried corn shocks by braiding their leaves and standing them upright. Years later in a snowstorm Betsy picked up an elderly lady who turned out to have been the woman working there that day. She described a big man and little boy coming over into the field. The man said, "You must watch this because you won't see it much longer. Now it's all done by machine."

NC and Newell returned to the car and headed up the hill toward the crossing, into a blinding sun. On the tracks the car stopped. An unscheduled mail train from Philadelphia was bearing down. Its brakes locked. The engineer saw the glint of NC's glasses, saw him throw up an arm as though to ward off the locomotive. Lydia Kuerner, standing in the farmyard waving to the engineer, heard the crash and saw something thrown up in front of the engine. She thought, "That's too much just to be a pheasant."

The locomotive rolled the station wagon over and over in front of the cowcatcher, 143 feet down the track. Evelyn Smith, waiting for NC at Mother Archie's, rushed to the crossing. The brakeman kept her away. "You don't want to see it," he said. The car, contorted metal, was upside down. NC's body in the front seat had to be cut free. Little Newell had

been thrown onto the cinder embankment. His neck was broken, his body unmarked. Caroline arrived. She picked up the little boy and held him, and with gentle fingers she straightened his clothes.

Releasing the steam in the boiler, the locomotive whistle kept on blowing—the whistle that the children once thought was their father's high yell calling them home. It reverberated in the hills. An old black woman told Andrew, "The killer's voice was blowing all morning."

13

N. C. Wyeth's death split his son's life in two. Andrew has spent the second half of that life processing the first twenty-eight years—a long unreeling of love and guilt and rage.

The morning of the accident Betsy was packing to return from Maine to Chadds Ford. "I don't want to call it a premonition," Betsy says, "but I thought we ought to go home. It was very peculiar." They were living in the little apartment in the barn at the Jameses Broadcove Farm and had no phone. A neighbor pulled up in his big, black car and told Andrew he should call home. He phoned from the neighbor's house. Ann said simply, "Pa and Newell were killed by a train."

Andrew stood alone, silent. "It was as though," Betsy remembers, "he could see something I didn't see. He looked like Hamlet, talking to his father's ghost." Then he told Betsy that NC had been killed. "I had an enormous sense of relief," she says, "as though a terrific responsibility had been lifted from me. I had never wanted the responsibility of being . . . playing this double game, being part of the cover-up against his father. I was tired of that."

They returned to the Jameses' house. "There was no crying," Betsy remembers. "Almost total silence, as though everything had stopped. It was like a train passing through and all the people standing silently, not waving or moving. I realized that I shouldn't even touch him. It was hands off." Andrew went into Bess James's bedroom to tell her. Through the door Betsy watched her mother enfold him in her arms.

As usual, they stopped for the night in Hartford with Betsy's sister Louise. Betsy woke the next morning to find Andrew by the window, looking out, sobbing. Outside the window was the radiance of fall leaves. Crows were cawing.

When Andrew and Betsy reached Chadds Ford, Nat was waiting for

them at the end of the driveway. In the schoolhouse Andrew noticed that the interior had been repainted. "Pa made certain everything would be in perfect shape," he says. Ann was there—and Caroline, controlled, taut with grief. It was she who had gone to the main house and told Carol Wyeth.

Andrew left Betsy at the schoolhouse and went up to see his mother. She was dazed with shock. The Unitarian minister was there and he told Wyeth, "Andrew, I think you ought to remember your father is in heaven." Wyeth remembers, "I thought, Fuck you, and got back in the car and away I went." Telling nobody his intention—but disgusted that the rest of the family lacked the fortitude to face the bodies—he headed for the Quaker Meeting House in Birmingham where they lay in open caskets.

Almost audible in Andrew's head was his father's voice saying, "Be sure you look at me in death." NC had once described to him his farewell to his mother: "I took the train right to Needham. I got there in the late afternoon and they had laid her in her bed upstairs. I sat there with her, with that amazing face that looked like the mother of Europe. As the sun went down, studying that face lying there on that white pillow and that waxy skin, it made such a deep impression on me. Andy, if you ever have a chance to be with someone you love, don't hesitate to do it. Because that's the most profound quality, a head in death. You'll see things you've never dreamed."

The Quaker Meeting House, steeped in age and simplicity, is almost square, modest in size, with rough plaster walls, a high ribbon of dark walnut paneling, and simple benches tiered toward the rear wall. In the middle of the floor, resting on saw horses, were the two open caskets, waiting for burial on Sunday, the day before N. C. Wyeth's sixty-third birthday. Beneath the caskets in the oak floor was a brown stain where the blood of Hessian soldiers dripped and pooled during amputations after the Battle of the Brandywine.

Newell lay in a small casket, fair-haired, wearing a white-and-blue sailor suit. Around his neck was a string holding a little silver whistle that rested on his chest. Andrew was struck by the family resemblance to NC, laid out in the long casket, hands folded on the rise of the huge chest. He was struck, too, by the broadness of his father's face. "He looked almost Indian," Wyeth says,

"with black grizzled eyebrows, hair parted slightly in the center. I was amazed by the smallness of his hands and the delicacy of his nose. My father was so right that I should see him. Their faces had become masks of eternity. I couldn't have taken the funeral the next day if I hadn't done that." In him rose a fury that he had never painted his father in life.

There is a painting of the head and torso of a nude woman lying cramped by Stygian darkness, her head on a pillow, a slight Mona Lisa smile on her square face. Titled *Night Shadow* (opposite page 342), it is Wyeth's memory of his father in the coffin, the moment he bent down to kiss the forehead, feeling the cold waxiness on his lips. The light was dimming into sundown. He could hear the faint sounds of dogs barking, roosters crowing. Dead leaves blew in the open door. A woman started to sweep up; another stopped her, saying, "Mr. Wyeth would have loved them."

On Sunday the family rode in black cars following the hearse along Route 100, parallel to the Brandywine. The cortege turned right toward Birmingham. Henriette remained in New Mexico. The writer Joseph Hergesheimer, from the glory days, was in the meeting house and wept. During the short service, the family fumbled through their thoughts and memories. "Everybody but Nat was dependent on him," Andrew says. "I mean really dependent—Carolyn a little less. I don't think the family has ever recovered, really."

Carol Wyeth, rigid with calm, wished that she, too, had died in that car. She comforted herself with the memory of a recent, loving talk with her husband, who told her there was so *much* he still planned to do, and thanked her for always giving him the freedom to do what he wanted. She had been very pleased.

For Ann, there was her last image of her father. The night before, she, Carolyn, Caroline, and Carol Wyeth went to the movies, and NC stood in the kitchen door, waving good-bye. In his hand was a copy of *The Robe* by Lloyd C. Douglas, which he was preparing to illustrate. One finger was stuck inside the book, marking the place he had been reading.

Ann remembered, too, the recent day when she played the musical portrait of her father, and he was very pleased and slightly embarrassed.

Now the piece she had composed for his birthday must be rewritten to end in a dirge. She would call it *In Memoriam*. She remembered a moment when the funeral was being planned and she was asked who should be invited. With the thoughtlessness of reflex she said, "Wait a minute, I'll go in and ask Pa."

That morning Betsy had realized she was pregnant again. She thought about her last moment with NC, when he came to say good-bye in Maine in late September. NC had held two-year-old Nicholas. Handing the boy back, he had said, "Be very, very understanding of this child. You have a highly complicated, sensitive son. You treat him with great care."

Nat sat unseeing in the meeting house, barely aware of the two caskets, resenting the fact that so many of the mourners had hardly known his father. His mind replayed the recurring dream of premonition that for weeks had been haunting his sleep—"Newell going down a slope into nowhere."

For Carolyn there was the memory of standing in a West Chester drugstore and hearing over the phone the voice of her sister-in-law Caroline, saying matter-of-factly, "Your father was killed this morning. I think you'd better come home if you can. I'm sorry I have to tell you." And hanging up.

There was, too, her memory of her father and the picture she had been painting only ten days ago—apple trees through her studio window. As she once told the story, "Pa said, 'The apple trees are too low; I want you to put them up *there*.' And he took a piece of charcoal and bang, bang, bang—over fresh new paint. I didn't say anything. The next day I rubbed it out."

At the time of the service, Henriette in New Mexico was ill with a difficult pregnancy, but she painted a spray of golden salmon–colored daisy chrysanthemums, given to her the day of her father's death. She thought, "That's what Pa would want me to do." In her mind's ear she heard his voice, coaching her over her right shoulder: "Paint the stem as though you know how it would sound if you broke it." . . . "Paint the air between the petals." Henriette thought, "Pa is with me. And he's going to be pleased."

Andrew, too, was grateful for that last long talk with his father in Maine. It felt now like a mutual benediction. As he says, "Thank God I was

absolutely honest; no bullshit. Thank *God* I gave him a complete worship of his own quality."

NC was buried in the family plot, a blank spread of grass amid acres of headstones, an underground convocation of Wyeths marked by a small stone listing the names and dates of the deceased. A short distance away is a similar grassy area, a plaque identifying it as the common grave of soldiers from both sides of the Battle of the Brandywine—Hessian, British, American—some 400 killed in the area. From time to time a loose handful of wildflowers lies on the Wyeth stone, an offering from Andrew, who sometimes hears in his head the mournfulness of the wind in the tall pines at Birmingham.

Shadowing the funeral rituals was the question of what had actually happened on that railroad crossing: Did NC commit suicide? Virtually in unison, the family says, "He *never* would have taken the child's life." Andrew agrees, but believes that "death was on his mind." He points out that all NC's painting gear was carefully lined up in his studio, where a Bible lay open to a passage on adultery.

Nat the engineer noted that the car's engine, choked by carbon, tended to stall when accelerated at low speed. In his scenario, the mail train did not whistle, and NC was at the crossing before he saw it coming. He jammed down the accelerator and the engine failed. Perhaps at this apocalyptic moment NC was immobilized by a heart attack.

Henriette said, "He was miserably unhappy. He allowed himself to become careless. Things happen to you."

A month after the funeral, pensive, dragged down by gloom, Andrew Wyeth was struggling with a watercolor at the Kuerner farm. Now the flow of associations at Kuerner's would forever include a current of grief. Sometimes his imagination heard that wailing train whistle. In his fantasy it mingled with the illustration for *The Boy's King Arthur* that NC finished the day of Andrew's birth: a knight sounding a five-foot horn—"It hung by a thorn, and there he blew three deadly notes."

As he worked on the watercolor, he saw over on Kuerner's Hill a boy named Allan Lynch, dressed in an army jacket and leather pilot's helmet, running pell-mell down the steep pitch in the sharp winter light, plunging off balance, his legs not quite catching up to his body. Andrew walked over to the hill, and the two crammed themselves into a ruined old baby carriage and rode crazily down the hill, laughing, crashing at the bottom.

The image of Allan's running figure, "all topsy-turvy like a rolling stone," fastened into Wyeth's imagination. "It seemed *very* important to me," he says. "Like the time I saw Spud Murphy walking among the trees." He spent the whole winter painting *Winter 1946* (pages 228–29). "It was the one way," he says, "I could free this horrible feeling that was in me, and yet despite that feeling, I had a great excitement for the painting—having a *reason* to do it."

Before the death of NC, says Andrew, "I just wanted to paint." He had been exploring the drama and feel of the landscape—dead crows in a winter field, soaring buzzards. But, he continues, "The seriousness, the dimension wasn't there. I didn't have much to say. Edward Hopper had an emotional reason to paint. Thomas Eakins, Winslow Homer. Frost had a reason to write poetry. I think the first time I felt a *reason* was that evening at Spud Murphy's. But that didn't dawn on me until after my father's death, which put me in touch with something beyond me, things to think and feel, things that meant everything to me. Then I needed to put them down as sharply as possible—with the clarity of the north wind."

Based on his memories, his internal undertones, Wyeth's paintings are often secret self-portraits. "He *is* the person he paints," Betsy explains. "His medium isn't acting, music, theater; it happens to be painting." *Winter 1946* was the first of these intimate metaphors, paintings of his state of mind. "There's the feeling of my own nature," Wyeth says, "my feeling at that time of being disconnected from everything. The boy was me at a loss, really. His hand, drifting in the air, was my hand almost groping, my free soul."

Ruthlessly honest with himself, he knew that the cloud of grief was lined with ambivalence. On one side was the irreparable and permanent loss,

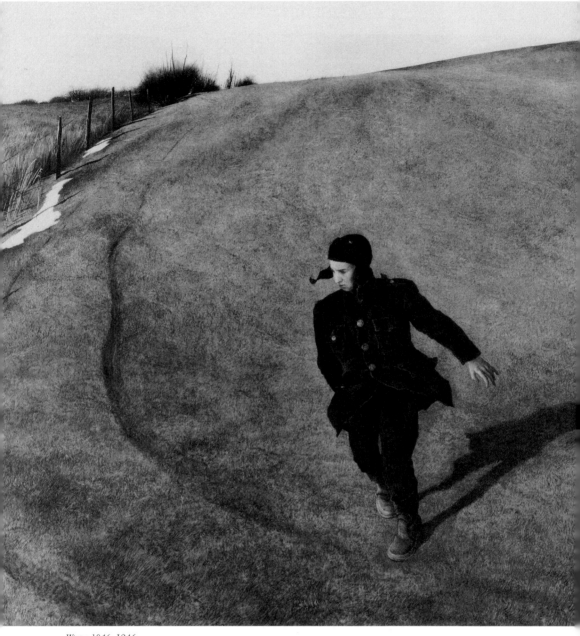

Winter 1946, 1946

Grieving for his father, despondent, Wyeth saw Allan Lynch
running down Kuerner's Hill and identified with the figure. In
the tempera it became himself, pursued by death, liberated from
his father's authority. A pivotal painting, *Winter 1946* began a
lifelong focus on emotion, on his themes of loss and the
fragility of life, and the anthropomorphic presence of his
father in the Pennsylvania landscape.

Gone was his father's love and support, that solid rock of his security, the man who "made it possible for me to paint." Wyeth says, "I don't think a father and son could have had a warmer relationship. I mean, there wasn't any—it was just happy. He knew I was serious about what I was doing. I loved the things he loved. I loved the Howard Pyles from the beginning, and he gave me all the originals he had been given, and all the books Pyle had given him through the years."

Truly gone was the keystone to his boyhood. Henceforth that past, filtered and dramatized in memory, the longing, the pain of loss, would permeate the present and his painting. "Everything moves," Wyeth says. "Nothing stands still. It makes me ill."

His sister Ann once explained, "Everything has to do with the past with Andy. Yesterday is the past. There's something so poignant about Andy. Sometimes I'll go into his studio and he makes me want to cry. Just to look at him. He's so magic. You know he's got this tremendous talent, and he's just made up of feeling. He's brittle almost. He'll drop and crash. His emotion will just tear him apart. But he almost enjoys the hurt it gives him. The more it hurts, the better he likes it."

In the chaos of his feelings, relief was laced with guilt. He was wrung by recriminations: He and all the children had abandoned their father, had been disloyal, ungrateful. His marriage against his father's wishes helped blight his father's last years. He had not prevented the friction with Betsy. Maybe his revolt was responsible for his father's death—if there had been no mar-

riage, there would have been no trip to get Evelyn Smith. He had betrayed this wonderful father by withholding his innermost self, by his secrecy. Wyeth says, "I had all this life over there at Kuerner's and I didn't tell anybody about it. And then he was killed over there. It all became very poignant to me in its meaning."

Compounding his grief and guilt was rage. He *still* felt the combined fear and anger toward his father, amplified by disappointment in his idol who had hit him, who had tried to chart his life and work and to quarantine him from romance. Once, four decades later, Wyeth blurted impulsively, "I hated my father."

Now "hate" became a part of the emotional text of Wyeth's painting. As he once said, "It's better not to love too much. You've got to have a little hate in you." He leaves himself open to "hate," that rage which ignites passion, providing a heat of emotion lasting through months of work on a single panel. It is rage in the sense that he hates whatever might somehow interfere with his work—like Betsy's building the house during *Christina's World,* like the possessions he felt had perverted his father's career—rage in the sense that he hates the brutality, the injustice that killed the hanging deer in *Young Buck,* hates the final injustice—death.

Beginning with *Winter 1946,* Wyeth dedicated himself to atonement, to stating his devotion, to justifying his father's effort and expectations. Wyeth says, "I had this terrific urge to prove that what my father had started in me was not in vain—to really do something serious and not fiddle around, doing caricatures of nature." He wrote a letter to Henriette and Peter Hurd saying, "If I don't do it now, I never will, because it's about time one of us did something that is worthy of what we were trained for." Whenever he finishes a painting, Wyeth wonders, "What would Pa have said?"

Now the work became in part a memorial to N. C. Wyeth. In a long unreeling of unfinished business, objects and people contained shades of NC. "My father's still alive," Wyeth says. "Everything's still alive to me. I feel my father all around. It's like taking a draft of rich cider."

Describing that period after NC's death, Andrew says, "I saw the country even more simplified and somber in its quality. Now it was apparent

Karl, 1948

Angry that he had never painted his father, Andrew used Karl Kuerner as a stand-in, choosing a man capable of both brutality and delicate sentiments. An early title for the tempera was *Foreign Man,* and it began decades of painting Kuerner.

to me what the whole country meant." In *Winter 1946* patches of rotting snow—"little islands of dying winter"—became images of death. "They're very symbolic to me," Wyeth says, "those drifts and the way they get smaller and smaller and melt and the shapes they get into, almost an echo of the clouds that move above. Very exciting." Cast behind the boy is his jagged black shadow, like fear and death pursuing a young spirit. "The hill," Wyeth says, "seemed to be breathing—rising and falling—almost as though it was my father's chest."

In this painting Wyeth tried to break away from what he considered classic design and become more naturalistic, have Allan Lynch truly "tumbling down." The picture was a stepping-stone to *Christina's World*—the fine working of the grass, the point of view, the artist's eye looking down from above the slope. This became a permanent emotional perspective, a feel of removal, a disembodied quality. It began in the Birmingham Meeting House, gazing down into the open caskets. "That afternoon," Wyeth says, "raised my spirit so that I was sort of hovering above, floating, as though I had died many years ago."

After *Winter 1946*, Wyeth's temperas focused increasingly on the human figure. He found in people the fugitive quality of life and the inevitable, eventual tragedy. Joy must be weighed and checked. Death waits just beyond joy. Sun creates shadows. But pain is endurable. The human spirit survives.

In Maine, Christina and Al Olson took on a far deeper level of meaning. "You can be in a place for years and years and not see something," Wyeth explains, "and then when it dawns, all sorts of nuggets of richness start popping all over the place. You've gotten below the obvious." In 1947 he painted *Wind from the Sea*, a major picture. Then in 1948 he painted *Christina's World*, which launched his commercial career.

Also in 1948 in Pennsylvania he painted *Karl* (opposite page 230), the quintessential Wyeth tempera portrait, which he believes is the best he has ever done. In 1948 Wyeth was still furious with himself for not painting his father. He says, "I'm still sick about it. So many things I've missed. It's just that you're blind. Why the hell didn't I ask him? I think youth is such a calloused thing. We don't really look or listen." He con-

tinues, "I latched onto Karl Kuerner because he was the closest thing I knew to a power. I was terrified of my father as well as loved him. That's where Karl was the image of my father—there was a bite there—dangerous—not to be fooled with. This man was undoubtedly the most brutal man I've ever known. I was shocked by him."

By extension *Karl* is also a portrait of a self he hides behind the boyishness. Wyeth once said, "The one thing that might someday make my work good—there's a grace in my work like spring flowers. But there's some harshness, too. I'm a coarse man, really. I'm a strange combination of delicacy—fragile, in another world—and brutality."

One of the first facts Wyeth tells about Karl is his service in World War I. Though Karl angrily denies the story, Andrew the fantasist likes to describe Karl lowering the muzzle of his machine gun and spraying the wounded with bullets. Guns and hunting were virtually his sole recreations. "Shooting a high-powered rifle," Karl once explained, "that's a hobby just like playing golf." Hanging from pegs in the house was Karl's arsenal of rifles with telescopic sights. He was a crack shot, and the farm rang with gunfire. His nephew remembers him walking out on the porch and shooting the heads off three chickens, one, two, three. He hung up his gun and told his wife, Anna, "Go get them."

With hunting pals he shared a camp in the mountains of Pennsylvania. On Sundays these friends often gathered at the farm to do target practice and afterward to drink Karl's home-brewed beer and hard cider. Each fall Karl drove to Canada, shot his moose or deer in two days. He cut it up into quarters, leaving the skin on to protect the meat, and hurried home. "If a ten-point buck runs past," Karl explained, "and you happen to be there with your rifle and shoot him running, that's a deep satisfaction."

As a farmer Karl performed the daily brutalities of ground-level subsistence—farming as life and death, killing to survive. "Kuerner's is a tough place," says Wyeth. He made a drawing of the chain hoist on a tree limb used for dangling a live pig. "Karl stabs it with a knife," he remembers, "and slits it open and lets the blood drip into a big barrel below, and then he skins it and scrapes off the hair. It's a rather cruel thing to watch. But it's life." Karl says, "Killing is what we like and the city people, they think meat

comes in a package." Karl tells that "a heifer was so narrow I couldn't get her calf out, and I had to save the heifer. I was lying there stripped to the waist, and when I pull on that calf's legs, its guts, the liver and all the lungs, they backed up in a big ball. I knowed the calf was dead." Reaching inside the heifer with a knife, Karl dismembered the dead calf, pulling out pieces bit by bit. "The intestines come out," Karl said, "and when the head—that was something *terrific!* But I saved the heifer."

Karl worked his five children—Louise, Karl junior, Clara, Lydia, and Elizabeth—like adult hired hands. He was always ready to reinforce his will—and release his frustration—with physical violence. "If the cows did something wrong, we got it," Lydia says. "He had to hit something, and if we were unfortunate enough to be there, we got it. The beatings I got—going to school with my thumb all bandaged up and I had to lie and tell the teacher that I hurt it, when he had actually done it. My sisters are better than I am. They have forgiven. Well, I have forgiven. But I haven't forgotten."

Lydia continues, "He was a mean drunk. You stayed away from him. One time he got on my brother, all of us . . . we didn't know what he was mad at—he said if he caught us, he'd take us down into the barn and tear us apart piece by piece. I'll never forget that. I was so scared." At least once he whipped his children's legs with a strap. His particular punishment for Karl junior was making him milk his allotment of cows without the restraining chains that kept them from kicking.

For Wyeth the painter, brutality in a subject serves practical purposes. He explains, "It can give you that final acid quality that lifts a picture into something. Keeps it from being nice—soapy—sudsy." The capacity for violence helped isolate Karl, made him and his farm an island constantly accessible to Wyeth alone. Karl and Anna were never truly accepted into the community. He was too foreign, too German, too hard on his children for most townspeople's tastes. One of them said, "Everybody absolutely hated that bandit. He was a Nazi sympathizer during the war, and every other fucking thing—had German POWs working for him on his farm. When he died, the boys at the gas station said, 'That's the best fucking thing that has happened to him ever.'"

Thus Wyeth alone could be the one who saw Karl as misunderstood. Brutality by itself is not the turn-on. Wyeth needs the dynamic of con-

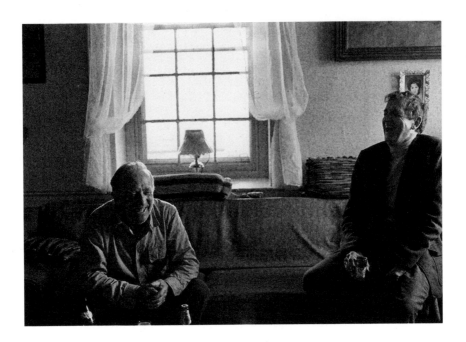

trast, of clandestine virtues unnoticed by the world. He says, "There was another side that saved Karl, that was understanding and wonderful." There was the thread of sentiment that held the Kuerners together more than fear. "No matter how tough Daddy was," says his daughter Clara, who is proud of the work ethic her father instilled, "we girls always liked him. No matter how miserable we thought our lives were, we always gravitated back to him."

Karl loved Christmas and played German carols on his Victrola and sang them in German with a strange sweetness. When Lydia's ears ached and even bled, he blew into them warm and soothing cigar smoke. He kept a supply of silver dollars he doled out to his grandchildren on their birthdays. When his children built a crude swimming hole by damming the stream with rocks and mud and clods, Karl came in with his tractor and scooped out a real pond for the hot summers. Often in March, Karl took Andrew down by the springhouse to see the first snowdrops pushing up through the dark, freshly thawed earth.

For Karl Kuerner, Wyeth was an exciting presence allowed to come and go at will. He would wander in the house, drawing, soaking up the Germanic atmosphere. Sometimes he used the top-floor room with the hooks as a studio. Often at the end of the day he sat in the living room with Karl, drinking beer and laughing.

The portrait *Karl* began one afternoon when Wyeth was in the white-washed attic room at Kuerner's, drawing the German smokehouse sausages that hung from one of the iron, scimitar-shaped hooks driven into the plaster-covered ceiling. They were echoes of Bill Loper's hook, of the hooks that held Bluebeard's dead brides. Wyeth asked Karl to join the composition. Suddenly, Karl broke the pose and grabbed a sausage from the hook above his head. In a flash of recognition, involuntary as a gasp, Wyeth thought, "Christ, *there* it is!"

When Wyeth is excited, his eyes come alight with a kind of rapture. He looks younger. "If I am steamed up on the subject," Wyeth says, "then I just can't think of anything else — so excited it affects my stomach. I'm a sounding board, there to catch this vibration, this tone, this image. If it holds and burns, I embellish it as I think about it, enriching it in my mind. Or it disintegrates and goes to nothing. Which so often happens. Vacuum. I call it blank brains."

Wyeth worked a month on the composition for *Karl.* "I knew what I wanted," Wyeth says. "You could see the iron character. In his black turtleneck sweater he looked like a German submarine commander. While he posed, you could hear the tramp of feet down below in the house and then stillness." Violence breathed in the room. According to rumor, Karl had raped a black woman there.

For the portrait Wyeth made some twenty-five drawings — Karl in profile, Karl's full torso, the sausages above him. Andrew reached out and felt his face, and said, "Goddamn it, Karl, why can't I get this hardness?" In the unheated room, Wyeth's hands became so numb he could hardly hold his brush. To keep warm, they had a jug of Karl's hard cider between them. "It was just like champagne," Wyeth remembers. "He took it with a rum chaser."

One night Wyeth spread all the drawings on the floor and chose one with Betsy. By the next morning a final version had taken shape in his mind's eye. "The difficulty was to cut it down to the essence, that core I dreamed about him. I finally figured out what I was *really* interested in: his head and those hooks." The sausages disappeared. Only a vestige of meat clings on the nearest hook. The gray ceiling, with its crack as jagged as a

lightning bolt, became like a sundial, the sharp shadows circling the hooks as the morning light moved to afternoon. Wyeth remembers, "It was marvelous to go there during a thunderstorm and suddenly see the light flashing on those damn things. Talk about abstract power."

He continues, "I painted *Karl* with that same feeling as *Christina's World*—with hate—rage at myself—that my father was killed that way. I was almost killed by the same train. I even had *that* experience. I was thinking about this picture and jammed on the brakes at the last second and the train went firing past me. It could have happened a second time."

14

With the release of *Christina's World* and *Karl* in 1948—the latter sold to Mrs. John D. Rockefeller III—Andrew Wyeth at the age of thirty-one received a rush of recognition unique for a young American artist. "I came along at the right moment in American art," Wyeth once said. "I was fortunate because realism was at a low ebb. I was alone. I was an oddity. I'm so glad I was in an age when everyone was fighting toward abstraction. Made me fight to take hold of myself even stronger."

In 1949, Winston Churchill, on a visit to Boston, requested that two Wyeth watercolors be hung in his room at the Ritz-Carlton Hotel. In 1950 at age thirty-three, Wyeth was elected a member of the National Institute of Arts and Letters. Showing the letter of invitation to his sister Ann, Andrew broke into tears and blurted, "Gosh, I wish Pa was alive." In 1955 he was taken into the American Academy of Arts and Letters, the youngest candidate ever selected for its limited membership of fifty. Much to his pleasure, he was inducted along with one of his few role models, Edward Hopper. At the ceremony, after the huge medals were draped around their necks, Wyeth whispered to Hopper, "How do you feel?" He answered, "Like a track star."

During the ceremony, Betsy waited in the anteroom. She wrote to her mother:

> Finally the big doors opened and out streamed the most remarkable assemblage of who's who I ever hope to see, and there's Andy looking like one of their sons brought along for the day. I sort of tried to hide behind the column until some of the holy of holies went downstairs for cocktails so I wouldn't have to meet such a barrage of fame. But Andy spotted one feather of my hat sticking out from a column and before I knew it, there were Auden, the

poet, Frank Lloyd Wright, Thornton Wilder, Van Wyck Brooks, John Steinbeck, Mark van Doren, Aaron Copland, John Hersey, Walter Lippmann, Carl Sandburg—heavens everybody! I kept saying, "Well, for heaven's sakes," and they kept saying, "Look what we have here. A *young* lady." So Andy's charm and humility and my tender (to them) years carried the day.

In the 1950s and 1960s Wyeth steadily compounded his fame. He accomplished the virtually impossible. He became a household name to the great mass of Americans—while his work was honored by elite museums and wealthy collectors. This elevation had received a major push when eight works were included by the Museum of Modern Art in a 1943 show, *American Realists and Magic Realists.* In 1951 his importance was further certified by the Currier Gallery of Art in Manchester, New Hampshire, and the Farnsworth Art Museum in Rockland, Maine, which collaborated on a ten-year retrospective of his work.

A single wall in Manchester held an impressive line of paintings: *Christina's World, Winter 1946, Soaring,* and a second godly panorama named *Hoffman's Slough,* done in 1947, and *Wind from the Sea* (pages 240–41). A testimony to thirty-four-year-old Andrew's status in the art world was the list of museums that contributed pictures: the Milwaukee Art Institute; the Toledo Museum of Art; the Dallas Museum of Fine Arts; the Addison Gallery of Art in Andover, Massachusetts; the Museum of Fine Arts of Houston; the Museum of Modern Art; the Metropolitan Museum of Art; the Pennsylvania Academy of the Fine Arts; the Wadsworth Atheneum in Hartford, Connecticut; the Art Institute of Chicago; the Museum of Fine Arts in Boston; and the Whitney Museum of American Art in New York—whose curator of painting and sculpture, John Baur, included in a 1953 letter to Wyeth the words, "I don't think I ever told you how impressive I found your retrospective in Manchester."

Now Wyeth was considered an ornament for university commencements. A series of honorary degrees included a Doctorate of Fine Arts from Harvard in 1955. His corecipients were the essayist E. B. White and Adm. Hyman Rickover, the father of the nuclear submarine. At the Harvard lunch, Betsy

sat between Rickover and White. When she asked the admiral what he had been doing lately, he answered, "Oh, knocking around in boats." White presented Rickover with "something very small from *Stuart Little.*" It was a tiny, tiny life ring suitable for the mouse in his famed children's book.

The purchase of *Christina's World* in 1948 by the Museum of Modern Art led directly to a friendship with Lincoln Kirstein. A member of the museum's board of advisers, he wrote Wyeth, "I think you have found a real, classic world, not as a chauvinist but as a poet. It doesn't have to be American, but it has all the lonely dignity, the stoic grandeur that the best American art has."

A large man with a thrusting head and huge hawk nose, Kirstein was always an intellectual curmudgeon, an activist aesthete, cheerfully perverse, passionate in his appreciations. Consigning his life and his imposing powers to the arts on the purest level, he lived exactly on his own terms. Openly bisexual, he had a long and firm marriage to Fidelma Cadmus, the sister of the painter Paul Cadmus.

A man of no minor reactions, with quick antennae for fools and a large capacity for affection, Kirstein (who died in January 1996) always spoke his brilliant mind with annihilating honesty and disarming wit. Unashamedly committed to realism, he once wrote Wyeth, "The Braque show at the Museum of Modern Art is a big, tasteful bore. There is a floor full of paintings and if there were twenty more or twenty less, who would know the difference. Not this reactionary horror."

Kirstein appointed himself Wyeth's friend, admirer, mentor, and stern critic—in essence a supersuccessor to NC. He took "the walk" to the Lopers' and Mother Archie's and the Kuerner farm, striding through the snow in his sailor's pea jacket and soaking wet jodhpur boots to study the locales of Wyeth's paintings. "He threw himself into it," Wyeth tells admiringly. "He wanted to *know.*" They often sat up till 2:00 A.M. talking, looking at working drawings. Kirstein helped sell paintings and resurrected *Soaring* from oblivion.

OVERLEAF: **Wyeth spends months painting a moment. In 1947, in a stifling upper room of the Olson house, a cool breeze lifted the ragged lace curtains and their delicate birds—metaphors for the femininity hidden by Christina's misshapen, crippled shell. *Wind from the Sea* was a favorite of the poet Robert Frost, who used to borrow it from its owner in Amherst, Mass.**

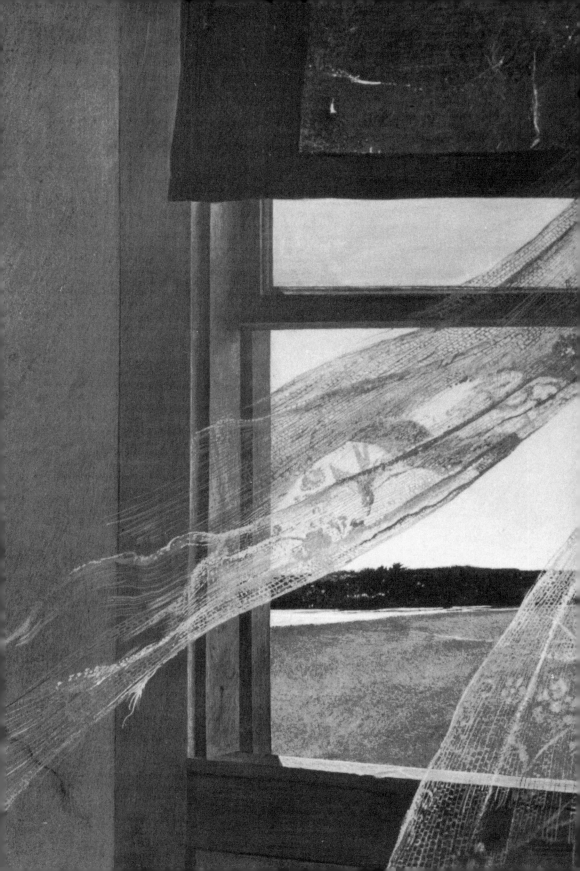

He bought a 1949 tempera called *The Cloisters.* He had to sell it ten years later, writing a letter of apology to Wyeth. He explained that he needed the money to help pay for the next ballet season. His ordinary financing had been soaked up by deficits at New York's City Center—including Orson Welles's *King Lear,* which lost $75,000.

Both Andrew and Betsy relished and valued the friendship of this dramatic, enriching, wooing personality. He took them to the ballet and to the School of American Ballet to watch George Balanchine train the children. He once sent Betsy a photograph of Christina Olson seated on her urine-soaked wet newspapers, and wrote on it, "Will you be my Valentine?" He trained her in his aesthetic. In New York, when she used the phrase "bad taste," he stopped their taxi in the middle of traffic while he explained that there is no such thing. Everybody is entitled to their affinities. Taste is truly a matter of taste.

With one hand Kirstein elevated Wyeth, lavishly writing that "like few people you have found in the ordinary an eternity of powerful details—fragments yet moments." And, saying of a set of 1953 watercolors, "They are so RICH AND GLAMOROUS and the best thing I've seen like this since Winslow Homer and they are better than most of his."

Then with an equally lavish hand—saying that "praise is useless"—Kirstein would slap him down. He wrote to Wyeth about "your predilection to make colored drawings rather than formulated forms." He noted a tendency toward silhouettes that have "an embossed life as if beaten out from the back without a true three dimensionality." He complained that "your monotone can become monotonous."

Kirsten once cautioned Wyeth about the dangers of "mood," saying that it "sometimes seduces you into a synthesis which seems to me papery. . . . The thinness of FORM fatally affects the strength of the MOOD which become transparently or luminously vacant . . . with a certain incandescence like a match struck but it pales away."

But always Kirstein would clothe his criticism in respect and self-deprecation. When he was highly critical of a tempera of Bill Loper, he ended, "No one else could have painted it. No one alive. When I look at Andy, it

is always with the ghosts of Eakins and Rembrandt who look with me over my shoulder, which is the highest praise and greatest blame."

Forever driving himself almost beyond his capacities, Wyeth thinks that in the 1950s he needed Kirstein to push him toward more form in his work, more solidity. He could handle such rough criticism, he explains, because he was so accustomed to it from his father and Betsy.

Few people have had such permission to judge Wyeth's work. "There is a terrible feeling of fright and self-doubt in Andy," said Henriette. "I feel it always. I never think of criticizing him sharply and unequivocally, because he is always afraid that somebody's going to attack him, find a soft spot. But it makes him try even harder. He's not to be pitied."

Before shows, Wyeth suffers intense jitters. Betsy, writing to Hazel Lewis at the Macbeth Gallery, said, "At this point Andy has to be reassured every ten minutes that the show will be a good one and yes, that it's the best he's ever had and no, it won't look like Grandma Moses and yes, it's better to have one now than after Xmas, and so on." During a show he is intensely interested in the daily attendance figures.

At issue for Wyeth is his philosophy of painting, the validity of his approach to realism in an era of abstraction. He is sure that in the short and long haul he is right—but not *wholly* sure. When insecure, he can be his own most disgusted critic. "Everything looks absolutely stupid on the panel to me," he once said. "I can't enjoy any of my paintings. None of them are any good. Maybe I can enjoy something, but it's a grand illusion, and it lasts about ten minutes after I finish it." The most he will claim for a painting is "a personal truth." But as he says, "That's the most difficult thing to search for."

Though praised by only a few art critics, such as John Canaday of the *New York Times,* Wyeth's unrivaled fame placed him by the early 1960s in his private Valhalla. Hiding behind his own elusiveness and Betsy's tough-mindedness, Wyeth was his own self-promoter. He made the final decisions about the handling of his work. A closet showman, he projected by his very nature a romantic aura, the excitement that once cloaked him as Robin

Hood and D'Artagnan. His inaccessibility, his scorn for art fashions—combined with his success—gave him a nimbus of mystery. For all his boyishness, he radiated a particular force. "Any kind of obsession casts a spell," Lincoln Kirstein remarked. "It's stronger than one's ego. People are fascinated with any kind of power."

Wyeth's place above the mainstream of art—and his enduring popularity—was further confirmed in 1962 when the Albright-Knox Art Gallery in Buffalo, New York, hung 143 Wyeths and 247,800 people attended. In its story on the monthlong show, *Time* said, "Whether realists or abstractionists, artists admire him; he casts a spell over layman and sophisticate alike."

In 1963 Wyeth's reputation was further reinforced when the Fogg Art Museum at Harvard University mounted a show of his dry brush watercolors and pencil drawings—and busloads of schoolchildren arrived, even as Robert Frost's funeral was held just across Quincy Street. The collection then traveled to the Pierpont Morgan Library in New York City, and next to the Corcoran Gallery of Art in Washington, D.C.

That same year Wyeth was the *Time* cover story, when President Lyndon Johnson presented him with the Presidential Medal of Freedom, originally awarded by John F. Kennedy. Stated Johnson about Wyeth, "He has in the great humanist tradition illuminated and clarified the verities of life." *Time* wrote:

> He paints landscapes and houses, the outside and inside of the world where man lives. Across these carefully recorded scenes, he shows the track, the flicker, the expression of life, even if the living object has long since departed. Millions are touched by these intimations, faint but intense; they are touched in their sense of mortality, and they count Andrew Wyeth an incomparable painter.

In 1965 *Life* magazine, calling him "America's preeminent artist," published twenty pages of reproductions and an interview with Wyeth. It

was centered around a single tempera, *The Patriot,* a portrait of Ralph Cline of Spruce Head, Maine, wearing his World War I uniform and medals.

A large book of his works published in 1968 by Houghton Mifflin Company sold more than 100,000 copies.

While his fame and the prices of his paintings grew, he avoided an inflated and destructive sense of personal importance. All his life he has resisted the delusion that every Wyeth brushstroke is special and valuable. Along with the battered tin tool box containing his painting gear, his watercolor pad is carelessly tossed on the back seat of the car, which he leaves unlocked. He draws one image on top of another, Anna Kuerner overlapping a head of Willard Snowden. He destroys hundreds of drawings, once setting ablaze a fifty-gallon drum full of pictures.

"These things aren't intended as paintings," he says. "They were just put down in excitement. I don't want them to be careful. To me a drawing that's done to be nice is usually lousy. I only keep them because they're useful" (pages 248–49). While painting a tempera, he spreads on the floor his watercolor working drawings that would sell for tens of thousands of dollars—and lets his dogs decorate them with muddy footprints. One drawing for the tempera *Karl* bears the bare feet of his son Nicholas.

Wyeth believes that egotism might inhibit him as an artist, make him timid, afraid to splash paint and risk wrecking a picture. He believes that to be successful, a picture must at some point be what he calls "out of control." An example is the big 1957 tempera *Brown Swiss.* He had spent months painting the Kuerner house seen across the little pond, a hill rising behind it marked by the cattle's signature, their trodden paths across the grass. "I had the literal truth, the workmanship almost overstudied," Wyeth says. "But I'd never gotten wild during it, given it the fire I felt.

"One evening just before dinner I mixed up a huge bowl of ocher color and raw siena, very watery. Then I stepped back and threw it all over this huge painting, color dripping down. Then I rushed out. If I'd seen it drying, maybe all patchy, I'd have doubted and tampered with it. The next morning I found I'd made it. I take terrible chances like that. Sometimes I

miss and it's awful—chaos. But I'd rather miss sometimes and hit strong other times, than be an in-between person."

When a tempera is finished, he hangs it in his house to see it in all moods, all lights, accidentally out of the corner of his eye. He gets reactions from viewers invited into the house. He watches keenly to see whether, in his favorite expression, "they get it"—feel the emotion that was his reason for the painting.

His antennae are exquisitely tuned. A viewer's enthusiasm revives his original excitement, and he will tell some fragment of the drama he felt. As it does when he is excited, his voice sometimes drops to a near whisper. When he talks about the technical accomplishment of a passage, his hand floats across the panel, sensitive as a bird's wing. But his remarks about a painting are pitched to draw out the viewer. "I'll tell you anything you want to hear," he says, "but it may not be the truth."

In the light of his own and others' reactions, he often returns the panel to his studio for final, finishing alterations. Sometimes the voices in his own head are contradictory. In 1994 he painted a tempera called *Jupiter* in three weeks. He was nervous about the loose handling of the pigment, the lack of meticulous cross-hatching. If he could produce a top tempera in three weeks, that called into question his philosophy, that power in a painting comes from meticulous months of emotional investment.

Jupiter brought raves from most viewers—except one, who thought it primarily a thing of beauty. Privately, Wyeth was upset by his friend's slightly tepid reaction. But Wyeth told him that *he* was the one person with good judgment, that he himself had doubts about the picture—"what worries me, everybody likes it." Both attitudes were correct.

The ultimate audience has always been Betsy, the one person who can truly shake Wyeth's confidence in a painting—and even in himself. She describes him waking her in the night after a tempera had been finished. He says, "You don't really like it, do you?" She answers, "I certainly do." He says angrily, "I can't get the truth out of you anymore." She answers, "I'm frightened of you. I don't like your anger. You'll never get the truth out of me if it's going to upset you." Betsy explains, "I'm very easy to lose. I just walk away. But then he leaves little notes."

Wyeth has no desire to keep a picture himself. The only tempera he owns is *Maga's Daughter*, his loving, 1966 portrait of Betsy. When she particularly likes a tempera, he gives it to her. Otherwise, it is put up for sale. All income goes directly to Betsy. He has no checking account, but takes pocket money in cash from their full-time business manager, Peter Ray. To Wyeth money means the opportunity to paint, "the absolute freedom to do something in the future better than what I've done in the past." He has zero interest in the possessions that money buys. "I don't have to own something to love it," he says.

There have been a few exceptions, in particular a classic Mark II Lincoln Continental he bought in 1956, black with white sidewalls—which Betsy described as "an airplane without wings." It was bought with the nest egg Betsy had put aside in a savings account in case of illness. As she tells the story, the evening she relented and he made the decision, "He ran upstairs and woke up the boys and told them. He called Ann and John. Henriette came down from the house in her bathrobe. He called Nat. Everybody kissed everyone else. We brought out a bottle of wine." Telling about his return in the car, Betsy said, "The closest description I can come to is that he resembled Toad in *The Wind in the Willows* when he caught sight of his first automobile."

Not only did he consider it a remarkable object, superb in its simplicity, but his uncle Nathaniel Wyeth had designed the shock absorber system, and died in the process. In 1954, driving an experimental Mark II on a test track near Detroit, he hit a bulldozer at 130 miles an hour.

Late one afternoon, returning in the Continental from a day of painting, dressed in his worn, paint-spattered dungarees and turtleneck sweater, Wyeth stopped at a diner and ate a sandwich in the car. A tractor-trailer parked beside him. The driver leaned out his window and said, "That's a snappy boat you've got there." "Yes, it certainly is." "How often does your boss let you drive it?"

In synergy with his fame, the big leap in Wyeth's prices came in 1953. At that time, the Macbeth Gallery, run by Robert McIntyre after the death of Robert Macbeth, was charging from three to six hundred dollars for water-

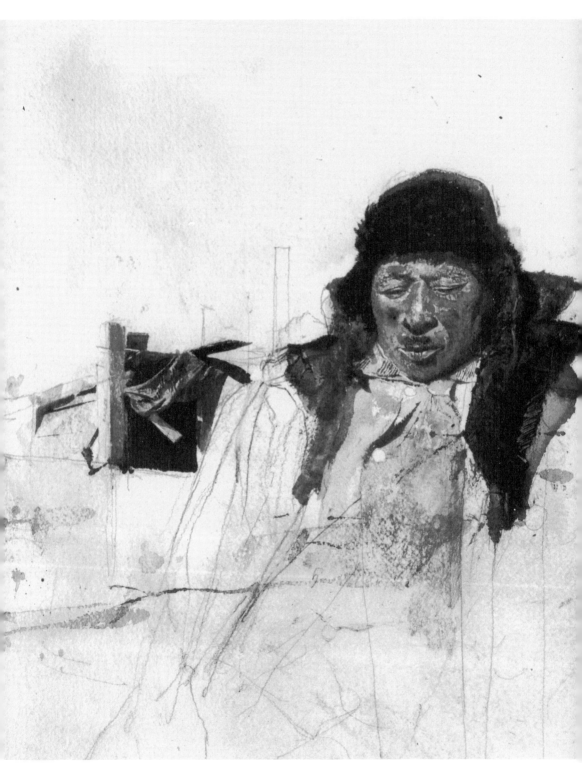

Fur Hat, 1963

To fight the self-consciousness that can come with fame and inhibit spontaneity, Wyeth treats his working drawings with casual roughness, like the scribbled notes they are. This study was tossed on the floor while he painted *Adam*—the 1963 tempera of Adam Johnson in his fur hat in front of his pigpen.

colors, and from two to three thousand for the several temperas Wyeth painted each year. Lincoln Kirstein was a sort of Greek chorus, urging Wyeth to insist on his true value. When Kirstein bought *The Cloisters,* he said to Wyeth, "You sell too cheap; you've got to learn to put high prices on your work"—and handed over a check for twice what Andrew asked. "That's the kind of man he was," says Wyeth.

In 1951, when Wyeth finished a tempera called *Trodden Weed,* Kirstein had railed that Robert McIntyre was "no damn good," and insisted that Andrew should move to a better gallery, to the prestigious M. Knoedler & Co. on Fifty-seventh Street just off Fifth Avenue—its stone facade a copy of a Florentine palazzo's. Kirstein wrote, "Knoedler's is a good deal richer and bigger and it will be easier for you, when you need a whorehouse, to go to the one with the prettiest bodies."

Indeed, the move was a milestone in Wyeth's career. Under the wing of Coe Kerr, president of Knoedler's, Wyeth saw his prices double and redouble. Their 1953 show sold out immediately. One man made a nice profit by flying to Boston, buying paintings on sale at the old prices, and reselling them in New York.

Now collectors lined up for pictures, and were grateful for the chance to buy. In 1956 Joseph Hirshhorn, whose collection established the Hirshhorn Museum in Washington, D.C., wrote Wyeth:

> You told me on the phone that you're doing a painting, but someone else is anxious to have it. I wish you'd give me a break on the first you finish, if possible. I should like to see it. Also any watercolors you may have in the studio. Of course, Andy, you understand that you are not dealing with the du Pont family. Money just rolls out of their ears and a great many of them do not work for "long and green," but on the other hand, you'll get a fair deal from me as some of the dealers will tell you.

From 1959 to 1962 the price of a tempera approximately doubled to $100,000 for private collectors. The history of a tempera called *Dodge's Ridge* shows the multiplication of Wyeth's fame and prices. A picture of a scarecrow on a hill in Maine, it was priced in 1946 at $1,500 and did not

sell. Both Andrew and Betsy considered it too flamboyant, so Wyeth used it for experiments with varnishes and finishes. After a few years, he gave it to his aunt Elizabeth. When she needed money, Knoedler's sold it on consignment in 1959 for $15,000 to a collector/dealer named Fred Woolworth (who years later represented Wyeth).

In 1978 temperas sold for $175,000. In 1979 and 1980 two brought $300,000 apiece. Ultimately in the late 1980s Japanese collectors began paying anywhere from $1 million to more than $2 million for a tempera. Though the art market has since declined, Wyeth refuses to lower his prices: "I've never done that. Never! Why should I? If people don't want to buy them, it's too bad. They'll just stay right where they are. If you paid a certain price, do you think I'd go around the corner and sell something for less? How would you feel?"

Wyeth is embarrassed when his prices are publicized. He does not want to be seen as rich. But he does see a bonus. He said in the 1960s: "When people see one of my pictures, whether they're half-wits or not, the price makes them look at it more than half a second before they go on by. And if publicity about money makes people think American art is important, I'm all for it. Let's face it, money speaks in America. It's a depressing story, isn't it."

Nevertheless, the sale of a tempera has been almost gleeful family news. Wyeth says, "It's quite a way to make a living—just painting what you like. I've been very lucky. I'm never blasé about selling a picture. I'm always surprised."

But Wyeth cares acutely what price it brings. Knowing that painting is his *only* ability, there has always been a worm of fear that the need to make money would conflict with his freedom. He has kept repeating the words of his father in their final talk—NC's judgment that Andrew could not make a living doing his kind of realism. As though reassuring himself, he repeats, too, his father's opinion that he will always be able to sell his watercolors. As late as the early 1960s, just in case, he had notices of shows sent to the American Artists Group, a clearinghouse representing artists interested in commercial work.

Huge prices also measure how seriously collectors take Wyeth as an artist—his raspberry in the face of critics. In addition, high prices also

guarantee exclusivity—an aura of rarity that he wants. He has a particular horror of his work and his person being too available, becoming common coin, becoming "cheap," a word Wyeth uses, synonymous with "inferior," "degraded," "shoddy," "low standards."

Top dollar is also a product of the fury he feels for the sake of his father. "I think he was gypped," Wyeth says. "These businessmen never offered to pay him what he was worth, and he was perfectly satisfied. I was there one day when these people said, 'Well, Mr. Wyeth, we will pay you so-and-so,' and he said, 'No, that is way too much.' Imagine!"

Wyeth's voice turns angry. "I saw these bastards from these advertising agencies going up to the studio in their big cars, their Cadillacs. My mother would usually have a lovely lunch for them, and they would sit there puffing their cigars, telling my father what was wrong with his pictures. I hated them. That had a lot to do with my feeling . . . I'm not one for money. I don't think it's good for anybody. I don't know what I have in the bank and I don't give a damn. But I don't like to be used. And I think that my father was used by these people."

In particular, Wyeth remembers the head of the Hercules Powder Company, which hired NC to do pictures for calendars. "He was a little pip-squeak," says Wyeth disgustedly. "After my father was killed, this man called my mother and said, 'You know, your husband and I were great friends, and I have a picture over my mantel that he gave me.' My mother said, 'I beg to differ with you. My husband hated you, and I want that picture brought right back.' She laid him out right on the phone, and I have never been so delighted. I couldn't believe it. Finally, she reared up."

In the 1960s Coe Kerr came down from Knoedler's to Chadds Ford to pick up new work. In the living room was a chest containing some of Wyeth's unfinished and withheld work. Furious at the thought that this man, like a vulture, was there to make money off him, Wyeth tossed most of the watercolors into the fire, one by one, in front of Kerr's stricken eyes.

Betsy Wyeth has been equally determined that her husband—and she—will not be exploited. There was the episode in 1959 when Henry Luce personally persuaded a reluctant President Dwight Eisenhower to pose for

Wyeth for a *Time* cover and told a reluctant Wyeth that the president *wanted* the picture. Wyeth acquiesced against his better judgment.

Wyeth spent five days at the Gettysburg farm, where Eisenhower, preparing for a historic visit to Europe, could pose only fifteen to forty-five minutes at a time. "The whole thing was a mess," Wyeth relates. "I'd say, 'Now, Mr. President, look out there.' He'd look out there, and I'd take my brush and lean down to work on the picture, and I'd look up and here was his bald head peering right at me. A little disconcerting to say the least. I was very depressed. I wanted to tear it up. Finally, the last day . . . he had to leave on some mission . . . he was sitting there in the late afternoon and a Secret Service man walked by, and Eisenhower tipped his head to see who it was, and the light hit him and I . . . it saved the picture. But I would have loved to do his head life-sized. It's a powerful head."

When Wyeth rushed down to Gettysburg, no price had been set with *Time*. Betsy insisted that he tell *Time* that the picture was not finished and bring it with him back to Maine. The magazine was on deadline and phone calls came several times a day. Wyeth tells with amazed glee how Luce himself telephoned and Betsy answered the phone. Wyeth heard her say, "No, no, it's over our mantelpiece." Pause. "No, it's not leaving yet." Pause. "If you don't behave yourself, I'm going to sell it to *Newsweek*." The usual fee was fifteen hundred dollars for a cover. Betsy demanded and got ten thousand. "She was furious that I had been used," Wyeth explains, "and all she needed was this excuse." When *Time* returned the picture to Wyeth, he gave it to Eisenhower.

The cover showed an elderly president, alone with his thoughts, slightly somber—free of the famous Eisenhower grin. The president remarked later, "You know, I'm one of the few people around here who liked that portrait."

Eminent names—especially U.S. presidents—have been attracted by Wyeth's status as an American icon. Richard Nixon put on a small Wyeth exhibition in 1970 in the East Room, the first one-person show in the history of the White House. Nixon gave a dinner in his honor, with a concert by the pianist Rudolf Serkin. When Wyeth arrived, he met Serkin, who

had come to check the piano. Admirers of each other, meeting for the first time, the two artists embraced.

After Watergate, the disgraced ex-president decided that Wyeth should paint his portrait. Seeing Nixon as another "misunderstood," a sort of modern-day Gen. George Custer, full of both mistakes and courage, Wyeth agreed. "The more that people came up and told me *not* to do Nixon," he says, "the more it made me furious and the more I wanted to paint him. Nobody can tell me what to paint and not paint. It's like telling me I can't paint a pine tree that's been hit by lightning. Christ, that makes it more interesting."

Wyeth planned to do Nixon walking alone on the beach at San Clemente. Nixon sent up a blazer bearing the presidential seal. Wyeth put it on Peter Hurd's sidekick, Johnny Meigs, and roughed out a composition showing the torso of a hunched Nixon from behind, with just a sliver of profile. His vision of Nixon was a Mafia leader—the Godfather. But the project sifted away when Wyeth refused to go to California and the ex-president was never quite able to come East and pose.

When Ronald Reagan, running for president, approached him to do a watercolor portrait, Wyeth said no. Reagan wanted to make reproductions to sell to raise campaign money—"Spread 'em all over the place," says Wyeth. "Cheap. But I voted for Reagan."

Most of his life Wyeth has refused commissions. Unable to embody the subject with personal memories and emotions, he finds paid-for portraits a debilitating technical exercise, a perversion of his prowess. "I don't think you could ever do a portrait commission," he says, "that some man doesn't say, 'There's something wrong with the mouth.'"

Wyeth once agreed to do a commissioned portrait of Walter Annenberg. Years later in 1978, after Wyeth had stopped doing commissions, the publisher of *TV Guide* and the former ambassador to the Court of St. James's cashed in on the promise. But he did hook into Wyeth's imagination, dressing himself in a high-necked, pale lemon-yellow choir robe he wore when meeting Queen Elizabeth—almost Amish in its simplicity. Though floor length, it reminded Wyeth of the German Air Corps uniform in World War I. "Annenberg is the toughest man I've ever met," says

Wyeth admiringly. "Just the kind I like. He'd drive down in his big Rolls-Royce and go a hundred miles an hour. I'd hear the horn blowing coming through Chadds Ford."

But Wyeth was not about to be overwhelmed by the powerful billionaire. As he tells it, "When the picture was finished, I said, 'Walter, we've never talked about price. And I don't know quite what I'm going to do. Maybe I'll just give it to you.'" Annenberg launched into a flurry of protests, saying that was impossible. He insisted on paying for it. "All right," Wyeth said. "My price is four hundred thousand dollars"—twice his usual sum for a tempera. Wyeth, cackling with delight, says, "That shook him!" In the end, Annenberg paid three hundred thousand and took several years to send the money.

In 1953 Wyeth received a letter from Robert Frost, who wanted him to paint special pictures for a new edition of *North of Boston.* "You wouldn't be illustrating it," wrote Frost seductively, "but gracing it with something in a spirit I can't help thinking kindred to mine. You and I have something in common that might almost make one wonder if we hadn't influenced each other, been brought up in the same family, or are descended from the same original settlers."

However, Wyeth knew perfectly well that this was an illustration job, and suggested the use of extant paintings. Ultimately, Frost's publishers balked at the reproduction costs. In 1954 a fund was accumulated to buy Frost a watercolor for his eightieth birthday. Wyeth selected *Winter Sunlight,* which the poet carried back and forth between his Cambridge, Massachusetts apartment and his Vermont farm. Then in 1958 a group of donors wanted to pay for a Wyeth portrait of the poet. Much to Frost's annoyance, he refused.

"I never wanted to be with Frost in person," Wyeth explained later. "The very best things he's done are just so superb that I didn't want to mar them with the personality. I know he was a great character and had very interesting things to say. But I think he became corny when he got with people. He looked like an old sweet potato that had been baked and found a week later in the cold oven—and for me to go over to Vermont and stick him up against some background and paint his old gray head—to hell with that. The art, the poetry, is the purest form. Not the man."

Wyeth's affinity with Frost is in part a sense that both have been misread. "I wonder if America is quite ready to understand Americans," Wyeth said in the 1960s. "France and England understood Frost long before we did over here. And we speak of him as a bucolic poet, a genre poet—which to my mind is his weakest point. Just as people say I'm a painter of rustic scenes. Well, that's nothing to do with either of us. Frost's best poetry is abstract. I think he makes Gertrude Stein's poetry sick in terms of sounds."

The symbiosis between fame, money, and celebrities has both attracted and repelled Wyeth. Aware of the effect of famous-name socializing on his father, fearful that loss of innocence would dull his own emotional connections to his subjects, Wyeth says, "I have to stay away from that sort of thing." But he has been intrigued by a few celebrities who somehow fit into the lifelong play he paints. Douglas Fairbanks, Jr., and Henry Fonda have been occasional visitors. Charlton Heston, an owner of Wyeths, premiered a 1990 made-for-TV movie in Wilmington. Betsy held a candlelit dinner for him amid N. C. Wyeth's *Treasure Island* illustrations at the Brandywine River Museum in Chadds Ford.

The rock star Michael Jackson—not long after the release of his stupendously successful album *Thriller*—sent word that he would like his portrait painted by Andrew Wyeth. Peter Ralston, who photographed all available paintings for Betsy's files, had fascinated Wyeth with a videotape of Jackson doing his "moon walk." Shortly thereafter, Wyeth was in South Carolina at the opening of an exhibition at the Greenville County Museum of Art. At the dinner, he was seated next to Governor Richard Riley, who leaned over and asked what he thought of Jackson—meaning Jesse. To general astonishment of the dignitaries, Wyeth answered, "I think he's a superb dancer."

Michael Jackson arrived in Chadds Ford in 1985. Like flies drawn to honey, all of Wyeth's business entourage converged—his dealers from New York, Atlanta, and London, and the agent in charge of copyrights—all wanting to be photographed with Michael Jackson, who had his own entourage of handlers. "God, these awful men," says Wyeth, "like Mafia

with big black cigars—everybody talking about how much I would be making. 'You'll make four or five million and we'll each make two million apiece.' Thousands of reproductions that I was to sign. They didn't give a damn about my future. They only wanted to use me for money."

The two met in the Brandywine River Museum, where Jackson looked carefully at each of Wyeth's paintings, and then they sat alone and talked. "I found him a very sweet, sensitive person," Wyeth says. "Very nice. Very intelligent." They talked about Marlon Brando and the acting lessons he was giving Jackson. As they spoke, the young black singer merged in Wyeth's imagination with Donald Smith, who had lived next door to Mother Archie's church with his aunt, Evelyn Smith, the woman NC was on his way to pick up when he was killed. Studying Jackson's black hair and pale skin, Wyeth thought, "God, he's really that boy Donnie." Thus Jackson was mingled with all those memories of Mother Archie's. Wyeth suggested he come and pose at the island Betsy had bought off Tenents Harbor, Maine.

Suddenly a large man marched into the room and said, "Jackson, you can have ten more minutes, and then we'll be leaving here." Wyeth remembers, "We had a real thing going between us, but these shits got into it. The poor guy is owned by these people. I felt sorry for him. God help any artist that gets caught up in that." Wyeth bowed out of the project. "Imagine me painting with those guards standing there," Wyeth says. "The whole thing was the maddest idea I ever heard. Just nuts!" But, says Wyeth, "I was fascinated. There was a connection. I could have done something interesting."

Speaking of his own immense fame, Wyeth says, "I got a kick out of it, as anybody would." But Betsy remembers that "Andy became the world. He wasn't just one person. We had to weigh acceptance, fame, and all the things that go with it." Now that his face and name were celebrated in national magazines, his high prices publicized in newspapers, Wyeth had to worry about the secondary fame he conferred on his models. Perhaps it would change their lives, or alter his relationship with them, make them somehow public property, or leave them feeling exploited—though he has paid most of his models. Now his wild abandon in his work was endangered. "He

likes to be free," Betsy says. "Fame is something he has to carry around. It's a responsibility. He has to keep up a standard. And if fame leaves, what's wrong with the work?"

According to Wyeth's sister Ann, fame was "hell on Andy. People were after him. Calling him on the telephone. They were always sucking up to him. He didn't believe anything anybody said about his work. People bought pictures without seeing them first. Just an investment. That hurt."

"The more fame he got," Betsy says, "the more difficult he was to live with." Constantly on guard against intrusion, Wyeth became more elusive, more secretive. He says, "My father loved the image of being a big artist. That's never had an appeal to me. I don't want to be a powerful person to direct . . . have people come to attention when I walk into a room. I don't want to exist. I'd like to be invisible."

15

Visitors to the schoolhouse entered an exciting experience of energy and fun. Alice Hammond, who cleaned for Andrew and Betsy, remembers the atmosphere they created: "They were always laughing. I mean, to me, I'd want to shake them. Nothing to them was really bad. You could say someone's dying. To them what's death? They just laughed."

But under the laughter was the exciting sense that here was a monastery of art, a reverence for a rare and all-encompassing rigor—God in the detail. For Henriette two visions summarize her brother: his boyish glee and then suddenly "this stricken look of intensity and seriousness."

Their friend Hyde Cox in Manchester, Massachusetts, invited them to visit his private Crow Island. Declining, Betsy described their basic life: "When we are with people we cover up an intense seriousness of life. Believe it or not, we receive great relaxation from simply discussing Andy's work, other people's work, and anything related to Andy's work. He is in bed by 9:30 and up by 6:30, leaves the house by 8:00 A.M. and does not return until 5:30 or 6:00 P.M. So we just do not see anyone. He has always tired easily, which limits our social activities. I am very careful not to take advantage of his few hours away from his work. We are sorry that our friends do not understand that Andy's limited strength is totally burned up each day painting what he feels he must paint."

Following the death of his father, Andrew was more than ever a man possessed. Wyeth has explained, "My one interest in this world is someday to put into a painting all that I feel." He pauses and then adds, "I think I would probably commit suicide if I couldn't paint."

Fending off distractions, Wyeth has never had a circle of friends in the ordinary sense. His need for intimates has been filled by models, the Walt Andersons and Karl Kuerners in his life, and by a succession of women confidantes, his sister Carolyn, their pediatrician and doctor Mar-

garet Handy, Helen Sipala who posed in *Marriage* and reminds him of Bess James—"the same bright, acid mind."

Skittish about strangers or even acquaintances, Wyeth feels safe in Chadds Ford and Cushing. In both places the protective locals turn vague and uninformative if asked directions to the Wyeths' house. When callers from the outside world come knocking, he looks trapped and hides. Or he calls out to Betsy, "For God's sake, go to the door!"—even though a week earlier in a spasm of warmth, he may have beamed at these people and said, "Next time you're in Cushing, come see us."

Seclusion has been as much a need for Betsy as for Wyeth. She has felt nothing in common with the women in the duPont-Wilmington social circuit, and instead preferred the companionship of one or two chosen local women. Though a superb cook, she has never given dinner parties, restricting her entertaining to small, informal gatherings, usually family. After the death of NC, the family was traumatized. "The place was like a big ship without a rudder," Wyeth remembers. "Everything disintegrated." Betsy took over the NC role, "going even further with Christmas. Terrific!" She has enjoyed meeting and beguiling great names when they came to her house, onto her territory, but never liked going onto *their* turf. Much to Wyeth's later regret, she once persuaded him to turn down an invitation from Jack Kennedy to join a party on the presidential yacht that steamed down the Potomac River to a candlelit dinner at George Washington's mansion at Mount Vernon.

Once they were invited to dinner at the Rockefellers, along with Henry Kissinger. Wyeth wavered. Betsy said, "I'm not going. You can go, but I think it's stupid." Wyeth turned down that party, too. He says, "Betsy's absolutely right. That's one of her great qualities for me as an artist. You can waste an awful lot of time farting around for great occasions. Pete and Henriette carried on the social game . . . all the artists I've ever known did it, except maybe Edward Hopper."

When Andrew and Betsy did occasionally appear at formal, public occasions, they were a golden couple, glamorous at the opening of a Wyeth exhibition at the Art Institute of Chicago, at the Metropolitan Museum of Art in New York, at private dinners at Winterthur with Harry duPont, a

quiet benefactor, purchaser of *Ground Hog Day* for the Philadelphia Museum of Art. Betsy was vividly handsome in coatdresses designed to her specifications by Bill Blass. Andrew wore his lifelong public uniform, an austere gray Amish jacket, buttoned up the front, high at the neck—like Nehru in mourning.

But Betsy never liked those formal performances. "I just didn't care for the glitz. I did it so well it worried me a little bit. Very dangerous. It's like becoming an alcoholic. Fame is very fickle and I wanted to be sure he didn't depend on it too much." By the 1980s she stopped going to exhibition openings, and increasingly she urged Wyeth to be unavailable to the stream of invitations, awards, honorary degrees.

Camouflaged by the colors of her charm, there is a central shyness, the insecurity of the girl who started life with curvature of the spine, who doubted her father's love, who made friends of heady older women—like Christina Olson. At the opening of an N. C. Wyeth show in Harrisburg, Pennsylvania, attended by ex-president Dwight Eisenhower, a red rash of nervousness spread up her throat from beneath her stunning white gown. Once, describing herself in relation to the artists surrounding her, she said in a flash of self-revelation, "I'm nobody. I don't have any talent."

Henriette once asked Betsy to pose. "I couldn't seem to make her relax," Henriette remembered. "Her eyes are plaintive. They're beseeching. Psychiatrists say that anyone when they clench their hands clench their thumbs, that means an insecurity. Now this is nonsense, but that's the way she holds her hands. And I used to think, 'Well, Betsy after all is pretty marvelous, and she is.'"

"Andy's never given her a trace of reassurance all her life," Lincoln Kirstein once said. "First of all, it's his painting. After the painting, it's people. She's never felt reassured. A woman in that situation cannot be loved enough. There's nothing you can do about it, except kill everybody else."

In the first decade of marriage, their primary social life was the Wyeth clan, its center still the Big House where Carol lived with Carolyn. Ann and John McCoy were constant companions. In Maine the families rowed out to the islands where the men painted and then assembled for cookouts. In Penn-

sylvania there were long walks with watercolor pads lugged along, and picnics and pauses while the children climbed trees—and three-dollar church suppers at Mother Archie's. When Wyeth was willing to take a day off, they drove into Pennsylvania Dutch country and explored the lower Delaware.

In 1948, two and a half years after the death of N. C. Wyeth, the family assembled in his studio to be photographed beneath the still haunting presence of NC in his self-portrait with a top hat—hung between his paintings of his mother and father. From left are Betsy, Andrew, Carolyn, John McCoy, Mrs. N. C. Wyeth, Ann, Nathaniel's wife, Caroline, and Nathaniel.

But by necessity Betsy became more independent, developing her own interests. Before Nicholas was born, she led a little Brownie Scout group. She became something of an authority on Pennsylvania antiques, spending hours educating herself with a local dealer, going to auctions with him, sometimes representing him. To raise money for the local school, she joined Ann McCoy selling flowers at the "May Fair." She researched Chadds Ford and Wyeth family history, doing property title

searches and spending hours exploring at Quaker Archives. "I used to knock on people's doors," says Betsy. "'Can I go down into your cellar?' I could tell where the corner fireplace was; they had this incredible storehouse in the middle of their Victorian monstrosity." By the late 1940s she had the care of her two sons, Nicholas and Jamie, and they explored the muddy banks of the Brandywine and picnicked. In the winter she pulled them over the countryside in a box nailed on a sled. "Andy always knew he was first in my thinking," she says. "But I was not so totally absorbed in him as a man."

The equation of Andrew's love affair with Betsy had been permanently altered by the death of NC in 1945. She elaborates, "Whenever tragedy happens, he's got to figure out who's responsible for this: Why do I feel this way? He had to blame someone, and I was there to blame in the sense that, 'She brought havoc to my relationship with my father; she took me from him.'" Betsy adds, "Andy likes to have something to hate. As soon as his father was removed, it was *me*. I mean that happened instantly. I think he was furious at me for living."

As Betsy sees their relationship, one of her new roles from that point forward was helping her husband deal with his rage or "hate." In her head she has been like a governor on an engine, leveling out the emotional chaos Wyeth sublimates into his work. Her job, says Betsy, is "to handle and take the viciousness out of his personality, try to control it." She explains, "I am spared nothing of his wrath. If a painting is not going well, I am spared nothing. If a relationship isn't going well, I am spared nothing. If self-doubts arise—I can tell when he walks in the door that he's in a terrible state. So I would fly into a rage to get control of his anger. Because you *have* to get it out of him. Otherwise he would lose his stability. It must be like a dentist hitting a nerve, a constant screaming. His brain must be banshees—like sirens or something.

"Thank God I have a sense of humor. But, oh, he can really make me mad. Towering rage. Slamming doors. 'I'll sleep in this room. You sleep in that room.' I mean so mad that I'll start to—and he'll grab my hand and I—'Don't touch me.' So, boy, he loses *me*. I'm absolutely gone. Then two days later I come down, there's a painting on the wall: 'It's for you.' He's

never been sure of me. I'm not so sure myself. I have this funny cold side where I never see people again. But it's absolutely worth it because of the quality of the work. Otherwise, I'd walk right out of this house. The level of the work has to be kept—and he knows it."

When Betsy discovered she was pregnant at the time of NC's death, Wyeth was appalled. Nicholas was two years old, and the prospect of another child made him feel even more trapped by family, whose toils he believed had tied his father's hands. "He doesn't like nine months of pregnancy," Betsy says. "Doesn't like to be held into any damn thing at all. That was a very tough period. Lonely."

James Browning, named after Jim James and Bess Browning, was born in July 1946. "I *loved* them," Betsy says. "Physically, I thought they were just marvelous. The pure joy of having small children was wonderful. Nursed them both. Just adored them. But their father came first. He always has. I never tied him down." She kept a baby-sitter available at short notice, so any impulsive plan—a movie—was always possible.

In their parenting modus operandi, nothing was hidden from the boys. "We didn't need privacy," Betsy says. "Had no secrets, made love, had fights, everything open. Once Jamie said, 'Is this going to be another moody dinner?' A picture would sell, we'd say, 'Let's go to West Chester and spend some money.' Had the most wonderful time. The best years of our life were when they were home. They were full of hell, but I just loved it. I never waited up for them, never sat up and worried. Interesting."

When his sons were little, Wyeth sometimes took one of them along when he painted—and ended up painting the child. Once in Maine, when the family was visiting Margaret Handy's little house on a small lake, he was doing a watercolor of three-year-old Jamie in a yellow-and-brown shirt made by Betsy's mother. When Wyeth looked up from his pad, Jamie had vanished. The little boy was at the bottom of the lake, small limbs thrashing in slow motion. Wyeth, yelling, pulled him ashore. Margaret Handy rushed from the house and did artificial respiration, pumping out the lake water. "And so Jamie's with us today," says Betsy.

As Nicky and Jamie grew older, Wyeth took on his permanent role as naughty confederate, more brother than father. Betsy says, "Bringing up the

boys, Andy was absolutely wonderful. He took them to dirty movies, I'm sure—told them, Go screw that girl, do anything you want to do. He would do all kinds of things to break any rule that I made. We contradicted each other all over the place."

Betsy was the disciplinarian. "She was a wonderful mother to those boys," Wyeth says. "Didn't soft pedal at all." Imitating her mother, she sometimes punished by withdrawing, by an emotional absence. "I'd just vanish," Betsy says. She tells of the day that Jamie, packing his bag, decided to run away. When he reached the driveway, he turned and came back inside saying, "Do I have to leave home?" Betsy answered offhandedly, "Okay by me. Stay around."

Nicholas has grown up a copy of his father, suffering the same fragilities but without the protective talent for painting. As a boy and man, Nicky's slender build, vulnerable mouth, expressive eyes project his father's impression of frailty. He even suffers his father's malformation of the hip joints. Like Wyeth, his childhood was distorted by illness, including scarlet fever around age five. "After that," says Nicky, "I was susceptible to everything."

In the art-centered, competitive Wyeth clan, Nicky became something of a loner. The cousin who was his contemporary—Robin McCoy, unusually mature and strong-natured—chose to be the inseparable playmate of his little brother, Jamie, a prodigy in both charm and painting. Left to himself, Nicky found an identity in the quirks and foibles—and the compensatory high jinks—that are so enchantingly outrageous in his father.

His early school years were a miserable experience, his attendance interrupted by flare-ups of poor health. Like his father, he felt himself a misfit. His difficulties persuaded his parents to consult a child psychologist, who decided that the problem was an overbearing father and recommended that Nicky go away to school. Furious at the therapist, Wyeth went around joking, "He had the wrong parent."

Nicky himself wanted to go to boarding school and was accepted in the sixth grade at Cardigan Mountain School in New London, New Hampshire. It was his father who delivered him. He attended Berwick Academy in Maine during high school, and in 1963 went on to Wesley

Junior College in Dover, Delaware, leaving after a year. "I knew what I wanted to do," says Nicky.

What he wanted was to deal in art, a talent he had tasted in the summer of 1963. Describing that incubation period, Nicky tells of selling Andrew Wyeth reproductions from the trunk of his car, driving up and down the coast of Maine, hawking them everywhere that anybody congregated—in cafés, in beauty parlors. During two more summers, he and his cousin Susie Cook ran the Two Sisters Gallery in the Cooks' barn on the road to Port Clyde, selling paintings collected over many years by Gwen and Betsy. The second year, changing the name to the Wyeth Gallery, they added paintings by local artists corralled by Nicky. The pay-off, he says with pride, was enough money to buy a 1964 Jaguar XKE.

In 1965 at age twenty-two, with a knowledge of American art absorbed from his father, he went to work in the library of M. Knoedler & Co., Inc. Personable, attractive, well-connected, with a first-rate eye for paintings, he moved that fall to Wildenstein & Co., where he was an apprentice art dealer under Jay Russek, an adviser to wealthy collectors.

In 1970 Knoedler was reorganized and Coe Kerr was dropped. He started a gallery under his own name in a brownstone on East 82nd Street, handling nineteenth- and twentieth-century artists with his partner, Fred Woolworth. Wyeth loyally left Knoedler and joined Coe, who also represented Jamie and hired Nicky as an in-house dealer, handling both his father and brother. Andrew says, "I couldn't honorably let a man who had done so much for me . . . not stick by him."

In 1971 Nicky married Jane Gleklen from Providence, Rhode Island, an art historian whom he had met when she worked as a summer intern in the Wildenstein Library. Andrew encouraged Nicky to marry Jane, but he did not come to the wedding. He told Jane, "I love you. I love Nicky. But I don't believe in marriage."

Like his father, Nicky chose a strong, able, beautiful woman. During fifteen years at Sotheby's, Inc., the New York auction house, she rose to vice president in charge of the client adviser service. In

In 1965 at the house on Bradford Point in Cushing, Maine, are Betsy (wearing a tunic she designed and made), Nicholas, age twenty-two, Andrew, and Jamie, nineteen, already a successful painter. In the rear is Andrew's studio.

1972 Coe Kerr died, and Fred Woolworth became sole proprietor of the Coe Kerr Gallery. In 1990 Nicky and Jane began handling Jamie Wyeth's work, first in conjunction with the Coe Kerr Gallery, which closed in 1992, and then with the Graham Gallery.

Within Nicky, alongside the art dealer, has been the artist who can be the practical builder, creating art that works. This was the path of his engineer uncle Nathaniel, who also had no gift for drawing and referred to himself as "the other Wyeth." Nicky's skills were also manual and he, too, was fascinated by motors and models, airplanes and boats. Taking after the teenage Nat who spent a whole summer in Maine building his design of a hydroplane he named *Silver Foil*, Nicky immersed himself in the dangerous sport of hydroplane outboard-motor boat racing. In the 1960s and 1970s Nicky towed his two boats behind his car to American Power Boat Association races up and down the east coast, even Florida.

Nicky also escaped into the sky—into model airplanes and kites made of newspaper. From the beginning, Betsy says, "Nicky was a builder. He'd wake us in the morning tearing into the room with some new invention—a long string he'd tied with paper butterflies, and it would *swooosh*. Everything was aerial."

Model airplanes tapped into the Wyeth family attraction to miniaturism. Continuing his father's interest in World War I, he built such fighter planes as a Fokker D-7 and a Spad. Wyeth helped him build the first model, and soon planes hung everywhere in his bedroom, looking like an antique fly-by. These ultimately evolved into planes handcrafted from scratch—a Spitfire Mark IA built to one-fifth scale. He also builds radio-controlled flying models with tissue-paper skins as fine and tough as wasp wings—his handiwork actually sailing in the sky. Then Nicky joined the field of competitive acrobatics, planes that he pilots precisely, delicately into snarling loops and Immelmann turns. His joy has been "seeing something I've created, knowing I've put it together with my hands and my imagination, all pieced together, and then see it actually flying."

Wyeth has always been his son's best friend and anchor to windward. Reporting on a Maine summer, on their time together out on the water,

Nicholas, 1955

Nicholas's dearest friend has always been his father.
One day the sensitive, somewhat solitary twelve-
year-old was sitting in Wyeth's studio lost in a
waking dream. Although working on a tempera of
a hill, Wyeth was electrified by the sight and immedi-
ately began a portrait on the half-finished panel.
Wyeth explains, "Nicky expressed much more
poignantly what I was trying to say in the landscape."

Nicky said, "What a wonderful man." Some of his earliest memories are of trips alone with Wyeth to the islands—where Henry Teel said of Nicky, "God love it. Ain't his hair some curly." Picnic lunches were just milk, crackers, and sardines. "The simplest," Nicky says. "But he was always there."

Often Wyeth telephones Nicky several times a day, sharing what is going on in the art market, in their lives. Betsy says, "Nicholas is Andy's weak point, I think because there is so much of himself in Nicky. The things that are misunderstood about Nicky are very evident in Andy. So if people criticized Nicky, they're criticizing *him*."

Andrew and his second son, Jamie, eye each other with a tricky mix of resentment and pride, rivalry and love. Jamie also regards his father as his closest friend. When Andrew needs a companion for a trip perhaps to Washington, D.C., it is often Jamie he recruits. Born in July 1946, three years younger than his brother, Jamie grew up anointed—a handsome, forever child, at once wide-eyed and sophisticated, full of hell and amazement, and a serious painting prodigy—his scrawled childhood letters illustrated with mature and facile drawings.

Artistically, he is a straight-line descendant from N. C. Wyeth, a product of the same influences that created Andrew. "I think it must be in my genes," Jamie says a little ruefully. His boyhood was saturated with the stories in the Scribner Illustrated Classics and his grandfather's illustrations and paintings. He was possessed by the mythic ghost of NC, who haunted the Big House, who still existed in the relics, the paraphernalia, even the smell of the huge, largely untouched studio up on the hill. "It was a magical paradise," he says—and half believes that he actually knew his grandfather.

Like the boyhood Andrew, Jamie played alone in NC's studio, dressing up in the costume collection. Later he assembled his own collection of military officers' uniforms. He, too, played with toy soldiers, and now has a collection of Nazi soldiers. He, too, had his little band of boy renegades—including Jimmy Lynch, that jack-of-all-talents who himself later became a painter. Eight-year-old Jamie received for Christmas a Robin Hood costume made by Betsy; Nicky got the materials to build a Wright Brothers plane. Jamie, too, was Robin Hood with his Merry Men in the

rocks up on the hill with his cousin Robin McCoy taking over her mother's role of Will Scarlet. Jamie repeated his father's high jinks—and then some. Once his little gang fired flaming arrows into an encampment of Boy Scouts.

He studied Howard Pyle's pen drawings—and did his own pen-and-ink illustrations of movies and the books his mother read aloud. He steeped himself in the Pyle books, *The Knights of the Round Table*, and *Men of Iron*. T. H. White's *The Once and Future King* was almost a Bible. He manned his father's medieval castle with lead knights, enacted dramas peopled with King Arthur, Guinevere, and Sir Launcelot.

When Jamie was six, Wyeth painted him in *Faraway*, the coonskin hat a counterpoint to the high tan grass. When the famed art historian Bernard Berenson saw the picture, ignorant of Andrew Wyeth, he assumed this realist must be dead. He wrote in a letter, "The portrait of the little boy is extraordinary. What talent we have had and ignored and starved."

After episodes of planning to be an airplane pilot and a butler, which he practiced by waiting on his parents at dinner, twelve-year-old Jamie decided to become a painter. As he once said, "It wasn't a question of 'My God, I'm a Wyeth; I have to paint.' But I have wondered, 'If I'd been born in Iowa to a farm family, would I want to paint?' I think I would, but you don't know, do you?"

Determined to follow his father's example, Jamie dropped out of the sixth grade to have more time to draw. "People ask, 'How the hell do you know at that age?'" Jamie says, "Well, I really did know. I wasn't interested in bouncing a rubber ball around a court and throwing it through a hole. I loved books. Marks didn't mean anything to me. All I wanted to do was paint. Better to really cut myself off, burn the bridges behind me."

Against Betsy's wishes, Andrew allowed his son to be educated by tutors through high school. Both father and son are sensitive about their lack of higher education, but Andrew bewails a society in which painting is considered a "sideline" to be pursued after formal education. In his head, art training should follow the tradition of the Renaissance, when promising boys were apprenticed to master painters.

Faraway, 1952

In 1958, Jamie started two years of academic training with his aunt Carolyn, who was conducting an art school in NC's lower studio. He drew in charcoal the same cubes and cones, the same busts of Lafayette and Washington, that NC had placed in front of his own children. Carolyn was likewise a taskmaster who marched up and down the studio wearing a theatrical black gaucho hat and her father's long brown coat. "She sort of *became* my grandfather," laughs Jamie. "It was the strongest visual exposure you could have, other than being with him physically. Maybe it was even stronger than if he had been there. His personality that I

Out on a walk with his father, six-year-old Jamie dropped a toy soldier in the field. After Wyeth searched for it, he returned to find his son lost in a reverie. Jamie was very proud of his outfit—his Davy Crockett coonskin hat and metal-tipped shoes worn by a boy before the Civil War. Wyeth considers *Faraway* his first completely successful work in drybrush, a watercolor technique halfway between washy watercolor and meticulous tempera.

found later in his letters—such a Mama's boy—I don't know if I would've been that enamored by him."

Carolyn influenced Jamie's work more than Andrew, introducing him, according to Jamie, to the sense of "inanimate objects taking on a life of their own in a really visceral way." He explains, "Carolyn doesn't have that Andrew Wyeth veneer of every brick looking like a brick. Her Mason jar doesn't look like a Mason jar. It *is* what it is and her mind's interpretation of it. It's *her*. You feel something seething under there. It horrifies."

When Jamie reached fourteen, he began working in oil, and Andrew estimates that his son's draftsmanship was six years ahead of his own development. Jamie had been attracted to oil paint as a little boy. "I used to sit and watch Carolyn squirt out the paint," he says, "and it was just so luscious the way it poured out. I just could eat it." When Jamie was nineteen, he studied anatomy with a Russian anatomist by dissecting cadavers at a New York City hospital morgue. He was never formally taught by his father, who talks to young painters only about broad principles, never painting technique. "Teaching doesn't appeal to me," Wyeth says. "I work so many different ways, I haven't got it down to one formula, one theory."

Jamie says, "My father was probably the greatest teacher because there was never . . . he's never worked on a painting of mine, never said, 'That's the wrong color.' He's never said, 'That ear is fucked up.' He would talk about the ear in general, 'Jamie, be aware of its relationship to the head, to the nose, the eye.' He'd only say, 'The figure is seven heads high, not ten.' He made you pull it all out of yourself." In 1993 Jamie received an honorary Doctor of Arts from Westbrook College in Maine. He told the graduating class, "Any of you that have graduated college with an art degree have just wasted four years of your life."

But Wyeth and Betsy did sometimes impose their principles on Jamie. When she happened on a heap of unfinished drawings, Betsy was incensed, and *she*, not Wyeth, made him sit down and finish each picture. Years later, when Jamie was invited to visit a Hollywood movie set and do drawings for a promotion campaign, there was a family uproar when his mother and father opposed the idea. But he went anyway. In 1967, when Jamie was twenty, Jackie Kennedy asked him to do a posthumous portrait of Presi-

dent John F. Kennedy. Andrew tried to influence him away from the project, not least because he believes that a first-rate portrait from photographs is impossible. Jamie accepted the job.

Summing up the benefits of being a third-generation Wyeth, Jamie says, "I had the ghost of N. C. Wyeth, who was this magical being, the painter who produced those illustrations and had left behind all the trappings to produce everything. His knights in armor excited me much more than what my father was working on. But my father was working constantly, from the minute the sun came up . . . a role model for total absorption—the belief that painting is a serious business. Those two pulls worked. Somewhere in between I could survive."

Jamie made his unruffled way in the family by observing his brother and his mother. "I think Nicky had it much harder than I did," he says. "I kind of skirted—didn't make the same mistakes—he would just infuriate her and I would see it coming, and he would just walk into it. So it was a good proving ground. I was a rather silent child."

Jamie has always been amazed at the sights his imagination contains. Before he could walk, his favorite plaything was an empty eyeglass frame he perched on his nose. "A woman would be putting on lipstick," remembers Betsy, "and here was this child watching. I've never seen anything like that intense gaze."

Like his father, he celebrates Halloween with gruesome masquerades. Jamie explains, "It's the anonymity that's exciting. You can really stare at people, which is wonderful." He began his macabre impersonations alone in NC's studio, a child putting on costumes, making up his face, though nobody was there to see him. In daily life when people are watching, he has worn another kind of mask, a dazzling, lifelong charm, a captivating combination of inclusive warmth, grace, and irreverent humor.

Betsy says about her son, "He's got the mask face. Something he puts on." Impenetrably defended, he keeps his angers and pains deeply hidden. Very few know what he *really* thinks. He once gave a glimpse: "People say, 'Jamie can get along with people.' I can because they mean nothing to me—except for the person I'm working on." When Jamie painted a 1972 self-

portrait, *Pumpkinhead*, his image of himself was a shabby, black-suited figure, bony wrists inside the sleeves, like a scarecrow come alive. On the shoulders, instead of a head, is a large jack-o'-lantern. Its expression, Jamie has said, "is not really a grin but a sneer."

Lincoln Kirstein was an observer of Jamie since the late 1940s, when he stood gazing enraptured into the cribs of the Wyeth boys. After posing for nineteen-year-old Jamie, Kirstein more or less shifted his allegiance from Andrew and became Jamie's friend and mentor. Kirstein told Betsy, "You gave me the only son I ever had." She says, "I thought it was wonderful. He could give Jamie a different kind of education than we could." Vaguely hurt, Wyeth was wistful about this loss of Kirstein's attention, but says, "Lincoln was the one person who took Jamie truly seriously."

Kirstein saw Jamie as "a very, very strange man. I can tell you, he's one of the strangest people I've ever known." Kirstein thought the decision to leave school was definitive. "The thing about Jamie is that the normal things of a young man going to high school and to college—he never knew any of that, he never knew anybody. He never had a real friend—except maybe Jimmy Lynch." One result, Kirstein believed, is that "Jamie's absolutely alone. He's had to be cold as ice. His relationship with his mother, for instance. But he's free of it. The first job of an artist is to kill the parents."

In 1961 Jamie met Phyllis Mills—a member of the du Pont clan, a delicately beautiful, smart, wealthy young woman and an avid equestrian. He was fifteen and asked her to dance at a Christmas party. She had worked for John F. Kennedy when he was a senator, and was then secretary for a special assistant to President Kennedy. In a 1962 automobile accident her neck was broken, leaving her paralyzed. Crippled from the waist down, her legs largely useless, she was spurred by intense urging from Jack Kennedy, and ultimately managed to walk using crutches, braces, and iron resolve. Several years later, Jamie saw Phyllis in the stands at a horse race in Pennsylvania and kept watching her through his binoculars, fascinated.

Jamie married Phyllis in 1968 and moved from one storybook world to another. They live just across the border from Chadds Ford on a huge,

idyllic farm in Delaware, her inheritance from an aunt. Phyllis has remained the day-to-day manager, raising horses and feed—hay, corn. Using her Washington connections, she has lobbied for environmental regulations in foreign aid. She served on the board of directors of the National Committee for Arts for the Handicapped, and for nearly a decade she was on the boards of both the National Trust for Historic Preservation, and the National Resource Defense Council, where she helped initiate a program to bring Russian nuclear physists to the United States.

She has been working with the Island Institute in Rockland, Maine, which fosters the ecological and cultural life of island communities. She is promoting research using satellites for ocean remote sensing—charting temperatures, currents, toxic areas, spawning patterns, plankton. And she has continued her romance with horses, almost daily driving a pair pulling her antique wicker ladies phaeton.

Jamie's marriage was a leap into freedom, but different from his father's use of Betsy as a counterpoise to NC. "Phyllis is a very wise woman," Kirstein once said. "She knows the real depths, and I've never known a freer spirit. She wants nothing. She's interested in what Jamie does, but not obsessively interested. She has her own world. If you ask who are Phyllis's friends, the horses are. And maybe Nureyev a little bit. But, of course, he's certifiable."

Phyllis's tough delicacy, her exquisite frailty and mighty determination to have a life—the complexity of another strong-minded woman married to a Wyeth man—became a major subject in Jamie's painting. "Nothing is more *uninteresting* than completely knowing somebody, being completely at ease," Jamie once said. "I've never been *totally* at ease with Phyllis in my life."

He painted her in the cart behind two horses plunging into a green abyss of woods. He painted her body submerged in a jumble of brittle, delicate wicker furniture. Just as his father portrays people through objects, Jamie depicted Phyllis as a straw hat with a long, pale dangling ribbon, set atop a straight-backed chair, its four legs representing Phyllis's base of legs and crutches.

Phyllis introduced Jamie to the Kennedy clan, which led to the posthumous portrait of John F. Kennedy, which led to a commission to paint Eunice Shriver. In 1965 Lincoln Kirstein agreed to pose. Jamie shows him from behind, arms behind his back, his commanding head set at the top of the picture, face in one-quarter profile, accentuating the large, listening ear, the arching nose, the mouth poised to speak.

Jamie was now swimming in that celebrity world where his father feared even to tread water. He was part of an era when artists became personal celebrities buffed by show business. The pioneer of this phenomenon was the pop painter Andy Warhol. Introduced to Jamie by Lincoln Kirstein, they became pals. Like two delighted, prankish kids, they would roam the city, shopping for exotic toys and taxidermy animals. In 1976 they had an exhibition together at the Coe Kerr Gallery and on opening night the police put up barricades to control the crowd. The show featured their portraits and studies of each other. As Jamie explained, holding an imaginary Polaroid camera to his eye, Warhol's portrait of him was just "Click!" Jamie's portrait of Warhol was basically a picture of interior rot.

Jamie the connoisseur of masks has fearlessly, ruthlessly penetrated the facades of his subjects. Through Kirstein, he met Rudolf Nureyev and painted him as a splendid animal and then Arnold Schwarzenegger in his incarnation as Mr. Muscle America. In his portrait of JFK, Jamie showed a vulnerable president, eyes reflective, even uncertain. Although Robert Kennedy remembered this look in his brother's eyes during the Cuban missile crisis, he felt the expression was wrong for an official portrait. Jackie was delighted with it, and the portrait hangs in the John F. Kennedy Library and Museum in Boston. In 1969, painting his father, Jamie showed the brooding, almost sorrowful seriousness of Andrew—who is not keen on this portrayal.

Jamie sees and paints the world with awe, tinctured with droll irony and psychic dread. He once explained, "There's some funny thing that makes me want to paint something. It's a terrible kind of insolence, this delusion that I am recording something nobody's looked at before, a unique view. That's why I paint."

Jamie says about his "beautiful people" image: "This Jamie Wyeth that's been created is out there in front of me—people can play with that while I'm working feverishly on my painting." He continues, "When I get inside my studio, everything stays outside the door. There's such a problem painting that *all* other problems go away—like will it stack up to *Christina's World*? Painting is agonizing but addictive. The opiate is when things work, and those times are few and far between. But when it happens, it's the biggest rush."

Despite his forays into the realm of the celebrated, Jamie has basically been true to his artistic roots and concentrated on what he knows best in his own backyard. Fascinated by animals, he has painted the personalities and natures of a menagerie of bulls, crows, ravens, dogs, geese, hens, sheep, and seagulls. Hanging in the Brandywine River Museum in Chadds Ford is a huge, full-length portrait of Den Den, Jamie's six-hundred-pound pig, a dear friend who comes when he calls her and lies down while he scratches her belly. During the painting of the portrait, he brought her into the living room to see her ensconced in front of the fireplace. Jamie says, "When you get eye-to-eye contact with an animal, a real connection, it's limitless."

Jamie's intent was to paint a definitive portrait of a pig. He says, "Pigs are *not* cute. They do eat their young. This one happened to be a friend of mine." At the funeral of Robert Kennedy, Jamie sat only a few feet from President Lyndon Johnson. "I studied him," Jamie remembers. "Head massive, ear lobes enormous, all those little veins in the neck, the tension in him, the power. The next day I was painting my pig and studying *him* just as closely, and thinking of it breathing and Johnson breathing. That was thrilling to me!"

When the celebrity played out for Jamie in the late 1980s, he topped his father's youthful Maine experience. He lived months of every year on remote Monhegan Island, ten miles off Port Clyde, buying a house built by the painter Rockwell Kent. The special quality of these island people, many living from the sea, became his subject matter. Again echoing Andrew's ways, he began following thirteen-year-old Orca Bates on Monhegan

Island. Uncontaminated by the cacophony of the mainland, Orca has been the flip side of Jamie's own complex, cosmopolitan life. Watching Orca growing up, Jamie has painted him balancing between child and boy, then moving into young manhood.

This has been Jamie's own evolution—studying souls in transition. A girl listening at a slightly open, light-rimmed door. Phyllis emerging through a doorway at Southern Island, a place she never expected to see again, after a potentially fatal back operation. Orca's young brother, eyes fired with wild innocence, beside hellish flames in a trash-burning barrel.

Jamie shares his feeling for islands with his mother, who in 1978 bought twenty-two-acre Southern Island a mile off Tenants Harbor near Port Clyde, and reclaimed its abandoned, dilapidated lighthouse that dates back to 1857. Betsy and Andrew spent part of each summer there until 1990, when they moved and gave the island to Jamie. Now he could be utterly undisturbed, his subjects coming to him, in his little country, entirely his own. One has been a young woman named Monica Shields, as androgynous as Orca, who posed inside the circular glass turret of the lighthouse. She seems a moth trapped inside a lantern. The palms of her hands are against the glass, a gesture that says, "Stay away" and "Rescue me."

The drama in Jamie's vision is more overt than in Wyeth's pictures, more sensuous, stronger in subject matter, more directly narrative. Carolyn Wyeth once said, "Andy's more of a spirit. Jamie, he's bread tack, solid down to the floor. Not any of that spirit stuff."

Lincoln Kirstein also analyzed the differences between father and son: "Andy's forms are diminished. They're very delicate and fragile and toward a miniature. I can't feel there's any awe in Andy. He has his universe and that's it. Andy is only himself. Jamie is interested in otherness. He has a more developed attitude about the cosmos, a worldly curiosity about everything that goes on. His best pictures have a human dimension."

The two approaches of father and son were typified when Jamie painted a watercolor of cats eating from their dishes in his own barn. By coincidence, Wyeth painted the same subject in the Kuerner barn, but

removed the cats from the picture, leaving just the dishes. Wyeth says, "I thought that was more interesting. I think it's what you take out of a picture that counts. There's a residue. An invisible shadow."

Everything that Andrew likes about the parched medium of tempera, Jamie hates. The surfaces of Jamie's pictures are usually rich and juicy. Increasingly the impasto of brushstrokes and glossy varnish has become virtually an element of style. "Jamie's a *painter*," Andrew says. "You feel that he uses heavy brushes and grunts. He certainly has more weight than I do—and humor. I think my temperas are thin to him."

Wyeth continues: "Jamie gets truth, but it's more academically truthful. I put my truth into a mood of tone. My work is almost nonart. Like *Christina's World*, which is not gobs of paint and surface textures. My pictures live strangely—almost like dried earth. I'm just the opposite of Jamie, and he has almost purposely gone back to his grandfather's tradition—and Carolyn's—and I think it's a fight against me."

Although the Wyeth name has been an open sesame attracting collectors, it has touched Jamie's artistic life with tragedy. Serious consideration as an American realist has eluded Jamie—despite a 1980 one-man show at the Pennsylvania Academy of the Fine Arts that traveled to Greenville, South Carolina, and Fort Worth, Texas—and in 1984 a solo exhibition in Maine at the Portland Museum of Art. Jamie believes that the name "Wyeth" carries the art-world stigma of "too accessible." The art critics who have dismissed his father have been even harsher on the son. When M. Knoedler & Co, Inc. gave him a one-man show at the fledgling age of twenty, he was savaged by the *New York Times*. During the past decade his shows at the Coe Kerr Gallery—usually near sellouts—and a 1993 exhibition at the Farnsworth Art Museum in Rockland, Maine, were ignored by large newspapers and magazines.

Half-relieved when his shows are not reviewed, Jamie believes that such negative reactions have nothing to do with the work itself. "Naturally, it hurts," he says. "I feel, 'Here it comes again—Andrew Wyeth, illustrative.' They hate him and they hate me, real hate. Thank God they have almost no power." He adds wistfully, "All that Wyeth baggage I've been

carrying all my life makes it *awfully* hard for people to tune into my work clearly and deeply. I'm just a name. They're conditioned to hear 'Wyeth' and *click!* their minds go into Wyeth-drive."

Andrew is entirely understanding of his son's predicament. "I think I've probably been a great handicap to him," he says. "It's hard for me to see it that way, but I think I give him a complex. The critics are disgusted with me, and here's a son coming along who does realism."

Andrew rues this sour role in his son's life and their relationship. "Betsy often says I'm closer to Nicky. Jamie can't seem to completely relax with me. Maybe it's because . . . when you get fame—you see, I'm in competition with my son whether I want to be or not. Just the fact that I exist as a painter. He doesn't come up to my studio. He doesn't want to see what I'm doing. And he kind of hopes I'm not doing it."

Wyeth continues, "But he's had it no tougher than I had against my father, except *I* am in the painting field. My father was in the illustration field. Thank God it never came between my father and me, and so far it has never come between Jamie and me. Outwardly, anyway. He's very sweet to me. He's a wonderful boy. He's not the type of person to break out and say anything to hurt anybody. Jamie keeps everything inside."

In his half of the equation, Andrew is sensitive to the *fact* of Jamie. Like NC, who feared being "old hat," Wyeth is needled by the thought that Jamie's painting is more contemporary, more "today," and by the possibility that his son is silent confirmation of critics' claim that Andrew Wyeth is an illustrator of a vanished America.

Moreover, in the dynamics of the family Jamie has been seen as his mother's son, the boy who takes after Jim James, has his sense of humor, who has a name from *her* side of the family, who is not a die-cut Wyeth. Occasionally Andrew plagues himself with the possibility that Betsy will somehow, sometime prefer Jamie's work. Once when he telephoned her in Maine, he asked grumpily, "Is that painting of Jamie's still over the fireplace?"

Jamie once told Jimmy Lynch, "I really envy you. You can be you, and nobody notices what you do. I always have to be me and *everybody* notices." On another occasion when Jamie was a married adult, he was playing with

a small boy, the two on the same wavelength. A woman friend said, "You ought to have a child of your own." Quicker than thought, Jamie answered, "Oh, no, I could never have a child. Not after what I went through with the competition."

Jamie has also said, "I happen to think that Andrew Wyeth is certainly the greatest living painter, and that is tough to live up to—but it is also a great goal." Andrew says of his son, "I don't know of another painter in his generation who has more ability." But he also thinks that Jamie still has not yet reached his full emotional potential. He fears the effect of contemporary trends on Jamie's innate voice, even by osmosis. "Jamie watches what's being done, what's in style," Wyeth says. "He's much more curious about that than I am. Much more contemporary. Remarkable. Technically head and shoulders over the young artists I see around me. But I think he's still searching, still groping for a reason to paint."

Wyeth believes that his own experience will repeat for Jamie. "There's a lot within Jamie's soul," Wyeth feels. "He has something to say. Most people don't have anything to say. But Jamie needs something to bring him back to earth. I think he will come into his own when he loses something truly precious to him—whether it's the death of Phyllis or when I die or . . ."

16

"Every artist of significance," says critic Theodore Wolff, "paints life perceived against a background of death. Wyeth does it in such a fashion you can't separate the two. His paintings are like a cluster of butterflies seen flashing in front of the mouth of a black cave." Within that cave, death is paired with madness, its first cousin. Together they inhabit Wyeth's moods of foreboding, of terror and the macabre. They are Halloween and Spud Murphy. They are the dramas that give his excitement a cutting edge, that stir acid into the fleeting moments he paints.

The preoccupation with the event of death, romanticized in his war play and favorite stories of tragic battles, has always energized Wyeth's imagination. The fixation has always been part of the poetic melancholy prized by the Wyeth clan. "We love our dark moods," Henriette says. "We need dark places to take shelter in."

The death of N. C. Wyeth deglamorized death with the pain of loss. But it was still a step removed, and once his anguish had been directly expressed in *Winter 1946* and *Karl*, his succeeding temperas drew on lighter emotions. In the opinion of Thomas Hoving, former director of the Metropolitan Museum of Art, Wyeth was "in danger of becoming truly sentimental."

But at the end of the decade Wyeth experienced death as a personal threat. In the fall of 1950 Andrew and Betsy visited Dr. Margaret Handy at her small camp in the interior of Maine. They slept on three cots in the same room. The first morning Dr. Handy discovered bloody phlegm on Wyeth's pillow. Betsy told her that this was common. Dr. Handy insisted that he see a specialist—which he delayed until his usual return to Pennsylvania just in time for Halloween. The doctors found bronchiectasis in one lung—a disease of the bronchial tubes. Untreated, the condition is fatal.

Dr. Handy wanted the acknowledged specialist in the field to operate in Philadelphia. Because it was "more convenient," Wyeth chose the less specialized Wilmington hospital and waited till after Christmas. In mid-January of 1951 he spent the night before the surgery in the hospital. He was much amused by an uninvited minister who knelt by his bed and somberly prayed for his survival. Wyeth read himself to sleep with a book on his boyhood idol, Albrecht Dürer. It was a Christmas present from Betsy, along with thigh-length French cavalier boots once owned by Howard Pyle and used by both Pyle and N. C. Wyeth in illustrations.

In the operations, Wyeth's chest was split open from top to bottom, severing the muscles of his right shoulder. The middle lobe of his right lung and a segment of the lower lobe were removed. During the operation, Wyeth's heart began to fail. In the sleep of anesthesia, he saw in the blackness a medieval figure, handsome, almost princely in his furs, moving toward him across the tile hospital floor. It was Dürer, who held out his hand to his disciple. Wyeth started forward; then pulled back. The figure withdrew.

In the recovery room, returning to consciousness, Wyeth found Henriette by his bed. His first words were: "How's your painting coming?" Then he passed back into unconsciousness. When he awoke again, he instantly asked, "How's John's show coming?"—referring to an exhibition by John McCoy.

The next day Wyeth nearly died a second time. He hemorrhaged in his lung, blood pouring from his mouth. He was literally drowning in his own blood. By sheer happenstance, a nose and throat doctor friend of Margaret Handy stopped by to say hello. He immediately aspirated the blood from the lung with a long tube.

Though the severed shoulder muscles had been reconnected, Wyeth worried that he might never regain full use of his painting arm. Convalescing at the schoolhouse, the pain was so intense, he could not sleep. Despite the agony he tested himself by painting watercolors looking out the windows.

Adam Johnson, the pig farmer up on the ridge, knocked on the door. He said, "Andy, I didn't send ya any flowers. Now I come over. I'll pose for

you three times if you wanna do it." Wyeth painted several watercolors, and when they were finished, Adam said, "Dat's my flowers to ya."

Allowed outdoors, Wyeth began taking walks to rebuild his strength. He wore Howard Pyle's tall boots and carefully watched his unsteady footing in the fields. Soon he was at work on the tempera *Trodden Weed* (page 287). "To hell with the arm," he tells. "I wanted to paint this picture."

In the studio, the small tempera panel flat on his lap, his arm in a sling suspended from the ceiling with pulleys and weights, Wyeth painted his own looming, leather-clad legs taking a step on the high ridge where he had painted *Winter Fields.* The right foot callously crushes a dead weed, exquisite in its scroll shape. The bottom of his coat, black as death, flaps above the knees—the Dürer figure stalking the land.

Thomas Hoving, former director of the Metropolitan Museum of Art, considers *Trodden Weed* a monumental picture pivotal in Wyeth's career: "He never again became sentimental, ever." In the judgment of John McCoy, the paintings then "took on more solemnity; they became more thoughtful."

Now death was a presence waiting to cut him off before he could say *everything* in paint. Returning year after year to the same places, the same lives—the continuous theater of his work—Wyeth more than ever was fixing his subjects forever in time, striking a blow against time. He was conferring a kind of immortality on objects and people. "I've seen too many things that have gone unrecorded," Wyeth once said, "those subtle things that go by. People I know. I don't know why I record them, because I really don't care about painting after I do them. I just want to get these things out."

The lives Wyeth has chosen to watch, the paintings that have emerged— and he himself—are touched with madness. Robin McCoy remembers as a girl playing monster with her uncle Andy. "He'd come after us, lumbering along going 'Grrrhhhh,' and he changed. We knew he was Uncle Andy, but we knew he *wasn't.* He didn't want to be inside with the adults. He wanted to be outdoors with the kids, just on the edge of out-of-control. Almost losing it. I think there's madness in the family, carefully covered up with a very sensitive veneer. I think there's an edge of madness in me—and in

Jamie. It's a desire to go to excess, flirt with the edge. It's the freedom, the utter abandonment you had as a child, spinning around in a circle and getting dizzy and being lifted up as though you were tilting off the side of the earth—the rush you got. I think Uncle Andy is fascinated with the danger of being on the edge of madness."

For Wyeth this is his defense against lunacy. Painting controls the interior chaos that frightens him. Calling upon the dicey fundamentals of himself, he stays balanced just on the edge of madness, just in control, out of its reach, but excited by those who have been taken over, who are possessed, who are the freest of all people, whose chaos is on the surface.

The interaction of life and death and madness was fundamental for Wyeth at the Kuerner farm. In the late 1950s he made Kuerner's even more of a touchstone, the Pennsylvania version of the Olson farm in Maine. Like Christina, Anna Kuerner has been the actual heart of the drama at the farm, a fabulous oddity, a tiny, darting figure, her mind long lost in a thicket of compulsions.

With her head wrapped in a kerchief to contain her vicious headaches, she was a perpetual-motion cleaning machine. She scrubbed the barn, washed the stone steps with a brush, raked the dead grass from the fields. Talking to herself in German, she swept the cow dung from the gravel driveway with a broom made from long twigs like those in the old country. She picked up pinecones for kindling, heaping them in Karl's World War I German helmet—a still life Wyeth painted in the 1976 tempera, *Pine Baron.*

Recovering from the operation that removed one lobe from his lungs—and a near-death experience on the operating table—Wyeth walked the countryside to regain his strength, wearing French cavalier boots. The vision of his legs became Death fatefully walking the world.

For years, Anna did not respond when Wyeth spoke to her, sometimes asking her to pose. So he painted the tokens of her life—the blankets and onions she hung from the ceiling hooks in the third-floor room. There, too, he painted the *kas*, a huge wardrobe against one wall. In a spasm of madness, Anna once locked herself in the room and like a frightened child hid inside that *kas*—till Karl climbed a ladder and crawled through the window.

Trodden Weed, 1951

Intrigued by the unknown imagined, Wyeth studied Anna's cosmos from afar. Within pine bow shadows like monster crow wings, Anna's kerchiefed head would appear in a window, her dust mop would be shaken in the air. Smoke from the chimney signaled Anna at the wood stove. In the dusk or late at night Wyeth could map her routines by the lights turning on and off. The kitchen window lit as she readied dinner. A glow in the woodshed indicated Anna splitting kindling.

Sometimes in quick sketches he caught Anna on the move: her hectic figure scurrying up the stairs, one jump ahead of his pencil—or her ghostly figure cleaning the milk room in the barn. More an atmosphere than a presence, she was usually gone from the final picture. Once, in 1959, Wyeth sketched her at rest, seated in the kitchen. Asleep at her feet was the fierce German shepherd, like his master a patroller for game when allowed off his chain. A series of these sketches joined scores of others to evolve into *Ground Hog Day,* Wyeth's summarizing tempera of Kuerner's, of death and madness beneath a thin skin of domesticity (opposite).

As though for lunch, the kitchen table is set with a knife, plate, cup, saucer. Someone is expected. A square of sunlight warms the faded, flowered wallpaper—tattered femininity—Anna Kuerner. She and the dog have disappeared from the composition. "I think a person permeates a spot," Wyeth says, "and a lost presence makes the environment timeless to me, keeps an area alive. It pulsates because of that."

The sleeping violence of the German shepherd has become the sharp, ripping points of barbed wire seen through the window. Beyond it, huge on the ground, wrapped with a chain, is a cedar log poised to drive through the window, like the great battering rams that once broke down the doors of medieval castles. Jutting from its end are vicious splinters, like wolf fangs. The single knife is Karl, who ate only with a knife. The air in the room vibrates with foreboding—Karl's rifle shot offstage, Anna's disembodied voice murmuring in German through the house, the sound of her broken mind.

Virtually from the day she arrived in America, Anna's loneliness and longing for Germany were like an illness. She was further isolated by her poverty. "We were really, really, *really* poor," says her daughter Louise with deep

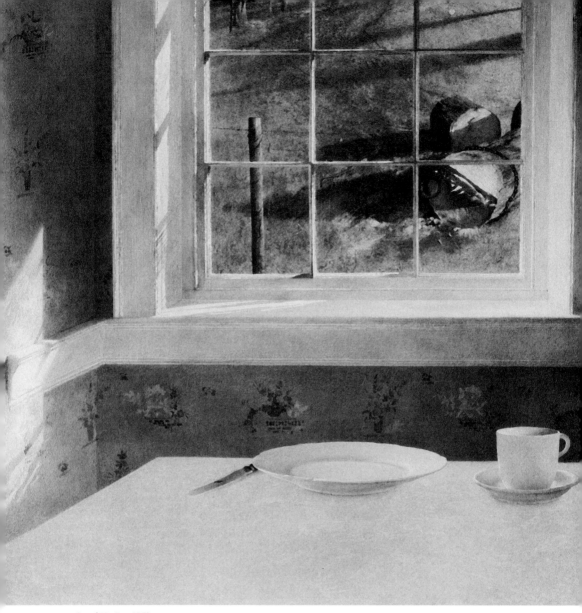

Ground Hog Day, 1959

At Kuerner's Wyeth felt death and madness beneath
the skin of peaceful routines—like lunch in a kitchen
bright with winter sun. The composition once
included disturbed Anna seated quietly by the window
and Karl's growling, killer German shepherd asleep on
the floor. Wyeth believes that when such elements are
removed, they leave a residue within the mood.

feeling. Exhausted by the farm work, by bearing three daughters and a son in five years, Anna's mind snapped in the early 1930s. "My mother had nowhere to run to," explains Clara Kuerner.

Anna was taken, screaming and fighting, to the state hospital in Norristown, Pennsylvania. "My father had a heavy cross to bear," Clara continues. "The main thing, he didn't crack up." Though social workers wanted to distribute the children, Karl kept the family together, hired housekeepers, including a saintly Mrs. Johnson, who trained the children in deportment by asking, "What would the queen of England think of that?"

Anna was in and out of the hospital for a decade. Her youngest daughter, Elizabeth, was born in the hospital. When Karl took the children there to visit, Anna sometimes did not recognize them. When she came home permanently, Mrs. Johnson stayed for another decade, followed by Anna's sister Matilda, who ran the house. But even when the full moon drew Anna even further from reality, she ironed the children's socks and underwear, lovingly warmed their towels for their baths.

Though Karl's fortunes improved, he remained tightfisted. Each Easter and Christmas Anna was forced to demand money for candy for the children. She had trouble prying loose two dollars each Sunday for the church collection plate. When their daughter Lydia got a job in West Chester—while still doing her milking chores—Karl insisted she pay board. She moved out. Karl said, "Well, just don't come back."

Even before the years at the state hospital, Anna's anger at her fate away from her homeland often focused on Karl. Hardened by her perpetual labor, she, too, could be tough. If Karl was not on time picking her up after Sunday church, she walked along the shoulder of the road, a small packet of fury. Arriving late, Karl drove slowly beside her till she was good and ready to relent. Once Karl bought her new clothes. In a paroxysm of anger, she took scissors and cut them into rags. Once, when Karl was drunk, she knocked him down and dragged him upstairs to bed. Once Karl did not come home from a moose hunt when she expected. Anna picked up a pistol and shot herself in the head—only grazing her skull.

During the final phases of painting *Karl*, Wyeth carried the tempera back to the attic room to make refinements from life. One morning he

arrived to find the portrait gone from the easel. Panicked, he searched out Karl, who said he had been awakened in the night by footsteps and found Anna on the stairs carrying the panel down to the woodshed. She said, "I'm going to chop you up!"

Anna and Karl sometimes competed for Wyeth's attention. Once he was in the living room painting a watercolor of Anna cooking at the Kitchen Comfort stove. Saying, "Don't bother with that," Karl stepped in front of him and shut the door to the kitchen. When Wyeth gave the Kuerners a reproduction of *Spring Fed*, Anna signed her full name at the bottom—Anna Faulhaber Kuerner. Karl wrote his name directly across her signature.

In 1970 Wyeth was painting Karl in his trophy room hung with deer heads and moose horns. Anna came into the room and stood in line with the gun cradled in his arms. If he had pulled the trigger, she would have been dead. Wyeth painted in her figure, dust cap on her head, instead of a moose head on the wall. Wyeth called it *The Kuerners*. Betsy, shaking her head, calls it "America's Sweethearts."

That same year, as he had repeatedly for decades, Wyeth asked Anna to pose. This time she unexpectedly said, "Yep." He painted *Anna Kuerner* (pages 292–93) on the third floor by window framing the pond and the snow-dusted Kuerner's Hill. Playing off against the dour, ravaged face is the faded sweetness of the pink flowered wallpaper and the pathos of the ragged pony tail bunched atop her head, echoing the topknot of pines on the summit of the hill. When asked about the portrait, she softly answered, "He didn't flatter me."

Describing Wyeth's work, Henriette said her brother paints "things that the sun, the weather shine on and hurt and tear to pieces and sliver, and they endure and death comes to them. The Wyeths are so concerned with death. But of course we're concerned with death because that's the whole drama of being alive for a while. Death is with us. And it's beautiful because it exists."

Painting Bess James in 1956 in *Chambered Nautilus*, Wyeth did dissolve death with beauty and poignancy, a kind of glory—perhaps because his relationship with Betsy's mother was the most uncomplicated love experi-

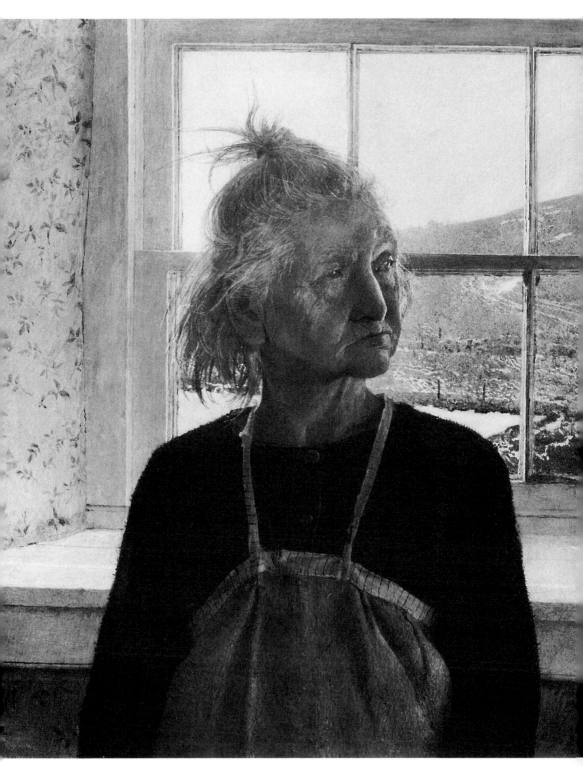

Anna Kuerner, 1971

ence Wyeth has ever had with a woman. He says, "We talked about everything from sex to . . . sometimes she'd say, 'You'd better go down and see my daughter.' We had a real communion. I actually fell in love with this woman. Crazy about her. It just shows that age has nothing to do with it." His voice drops to a whisper. "She had as much sex as Betsy has. There was something terrifically youthful . . ."

Wyeth once said to Bess, "You didn't marry the right man, did you?"

She answered, "No."

"You should have married me."

"Yes."

In 1952 Bess had been stricken with scleroderma, a rare and incurable autoimmune disease in which the body overproduces collagen, the fibrous protein that gives skin its strength and elasticity. The disease usually turns skin shiny, thick, and tight. Proliferation of collagen elsewhere in the body can disrupt lung, kidney, and heart functions. Two years later she suffered a severe heart attack, then contracted pneumonia. Apparently dying, she ended up in an oxygen tent. Remissions are common in scleroderma, and one morning Bess simply got out of bed, telling the nurse, "This is all

Anna Kuerner, Karl's wife, was always an elusive spirit in the house, unwilling to pose, her mind broken by loneliness for her German homeland. Compulsively cleaning, talking German to herself, she added an eerie, possessed quality to Kuerner's.

ridiculous." She dumped out her pills and soon she was out driving her car. Later, though never a convinced Christian Scientist, Bess had a reader come regularly to the house as a source of hope and comfort. She once told Dr. Margaret Handy, "The most difficult thing in life is dying."

Bess habitually rested twice a day. During the summer of 1956, Wyeth came up each morning for coffee, and sat beside the massive four-poster bed that seemed to dwarf the frail figure. Skeleton thin, Bess sat with emaciated hands clasped over her blanket-covered knees. Beside the mound of pillows was a wicker sewing basket that held the heart of her life, her Bible, which she read at night, her paper and pencils to preserve her thoughts—a comforting verse from Saint Timothy, "God hath not given us the spirit of fear, but of power and love and a sound mind."

By then illness had eaten her away to the core of her being. Wyeth felt he was looking at pure life, the very spark of life. Sometimes she turned her head away from him to gaze out the window toward the distant ocean. Even on gray days and in the fog, the light from the limitless sky was radiant on the sliver of her profile. It bathed the transparent lace curtains hanging like a scrim from the four-poster frame. The light penetrated the transparent skin of her fingers and brought to vibrating life a relic of the sea at the foot of the bed, a chambered nautilus shell on a wooden chest shaped like a coffin. When the front door stood open, a sea breeze billowed out the curtains, as though the bed was bearing Bess across the water to eternity— Wyeth's image of dying.

The margin between bed and boat was blurred in Wyeth's dreaming mind. He remembers, "I felt the end of the river down below, and Teel's Island, Bird Island. I went on a picnic with Betsy to Teel's Island, and I kept thinking of this bed back here in this house. There was a little inlet here and I thought of the bed sitting there on the water. Strange."

Intensely aware of the "amazing, fleeting, youthful, timeless quality" he had never found a way to paint, Wyeth set up his easel in the room and painted *Chambered Nautilus* (pages 296–97). He analyzed the scene with the clinical detachment of the watcher artist. The blowing bed curtains were key. Wyeth once said, "There is motion in Rembrandt—his people turn toward the light. But it's frozen motion; time is holding its breath for an

Adrift, 1982

As teenage boys, Andrew and his closest friend, Walt
Anderson, liked to sleep in the drifting dory, rocked by
the sea swells. Now Wyeth's Scandinavian friend—like a
Viking to him—was gradually dying of throat cancer
and the dory became a funeral barge.

instant—and for eternity. That's what I'm after." He continued, "I think there's more chance of getting motion by stillness," he says, "than by a thing that has great speed. I mean, most airplanes in paintings don't move at all."

Also, he was recording his own childhood. "As a kid when I was sick in bed so much of my life," Wyeth says, "my mother used to always have clean linen for me to sleep on, and I'd lie with my cheek on that and feel the stretch of the bedclothes over the mattress. And pillows always seemed like big mountains to me." Once he wrote, "Ever since I was a small boy the movement of a curtain in the breeze has thrilled me in a very strange way."

That September Wyeth wrote Bess a uniquely tender letter from Chadds Ford: "I can never be sure of the quality of the painting I produced but I can be certain of the deep warm feelings I had within while I sat beside you. *You have made my life richer in so many ways.* If I could only put into words the way I feel but someday I will paint these feelings. I pray to heaven I will."

In January of the next year, 1957, *Time* magazine contained a story that included *Chambered Nautilus.* Bess James wrote Wyeth: "To you, Andy dear, goes all the honor and glory and what a wonderful article it is. I am all teary. It brings back to my mind again the dear hours I spent with you posing for this great painting, the understanding, the uplift, the patience, inspiration, and loyalty to me which lifted me and carried me through the hard hours. You are always so gay and strong and sure. I feel very shy and humble and grateful to the good God. And it was such a joyous time. We had fun, didn't we? No tensions. Remember the foggy mornings? Remember when callers came up the hill and stopped outside the windows at the wrong time? Remember when the sleeve on my nightie refused to pose? I live it all over again and our conversations and now here is the beautiful picture."

In October 1959, weighing seventy-five pounds, Bess died of kidney failure. Wyeth was there beside her, holding her hand. "You could feel the spirit going out," he remembers. "The gums and cheeks recede almost immediately, a strange death grin. Amazing."

In the room the breeze from the sea again blew the curtains against the posts of the bed, the only sound. Wyeth remembers, "I felt the whole

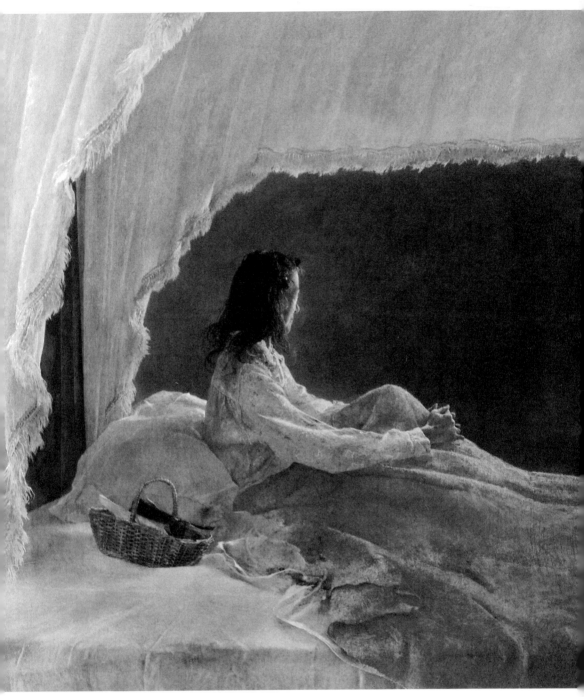

Chambered Nautilus, 1956

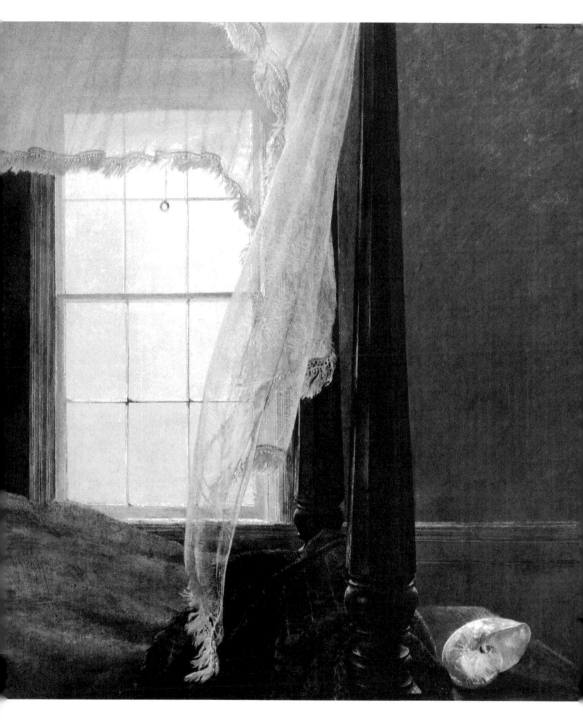

Andrew's affection for Betsy's mother, Bess, was almost romantic. Struck by her "dynamic fragility," he painted his friend fatally ill with a wasting disease called scleroderma. To him her life had been like the chambered nautilus shell at the foot of the bed—a series of compartments of which this was the last.

bed would drift out that front door and down to the river, moving away, sailing on." Wyeth pauses. "I feel the bed is still there in that room—and it isn't there." Sitting by the body, he had sensations from childhood Christmas Eves, hearing the imagined sound of sleigh runners on the snow.

The morning after her mother's death, Betsy drove down to Olson's, but the news had traveled ahead of her. Al was beside the road. Betsy stopped and rolled down the window. Al said, "Well, I see she used it all up."

Even in death Bess stayed in charge of Jim James by keeping her hands on the purse strings. She left her money to her three daughters, giving her husband only the investment interest. "A real slap in the face," Betsy says. "Interesting." He lived with a housekeeper in the Maine house and passed the hours with his books and newspapers. But he was something of a lost soul. "Betsy's father was an example of what not to do," Wyeth says. "He loved Maine, came up here and finally he got tireder and tireder and died. Bored to death with life. As long as I have something ahead, I'm okay."

Betsy became impatient with what she perceived as Jim's helplessness. He once asked Betsy to work on Bess's garden. She said, "Well, what the hell is wrong with you? You aren't doing a damn thing." He said, "You shouldn't talk to your father like that." Betsy said, "Well, I am."

Jim James's sons-in-law were his great comfort; they enjoyed his sympathetic charm. Louise's husband, Dudley Rockwell, says, "When I met Jim, he changed my whole life. Whatever patience I have, I got from him." Wyeth relished this same quality. "A wonderful man," he says. "Had a great sensitivity about painting. Taught me a lot about simplicity and quietness. I'd been trained by this marvelous father full of bombastic drama, and Jim was a quiet man who loved quietness." Jim James, says Wyeth, was behind *River Cove* (opposite page 406), a study in quiet. A bank of gravel projects into the still, black water of a tidal pool, backed by the dark green of spruce trees. A heron is a disappeared presence, its passage recorded by its tracks marching across the sand.

In 1963 Jim was diagnosed with pancreatic cancer. Betsy, who has a phobic horror of illness, largely stayed away during Jim's last summer. Andrew, too, recoils from illness. But he is fascinated by the inexorable currents of existence—and in the clutch can be selflessly kind. Almost daily he

sat by the four-poster, where Bess had died, and talked with Jim—while a slant of sunlight, traversing the door facing the sea, measured out the hours.

Jim died in November 1963. The next spring Wyeth did the watercolor *Open and Closed.* The door is slightly open to a sliver of darkness pregnant with death. But on the door the inexorable progress of the sun is stilled forever and for an instant. Wyeth told Betsy's sister Gwen, "Long after I'm gone, that light will still be moving across that door."

Each death left a gap in Wyeth's circumscribed world. His mother died in March 1973. Since NC's death, she had continued in the Big House, devoting herself to her daughter Carolyn. Andrew often stopped there at the end of the day.

She mourned NC for the rest of her life. "When father died," said Nat, "her life stopped. Her whole life was him. Any decision of any importance was checked with him. His death was like cutting off her bloodstream. She'd be telling me about their experiences together, and all of a sudden she'd break into tears, uncontrollable. Everything meant something to her. I remember many, many nights that my wife and I would have her over for dinner. When I would leave her back home, I could see into the dining room where she had all her silver, the candlesticks, coffeepots, and so on. I would see her holding one of these things in her hand and sort of rotating it and looking at all sides of it. Each one of those pieces had been given to her by Pa, and each one had a certain thought that went with it. She would hear my car and look up and give a little wave. She couldn't see me. It was dark, of course."

In the winter of 1973 Carol Wyeth's heart gave out. On March 14, her granddaughter Anna B. McCoy came before dawn to sit beside her bed. On a small shelf above her was a picture of N. C. Wyeth. Mumbling, half crying, she kept groping toward it, touching the wall. "I thought, 'God, she wants to be somewhere.'" Anna remembers. "I panicked and called out, 'Grandma, no, come back.' It was almost as though I was fighting someone in this wall."

The next day—Ann McCoy's birthday—Wyeth's sister Carolyn telephoned him. Their mother was lying in the upstairs hall. She had

started for the bathroom unattended and had fallen. He rushed to her—while his terrified sister stayed away in the far reaches of the house. He found Carol Wyeth nearly dead. He held her in his arms, feeling the lightness of her frail body. She said, "It's raining, isn't it?" He gave her mouth-to-mouth resuscitation, but felt her spirit slipping away, sailing out the window.

Carol Wyeth was cremated and buried in a treasured, midnight-blue cookie jar with gold designs, brought back from China by her mother. There was no church service. The family gathered in the family plot behind the Quaker Meeting House. Nat and Caroline had a minister read some verses over the tiny mound of earth.

For years Walt Anderson ignored a growth on his neck, hiding it with a beard. As his immune system broke down, he became vulnerable to little sicknesses. His eyes ran with water; he had nosebleeds. He blamed his condition on allergies, on the preservatives in food. He thought being out on the sea would cure him.

As early as 1982 Wyeth had seen Walt as a spirit in transit. He painted *Adrift* (opposite page 294), a Viking funeral for his Nordic friend. It shows a close-up profile of Walt's head and torso prone in Wyeth's dory as it drifts on the surface of the sea. Folded on his stomach, Walt's hands are knobbed and knotted and salt-cured by a lifetime of grappling with the sea. Beyond the dory is a line of frothy waves, white as Walt's beard, breaking across Hay Ledge off Port Clyde—where as boys they rode these tiny combers. "Andy grieved for Walt a long time before he died," says Jimmy Lynch.

There were five more years of paintings, including a symbolic tempera of the two rocking chairs on the porch of Eight Bells. Walt sits in one. The other is empty. The picture dangles the question: What spirit has already departed? NC? Andrew? or Walt? In July 1987 Wyeth started a picture of Walt at Horse Point near Eight Bells, where Wyeth as a boy played in the tidal pools. As Walt posed, he said, "You'd better hurry. I'm not going to be around long."

A week later, in the last days of July, the tumor so blocked his esophagus he could not swallow. He was taken to the Penobscot Bay Medical

Center in Rockport. His pancreas was cancerous. He was beyond help. Wyeth paid all his medical bills and visited nearly every day. Ann McCoy came and remembers his pale blond hair, pale face, pale, washed-out blue eyes. "He looked like Pa's painting of Robin Hood dying," she says. She kissed him on the forehead and sobbed as she went down the hallway. Wyeth telephoned Carolyn in Chadds Ford, saying, "God, it's horrible," and he wept on the phone. The next day, on July 31, 1987, Walt died. According to the Wyeth family lore, he choked on his breakfast and died of suffocation. The death certificate reads "metastatic carcinoma of the esophagus."

Wyeth arrived with Jimmy Lynch, who had Wyeth's pad hidden under his shirt. While Jimmy barred the door, Wyeth made a drawing of Walt dead. Later Wyeth said, "Everybody told me, 'Isn't it a blessing he died!' I answered, 'Blessing to who? Not for Walt. Not for me.' I'd like to prop him up and finish the picture. But it would probably finish me, too."

Joseph E. Levine, the movie producer who owned pictures of Walt, died the same day, and they appeared on the same obituary page in the Portland, Maine, newspaper. His widow asked Wyeth to be a pallbearer. Wyeth chose to go to Walt's burial in the cemetery at the Ridge Church in Martinsville, just down the road from Port Clyde. Before the ceremony, Wyeth was jittery, short-tempered. At the grave a calm settled over him. The whole family came, Betsy, Nicky, and Jamie—who was dressed in a Nazi admiral's uniform. Walt had served in the army, and the casket was draped in an American flag. The gathering was tiny.

Walt's death ended Wyeth's deep emotional ties to Maine. Christina Olson had died in 1968. In the summer of 1967, remembers Andrew, "I had a premonition that things were coming to an end, and I thought, 'God, I'd better zoom right in on her and do just her remarkable head.'" In the mornings he worked alone in the kitchen, painting *Anna Christina* (opposite page 22). At midday he retreated to the shed and closed the door while Christina made her agonized and humiliating crawl from the parlor room to the kitchen and hoisted herself onto her chair. Then she called out, "I'm ready." When the picture was finished, she thanked him for his thoughtfulness.

Christina's face is in three-quarter profile. She is seated in her kitchen chair, the pine back with its primitive New England scrollwork tilted away from her body. Her right eye, like that of most of Wyeth's subjects, gazes away, contemplative. But her wild eye stares out into a high and unknowable distance.

Wyeth posed Christina against the opened kitchen door and a bright gray rectangle of the fog that hung on for weeks, the moan of a foghorn sounding in the blanketing stillness. Wyeth once told Thomas Hoving that, "The fog crept into all the tonalities of her skin. That was fascinating to me because it brought out the intensity of her eyes, the light pinks around her eyelids, her mouth."

Wyeth talked, too, about the transparency of Christina's skin and its contrast with the green background of her dress—echoing the flour and the sour green apples she used for her pies. "There's a tonality," Wyeth said, "that brings out the quality of her eyeball and the way she looked at me. Every now and then she would look up at the clock which was up above and she had the strangest expression. Amazing. Just amazing. A powerful face with a great deal of fortitude. The quality of a Medici head. Terrific power in her strong neck. And there she was without any affectation."

For a long time Alvaro had been failing slowly but steadily. Christina once explained in a letter, "As he said nothing, I didn't." Cancer was eating away the bone of Alvaro's left arm. He kept on lifting Christina in and out of chairs, and, says her nephew John Olson, "She was a mighty handful." Stoically Al would remark, "I'm awful lame today."

When *Anna Christina* was finished, understanding that the situation was desperate, Andrew and Betsy broke his rule against altering the circumstances he is painting. At long last Christina *must* have more mobility. Planning to surprise her, Betsy took Christina off for the day. When they returned, a wheelchair waited on a new, smooth kitchen floor. But this best-intentioned gesture backfired. Wyeth remembers, his voice angry with self-disgust: "Oh, God, she came back and Jesus, she *hated* it. She blamed Betsy and me. It was as if somebody came in and cleaned up my studio. You can be a do-gooder and do *more* harm!"

During the late fall of 1967, Al Olson's mind began to slip. One

wintry night he tried to load wood into the oil stove in the parlor. John Olson had been "tending pretty close," and Christina asked him to move them out of the house before they "got burnt up alive." Al went to the house of his brother, Sam Olson, and John took in Christina.

Forced to go to a doctor for the first time, Al was diagnosed as inoperable. He was placed in a nursing home in Waldoboro. Two days before Christmas he was found wandering in a snowstorm struggling to return to the house and to Christina. The next night, Christmas Eve, he died. Betsy's sister Gwen went to the small funeral with her son, who wrote the Wyeths that "Poor Al looked sort of out of place in his tie and white shirt."

Christina lived with John Olson for nearly a month, but his wife was not equal to the required nursing on top of her daily life, which included running a lobster restaurant at the tip of Hathorne Point. They passed Christina on to John's sister Ida.

The Wyeths sent Christina a check for five thousand dollars. With her spidery handwriting, she replied in a letter dated January 15, 1968:

> I came to Oakland last night with Ida. I hated to leave John's. She was good to me and kind, though I hated to have her do any more for me than was really necessary when I knew she was getting tired of me. Ida has a nice home, quite a large house, but they have put me in a room alone and that is hardly where I want to be at this time. Alone. Sure am glad to have the money you gave me. Of course, I do have a Social Security check, but that is only $35 so that yours is wonderful to have. As far as I know, no one knows that I have it. I got the plants you sent me. Cyclamen. Two shades of pink. It is growing fine and has many new buds. I left it at John's. I hope she takes care of it.
>
> Hope you can read this.
>
> Love, Christina

Write to me. If ever I needed a friend, it is now.

On January 20 Christina moved in with Marge Olson, John's first wife, who had not remarried. On January 27, 1968, Christina died—"of a broken heart," says Wyeth. He and Betsy received a letter from Marge.

Day Before Christina's Funeral, 1968

Christina Olson, Wyeth's friend and model for twenty years, died
in January of 1968. The day before the funeral Wyeth went alone
to the Olson house. He walked through the snow to the little
family graveyard where workmen had dug a grave in the frozen
earth near her mother and father. In later years plastic flowers
often bloomed by her headstone.

I wrote to Christina while she was with Ida and told her she was welcome here any time and got a letter back that she wanted to come as soon as she could get here. She didn't have a cold, but just that tickle in her throat all week. Thursday and Friday she asked me to mix her some soda and peppermint in a little water. She said her stomach was a little upset. Friday night she went to bed at 8:30. I think she was okay at six in the morning Saturday when I came and sat by her. Then at eight I realized she hadn't made any noise for quite awhile so I went in and she was gone. She was so depressed but did play games with the kids a few times and seemed to enjoy the birthday party I had for the twins Wednesday. I also know she had a letter from you as she asked me to open it for her and which I gave Laura Saturday so she could see it. I hope I did right.

Wyeth went to Cushing. The morning of the funeral he went out to the Olson house. "It had snowed hard during the night," he said later, "and the snow had sifted in the cracks and chinks of the kitchen door so that there was a thin line of snow right across the floor right up over her chair and down. It was icy white, almost like a finger pointing. Damnedest thing. It was like lightning coming across the chair. At the same time I could hear them using a jackhammer to dig the grave down there because the ground was so frozen."

Christina's death was national news. The press was so intrusive that journalists were asked to leave before the service at the funeral home. Christina's four nephews were the pallbearers, carrying the coffin across the field to the grave where she would lie next to Alvaro. There were no prayers. A light rain fell.

17

Christina's death in 1968 brought to a symbolic conclusion the long, seminal period of painting that reached back two decades to *Christina's World* and *Karl* and the artistic breakthrough triggered by the death of N. C. Wyeth. Now Andrew faced another time for reappraisal, for a new reason for painting. He was concerned that he was "beginning to just skim," was painting formulas, a Wyeth recipe. He says, "When you have a blank panel, you want to free yourself. You don't want to sit down and do the same thing you've done for the past thirty years. That's boring. Why do it? Except to make money. I'd done a painting of a farm horse in a field, and Lincoln Kirstein said, 'Andy, that's a horsey *Christina's World.*' He said, 'You're repeating yourself.' That was a hell of a shock to me."

Looking back on his development, Wyeth said, "I had great freedom with my watercolors, just swishing around. Then I got married, and Betsy took the place of my father, really, right in the bedroom. I felt so controlled by this strong personality. And that built up for years. Betsy and I had a very warm association, a wonderful happy marriage of completeness. I was doing well—and then I began to ride."

As early as 1966 Wyeth was saying, "I love to go against a theory of what's right and what's wrong. I think anything that becomes a dogma is dangerous." Searching for an extreme step, he added, "I'd like to have sheep come into pictures, and chickens. I'd like to end up doing a couple of nudes."

That classic subject, the female nude, felt like a radical departure. He had never drawn nudes in an art school life class. Instead, he was taught by a puritanical father who, Wyeth says, "was horrified by sex." So nudes had always carried that New England sense of the forbidden, a whiff of prurience, the excitement of reading about sex under his mother's bed.

He had done a few pencil nudes of Betsy during the first years of their marriage. Then in 1948 when he was thirty-one, Evelyn Smith, living

behind Mother Archie's church, allowed him to draw her in bed from behind while she nursed her first baby. She was nude under the sheet, and bit by bit he twitched it off down her body.

Wyeth has always shied away from any sudden, radical change in his work. He has occasionally longed for the ultimate freedom and challenge of dispensing altogether with the image. He has remarked, "I would love to paint just backgrounds." When asked why he didn't do that, he answered, "It would be too shocking." Moreover, any evolution must happen for a reason, naturally, seamlessly. He believes that a sudden, intellectual decision to change approach, style, content would flatten the emotional inspiration, thin out the work. The nude model must be part of some continuity of feelings and associations.

Wyeth's new evolution began in the fall of 1967, just after the completion of *Anna Christina* and days before they returned to Chadds Ford for the winter. Betsy and Andrew stopped along the road from Thomaston to Cushing to check out an odd structure behind the ramshackle home of a Finnish man named George Erickson. While they talked, a short thirteen-year-old blond girl, full-bodied in a bikini, appeared in the doorway of the woodshed, stroking a black cat in her arms as she watched them with a steady, unabashed gaze.

Galvanized, Wyeth spoke to Siri, and then hurried to the car, grabbed a piece of paper and a blue pencil lying on the seat, and made a rapid sketch. He asked if he could come back the next day and draw her. Shyly, she said, "Sure." But he should come after school let out.

The image of this young girl was still in his mind when he returned to Cushing the following January for Christina's funeral. Wyeth says, "As I followed the hearse to the funeral, I looked at her house surrounded by enormous pines and thought, 'God, that little girl's in there.' I was really hanging onto the thought because I realized that this moment was the end of Olson's. All the rest of the day I kept thinking how that young girl was there."

Christina in the Olson house had been a "source" that he could plug into, a place he could count on to excite his imagination, a bulwark against the nightmare of "blank brains." The end of Olson's left an anxious empti-

ness in Wyeth. The possibility of filling it with this child, at once untouched and exotic, was electrifying. Olson's had come to represent deterioration and dwindling. Here was effulgent, blossoming youth, a part of life he had never painted, a girl who could be the instrument that lifted him into another realm of painting.

When Wyeth arrived in Cushing for the summer in 1968, he immediately painted a watercolor of Siri in a bikini, from behind, leaning in the shed doorway. Next he posed her in the Ericksons' primitive little sauna, her hair damp, her body modestly draped in a towel. He made a drawing and showed it to Betsy.

Once again Betsy pushed him beyond caution. This time she said, "For God's sake, Andy. Nobody sits in a sauna with a towel around them. You don't dare go the whole way, do you?! Why don't you really *do* it!"

Wyeth answered, "Jesus, I can't do that. This girl's only fourteen years old. George Erickson will shoot me."

Betsy said, "If you have any guts . . ."

The next day in the sauna Wyeth asked Siri, "Would your father and mother mind if you removed the towel so I could just get your naturalness above?" She went to the house to ask her mother. Wyeth recalls, "I thought, 'Oh shit, here's where they're going to get a shotgun.'"

In a few minutes Siri returned and said, "Fine." She sat down in the sauna. "Now shut your eyes." Pause. "Now you can look." Wyeth says, "I almost fainted when I saw those beautiful little pointed breasts and nipples. And she looked right at me. I was as shocked as she was. And that's part of the picture."

Indeed, in *Sauna* (opposite page 310) there is an air of challenge, a feeling of "Okay, here I am." Virtually unique in Wyeth's work—one of the very few which imply that the painter is present—this subject stares directly out of the picture. The eyes are unsettling, as though she has been accidentally surprised, alone and exposed.

To Wyeth, Siri was "a burst of life, like spring coming through the ground, a rebirth of something fresh out of death." She was a true continuation of

Christina. Instead of a crippled woman hidden in a disintegrating Maine house, he now had a beautiful, blossoming young girl, hidden in another dilapidated house, where she slept on a mattress on the floor.

Wyeth described her environment when he spoke of a 1973 tempera, *Ericksons,* showing George Erickson seated in his kitchen, behind him the iron stove and a view the length of the house—a compendium of experiences in Finnish homes and Olson's and Teel's Island. Something mysterious, perhaps unwholesome, is beyond the door at the end of the hall. "I've been very involved with the Erickson threesome," Wyeth said at the time. "I spent the summer going back and forth down that long hall and shitting in the outhouse—the flies, the smell, unbelievable. But that's what interested me. I wasn't going to pick some idyllic scene in a Maine landscape. I'm not a person who looks from the outside in. I look from the inside out. To me the house has a sordid quality."

His imagination was teased by this seventy-five-year-old man, who was born the same day and year as Karl Kuerner and who had this luscious young daughter who walked topless around the house. "I suppose I like acidness in things," he once said. "And if I can't get it, I'm not interested. I get all these letters saying 'What a beautiful man you are!' I'm not very nice. When you paint the type of things I do, if you don't have that other edge, I think it becomes just soap opera."

Betsy Wyeth has always considered *The Sauna* one of her husband's finest temperas. Nevertheless, she criticized Andrew again for leaving the towel on Siri's lap. She told him, "Let's go the *whole* way. You're just being a nice boy and you're not a nice boy."

That was Betsy the "editor," who supported Andrew's strengths and policed his weaknesses. The next summer—1969—angry at himself for being wishy-washy, Wyeth painted a full-length frontal nude of Siri titled *The Virgin.* The tempera shows Siri almost floating in the darkness of the Ericksons' barn, arms folded, her flesh and blond hair glowing in a shaft of light that cuts across her torso. "When I showed Betsy *The Virgin,*" Wyeth says, "it shocked her." That was the other Betsy, the wife and woman who was upset by this young girl so involved with her husband—the Betsy who

years later reprimanded him for saying "pubic hair" in an interview with Thomas Hoving.

Betsy was further disturbed by disapproving town gossip: Andrew Wyeth was corrupting a minor. The storekeeper, Irving Fales, warned him that the rear of his car was often visible behind the Ericksons' chicken house. Nearby, along the road to Thomaston, a sculptor of gigantic wooden figures kept his wares set out for sale, and he now included a towering penis painted pink. When townspeople complained, he changed it into a finger.

That summer of 1969, pointing at the Broad Cove house, Wyeth said, "Oh, we have our arguments. Sometimes that roof lifts up and down." He described Betsy at dinner asking what he'd been working on that day. He continued, "I'd get this queer expression because I'd been working on her crotch." He added, "You can't have someone around questioning you that way."

Late in the summer *The Virgin* hung on the wall in the living room over the sofa. One day he lay beneath it and speculated that marriage to "a difficult woman" perhaps heightened his emotions, maybe gave everything an edge that a placid life would dull. He talked about the need for absolute single-mindedness in his work, the necessity to move ahead no matter what the stress at home. He explained that the death of his father was a reason to paint that had carried him a long time, but had finally petered out. "Now I've found something else that excites me," he said, and described his hand shaking as he painted. He hoped these wild emotions found their way into the picture. Referring to the toll paid for being so involved with a subject, he said, "Every time we work we commit suicide a little."

He talked, too, about an artist's almost religious obligation to follow a string to its very end, no matter where it led. He wanted to follow Siri through her entire life, show her mature, even pregnant. "It's never been done before by an artist," he said.

After *The Virgin*, Betsy lived in the irons of her predicament—the historic plight of wives of possessed artists. She had the perks and powers that went with the position of being Mrs. Andrew Wyeth. She had the artwork she so

The Sauna, 1968

The dramatic successor to Christina Olson, the
trigger for a radical turn in Wyeth's painting,
fourteen-year-old Siri Erickson sits in her family
sauna—a girl seemingly surprised, almost defiant.
The painting was Wyeth's first major step
into the classic tradition of the female nude.

revered. She could dedicate her life to enabling it, to being its archivist for posterity. She once said that art, which is for the ages, is more important than relationships.

But she also suffered the ripple effects of Wyeth's obsession, the stress of a husband whom she loved on a deep level but who routinely reviled marriage, regularly announcing that the bachelor Winslow Homer had been the only wise artist. Wyeth once said in Betsy's presence, "I think women are wonderful and I think men are wonderful. But sometimes together, they're a bunch of shit. Possess! That's what it is. And that finally wears thin. Get married and the romance is out the window."

There was a kind of comfort for Betsy in her view that Wyeth's relationship with all models is ultimately detached and temporary. As she once explained, "When Andy is going to begin a tempera, he sees a total play, a total situation. It's as though he's creating the role of Hamlet from first to last on the panel. Siri can't act it out. She doesn't know the part she plays. He is using her face to tell what's on his mind at that time in that situation. He assumes the role of Siri himself. He uses her, pays her, keeps her happy because he needs her physical presence. But he's *becoming* what he paints, the intangibles. He *is* the person. When he comes home he doesn't leave off."

Betsy's assignment, living with "this remote, peculiar side of his nature," was to be the stable contact point that kept Wyeth's sanity in his world so saturated with imagination. During a walk up on the ridge, he turned to her and said with wild intensity, "You must remain real. You are the only real thing in my life. Everything else is . . ." But now, faced with a nude teenager, being that rock felt superhuman to Betsy: "I told Andy I wasn't sure I could handle it. I just . . . well . . ."

But nothing was going to deter Wyeth, no emotional cost to himself or to anybody else, no force except George Erickson with a shotgun. He had wholly bought the principle that the work justifies the means, that every aspect of his life is subordinate to painting the best possible pictures. "What does she want?" he said angrily. "For me to paint wagons all my life? I've done that. I've exhausted that."

To Wyeth the arrival of Siri as a model was like the World War I classic *The Big Parade* that had gripped him as a boy. Wyeth once explained

Witching Hour (detail), 1977

Andrew painted the power of Betsy's anger and beauty in two por-
traits. One shows candelabra flames blowing in the still air of a typ-
ical Betsy project—a one-room school added onto the Bradford
Point house in Maine (ABOVE). The second portrays Betsy stun-
ning in a Quaker riding hat, her cheeks flushed with a sudden rush
of indignation (OPPOSITE). It is also a surrogate portrait of her
mother, Bess, and the only painting Wyeth personally owns.

that the beginning of the movie "is monotonous, which is interesting. Then the scene comes when they move up to the front. There's an abrupt stop. The bugle sounds the call to move up. That's practically what happened in my life with Betsy. There's an abrupt stop with Siri, as if I just shut the door."

But Betsy had already closed a door partway behind her. On one level she and Andrew were a prototype of an exciting marriage—serious talents full of fun and zest for life. Time with them was uproarious with laughter and enthusiasm—or mesmerizing with reflections on the creative existence and the essences of painting. Nevertheless, the ties binding these two determined personalities were already being stretched, even before Siri complicated the relationship.

As the 1950s evolved, Betsy had felt trapped inside her husband's life—and her own. The schoolhouse was a Wyeth family artifact she could

Maga's Daughter, 1966

never wholly make her own, and it was located cheek-by-jowl with the shrinelike Big House. "I had to get away from that family," she says. She needed her own canvas. She found it in 1958.

That year Wyeth walked a mile upstream along the bank of the Brandywine River to Brinton's Mill, a stone gristmill, granary, and miller's house on a five-hundred-acre land grant made by William Penn in 1697. Built around 1706, the gristmill had been in continuous operation from 1748 to 1948, but since then had been left to disintegrate, rented to anybody willing to live there.

Chained in a dank, sunless hole under the steps to the gristmill were three hounds. The tenant, a hunter, kept them starved to make them avid raccoon trackers. One of them, named Jack, his ribs showing, slept in an oil drum with one end cut out, his coat matted with black sludge. Once the lead dog in the hunt, he was old and blind and kept permanently chained. Especially to Wyeth, addicted to freedom, this was a horrifying fate, and he saw in Jack an impressive, innate dignity, another unappreciated soul, another study of brutality.

Wyeth painted Jack's portrait in *Raccoon*. During the posing, he treated Jack like any other model. They were inseparable companions, Jack sitting erect in the front seat of the car. When Wyeth went to Maine that summer, he gave the owner money to feed the hounds and promised to buy Jack in the fall. The man, Wyeth later learned, pocketed the money, maneuvered the dog into a hole, and shot him twice in the head.

While Andrew was drawing at the mill, Betsy brought him lunch and explored the place. She unearthed a FOR SALE sign half buried by a recent flood. Betsy telephoned her mother who sent ten thousand dollars to help with the purchase. Wyeth had no interest in buying real estate. He once said, "I own lots of property around that belongs to other people. I've been there in rainstorms and blizzards and the cold and the summer, and I have it through my personal connection. I don't need to own something to love it."

In fact, the mill had always been a landmark in his life, a place where he had played and painted. As a boy he had swum there on family picnics when the mill was operating, and he remembered the last miller with his bright blue eyes and the rest of his body, even his eyebrows, white with

flour. He remembered crawling through the darkness of the tunnel-like rooms clogged with machinery and coated with mud swept in by floods. He remembered "the shaking quality of it, terrifying, rattling chains and horror." He remembered the deliciously shivery story that one miller had buried there a stillborn baby.

He was excited by the Revolutionary War history that had happened on that ground. Brinton's Bridge was originally Brinton's Ford, upstream from the crossing controlled by John Chadd. In the Battle of the Brandywine in 1777, General John Sullivan was in command at the mill, fighting an artillery duel against the Hessian general Wilhelm von Knyphausen, positioned on the ridge across the river. Wyeth once stood under the roof of the mill and marveled that those beams had heard the thunder of those cannons. In his imagination, the British forded the river there, rifles held above their heads, and the Redcoats stopped at the mill and used its flour to rewhiten their leggings.

Hating any change, interested in natural decay from weather and time, Wyeth dislikes anything that is fixed up. As soon as Betsy had bought the mill buildings, he began a flurry of pictures to preserve on paper their semi-ruined state, "before the wrecking crew moved in," says Betsy, ironically.

The restoration became the focus of her energies and her days, and a new direction for her life. In danger of having no identity of her own, no separate power base, Betsy had found a forum to assert herself, found her métier. She is an artist—a painter, a writer, an architect—who is all instinct and taste, without the accumulated craft. However, she can realize her visions by her remarkable ability to work *through* men, inspire them with her ideas and insights—as in her role with Wyeth. Men have, says Betsy, "helped me fulfill my ideas of what to do—they've been innocent, never done it before. Men are so wonderful because they're so open to an idea—kind of sharing a vision."

She hired two jacks-of-all-trades, Louis Pepe and George Heebner, a chemist by training. They were men who discussed free will and existentialist philosophy as they gutted the granary and miller's house down to the stone shells and rebuilt the interiors. Heebner has since spent his career maintaining Betsy's small empire and restoring the gristmill to working

order—with its sixteen-foot-high waterwheel, ten-foot paddles, and French grinding burrs.

Her baseline compulsion, Betsy believes, "is making order out of disorder," and she shares Wyeth's feelings for castaways, whether neglected houses or toy soldiers. When she first settled in the schoolhouse, she repainted Wyeth's soldiers, which had been damaged in a flood in the basement playroom of NC's house, and she reassembled the broken houses in the toy German village. "I love things that need attention," she says.

Her extraordinary passion for houses first surfaced in Betsy's childhood, when her favorite game was "rooms." She arranged flat boxes in a floor plan, each compartment a room that she furnished with pictures of sofas, lamps, rugs, and so on, cut from *House Beautiful*. Through these rooms she walked elegant ladies, scissored from a dress pattern book.

The mill buildings were part of a long march of projects that started with two stalls in her parents' barn, converted to living quarters. She added a kitchen and dining room wing to the Chadds Ford schoolhouse. Since the mill, she has bought and redesigned three nearby buildings in Chadds Ford. In Maine, after reconstructing the colonial house on Bradford Point during *Christina's World*—and later adding a one-room schoolhouse as a dining room—she redid three buildings at Broad Cove Farm. She moved a one-room library to the field beside the driveway. Going past it, Andrew remarked, "This is part of Betsy's village."

When she gave Southern Island to Jamie in 1990, Betsy already owned two other islands three and a half miles offshore—tiny Benner, where she designed and built a house from scratch, and the mile-long Allen Island, a place of five-hundred-year-old birches and ferns up to Betsy's waist. She had unfulfilled plans to raise caribou there, and in collaboration with the Island Institute did install an experimental sea hatchery for salmon and sea trout.

One result of the project was the lyric *Pentecost* (opposite page 326)—fishing nets like handwriting hung up to dry. In fact, Wyeth regards the picture as "a more mature *Wind from the Sea*." It has, in his mind, "a fateful quality, the eerie feeling of a phantom." As he painted, he thought about the daughter of a friend who had fallen overboard and drowned. Her body,

the head smashed, eaten by crabs, drifted by Allen Island until it was found to the south off Pemaquid Point.

In October 1961 Betsy and Andrew returned from Maine and settled directly into the granary at Brinton's Mill. He continued working in his studio, and Jamie moved immediately into the adjoining schoolhouse room, annoying his father by playing music as he painted. Wyeth said nothing. "Andy likes to have people around," says Betsy, though she herself no longer felt able to drop by the studio, now very much his private preserve.

Two years later, in October of 1963, they settled into the miller's house—henceforth named The Mill—which was enlarged by a wooden wing and a long garage shed. Betsy's perfectionism was now implemented by money, and the interior was a study in elegant, almost glamorous simplicity. The furniture includes Pennsylvania antiques—original Chester County crown chairs, a 1720 walnut corner cupboard, a set of Green Edge Leeds chinaware—mixed in with fine reproductions and new pieces.

Betsy explains: "People think if they can afford diamonds, then everything *has* to be diamonds." Describing her vision, she continues, "It's how you look in a chair, how a human being looks in a room—what you do on my stage. I love what people look like in spaces and paintings." In Betsy's interiors, the tones and atmospheres, the austerity, repeat Andrew's work—"Like walking into a Wyeth tempera," she once said. But these are not his natural settings. When he walked into The Mill that fall of 1963, he said, "Where do I register?"

In its own way, Betsy's move to The Mill duplicated Andrew's later insistence on setting his own course with the Siri nudes. Both were experiencing feelings of abandonment. Wyeth, the watcher, concealed his real feelings from Betsy, even encouraged her in the restoration. "I had no idea that was destructive to Andy because he didn't want things to change," she says. "It's the kind of thing that drives me nuts about the Wyeths. You can't change anything."

For Wyeth the move from the schoolhouse to The Mill was a frightening, infuriating disruption of the routines that structured his creative

process. His anger still active in his voice, Wyeth says, "That was a shock to me because that was my environment—walked up over the hill—the country I loved to paint—and all of a sudden I was moved out, and there I was living up at The Mill. I would come down to the schoolhouse, but I was used to rolling out of bed onto my easel. That was a really great shock to me. I had to overcome that. I had quite a hard time—treading water for a while—sink or swim."

Betsy says, "I've heard over and over again that 'It was the worst thing you ever did, that day you left the studio.' You see, the security of me in the house left. The studio remained for Andy, but I wasn't in the kitchen doing things. I removed myself from the spontaneity—from being involved with his work on a daily basis. Putting him on his own somewhat. The time had come. He needed me to walk away. He needed to have secrets."

She continues: "But it must have killed him to come home at night from the studio. He must consider it a terrible weakness on his part to have to rely on the affection of a woman. He hates himself for it; hates me for it. Moving to The Mill—that's the sort of thing he is still getting back at me for. Andy's always felt abandoned by me. I'm not easily tied down—which made it possible for me to come down to Chadds Ford, where I didn't . . . can you imagine Andrew Wyeth doing that—leaving all his chums?"

In addition to her real estate enterprises, Betsy expanded her energy and independence into a second, consuming mission. She kept a black book of every picture, carefully numbered. In those early days many of Andrew's rejects and working drawings—whatever was not sold—were stored at The Mill in the attic and in the living room in a chest. In Maine the repository was a top-floor room at the Farnsworth Art Museum.

In 1967 Betsy began to channel her considerable energies into curating and capitalizing on her husband's work. That year she was the guiding mind behind the hugely successful Houghton Mifflin book of Andrew Wyeth's work—a project that opened up her horizons to larger enterprises. She was part of the energy behind the Brandywine River Museum, conceived in 1968 by George Weymouth, know as Frolic, who is

himself a respected artist and was married to Wyeth's niece, Anna B. McCoy. Betsy wanted a place to commemorate N. C. Wyeth by hanging his best work and she needed space to store and exhibit her own collection of Andrew Wyeths. On the day of Frolic's deepest discouragement—when the finances seemed impossible—they were together in the shell of the riverside mill he wanted to convert for the museum. Betsy told him, "You build the building and we'll put the pictures in it." A promise she kept.

The museum opened in 1971 and was an immediate success. A new wing was added in 1984. There is a room for a constant rotating show of Wyeth's paintings, using Betsy's stock of more than a hundred of his top works. The originals of N. C. Wyeth illustrations are on permanent exhibition. Also hanging are the works of the Wyeth clan—Jamie, Carolyn, Henriette, Peter Hurd, and John McCoy.

In the late 1970s Betsy rented an office behind a Chadds Ford antique shop. With the help of Dolly Bruni, a friend who had worked at the museum, she founded Chadds Ford Publications, marketing Wyeth reproductions—pictures from the 1976 Kuerner-Olson show at the Metropolitan Museum of Art—signed and numbered collotype reproductions by Triton Press. That year, she produced the book *Wyeth at Kuerner's*, and in 1978 moved her office to the granary, the third building in the mill complex. In 1979, needing an assistant also steeped in Wyeth's paintings, she hired and educated a full-time curator, Mary Landa, and Deb Sneddon was later added as the computer expert. In the early 1980s Betsy helped found the Island Institute in Maine. In 1982 she produced a book on Olson's, titled *Christina's World*—with her new helper, Patty Ralston. Betsy became interested in film, and after one aborted attempt, finally in 1995 produced *Snow Hill*, a sixty-minute documentary on Wyeth—done with the help of a young realist painter named Bo Bartlet. It has won a CINE Golden Eagle, the "Oscar" for educational films, which qualifies it for international festivals.

Her staff—with Patty Ralston replaced by archivist Diane Packer—maintains Betsy's records and the several thousand meticulously indexed sketches, working drawings, early untitled watercolors. Jamie once joked, "After Dad dies, we'll open a drawer and find him there with a number on his forehead."

In 1981 Betsy bought a split-level house for her reproduction business and named it The Ark. In 1987 Thomas Watson, Jr., the late chairman emeritus of IBM, visited Betsy and was impressed by her encyclopedic archives of her husband's work. They discussed what computers could do to preserve, organize, and reproduce images and information. IBM then set out to design a scanning device and computer software program that could store on disks reproductions that met the Wyeths' exacting standards. The result after three years was a milestone in computer imaging technology. In addition to Betsy's, there are just five other installations, two of them at the Vatican Library in Rome, used for copying illuminated manuscripts.

With Dolly Bruni and Deb Sneddon manning the computer and scanner in The Long House—another converted residence and successor to The Ark—Betsy is steadily accumulating a record of every Wyeth work of every kind. From this will emerge a catalogue raisonné of Wyeth's entire oeuvre, which she expects will list nearly ten thousand works of art.

Betsy describes her entire operation as "getting things on the right shelves in this big pantry of mine, all the cups on one shelf, all the plates on another, that kind of order." Using this "crockery" she can pursue her deepest interest: trying to fathom the emotional and mental processes that her husband will not, cannot verbalize.

To deduce what Wyeth was thinking at a given time, she and her staff began in the late 1980s the long challenge of ordering his entire works chronologically. As though assembling a gargantuan jigsaw puzzle, Betsy studies photographs and transparencies of every stroke of Wyeth's brush and pencil, following the spoor that leads to major works. "I'm not doing it for anybody," she says. "It's just—I'm funny. It *fascinates* me."

When Betsy talks about Andrew's methods, her eyes are bright, her voice excited: "I often think of Andy when they're reporting earthquakes. Everything's quiet and suddenly it's *WOW* over there. There's no way you can tie him down, this man I've been living with. I mean, why does *Christina's World* suddenly appear? Makes no sense at all. What goes on? Why is something discarded, thrown away? Or something is so important he thinks, I really ought to do more about it, do a tempera." She elaborates passion-

ately, "An artist speaks through his painting. And Christ, it makes me sick that people don't pay attention to what an artist paints. It absolutely drives me up a tree."

Surrounded by an interest that had become a small industry, Wyeth talked of Betsy's accomplishments with amazed admiration. But he felt merchandised, saying, "You finish a tempera and right away she's talking about a reproduction." He felt displaced

Managing their business affairs, dealing with the outside world, secure in her judgments, Betsy became a potent force in Andrew's practical and painting lives, even more powerful than his father. Here in the living room of the Bradford Point house, Betsy charms and persuades as Andrew takes a back seat.

within Betsy's domain. During the Siri era, in a typically perverse gesture of rebellion, Wyeth swapped a painting for a successor to the Lincoln Continental, a custom-built Stutz Blackhawk as long as a locomotive with a booming sound system. He explained, "The reason I got this car was to cut the grease. I'm so sick of antiques. Quality houses and beautiful simplicity. I'm really bored to death with it. I'm sick of tastefulness, the thought of the precious artist who knows how to live, has the finest options. I'm delighted to say that Elvis Presley has two of these cars—and Sinatra." When a Japanese curator for an exhibition murmured that the Stutz was out of key with what he had expected, Wyeth said, "It's my geisha girl."

The Mill became a place he goes to, a Kuerner's on a grand scale, an environment to be experienced and painted as a portrait of its impressive creator. Now that she was more detached, Betsy became a far more important subject. "What Andy needs to do is observe me—from a distance," she says.

In 1965 he painted a harsh portrait of Betsy called *The Country*, her resolute face framed in a window of The Mill, her castle, eyes challenging the world. He painted *Maga's Daughter* in 1966—Betsy beautiful with cheeks flushed by annoyance (page 313). Then *French Twist* in 1967. She says of those years in The Mill, "It all became looking at Betsy." Her dramatic hats, her hanging clothes, her shoes, became surrogate portraits. She has always set out objects that she knows will excite Wyeth—a black doll beside a stuffed black cat (opposite page 54). It is a role that both pretend is not happening, but, says Betsy, "It's part of the excitement. I'm expected to."

Betsy had designed one end of the granary to be her husband's new studio. Unsurprisingly, he continued painting at the schoolhouse. Jamie took over the granary as his dwelling. In a quiet voice, a mingling of rueful with matter-of-fact, she says, "Andy withdrew himself. Didn't come along. Didn't make the change of one mile. Stayed in the studio, and the close relationship vanished ever so slowly. Vanished."

The process of separating church (Andrew) and state (Betsy) that was begun in 1961 was consolidated by Andrew's new push into painting nudes. In October 1970 he did *Indian Summer*, Siri standing nude on a white-veined granite ledge deep in the spruce woods. He delighted in the

stillness there, emphasized by the wispy buzz of a faraway chainsaw, the tiny barking of a dog. In the silence a fall leaf would float past him. "Nobody knew I was there," Wyeth said, his voice a whisper. Siri laughs, remembering herself posing there during chill, damp October days, shivering, covered with goose pimples, while Wyeth sat happily bundled in a sweater and pea jacket.

Far more than any previous model, Siri, in her direct, uncomplicated way, opened up to Wyeth completely, trustingly, to a degree he had never before experienced. It was intoxicating from such a young girl. She allowed him to touch her, feel the construction of her ankles, the softness under her arm. He wondered at the vulnerability of her flesh exposed there in the woods. "It is so rare that you can get complete access to a person," he said then. Her inner freedom made him feel constricted. He fretted, "I can't free myself in my painting."

Sometimes the two were like children together, sometimes Wyeth was parental, and he told Siri, "I'm not a good man, but I was well brought up, and not all men you're going to meet will be. So be very careful." As he once remarked, "She was like a marvelous daughter to me. Thank God I never had a daughter."

He felt that sex with Siri would fatally alter the relationship on which the paintings were poised. "I'm not physical," he said at the time. "I'm dangerous in the mind." For her sake he withheld the nude paintings until she was nineteen years old. "With Siri," Wyeth says, "I was a very upstanding, righteous man. But I still have this juvenile romanticism toward her and I can't break it. I don't want to break it. Isn't that terrible? I consider this a weakness in me. I'm a born romanticist, to the point where I didn't want to see her changed into something completely different."

Siri began seeing boys and telling Wyeth about them, such as the one who kissed like a wet napkin. He felt that he was painting against time. Soon some boy would take her away from him. The openness of their relationship, her innocence, would change, her loyalties and time divided. "It will be all over," he said then.

Typically, Wyeth was developing another potential nude model, Helga Testorf. He first saw her in 1969 when she was thirty years old. He

was struck by her Germanic, blond beauty as she sold home-baked bread from a van during the May Fair at the Chadds Ford school. In December Wyeth located her split-level house across Ring Road from the Kuerner farm. He bought bread and suggested she go to The Mill and sell Betsy some German Christmas cookies. Betsy at the door said she was sorry, but she did her own baking. She was left with the impression of a worried face and three children peering out of a van.

In the spring of 1970 Wyeth was painting *Evening at Kuerner's*, a watercolor of the square white house, the cooling shed, the pond waterfall, and the light in Karl's bedroom window. Karl had been diagnosed with leukemia, and from then on his life would be up and down, attacks and remissions. At that time, Wyeth thought he was dying, thought of the square of light as "Karl's flickering soul."

During the daytime drawings for this picture, Wyeth saw the small figure of Helga going back and forth to her job at Kuerner's, helping to care for Karl and doing what housework was beyond Anna's capabilities. That spring, too, as he worked inside Kuerner's doing a dry brush of Karl cradling his rifle in front of a set of moose horns, he was aware of Helga. Into the hush of his third-floor studio room came the sounds of the whole farm—the voice of Karl drinking home-brewed cider with his friends, the rumbling of the Brown Swiss cattle on the hollow barn floor, the rhythm of Helga's accented voice, reminding Wyeth of Marlene Dietrich's.

In the living room he listened to Helga and Karl Kuerner talk in German and sing songs. "I just sat there and watched," he says. "I was involved, but she almost didn't know I was there." If Karl died, here was a continuity with things German; now Wyeth was finding excuses to probe into her life. He drew Helga's reddish blond, ten-year-old daughter, Carmen, on Kuerner's Hill, perhaps connecting her in his mind with Siri. Helga invited him to her house for tea, and he drew her in pencil. Learning that she played the mandolin and guitar, he visited her at home, along with Jamie and a friend who was a professional guitarist.

Helga's American environment—her stock split-level house with its swimming pool out back, children's plastic toys lying about—was a setting

dramatically distant from the usual Wyeth haunts. But this was vital to his interest. His voice high with passion, Wyeth says, "Jamie said, 'Can you imagine living in a place like that!' It was *very* important to me that she lived in a split-level house. The odors in the house. Sweat and the sweet smell of sprays. Gracious living is not something I can sink my teeth into. The split level cut the grease from the Swiss Alps stuff. It was the *contrast*."

Elaborating, he talks about his boyhood crush on Janet Miller, stealing kisses on her porch. Two years later, he stopped by one evening and saw Janet through the window, nude. "It was the contrast of it that shook me. Contrast is the thing that probably has interested me the most. It's like the Kuerner house. The smell of gingerbread is there, but there's another side—Karl machine-gunning American troops coming toward him through the woods. If you're sensitive, there's a contrast. That's all we have to work from."

In the late fall of 1970, following *Indian Summer,* Wyeth painted Anna Kuerner, and then began reworking *The Kuerners* after Anna walked into the line of sight of Karl's gun. But Wyeth's interest in Helga was growing. In December he encountered her in the entryway, bringing a decorated ginger-bread house to Karl, her dark fur hat dusted white with snow. Wyeth commandeered both Helga and the gingerbread house—a tiny German reverberation of Kuerner's—and took them to his studio to make a drawing.

In the winter of 1971 Siri was still much on his mind. For years he had wanted to see Maine in the deep snow and he wondered about Siri in that landscape, perhaps also wearing a fur hat touched with snow. Jamie was going up to Maine; Wyeth decided to join him. "I had a compulsion to settle some things in my mind," he said later. But he feared a fight with Betsy about Siri. Only when Jamie picked him up at The Mill at 7:00 A.M. did Wyeth annnouce to Betsy his plans. As Wyeth tells it, she threw his suitcase at him.

In Maine he was furious with himself. The anticipated excitement was not there. Jamie wanted to go to his house on Monhegan Island. Andrew felt stupid, coming all that way to paint Siri when Helga was at Kuerner's. He had never been able to paint Karl's daughters because they were con-

stantly busy with farm work. He says, "I could not get out of my mind the image of this Prussian face with its broad jaw, wide-set eyes, blond hair. I thought about my Swiss background and the kind of girls that Zirngiebel must have known in Switzerland."

Wyeth continues, "This girl was very beautiful, remarkable in her earthy, German quality. Not made up, not the American beauty. Very clean. Sweet smelling. Rosy cheeks. Not talking about getting a new dress and all the kind of crap I have to hear." After a week in Maine, much of it with Jamie on Monhegan, he returned to Chadds Ford and immediately painted Helga in a peasant dress—but said nothing to Betsy about this new model.

The following summer, 1971, when Wyeth arrived in Maine, he found his fears realized. Siri had a steady boyfriend who forbade her to pose in the nude. Wyeth told a friend, "Siri's gone. But I've already got something new that's twice as good. I think it's very sad—writers, artists work on something and they see it fall apart in front of them, and that destroys them. I believe you already have to be working on something else that you care about."

Betsy was still focused on Siri. In the next summer of 1972, Betsy hired her as a live-in maid of all work. Siri was thrilled: "I was living in dullsville, I thought. They made simple things very, very pleasurable. Life was fun with them. I don't know what happened after the incident."

Late that summer, Wyeth painted a tempera called *Black Water,* showing a nude Siri prone on a sandbar, like a sea creature beached there by the outgoing tide. The water in the pool is dark and deep, with a sense of swirling, invisible currents. Wyeth said to a friend, "You can't tell whether she's alive or dead."

During a break in the posing, Wyeth lay fully clothed on the sand beside Siri who was blistered from sunburn. Gently he rubbed her back. At this moment, Betsy, out on a walk, stumbled on this scene and demanded to know what in God's name was going on. Siri gathered up her clothes and fled. Wyeth was apoplectic with rage. Betsy says, "If he'd had a rock, he would have hit me with it. He followed me home just screaming at me,

Pentecost, 1989

A rare Wyeth painting of sheer beauty, *Pentecost* shows nets "like a fog" drying at Betsy's Allen Island with Benner in the background. A young woman had drowned nearby and, he says, "the nets became her spirit." Always ready to try anything technically, he did the cold blue tracery of one plastic net using a simple pencil on top of tempera.

'What are you doing, coming down interfering in my life. You always—Goddamn it—you're the worst woman I ever . . .'"

Back at the house Siri sat ashen-faced. Betsy said, "Siri, should I be disturbed by this? Is this something I should just put out of my mind? Has he gone too far? Has Andy made love to you?" Siri looked straight into her eyes and said, "Of course not."

Betsy remembers, "I vowed then and there that this was the end of Siri." She said to Andrew, "If you do this again, don't tell me"—a decision he had already made.

18

Helga was Wyeth's model for fifteen years. He did not tell Betsy, and he hid most of the paintings. This decision caused painful, permanent repercussions in his marriage. The secret collection was revealed and exhibited in 1987 at the National Gallery of Art in Washington, D.C. The pictures traveled to six other major museums throughout the United States and were seen by a million Americans. They triggered a front-page uproar in the press, including simultaneous cover stories in *Time* magazine and *Newsweek*—and they severely damaged Wyeth's standing in the art world.

Ignorant of the actual circumstances—the compulsions, the conflicts, and the agendas—the press played the story as a tabloid sensation. Columnist Paul Richard wrote in the *Washington Post:* "The tale as recounted had the irresistible ingredients—a blue-eyed naked beauty, no identity disclosed, a suggestion of illicit sex (she took her clothes off, didn't she?) . . . juiciest of all, a wife misled for fifteen years until husband, fearing death, reveals the stunning truth."

Most of the art-criticism establishment once again dismissed Wyeth as pictorial and sentimental—and routinely pushed the theory that the whole event was a hoax concocted by Andrew and Betsy to boost sales. This proposition originated with Richard, who continued: "There is one flaw in the story of Wyeth's 'secret.' Much of it is not true. That Wyeth had been painting a sexy blond model with high Germanic cheekbones and fine, curvaceous body was no secret to Betsy. Nor was it a secret to the world at large."

In fact, the real story of Helga is a textbook study of the modus operandi of Wyeth, whose nature and art are all about hiding. He once said, "The whole drama of Helga was a lightning flash of excitement in my mind. I didn't sit back and ponder, 'Should I do this at all because of my marriage?'

I didn't give it even one thought. But that's the way I do things. I jump overboard and then think about it afterwards. To hell with what little minds think!" Exactly as he had done as a boy, escaping his father in Chadds Ford, he slipped away over the hill.

In Wyeth's head he had no choice. To paint as he wished, he *had* to escape a replay of Betsy's acute ambivalance toward Siri in the nude. More important, he *had* to break loose from her influence—even as he sometimes invited her to the studio when there was a problem he sensed but could not solve. Describing these critiques, Betsy said, "He's apt to hang on to an original idea, maybe it's a shaft of light. I don't know this, but when I tell him, 'The weak point is *that*,' he says, 'But the whole painting depends on that, Betsy.' I say, 'Well, it's crap. It's absolutely crap. It's got to go. *That's* your problem. Put your hand up there.' He says, 'Well, leave me alone. I'll think about it.' Or 'You're going to ruin it.' Then the next day: 'How do you always know?'"

Wyeth was repeating the syndrome he had lived with his father, simultaneously seeking Betsy's judgment and feeling stifled and overpowered: "Any strong person—you begin to lean on them. You ask them before you make your mind up. There's nobody I loved more than my father. But when he got dictatorial, it became too much. I depended on Betsy to the point where I thought, Jesus, can I do anything away from her?"

He continues, "Betsy's very clear-sighted, and really a remarkable person to have around because she's full of bright thoughts and new ways of expressing things. But, Jesus, I felt regimented. I had to break that bond, flex my muscles on my own. People may think I was brutal in the way I went about it. But it was the only way I could feel I was doing something on my own. Nothing between me and the panel. I had begun to wonder, 'Is this me or is this Betsy painting this picture?'" His voice turns angry. "I wanted to see if I could do it with my own 'genius,' not Betsy James's 'genius.'"

While painting Helga in her peasant dress in Anna Kuerner's sewing room, Wyeth felt, "I couldn't stand *The Sound of Music* niceness. Just corn! I had to cut the grease from the Swiss Alps stuff." He asked Helga if she would take down the top of her dress and sit for a seminude. Though she had promised her hus-

band, John, that she would not pose in the nude, she undressed. "It was something I felt was right," Helga says. "The depth was there, and everything that goes with it was natural."

So there was another need for secrecy—Helga's husband must be kept ignorant. With Karl's tacit consent, Wyeth painted *Letting Her Hair Down* (opposite). The tempera is a first cousin to fourteen-year-old Siri in *The Sauna*. Thirty-one-year-old Helga shows the same slight coarseness, the same strength, the same defiance, but diluted by a feeling of come-hither. Her arms are folded, supporting her breasts, denting them, communicating weight and softness, a sexual reality.

"If anybody had known about this picture," Wyeth says, "that would have *broken* the amazing quality of Helga. When Betsy finally saw it, she said, 'Now, that's a bad picture. That's just a picture of a whore sitting there with her hair down.' If I'd heard that at the time, it would have stopped me cold. It would have taken the air right out of me."

A major attraction of Helga was her isolation. Unlike Siri, Helga's life was empty and static. She had become an American citizen but remained resolutely Prussian, refusing to assimilate herself and find friends in Chadds Ford. Lonely, unhappy, homesick, she was planning to move back to Germany. She would wake in the night, sweating, calling out her father's name.

While still painting Siri, Wyeth found a new model in Chadds Ford: Helga Testorf. This first nude, *Letting Her Hair Down*, was painted in 1972 in secret in a sunlit room on the second floor of Kuerner's. Instead of a virgin on the cusp of womanhood, he was painting an experienced German woman who had lived through the fall of Prussia in World War II and could inherit the military themes of Kuerner's.

"I didn't know anybody," Helga says. "I didn't know the next road what it was called. I knew Karl and my aunt and uncle, and that's it—and my home in Germany."

Unlike his other major models, Helga was not an extension of her surroundings, of a house, a farm, the sea. She arrived in his field of vision a disembodied figment of his imagination. In his imagination she shared his own sense of removal, of floating high and free above the subjects he paints. "She's almost not a person here," he once said. "Nobody knows her. She's an enigma. She hovers over the land she lives on."

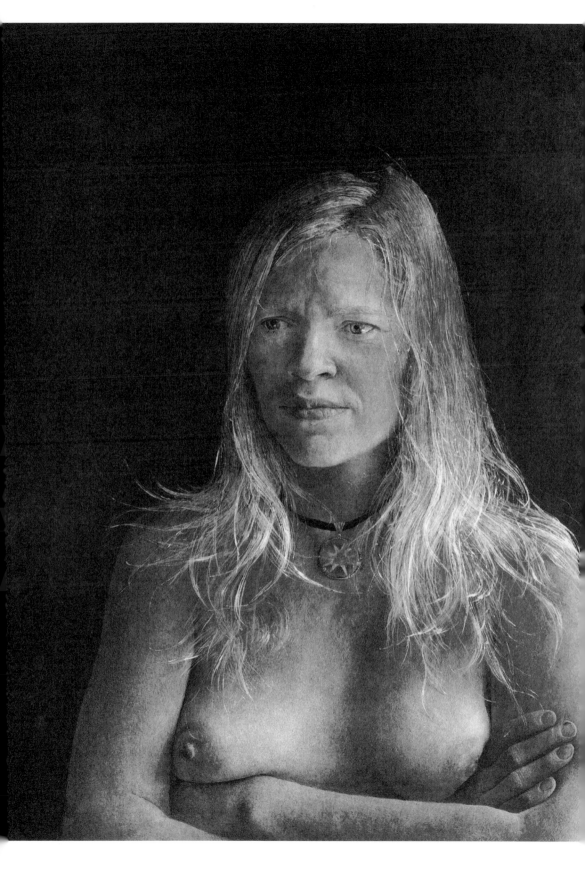

Helga came wrapped in the mystique of war and Germany. She was born in 1939 near the eastern Baltic seacoast town of Königsberg, the former residence of the dukes of Prussia and the coronation city of the later kings of Prussia. When the German state was re-formed after World War I, East Prussia was isolated from the motherland, a province boxed between the so-called Polish Corridor and Russia.

Helga had clung to her roots in the Prussian empire. "I'll never be German and I'll never be Polish," she says. "I'm Prussian! I know what people have on Germans. Why should I take anything for what they blame Germans for, because I wasn't part of that. I paid enough for that. I was chased from my homeland." In the self-image she projected for Wyeth, her heritage was still intact, the romance of a culture that had become a synonym for tough-ness, for cold and brutal authority. Wyeth was delighted by Karl's warning, "Oh, dear, you're painting a Prussian girl. Watch out. They're strong people, the Prussians." When Wyeth worried aloud about John Testorf, Karl said reassuringly, "Oh, she rules him like a Prussian general."

Wyeth stimulated his imagination with Helga's German icons—a medallion made from amber, a transparent, golden stone that is found on the shores of the Baltic Sea and that she calls "Prussian gold." When she posed for *Letting Her Hair Down,* Wyeth hung it around her neck. She says, "The gold and the German and the Prussian, it all melted together" (page 331).

She wore her girlhood wartime memories like another medallion, a precious part of her identity, doling them out to Wyeth in dramatic tidbits, sometimes changing them in the retelling. "My life," she says, "flowed with events that were always on the edge of life and death."

Helga describes herself as a "love child," special to her father in the family of two girls and a boy. But he was constantly absent from the family, first as a self-educated engineer drilling wells and building bridges. When she was two and a half, he left for the German army construction corps in Russia.

In the spring of 1945 Königsberg was designated a last-ditch fortress by the Nazis and bombarded by the British and the Russians. The streets, Helga said, were strewn with parts of incendiary bombs lethal to the touch—"death lying in the streets." Her mother took clothing to her hus-

band, then stationed in Germany. She rushed home across the disintegrating country in a freight train, sleeping standing up, and hustled the family to a refugee ship leaving for Denmark. "She had the guts of a Viking," Helga says.

Suddenly at the dock, tells Helga, her mother announced, "I am not going on that boat. I have nothing to cover my children, no beds, no blankets, no warm clothes." She and her son went to fetch a sled full of blankets and featherbedding. The boat they missed was sunk by the British. "Destiny had its own way," Helga says.

After weeks hiding in an apple boat, the family was loaded aboard another ship, the refugees tumbled together in a cargo net like a shipment of fish. As the convoy slipped out of the harbor that night, Helga described herself below decks, where "everybody was lying down, throwing up, crying, and I thought, That's not for me." She insisted on going up on deck with her grandfather, and so celebrated her sixth birthday watching Königsberg in flames.

In Denmark, according to Helga, they were semistarved prisoners for three years, hated by the Danes. Unable to return to East Prussia, then under Russian control, they lacked the necessary papers and sponsor to enter Germany. One of their several refugee camps was a converted stable. The families were separated by blankets hung from ropes. They had no heat, no electricity, barely edible food, straw mattresses they stuffed themselves. Helga was trained by her mother to be constantly suspicious and to speak to nobody, not even to say hello.

Helga's stories turned Wyeth's imagination to full throttle, and he describes Danes throwing the hated Germans fruit that was booby-trapped with hidden razor blades. He makes up the scene of Helga hiding by a railway embankment while British planes strafed the area. His eyes glittering with excitement, Wyeth tells of nine-year-old Helga, finally settled in Germany, helping her father bury his Nazi uniform, now a dangerous artifact.

In 1948 an uncle sponsored the family, and they settled in northern Germany near Helga's father, who lived alone in a single room. He visited but never truly rejoined the family. "He was a bachelor by the time we arrived," says Helga. Now she considered herself the family caretaker,

responsible for her siblings and helping her mother and father through illnesses. Music was a happy bond with her father when he was present. But, teaching her the mandolin, he once hit her across the side of the head, saying, "Practice, listen, pay attention, just concentrate!"

Helga's personal saga during World War II joined her with the boyhood World War I fantasies Wyeth had been replaying at Kuerner's. "The whole thing built in my mind," Wyeth says. "And it all fit in with the French girl in the movie *The Big Parade*, and it was very real."

In his studio Wyeth again and again reran for himself and Helga that 1925 classic war film: John Gilbert leaving for the front, Renée Adorée desperately running behind the truck as it steadily pulls away; American doughboys advancing in a wavy line through the woods, one man falling, then another, shot by invisible machine gunners like Karl Kuerner; John Gilbert returning after the war to France and to Renée Adorée. His figure jerks like a jack-in-the-box as he careens on one leg and a crutch down a twin of Kuerner's Hill—like Allan Lynch in *Winter 1946*.

Describing one way Wyeth invests his realism with fantasy, Betsy says, "Andy will suggest to a model certain things that he would like to have them think about themselves. He's going to make the actress do what he wants. Remember, he's a Bergman. He's creating a world they don't realize and they're acting out a part without any script." His manipulation was wittily described by his friend Helen Sipala, who has posed for a series of paintings, including *Marriage* (opposite page 182). "I have Indian in me," she tells, "so he sees Indian. He sees my high cheekbones. He sees that there's strength from the Indian. I'm thinking, 'Indian? High cheekbones? Really? That's interesting.' If you're German, he's going to see a German strength, and I'm sure that's what he's been telling Helga."

In later years Wyeth impressed on Helga his Robin Hood fantasies, telling her those epic boyhood dramas. She crammed for the part, reading the Scribner edition and jumping off the rocks as they secretly roamed the woods up behind the N. C. Wyeth house. When Wyeth talks about Helga, he sometimes mentions that she was a nun—which hooks her into his fascination with virginity and into the death of Robin Hood in the nunnery.

At age sixteen, in 1955, Helga entered a convent chosen by her father because it was a Prussian Protestant order. She had dreams of becoming a nurse or a teacher or maybe a missionary. After a near-fatal neglected appendicitis, she left the convent and continued training as a nurse and masseuse in Mannheim, Germany. There in 1957 she met John Testorf, born in Germany but a naturalized American serving in the army during the postwar occupation. They married the next year, and in 1959 Testorf was transferred back to the United States. Helga, equipped only with three years of school English, traveled by ship with their daughter, Carmen, to New York.

By 1961 they were living in Philadelphia, where Testorf worked in a leather tannery. The dust and chemicals aggravated his preexisting lung problems, and Helga insisted they move to the country. Through friends she found an opening for Testorf at Longwood Gardens near Kennett Square, Pennsylvania. "I'm the fire behind everything," she says.

She had an uncle living in the area who came from the same town as Karl Kuerner, and he steered her to Chadds Ford. She insisted on buying a house beside Kuerner's Hill. "You could call it a Black Forest hill," she says, adding in her hyperbolic way, "It was the concept I had in reflecting the scene at home that I was so attached to—premonition and fate and almost magic and depth and background all floating together. And so I thought it is destiny. I go no further." To make ends meet she did her baking—getting up at five A.M.—and taught music. Helga says, "I am German, I am Prussian, I can make something out of nothing."

From the beginning Helga saw herself and Wyeth as two magnetized atoms that joined in a void: "I was lonely. He was at a point where he couldn't go any further in his work, and he sensed that . . . he thought, What can I do to make her see what is here, so I wouldn't go back to Germany. He stopped me from being homesick. I think we were both ready for what became a reality. It was inevitable. I think it was in the—what do you call it—predestined."

Betsy remarks dryly, "They all feel that way. Siri felt that way. But then she was strong enough in character to put it in its proper place and go

on." In Betsy's view: "There are strong things about Andy's personality which are constant. He's a flirt. He can mesmerize any woman. Fantastic. He makes whoever he's interested in truly the most important person, and they never forget it. You find yourself. He's changed a lot of people's lives. Maybe that happened with Toulouse-Lautrec, maybe with Rembrandt. It is extraordinary."

Helga says, "He hypnotizes people. He plays with your mind. He brainwashes you to the point where you are forced to see through his eyes. You can't help being any other way because it is so strong and so irresistible. When he's at his best, you can't resist." In the experience of Jimmy Lynch, "He extracts things out of you that most people can't get to. There's no words to describe the love that you have toward yourself when you come out of it. He fills you up, makes you high with all kinds of self-esteem." Even the animals feel this, it seems. Karl's bull, after posing for *Young Bull,* followed Wyeth around the field.

Posing for Wyeth transformed Helga's life, gave it meaning and significance. "I became alive. It shows in the pictures. I became young overnight. I've never done anything more worthwhile." The experience unfurled the artist she had always felt in herself. She explains: "My mother tried to tell Johnny many times, 'Helga is supersensitive. If you do not realize this, you're going to lose her.' He never got to the creative me that needed to be nourished. I was starving at home for doing something like this. I wasn't born to be just a housewife. That bored me. I was brought up in the art world, and I knew it."

Her walk home after posing "was just something that nobody can even talk about, it was just so emotional, the richness of what I was thinking can never be recorded. I even regretted walking because I didn't want to be disturbed. I was like a deer. I was like a hunted animal."

Helga continues, "Shakespeare said, 'Every good-bye is a little death.' But death is a big good-bye. I lived by that with Andy. Death was my only fear during all the process of painting. Every time he'd go away it was a little death."

Helga has identified her whole being with Wyeth. From her mouth comes his vocabulary, his philosophies. She sees herself forged by the same

forces. "He was the forgotten child like I was," she says. "He was in bed drawing. I was in bed painting and scribbling and all that by myself. Nobody even knew I lived where I lived."

Under Wyeth's tutelage, Helga has become a painter herself—though she never shows her work to anybody. Excitedly she voices her version of Wyeth's obsession, words tumbling over each other: "The need to revitalize yourself through expression is the only way for me to live. The house will still be there dirty when I come back, but I cannot catch that light, that moment, I cannot catch my thought, re-create the way I feel, if that is not fulfilled. If I've done something for the day, then everything else goes smooth. Art and life is not disconnected."

Helga also writes poetry, which is likewise never shown: "If I haven't done a poem or something for a couple of months, see, it eats me. It can be fun if you have the poetic language that floats—all of a sudden you find these words—not like it is hammered out of you or something."

Often Helga stays up much of the night compulsively recording the day in notebooks. "How does one conceive what Andy conceives? By God, if I'm living a metaphor, I want to know how it comes about. So I have to keep track of every day until I know how the sparkle of magic happened. You don't go to sleep because your whole system is so stimulated through the experience. Unless I write it down, I can't sleep. I'm a driven dog. My head is burning. I have headaches all the time. I left my whole family in order to pose. Do you think that is normal?"

She feels between herself and Wyeth a mystical communication. While he was in Maine and painting *Off at Sea,* Helga brought her mother to the United States and took her down to Cape May. At the hotel, Helga remembers, "I went out by myself on the porch, which looks out to the sea, and I wrote the most beautiful poem of the ocean. He's doing a picture; I have an identical poem. I could be so far away and there it is. That's the connection he seeked [*sic*]. Through all the paintings, there was that connection."

Helga became, says Wyeth, the best of all his models. "She didn't care," he says. "I never had to baby her, worry about the room being too cold, all that shit that has nothing to do with the painting itself. She'd pose if I stood her

on her head. For hours. Once she was on her knees and got so numb that she fell over. I'd be lost, just painting like mad, slashing away, wild. She'd be smeared with paint 'cause I'd flick the brush."

He explains further: "I was a wild kid. The rest of the kids were going to school, college, having lessons and with their music, and I was on the outskirts running around, full of hell, interested in peering in. And now I meet this girl and can walk right up to her crotch and really look at it and draw it. With no feeling of Oh, you can't do that."

For Wyeth, posing is an intimate transaction. Breaking the zone of privacy, he brings his face within inches of the subject's. "I like the communication," Wyeth says. "You can see the pores and the act of breathing, feel the hot, moist breath." Often he measures a model's face, his hands close, fingers smelling of rotten eggs from the tempera.

His scrutiny is unblinking, a physical experience. One model, the American Indian Nogeeshik, said that Wyeth was the only white man who could meet his stare and not look away. When Wyeth was recovering from a hip operation in 1980, he painted *Bareback,* a nude of his nurse Pam Cowe, a small, blond, open-hearted, uninhibited woman in her thirties, full of gusto. "Being a registered nurse," she says, "I've handled millions of people in various stages of undress. I go to nude beaches. I have pictures of myself skiing nude. I'd been sunbathing topless with Andy. Never thought twice about it. But the second he started to sketch me—he was off to one side and I couldn't even see him in my peripheral vision—but I could feel him *really* looking—I felt the color going right to my face. That's the intensity. My nipples were erect three-quarters of the time."

Helga once said: "You know Andy, he makes everything fall in love with him. He can't help it. He'll create it, and if it isn't, it should have been." She paused and looked down. "Love is pain, too. Love is in the giving and that's not always . . . it can be painful, giving love."

On another day she continued, "Andy wants to be in control of the whole thing. Your body in love. Your body in hate. Your body in your emotions every day. Your body in his paintings. He needs to be in control."

Wyeth once asked Helga, "Do you think I'm selfish?"

"Yes, but you call it love."

19

Because the prime Helga paintings were kept together and secret, the series could exist in Wyeth's head as a single painting, a fifteen-year reverie. Wyeth says: "I wasn't trying to make pictures like *Ground Hog Day* or *Spring Fed*, very definite things I would just stick at. She was an image I couldn't get out of my mind. It was a constant flow, things happening quickly, making these drawings, most of them incomplete. I was almost writing a journal of an experience, coughing up my own life. Very few people do that."

Struggling to express fully the recurring themes he felt, Wyeth never thought of the paintings as completely finished. In fact, he planned to keep them secret throughout his lifetime, and he made that compact with Helga. To *her* the pictures were a secret offspring, totems to the bond she felt between them.

He stashed each picture in the third-floor room at Kuerner's. To keep a single, overarching vision, he returned there again and again to view them with the fresh eyes of a critical stranger. He says, "I had to do something absolutely alone, so I could do it for a long period of time—break the rhythm of finish and sell. That puts a fence around you." Liberated from judgments of good or bad, he felt free to do *anything*, almost a return to those childhood drawings that he hid from his family.

On a grand scale this was his usual process, keeping a painting fluid until the last minute, the composition unfixed, his options open—all to preserve the initial excitement that triggered the picture. He says, "That's one reason I don't like to show anything before it's done—because it makes it into a *painting*. Showing the Helga paintings would have turned the mood into *pictures*, broken it off."

During the Helga series, Betsy issued an inadvertent dare. Wyeth remembers her saying, "You know if you didn't have acclaim—I swear you paint pictures just to show people. You'd no more paint a picture and turn

it to the wall than commit suicide." He adds grimly, "I thought at the time, You don't know what you're saying, but go on."

In 1972 Anna's sister Matilda came from Germany to help care for Karl, who was increasingly weakened by leukemia. She strongly objected to Helga's posing nude in her domain. Karl reluctantly asked Wyeth to move out. But where? His own studio was impossible—too public. Helga's comings and goings could be seen from a house just down the road, and from above by the director of the Brandywine River Museum, James Duff, now living in Dr. Margaret Handy's house. Moreover, without the Kuerners, Helga had no pretext for prolonged absences from home.

Their savior was Carolyn Wyeth. Like her brother she believed that art justifies any behavior and stratagem. "I didn't disapprove," she said. "You see, with artists—he was doing those great pictures of Helga, so what does it matter anyway? People say I'm unconventional, but it's beyond that. It's painting."

Carolyn lived in the Big House with her mother and ran an art school in her father's huge mural studio. Attached to it was her own small studio. She now turned it over to her brother. A joyous, almost pathological conspirator, Carolyn was her brother's enthusiastic enabler, feeding Andrew and Helga baked potatoes for lunch. Ever since childhood they had shared what Betsy calls their "deliberate collaboration to get away with things they weren't supposed to do." Carolyn once announced with pride, "Andy told me he'd learned from me—he said, 'You've always been so secret and private. You're the one who taught me the position I had to have in this family to keep painting . . . the only way to do it.'"

Secrets were her soul food. "She loved intrigue," Betsy says. "If any girl needed an abortion, needed a meeting place with a lover, they could

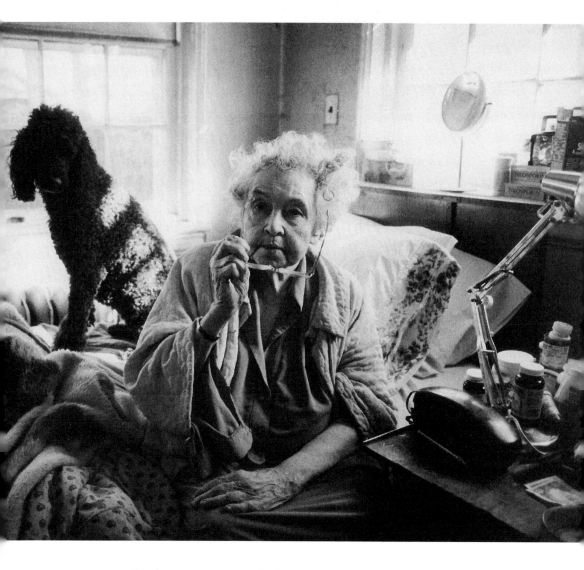

count on Carolyn to arrange it. She knew secrets about men, knew who were cheating on their wives." Betsy laughs. "Because she made sure they cheated with her."

After the death of their mother in March 1973, Andrew was the one person Carolyn loved and respected without qualification, the only being she never bad-mouthed, the only one who could control her. While dependent on him, she

When Karl Kuerner asked Wyeth to stop painting Helga in the house, Carolyn Wyeth joined the conspiracy and made available her little studio. Semicrippled, congenitally rebellious, she was living alone with her dogs in chaos in the back of the N. C. Wyeth house and took Helga on as a nurse/caretaker.

still thought of herself as the protective big sister—calling Andrew "poor boy" and "poor kid." She worried about his health—along with her own. She was severely handicapped by an arthritic knee and the ankle crippled by her fall from the window while she was married to Frank Delle Donne. She suffered from an irregular heartbeat and a burning acid stomach.

In one of her headlong monologues, she once said, "I haven't told Andy I have this awful pain in my stomach. I'm not going to have him worry that I'm going to pass out on him." She pauses for effect. "He doesn't realize I've been sick as hell. I don't tell him. I leave him alone." Hurt fills her voice: "I haven't seen him for three days." Defiantly she continues, "If I've lost him, I've lost him," and, sobbing, adds, "Andy's great. Who the hell is he going to talk to but me?" Now she is angry: "They're all damn fools in this family, the whole damn bunch. I'm the only one." Now matter-of-fact: "He's excited about the picture he's doing in the Big Room." And finally conspiratorial: "Betsy'd kill him if she knew he's here with me. Oh my God! I just hope somebody doesn't let go on me."

In fact Betsy and Andrew were crucial to Carolyn's survival in a world that she could not handle. He was determined that she remain in the Big House undisturbed. "She'd do the same for me," he once said. A free spirit, she should live as she wished. Never mind that she might burn down the house. He blocked all talk of moving her out. "They don't like me here," Carolyn once raged. "I'm too strong, and my mother left me too much."

The Big House had been willed to all the children, with the proviso that Carolyn remain in residence during her lifetime. Andrew and Betsy arranged with the other heirs that it pass to the Brandywine Art Museum. Carolyn also received the money in the estate, NC's store of unsold paintings, and full title to Eight Bells—which she willed to Andrew. He paid all her medical bills, and she supported herself by selling her father's work and her own and the drawings that her brother deliberately left in NC's studio. She once sold an Andrew Wyeth for a million dollars—and spent the money in four years.

At first the house remained relatively presentable, much to Wyeth's surprise. "Andy is so disappointed," Betsy said at the time, laughing. "He expected there would be some really creepy things, a dog at every window."

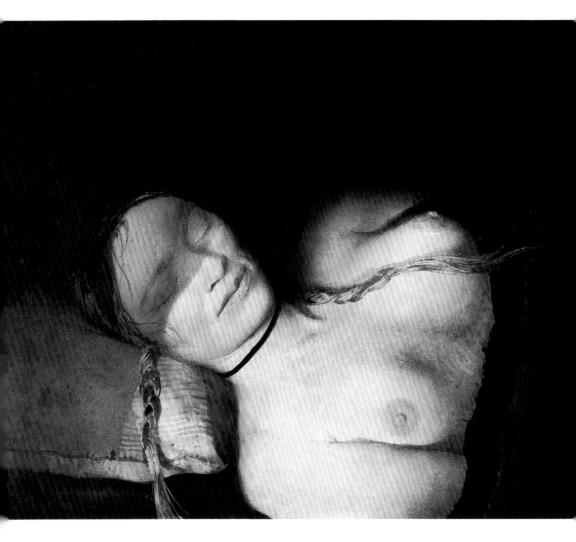

Night Shadow, 1979

When his father was killed, Andrew went alone to the
Quaker Meeting House where NC lay in an open casket.
Thirty-four years later he painted that moment and its
emotions, using his model Helga Testorf as a medium
for that memory. "All past experiences are endless in
their return to me," Wyeth has said. "So in my paintings
there is a quiet, personal tie-up, an echo of the past."

Sounding like Carolyn herself, Wyeth kept saying, "I just can't believe that she has this conservative side underneath everything. That's the trouble with my family. They're too damn conservative."

Much to the disgust of Nat, Henriette, and Ann, their sister's eccentricities did in time desecrate the childhood home their mother had kept so immaculate—"like an old polished shoe," said Nat. Carolyn settled into the back room off the kitchen. She regularly kept at least three dogs, often outcasts like herself in danger of destruction. She indulged them with filet mignon—and screamed at them till they cowered beneath her bed.

Impatient, she refused to use crutches to get around. Afraid the dogs would run away, she tried to expedite their bowel movements by shoving suppositories up their rectums. If these did not immediately work outdoors, she brought the dogs back inside, where they left brown turds and yellow pools on the wood floors and the islands of newspapers she spread. Cleaning people she hired soon quit.

But despite her oddities, Carolyn had a coterie who adored her, who were fascinated by the torrent of emotions, by the vicarious smashing of every boundary, by her needy warmth that could be as capacious and as unbridled as her person. She embodied her paintings as described by Andrew: "Very personal, powerful, warm, ugly to many people, but I think terrific."

Her fans came to see her, stiffening their resolve, inhaling shallow breaths, watching their steps. In a cloud of cigarette smoke, she presided from her scarred wooden chair beside the kitchen table. The enameled metal top was covered by cans of dog food, stacks of imitation china paper plates, boxes of plastic forks, rows of pills for herself and the dogs, a pile of cigarette packages, all with their tops torn off. Facing the room, huge breasts swaying loose beneath the cotton dress, skirt hiked up to her thighs by her spread legs, fat bulging over the rolled tops of her elastic stockings, she would sit defending her brother—"Those critics are just little mice. Nincompoops. Nobody home. Pay no attention to them." Then, delighted with her own bombast, she would laugh hugely, head back, body jiggling. Her smile was as lovely as a young girl's.

Henriette's daughter, Ann Carol Hurd, remembers, "Carolyn once made a great show of vacuuming at Eight Bells, naked, with only an apron

covering her front. There was a knock on the door, and it was the boy from the village with the mail and groceries. I said, 'Carolyn, let me open the door.' 'No, no, I can do it.' The vacuum was going—roar, roar. 'Hi, William. Wait a minute. Let me turn off this damn vacuum cleaner.' She turns around with this enormous bare bottom, and she leans down to turn it off. God! There is William looking utterly stunned."

Carolyn kept enough tubes of oil paint to supply an art school. There were shelves of books on Lawrence of Arabia. Cases of Mylanta for her heartburn. Forty pairs of tweezers. Boxes of combs, scissors, and shoe laces. Still yearning to be feminine, she dumped half a dozen boxes of talcum powder into a drawer and dug it out by the handful—but preserved her mother's perfume untouched, a memorial. She so slathered her hands with hand cream that the doorknobs felt greasy. She "peeled" potatoes by chopping off four sides, leaving a cube. She would order a dozen of the best, thickest steaks, unwrap them immediately, and stick them in the refrigerator, where many spoiled. She would order three lobster dinners from the expensive Chadds Ford Inn and feed two of them to the dogs. When somebody she disliked gave her a present, she threw it out. If she disliked the person on a magazine cover, she ripped off the face and threw it out. She hated Howard Pyle's small pen drawings. At a Pyle show with Andrew, she refused to go inside and sat in the hallway smoking.

Fouling the world she felt had abandoned her, she sometimes allowed the dogs into the hallowed Big Room, where they relieved themselves on the antique Persian rugs. "Andy never says anything," said Betsy. "He's not a missionary. He doesn't like to go in and say, 'Carolyn, that rug meant a lot to Ma.'" In spasms of impatience and repudiation—often fueled by alcohol—she got rid of family keepsakes and archives, burned her own work and her childhood pictures, and sold NC's pen-and-ink drawings to her art students. "There's a balky side to Carolyn," Betsy said once, "and Andrew Wyeth loves that. I'd save everything, and he just loves the fact that she just— Destroy it! Get rid of it! She just doesn't care."

Wyeth and his sister were mutually unshockable. "She has a side," he once said, "that is probably the most brutal, cunning, vicious—the biggest manipulator I've ever known, cajoling, full of charm and hardiness and

laughter. God, she emanates power. Fabulous to me. Terribly sophisticated under the facade of a childlike quality. Carolyn brings you back to basics. You have to have it in a family that was rather well brought up and educated. It's a necessary thing."

Unshockable, Carolyn supported the wild, coarse strain in Wyeth that is at war with the careful, gracious, tidy, even fastidious side he views as a source of weakness in his work. These extremes in his makeup determine his approach to painting—the profane hidden beneath beauty, cosmic jokes on those who consider him a bucolic genre painter.

Andrew believes that knowledge of unseen earthiness mysteriously finds its way into a painting, giving an edge that cuts sentimentality. An extreme example is the 1960 watercolor *May Day,* a patch of spring beauties blooming in the boggy forest floor. Wyeth was sitting quietly in the woods behind his father's house. A young woman of his acquaintance stopped on the trail above him. Thinking herself alone, she lifted her dress and defecated. "The white curve of her bottom was amazing," he says. The feces rolled downhill and came to rest beside those blossoms, which N. C. Wyeth loved to find during family walks. Fascinated by the collision of the pretty and the gross, Wyeth painted this picture, which is often reproduced as a bit of woodland loveliness.

"I'm not interested in quiet, placid landscapes," Wyeth says. "There's always something in it—violence appears—a blue jay—a storm comes up. Nature is not lyrical and nice. In Maine I'd lie on my belly for an hour watching the tide rising, creeping slowly over everything—the shells that were dry in the sun. Nothing can stop it—amazing—sad."

Wyeth's tough and clear-eyed empathy with the misunderstood men and women in the odd corners of his bailiwick is an extension of his relationship with Carolyn. "He seeks out the sick soul in order to save it," says Helga Testorf. The posing, the one-on-one with Wyeth, becomes the salvation. Speaking from experience, Helga continues, "To save one's soul is to give them faith, give them hope and a new lease on life. Everybody needs an eternal memory of doing things out of the ordinary."

In the process there is a kind of salvation for Wyeth. Betsy says, "Someone triggers emotions which come charging in like arrows. I always

thought he was like a little knight in battle in a rain of arrows, and his painting is like a shield that he puts up and, chunk, the arrows all go flying back."

After finishing *Letting Her Hair Down*, Wyeth remembered one of his father's precepts: "Before you paint part of a body, paint the entire body." He posed Helga on a mattress, in Carolyn's cramped, cluttered, slovenly little studio, and did *Black Velvet*. Inevitably compared to Édouard Manet's *Olympia*, a reclining Helga is levitated in a black void, her head turned away, around her neck the black ribbon that in *Letting Her Hair Down* held the "Prussian gold."

Each afternoon Wyeth returned to Betsy around five o'clock. Helga stole back to her house through the woods, traveling the route of "the walk." In 1973 Wyeth found Helga an excuse for extended absences from her family. After Carol Wyeth died, Carolyn was alone and hired Helga as a maid of all work. There was no danger of Betsy discovering her. Repelled by Carolyn and the condition of the house, Betsy never set foot there, just talked to her sister-in-law on the telephone. She explains, "You never could say anything because Andy was so close to her. So I just did my little vanishing act. Didn't see her for years."

In the mid-1970s Helga took on a role that more deeply identified her with Kuerner's. Anna's sister returned home to Germany, and Helga was welcomed back to the farm by Karl. Now his leukemia was wasting him away. He was put in a nursing home but kept begging to see his wife and farm. After a time he was brought home, and a hospital bed was set up in the living room. Two women were hired to do nursing.

But in Helga's head *she* was the chief caretaker. Wyeth remembers her singing German songs to Karl and bathing him, bringing him in her arms back downstairs like a pink-cheeked doll. Helga describes herself taking Karl off his tranquilizers and getting him up out of bed. Wyeth said at the time, "One day I think he's going to die any minute, and the next day I'm down there drinking beer and whiskey and he's thrown all his medicine through the window."

During 1978 Wyeth and Helga often kept witness by Karl's bedside. Speaking from his no-man's-land between myth and reality, Wyeth told Thomas Hoving, "Once Karl woke up suddenly and said, 'Andy, did you hear the *snapping*?' He had this far-off look. The snapping was his memory of the barbed wire being cut on the line in the First World War. When he'd heard this sound one night, he'd opened fire with his machine gun. His officer gave him hell. When the dawn came, there was a whole battalion of French dead on the wire just in front of his position. Got the Iron Cross. God, I felt I was there on the Western Front sitting with him. That story broke me loose from where I was—with an old man lying in bed—and I thought, This man is timeless."

Wyeth did a quick watercolor of Karl (page 348), cadaverous, the skin tight on his skull, legs like two long bones. He is dressed in one of Anna's short, frilly nightgowns which she kept putting on his helpless body. He was an emaciated reverberation of attenuated Tom Clark lying on his quilt, of the stick doll Andrew once found in his Christmas stocking. Through the window is the little pond, ice billowing at the overflow, Kuerner's Hill beyond. Across the yellow-green grass of winter are long swatches of lingering, rotting snow dissolving into the earth. Karl died in January 1979 at the age of eighty.

Now Kuerner's was finished as a hideout. But by then Helga was driving Carolyn and her dogs to Maine and spending the summer at Eight Bells. Carolyn had ended her art school in N. C. Wyeth's studio, so both that and Carolyn's own studio were available as sanctuaries.

Wyeth drew Helga in his father's studio under the three death masks on the wall—Beethoven, Lincoln, and the peacefully smiling girl who drowned in the Seine. Then he moved Helga to a mattress on the floor. Shining through a hole in a shade that covered a high window, a beam of light moved across her face, like a sundial tracking the hours. In *Night Shadow* (opposite page 342), the painting of N. C. Wyeth in his casket, Beethoven is in the broad cheekbones; the dead girl's Mona Lisa smile is on Helga's lips. The black night of the grave is a blanket around the nude torso.

Speaking of *Night Shadow,* Wyeth talks of "the quality of moisture

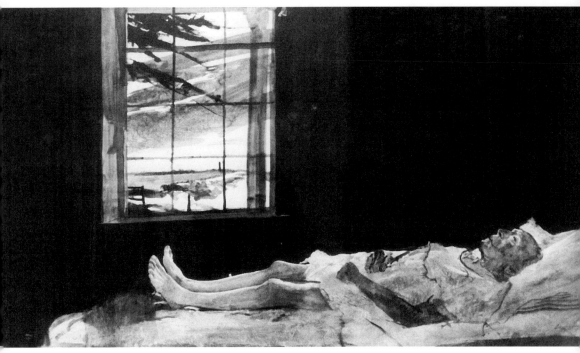

Study for *Spring*, 1978

around the mouth," and he says, "It's not just anybody lying there. It's that momentary thing—something you'll never see again. It could be a casket, the way my father's features were when I looked at him. That's what I felt. That's my relationship with Helga. Timeless. She epitomized all my German background—all imaginative things embodied in her. I used her for a stepping-stone."

In addition, just having and maintaining the secret of Helga was an ultimate upper, the climax of his covert boyhood escapades. "Andy loves the risk. Likes the sleight-of-hand," Betsy says. "He's not what he appears to be at all. It's shuffling the cards. Dealing the cards—different meanings of all those different cards—and win the game. Each card a different situation. I ask myself, 'What am I today? Am I the queen? The ace of spades?' We keep changing and, boy, he has won a lot of card games. He hates to play a game unless he can cheat. Adored Monopoly because he could cheat—took all the money and ended up with the hotels and Boardwalk. He

As he does with all his major models, Wyeth followed Karl, year by year, to the very end, to his deathbed, lying wasted by cancer and dressed by his wife, Anna, in one of her nighties.

cheated on his father. He cheated on his mother. He cheated on his sisters. He cheated on me. He's just had the best time. What a card shark. That will always be my final vision of this man I married."

Wyeth had a hand of Helga cards that he played to confuse and deflect Betsy. Though she was banned from coming uninvited to both the schoolhouse in Chadds Ford and to Eight Bells in Maine, he rehearsed Helga, just in case. "Andy's always prepared," Helga says. "When we were in his father's studio, he'd challenge me all the time: 'What if Betsy came right now?' And he wanted to know my answers and everything. I told him, 'I don't care.'" Indeed, Betsy did once appear at Eight Bells. Saying he was painting, Wyeth sent her away.

Betsy's curiosity and suspicion could be aroused by any decrease in her husband's normal output of paintings. So he had to maintain his normal flow. Through the years of the Helga series—from 1970 to 1985—he delivered sixty temperas on other subjects—including two nudes of Siri, who came down to Chadds Ford in 1978. Other works were *Off at Sea* (1972), *From the Capes* (1974), *The German* (1975; page 86), *Wolf Moon* (1975; page 408), *Flint* (1975; opposite page 102), *Sea Boots* (1976), and *The Witching Hour* (1977; page 312). This production was possible because, in fact, Wyeth did not paint a large number of Helgas. The collection was publicized as consisting of 240 paintings. In reality it contained a *total* of just four temperas, twelve drybrushes, and twenty-nine watercolors. The rest were quick watercolor and pencil studies.

But while actually painting Helga, Wyeth felt acute pressure to account for his time. In 1979 he was doing *Braids* (page 389). That year his hip joint began to deteriorate and eventually required a replacement operation. "He would work all morning on the portrait," Helga remembers, "and in the afternoon he was exhausted, but still he would think of other works he knew he had to put up in order to show he was doing work. He painted on those and he did watercolors to relieve himself, not getting too tight, getting fresh again. And all with legs that were almost not carrying him anymore. Always with pain from arthritis, trying aspirins that didn't work."

In the late 1970s Wyeth began multiplying the risks, walking ever closer to the edge, developing ploys within ploys. The stimulation from the secrecy required refueling. Also, unwilling to paint without inspiration, he was limited in the amount of work he could paint for Betsy. He began slipping the occasional, lesser, clothed Helga picture in among those he released from his studio—almost always in Maine, to impress on Betsy's mind that the models were Maine women.

"I would show them to Betsy at odd times when she least expected it," Wyeth says. "There wasn't any consistent lineup. This was a continuation of what I'd always been. I'm a sneaky son-of-a-bitch, and I've been that way from when I was a little boy—crawling into the clothes hamper to watch women go to the bathroom, right from there on." He adds with a whiff of pride, "I'm a master of subterfuge."

The challenge was keeping Betsy unaware that she was seeing the same model. Some works he produced did not show Helga's face. In 1978 when he needed pictures to sell to Joseph E. Levine, Wyeth included *Loden Coat*—Helga from behind walking down the Kuerner drive. Betsy saw the picture only in a photograph, and was told that the woman was Karl Kuerner's nurse.

For a 1980 show in Paris, Wyeth released a two-year-old watercolor called *Knapsack*, again the back of a faceless Helga, this time seated on a granite ledge in Maine. It was just part of the year's output: four temperas, including Betsy herself in *Seven-Forty-Seven*, sixteen watercolors and two dry-brushes, including *Bareback*, a nude of Pam Cowe.

During the two months that Pam nursed Wyeth at the Broad Cove house after his hip operation, Betsy was cast as N. C. Wyeth, the authority figure to be circumvented. She absented herself in her rebuilt lighthouse on Southern Island. "For a while," Betsy says, "I felt Pam meant a lot to him, and I didn't interfere with that." She once explained, "See, a man, when he's involved with something, leave him alone. Just don't pry. I'm not somebody who wants to know everything. I mean, you're lost with him if . . ."

Pam was part of a strategy to confuse Betsy: doing composites of Helga and other models. In 1980 he used Helga and Pam in *Day Dream*, a

nude asleep under a mosquito netting, painted at Eight Bells. In 1978 he painted a tempera titled *Surf*, using Helga's nude body in an ocean wave, but Siri posed for the head. That year he returned to Siri and painted her twice in the nude —*Fair Wind* and *The Huntress*.

The more models Wyeth used, the more Betsy was confused. In addition to Helga, four were involved in the 1974 tempera *Maidenhair*. The picture evolved out of a drybrush watercolor titled *Crown of Flowers*—Helga with a circlet of spring beauties on her head. It was kept each night in a bucket of water in Carolyn's studio. The next day rivulets like tears gleamed on her skin. Wyeth tells, "I took the picture to Maine because I thought, 'My God, I can use this in something.'"

In Waldoboro he saw a white, sternly simple New England German church and imagined a bride alone in the front pew, wearing a crown of flowers. From memory he drew a version with Helga as the bride, and allowed Betsy to pick through the working drawings and find *Crown of Flowers*, which she hung over the fireplace. Betsy remembers, "I had this kind of female curiosity. I would say, 'Andy, who is she?' And there would be this vague response."

He told Betsy a story about stumbling into a wedding in a pristine New England meeting house in Waldoboro and hiding in the choir loft. He said the model's name was Mary Connolly. Later, perhaps forgetting that name, he blurted out Mary Kahreau. Betsy's original Rolodex file card describes *Crown of Flowers* as a "very complete drybrush head and shoulders of Mary Connolly with flower wreath in her hair. Done for *Maidenhair*." The name Mary Connolly has been crossed out and replaced by Mary Kahreau. It also notes that on the back of *Crown of Flowers* is a brief pencil sketch of Elaine Benner, the final model for the tempera (page 352).

Unsatisfied with the Helga version of *Maidenhair*, Wyeth substituted Ralph Cline, *The Patriot*, as a father, and Ralph's daughter as the bride. Then he dropped the Clines, and with Helga still in his mind, drew a woman named Shirley Russell. Finally, he found the Helga look-alike Elaine Benner, another Nordic blond with freckles, high cheekbones, blue eyes, and no makeup. Later that year she posed for a portrait called *Drumlins*.

Through the years there have passed in front of Betsy many drawings of men and women she did not recognize. She has never known where her hus-

M-1618 R

"CROWN OF FLOWERS"

Very complete drybrush head and should-
ers of ~~Mary Connolly~~ with flower wreath
in her hair. Done for Maidenhair

*Mary Kahreau

1974 11 X 13
framed- 21 1/2" X 24" (Elane Benner final
framed ↑ model for tempera)

Verso - pencil brief head.

M1618

band goes, whom he sees each day. There have always been people he keeps on a string. His wallet spills out paper hen-tracked by names and phone numbers, people who momentarily catch his eye but not his long-term imagination. "It's like walking in the country and doing a quick sketch of something," he says. "I like off-the-cuff things—which is the way Helga started out."

Nobody, not even Betsy, is allowed to ask Wyeth what he is painting. If anybody dares, a curtain descends. The same rule goes for finished pictures. If he is quizzed, he pretends to give revelations, but they are calibrated to be safe and surface. The true emotions and connections behind a picture are his best-kept secret, preserved to energize paintings perhaps decades apart. When exposed to air, fantasy and inspiration tarnish.

Betsy is defensive about not focusing on Helga. She demands, "Am I supposed to know every model? Ask 'Well, who's that? Well, where does she live? Well, why didn't you bring her home?' He's in the middle of a creative thing, and am I going to break into that? I never question anything because so many people come into a picture, posing for parts of bodies, the back of the head. Dee Parker will pose maybe for a leg. He had her in a bathtub at Eight Bells for Susan Miller in *Coming Ashore. Christina's World* is a lot my body. It isn't *just* Karl Kuerner. I feel so sorry for these people. They think the painting is all them and it's not. Andy's always fiction. He's rarely nonfiction."

Wyeth's tricky release of seven Helgas was blurred by her radically different appearance in various pictures, her face delicate or broad, her body slender or thick. He was, in essence, painting different women, each one a separate imaginary character, each one a role Helga sensed and played. When he showed in Maine a Pennsylvania portrait of Helga, her hair tucked into her coat collar, Betsy thought the face so mannish she named it *Pageboy*.

Only once did Wyeth paint an exact rendering of Helga's face. Titled *Braids* (page 389), he worked on it off and on for two years. "It was important for me to get that out of my system," he says. "I just wanted to make a record of the way she looked, because I had been away in my imagination."

A Rolodex record of every painting is central to Betsy Wyeth's elaborate files. To get her reaction to *Crown of Flowers* while hiding the existence of Helga, Wyeth pretended it was a study for the tempera *Maidenhair*. He made up the name Mary Connolly for the model and later changed it to Mary Kahreau. Betsy dutifully, innocently, listed both names on the card, with an image of *Crown of Flowers* on the reverse side.

As he finished *Braids*, Helga told him a crude experience in her life involving a man masturbating. "A slight thing like that can keep you on the line," Wyeth says. Suddenly, the picture seemed too pretty. He explains, "I'd painted these braids beautifully coming to the fine end, the fluffy blondness of the hair. I thought, Fuck it. This is not it. It was like making a banner that was too big. It gets to be a caricature of a caricature." Wyeth sawed off the bottom of the panel, cutting it along the top of her chest and eliminating the ends of her braided hair.

The nude Wyeth considers his finest—*Barracoon* (opposite page 358)—came out of his slickest subterfuge. Three times he hid Helga inside a black skin. One picture was *Black Caps,* a watercolor of her black beneath apple blossoms. It hung in his studio, and he asked visitors how they liked it, his eyes sparkling at the deception.

Barracoon began in 1976 with a watercolor sketch of Helga's back as she lay asleep on her side beneath the hooks in the Kuerner attic. He repainted it in tempera. Helga became a young black woman—a reprise of the pose of his first black nude, Evelyn Smith. Wyeth explains, "I'd been painting Helga, and then I was alone in my bedroom at The Mill. I thought of Karl making love to that Negro girl in that attic room—which I don't know whether it's true or not. I rushed down to my studio and started painting it. Probably the realest Negress I ever painted. I had no reason to do it. All my imagination."

He considers *Barracoon* "way beyond a nude—something almost streamlined, like a figurehead on a clipper ship. I was trying to achieve something dateless. This could be any period—Egyptian, the Renaissance." When Helga saw *Barracoon*, she exclaimed, "God, how I've changed!" Betsy installed it in her personal collection. Wyeth told her the girl was a niece of Andy Davis, one of the last of the blacks in Chadds Ford. This tale is in the notebook Betsy keeps on important pictures. "I made up more goddamn stories," Wyeth admits unashamedly.

Sleep suffuses the Helga series. For Wyeth it is the ultimate, ideal pose, subtracting the model's personality from the equation, allowing the remote fascination of the voyeur. He is alone with his thoughts, his imagination.

Though he keeps a flow of conversation to animate his models and explore their beings, he also longs to be separated by the silence he paints. His subjects, removed from the artist and viewer, gaze away at an inward distance. "When a model is looking at me," he explains, "I'm constantly thinking about what they're thinking about me."

Wyeth longs to be alone with his thoughts—a reason he loves painting the backgrounds of portraits. He says, "One thing about Helga—she was very quiet. I could do a lot of thinking." He continues, "I'm not really a portrait painter. A certain magical not-knowing gives somebody a quality you can put down. Sometimes you have to get away from something that's very real, so that it can grow in your imagination. You need a change from excitement, back to quietness. Then you need a change from quietness to excitement."

Just as the emotions inspired by Bill Loper's hook matured for decades, the feelings around sleep continued unresolved. In 1978 Wyeth watched Helga undress in front of the *kas* in the third-floor Kuerner room, arms over her head like a dancer as she pulled off her blouse. A drawing of this moment evolved into a sleeping nude, the drybrush *Overflow*, a rich-bodied Helga on her side, head on a faded blue striped pillow, the dancer's arm arched above her head in the moonlight, the gleam of an unearthly peace. Framed in the window is a stream of water over a dam, like a mane of blond hair. Wyeth has said, "I felt the country, the house, Germany, the dreamy, moist, rich female smell—the whole thing." She is woman incarnate, submerged in her secret dreams, which are Wyeth's dreams.

The impulse behind *Overflow* streamed into the major 1979 tempera *Night Sleeper* (pages 356–57). As a little boy Wyeth traveled to Needham, Massachusetts, lying in a Pullman car on the brink of sleep, bathed in memories and fantasies. Here his hound, Nell Gwyn, lies in the moonlight on a window seat in the living room of The Mill. Her head rests on a sack tied at its top, striped a faded blue like the pillow in *Over-*

OVERLEAF: In *Night Sleeper*, 1979, Wyeth further explored in his public work the Helga theme of sleep and removal into dreams. Using a sack that echoes the pillows in *Night Shadow* and *Barracoon*, he substituted his dog, Nell Gwyn, lying in his living-room window seat like a weary train traveler rattling past an eerie moonlit landscape.

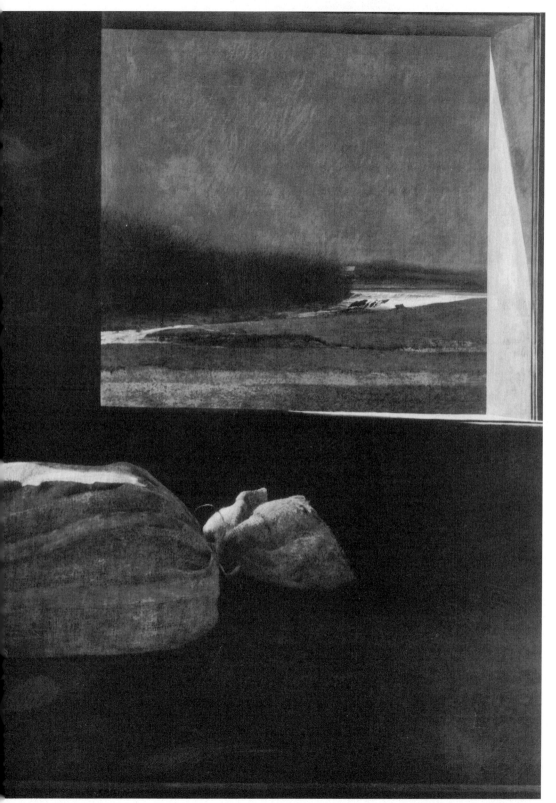

Night Sleeper, 1979

flow. Nell's eyes are slits—wary, almost menacing—slightly open like the eyes of the dead/alive Karl in the tempera *Spring*. It could be a self-portrait. Asked what is inside the dog's sack, Wyeth answered, "Nell's dreams."

In *Night Sleeper* the dreams are nightmarish. Through a window to the left, the moonlight is ghastly on the gristmill, like the flash from an atom bomb in the nanosecond before the shock waves hit. Through a right-hand window, this light strikes another overflow—the shallow dam in the Brandywine River where the British crossed in the Battle of Brandywine.

Betsy once said, "I don't think Andy's much interested in dories and buildings and people. I think he's talking about intangible speech, the sound of a voice that's not there anymore. The sense of history that's gone before. Wars that have been waged. Births. Deaths. Violence. He said to me once, 'You know, the Gettysburg Address is still floating around in the air and will be recalled sometime.'"

In 1977, Wyeth told a friend about a mysterious model and a hidden body of work—"in case anything happens to me." He said that if Betsy found out, "it would finish me." Keeping up the Helga deceit was increasingly confining. Wyeth's dealer in Tennessee, Frank Fowler, once remarked, "I've never known whether Andy wanted to get caught or not." Henriette spent time with Helga in Maine. Nicky and Jamie knew her and kept silent. Disguised in a brown wig, Helga escorted Carolyn to the opening of her one-woman show at the Brandywine Art Museum in 1979.

Wyeth also missed reactions from viewers, the clues that tell him whether a picture communicates, whether it has power, whether he succeeded. He began trying out paintings on a few trusted people. While Betsy and Thomas Hoving planned the Kuerner-Olson exhibition, Wyeth took Nancy Hoving on a tour of his territory. They went to Carolyn's, where he showed her a watercolor drawing of a nude sleeping Helga and the tempera *Letting Her Hair Down*—and said they were a secret. While Walter Annenberg was posing for his portrait, Wyeth showed him *Braids*. Stopping by his studio with a friend, Wyeth said, "Here's something I've been working on," and flashed *Braids* for about thirty seconds. He was universally disappointed by the reactions. "The pictures meant nothing to them," he recalls.

Barracoon, 1976

Wyeth painted a watercolor of Helga under the hooks in the attic room at Kuerner's. From memory he repainted her as a black woman, giving the picture a dateless, eternal feel by blanking out all extraneous details. Thus he could safely release the picture to Betsy, who named it *Barracoon*, the word for slave quarters in the time of Thomas Jefferson.

Wyeth showed *Braids* and *Night Shadow* to Jamie, who remembers, "My father was torn between realizing the stuff was important work, and yet realizing his life would be hell once my mother learned about it. I always used the argument, 'Why let her see it?' I thought, How wonderful to work on something that nobody will ever see until you die. If that doesn't legitimize painting, I don't know what does."

But always there was just this one person whose opinion truly mattered, who could ease his self-doubts, could tell him whether these pictures were "such a move ahead." In 1981 in Carolyn's studio Wyeth painted a small drybrush watercolor nude of Helga seated on a stool, washed by a cool fall light. A delicately veined brown leaf floats through the window like a weightless wing—like those leaves that blew into the Quaker Meeting House as his father lay dead.

He took the picture to Maine and showed it to Jamie, who said enthusiastically, "You've *got* to show it to Mom." Wyeth says, "I don't think I would have had the courage, if it hadn't been for Jamie really saying—I thought the picture was rather complete, pungent and technically probably one of my best watercolors. I really wanted to see . . . you know after working for years as I did on the collection, you begin to wonder what the hell you are doing. I had gotten to that point."

He gave the watercolor to Betsy for her birthday at the house at Broad Cove. In Betsy's records is the notation that it was painted at Eight Bells in Port Clyde, Maine. She was delighted with the picture, and named it *Lovers* because she thought a shadow on the left wall implied a man. "It could be *The Scarlet Letter*," she said—and Wyeth told Betsy and their longtime friend Dolly Bruni that this girl was a composite of all the blonds he had ever painted in Maine. He asked Dolly to please pose for the foot, which still needed work. She complied the next day in the studio, while Betsy made cookies over in the house. Dolly remembers, "I knew the painting was finished. He didn't need my bunions. He never changed the painting. I thought to myself, You *know* he's doing this for Betsy's benefit."

But Betsy was not entirely oblivious. As the years proceeded, she sensed something subterranean happening in her relationship with her husband.

"Andy's like a volcano," she explains. "When he's painting, there's a lot of rumbling underground, and anger. He gets moody. Very critical. Irascible. His release was in his painting. This strange mood is a normal kind of thing I would always wonder about."

She continues, "Then it began happening much more often. It was very—I realized I could do nothing right. There'd be situations I couldn't believe. And no painting came out of it. I decided the best thing for me to do, whatever was going on, was to just—I didn't know—I was baffled. It was a rocky period." A tension seemed to grow within Betsy; her girlish, conspiratorial, hearty joy was less consistent. Her moods were sometimes unpredictable: She avoided solitude, arranged regular companionship, often members of her staff.

The major shift sensed by Betsy took place in 1981, when Wyeth began a new pattern, finding excuses to be alone in Chadds Ford. That year he took several spring weeks in Pennsylvania, ostensibly to finish *Oliver's Cap*, one of his least successful temperas. This began a routine of remaining behind in Pennsylvania for a month while Betsy went ahead to Maine, and then in September returning alone a month early.

"The thing that was most disturbing," Betsy remembers, "I thought he no longer cared for my company. Evidently, because she was there—that was one thing I didn't understand. Why the hell would he fly down for an opening at the Brandywine Museum? I decided, He's probably working on something and wants to see it in a different light. Those are the funny things I didn't question him about. I'm not the kind of person to say to him, Well, why? It's fatal. You don't say, Why are you acting this way?"

Betsy was suspended in a vacuum of silence. Andrew, beloved by all, was the one person nobody would betray. If *she* confronted him, if she found out God knows what—her relationship with Andrew might become impossible, irretrievable. As she had with Pam Cowe, she left well enough alone.

20

The events and pressures, the schemes and calculations that led to the release of the Helga collection began in the early 1980s. After Karl Kuerner's death, the pictures stored in his third-floor room no longer seemed safe. In addition, the extremes of moisture and temperature were causing mildew and mold, and a crystalline bloom was growing on the temperas. Passages of impasto watercolor were crazing with cracks. One major watercolor had been chewed by mice.

Ending an era in the Helga saga, Wyeth had the paintings transferred from Kuerner's to his studio. As a personal favor, working alone on his weekends, the director of the Brandywine River Museum, James Duff, crated each picture for storage in the museum vault. To preserve the secrecy, the cases were marked with the name of Frolic Weymouth, the museum's founder. One Sunday, when all museum offices were closed, the major paintings were checked by Wyeth's conservator, Timothy Jayne, who took certain pictures away for restoration.

In 1982 Helga became less and less feasible as a model. For more than a decade, she had been jailed inside Wyeth's secret. Her world was dominated by Andrew and Carolyn, with time out for her four children. She was like a gerbil rushing from wheel to wheel. "It took a lot of arrangements," she says. "Go shopping, do the housework, do the cooking, do the kids, teach homework, teach music. Lot of night work. You know how much I weighed? 110 pounds. I was dead on my feet."

Demanding and imperious, Carolyn treated her like a possession. Helga shopped, cooked, cleaned up after the dogs, and bathed Carolyn, who could barely maneuver herself in and out of a tub. When the doorbell rang, Helga had to hide. Chauffeuring Carolyn, she had to wear a wig. She had to sit in attendance while Carolyn painted and talked. "If you were lis-

tening," Helga says, "she would be inspired to paint. I didn't dare move. If I had to go to the bathroom, that was already offensive." Helga also had to sit by Carolyn's bed, sometimes all night. Awaking in the dark, Carolyn would roll over and ask, "Are you there?"

Helga remembers, "She didn't want to share me with anybody. The fifty percent with Carolyn became seventy-five percent, the day *and* the night, and only twenty-five percent with Andy. I had nothing of my own. But I was game for anything because I hated to see her drink because of loneliness. She wanted her mommy to take care of her. What we all want is to be touched and waited on. With her and Andy I played every part! You name it! I was a little bit young, but I caught on."

Despite Wyeth's inspiring attentions, Helga the model was submerging her identity into his metaphors, striving to be what he wanted, trying to be him. Like Betsy, whom she saw as a rival, Helga could never possess Wyeth. She once described him as the Scarlet Pimpernel, after the eponymous hero of a book he had given her to read. She quoted the novel, "They seek him here. They seek him there. Those French, they seek him everywhere. Is he in heaven? Is he in hell? That damn elusive Pimpernel."

Fault lines kept private gave way under the psychological and physical strain. In 1982 Helga began showing the symptoms of severe depression. That year she appeared in just three watercolors—while Wyeth produced a spate of major paintings: *Adrift* (opposite page 294), Walt Anderson in his Viking funeral barge; *Ann Wyeth,* the portrait of his sister (page 32); and *Little Evil,* a black doll like a tiny demon (opposite page 54). He painted an icicle at Kuerner's, hanging like a spear against the enormous incantation of a rising full moon. It is named *Moon Madness.*

By February 1983, Helga's withdrawal and mood swings seemed so acute to Wyeth that he summoned his trusty nurse/model, Pam Cowe, who took Helga to the family physician, Dr. Joseph Valloti. He placed her in the psychiatric unit of a Philadelphia hospital, where she spent almost a month treated with antidepressants and tranquilizers.

"It's a great tragedy," Wyeth once said of Helga's condition. "I guess you have to wonder if you're responsible. Well, I don't believe that I am." He pauses. "Unconsciously, we artists do a devastating thing. You're really

raising hell with models mentally and emotionally. I don't think I caused Helga's problems, but I didn't help much."

She emerged from the hospital certain that nothing had been wrong with her, that she had been the victim of people jealous of her closeness to Wyeth. She refused all medication and did her best to disappear, fleeing most human contact, hiding out mainly in the schoolhouse.

Betsy has said, "Andy's subjects have a depth of character because they're flawed. There's something there that nobody else will ever look at." Reflecting on the fragile, off-kilter psyches that attract him, Wyeth exclaims, "What is there about this valley? Every damn person I paint goes mentally off. Allan Lynch in *Winter 1946* and *Young America* killed himself. Allan Messersmith, the *Roasted Chestnuts* boy. Bill Loper, the man with the hook, went mad. James Loper. Anna Kuerner. Helga's father committed suicide. Now she's terribly supersensitive. Very emotional. It's a drama that's really shaken me."

Wyeth was torn between his clinical detachment and his agonizing emotional involvement. Helga's condition was not a scene that Wyeth could just visit, like a film director, secure from the chaos of real life. He was willy-nilly in the middle of Helga's private life—a position he intensely dislikes. William Phelps—one of Wyeth's few close friends, an older man, perhaps a benign father figure—said in the early 1960s, "Andy doesn't want to be disturbed by people's lives. He's fascinated with them. He's warm to them. But I'm not sure he loves them."

But next to Betsy, Helga was *the* important woman. Wyeth is by nature deeply loyal, and he felt an almost unrepayable debt and obligation. He stuck by her, gave her the run of the schoolhouse, day and night. But for two years, 1983 and 1984, Wyeth did not paint Helga. For her, posing was like an IV sustaining her self-image, feeding her life. Now she was replaced by other models. Wyeth painted *Beauty Spot,* a nude of a young woman named Ann Call. He drew a heroic blond named Susan Miller, who worked for Betsy in Maine, and he went on to paint her in two temperas.

The release of the Helga collection was ultimately dictated by the work itself and by Wyeth's constant, lifelong sense of imminent death. Ever

since his sickly childhood and the loss of a lobe in one lung, death has been a present part of life. He worried now what would happen if Betsy learned of the pictures from somebody else after his death. She might feel so betrayed by the Brandywine River Museum for joining in the secret that she would refuse to donate her personal collection.

Moreover, now that Helga was no longer a central current in his work, Wyeth felt adrift. Nothing replaced her. He found no new drama to construct, no Christina, or Siri or Karl. Explaining his brother's decision to surface the series, Nat said, "Andy wanted the excitement. He needed it. He was in a state of flux at that point." Wyeth himself said, "I don't know why I did it . . . just got bored with it, got bored with life in a certain way. I just get—it makes me furious because—seeing myself, and I felt—I don't know why I did it. You get awfully set and happy in old age and become an old fart."

The impish side of Wyeth thought these pictures would jolt those who consider him a painter of country folk and artifacts. These nudes felt scandalous to this man whose youthful sex had to be sneaked behind the back of his puritanical father. "Pa would have been horrified that I took another man's wife and took off her clothes," Wyeth said. As early as 1972, referring to Helga, he told one confidant, "If you want to know what I'm really like, I'm working on something so shocking, you won't want to be my friend anymore when you see it."

Wyeth believed that the Helga pictures were so radically different and unexpected, were such an advance in his work, they would revive his stature in the art world and break his image as a mere painter of Americana. He considered himself "a forgotten artist who's done my work and had my little thing, and that's that." Once, justifying his decision to release the Helga series, he said angrily, "People wanted to put me into a little drawer where I was the American scene . . . Robert Frost . . . Gary Cooper. And fine, I was supposed to stay there!"

He once said, "I know the pictures are uneven. But the good ones have a depth I hadn't reached before, some of the most powerful work I've ever done. I won't listen to anybody who disagrees. *Night Shadow*—I don't think I have ever done anything better. I think I have lifted myself from very good

watercolors technically into something that's a little different. If I had died before I had done that, or I hadn't met Helga . . ."

He needed to know whether his judgment was accurate. He needed that moment when the artist with a mysterious intuition can see the work through others' eyes, see it with a relentless, impersonal clarity—in Wyeth's case, see the paintings through Betsy's eyes. In the solitude of his obsession, he needed that solidarity with Betsy.

So he wanted to be present when the world took notice. Helga says, "The pictures would have been shown after his death, but he could *not* live with that. He wants to just—like he stages his own death, he stages his life anyway."

The prospect of revealing the full collection to Betsy was terrifying: She might be irreconcilably furious. His instinct was to prepare the ground and ease the shock. In 1983 he took his first step, summoning Timothy Jayne to the studio to frame and restore two large drybrush paintings to surface for Betsy. One was titled *Cape Coat.* Painted in 1978, it is a huge vertical of Helga, full length against a towering tree trunk in the wintry woods behind NC's studio. She is wearing the green loden coat she bought on a 1971 visit to Germany, a reincarnation of the one she wore as a child in Prussia. The second painting was a drybrush called *The Prussian,* a 1973 portrait of Helga in the same coat. "Andy didn't want anybody to know anything," Jayne remembers. "It was *very* secretive. In fact the frame maker we have here—I just gave him measurements and my wife and I put in the pictures."

In the spring of 1984, shortly before Wyeth left for Maine, the paintings were delivered to the studio in beautifully wrought walnut frames. But Jayne could not be paid. The pictures were still a secret from Betsy, who handled all the bills. Then, in the fall of 1984, Wyeth had made his decision. He told Jayne, "I don't see how I can hide these paintings any longer. I'm going to have to tell Betsy. I'll tell you when you can send a bill."

In the early spring of 1985 Wyeth painted Helga again, another tall vertical, this time showing her upper body huddled in a high-collared coat against a coarse and massive tree trunk. Her downcast face, this time deli-

cate, even gaunt, is subtly disturbed. Titled *Refuge*, it is a painting of a woman who, said Wyeth, was "pulling away from life" (opposite).

Wyeth knew that this was their finale. Because of her fragile condition, her depression, her instability—Wyeth did not tell Helga. His guilt, the trauma that always accompanied endings, the loss of his finest model, the irony of a death that was not a death, the sense of his helplessness was agonizing.

But the continuous reverie was no longer possible. Helga could no longer be a medium for evolving fantasy, for extended excitement. "When you're over with something, you're over with it," Wyeth said at the time. "I could carry this on. But unless it has the sharp flash of the real thing, I don't want to drag it out. I hate repetition without a reason."

Helga remembers that during *Refuge*, "He was so consumed in his own thoughts—so driven—he didn't know what was going on around him—the cold—the wet snow—he didn't pay any attention. The bare skin of his back was showing. He wouldn't talk. I kept thinking, What's going on? I felt it the whole time. Something must be terribly wrong."

"When Andy paints you," Jimmy Lynch says, "it's a romance to the degree where you're the most important thing in the world to him. There's a whole string of models that really weren't able to cope with it because they believed it, and if you *believe* it, you don't cope with it. He gives you one hundred percent, but there's two hundred percent there and he keeps the other one hundred percent. You can't take that home with you. You have to separate it and stop right there. When he's done with you, when he pulls the goddamn stakes up and the tent is taken down, there is nothing but a bare spot and the wind's howling and you're out there in the middle of the bare spot and he's gone."

In the final painting of the Helga series, *Refuge*, 1985, a downcast Helga in the grip of depression huddles by a looming tree in the woods above the N. C. Wyeth house.

In April 1985 Wyeth put his strategy into operation. Withholding *The Prussian*, he gave Betsy *Cape Coat* and *Refuge*, both nonthreatening, outdoors, clothed, and plausibly explainable with the truth: This woman had been Karl's nurse. Betsy kept both paintings, turning down an offer of $250,000 for *Refuge*. In her records

Refuge, 1985

dating back to that time, a Rolodex card on a *Cape Coat* sketch reads, "Pencil drawing of Mary Kahreau."

In May 1985, during an interview with Jeffrey Schaire of *Art & Antiques* magazine, Wyeth seemed to force his own hand. Talking of his need for privacy, he blurted out the existence of "a vast amount of my work nobody knows about, not even my wife." Now he *had* to tell Betsy by September, when the interview would be published.

As usual Betsy went alone to Maine in May. In early June, Wyeth telephoned his Southern dealer Frank Fowler, co-owner of a small jet: Would Frank please fly him to Maine? Sensing strain and anxiety, Fowler arrived at the Philadelphia airport with a pound of caviar and a fifth of vodka chilled in a block of ice inside a plastic milk jug. During the two-hour flight, they finished the bottle. Getting off at Rockland, Maine, Wyeth said, "I've got to tell Betsy something," and Fowler returned immediately to Tennessee.

As Betsy drove him back to Cushing, Wyeth said, "Darling, I have something to tell you. I've given an interview to an interesting man from *Art & Antiques.* I mentioned some paintings nobody knows about." She asked, "Where?" "At Kuerner's." "When are you going to show them to me?" "When we come back in the fall." Betsy told him she could hardly wait. Then Andrew lost his nerve and said no more. The next day he telephoned Fowler and joked, "I'm still alive. Can you get me another pound of that caviar?"

Whatever questions and curiosities buzzed in Betsy's brain, she knew better than to quiz her husband for details. The ceremony of showing a new painting *must* include a first instant of reaction—hopefully of surprise, even shock—which tells Wyeth whether he has succeeded. In this relationship wired with secrecy, the subject of the mystery pictures never came up again that summer, not even when *Art & Antiques* appeared.

Andrew and Betsy returned together from Maine on October 27. Almost never sick, she was prostrate with the flu for a week. Then she asked to see the paintings that he had promised. He said yes, in two days, and would she please clear out the second floor of the gristmill? The crated panels and watercolor sheets were brought from the museum vault and opened there in the gallery that Betsy had designed. Fifteen years of

images emerged, years that stretched for Wyeth from middle age to the edge of old age.

"Taking the lids off the boxes," Wyeth recounts, "undoing them in front of my eyes, I got a fairly clear vision of the pictures. They brought back the smell of the cold rooms upstairs in the attic at Kuerner's—just fragments, one of them torn in two, and they had the odor of the girl, they had the whole—I knew they were not just pretty pictures. Somebody wouldn't come in and say, 'Oh, there's a Wyeth.'"

He felt that viewers would "feel the subtle involvement of someone struggling to get something, trying to explore a full-grown woman with four children, and not really getting very far, but striving." He added, "That's what we need in realism, because we've lost it. All we're getting is photographic copies. *Live* your life. *Write* your life. *Paint* your life. I coughed up my own life, and very few people do that. They're scared of it. They have to be once removed down the track—a window in between."

He hung the important work, many in stock frames borrowed from the museum. On the third floor roughly 175 watercolor sketches and drawings were piled in boxes. On the day he picked for the revelation, Wyeth tried to round up buffers and moral support. Jamie agreed to be present, but said, "It's *your* funeral." Frolic Weymouth refused, saying, "No way, honey."

In the late afternoon, Betsy remembers, "Jamie suddenly arrived, which felt odd. It went through my whole body that something major was going to happen." Wyeth invited Betsy to come over to the gristmill. Walking across, she thought, "How could they move anything in without my knowing it—where the hell was I? Terribly strange."

On the first floor they stood at the foot of the oak steps rising steeply in front of the gigantic wooden paddle wheel. Andrew said, "Why don't you just go up?" Climbing the steps, Betsy said, "These had better be good." Andrew thought to himself, Uh oh!

Betsy pushed open the trapdoor and from floor level beheld some of sixty-five paintings, hanging or leaning against walls and posts. She remembers, "*Whew!* I was absolutely overcome." The pictures filled the room with inward meditation and memory, with the heaviness of sleep, with the feel of

femininity caught alone and unaware through years of atmospheres. The model seemed several women, her face large-boned, broad, even coarse; elsewhere fine-chiseled, delicately beautiful. Her slender body floated nude and gleaming in juicy blacks and lay vulnerable on white sheets, a tenderness in the sinuous horizon line of hips and waist, shoulder and arm. Her body ripe, she knelt with full frontal trust. In winter and early spring, clad in dramatic coats, she walked briskly away, or stopped pensively in the woods. Hovering, too, in the room was the obsessive absorption of an artist who loved with his eyes.

One of the first pictures Betsy saw was *Night Shadow* (opposite page 342). She remembers, "I thought it was the greatest painting I had ever seen. I thought Who is she? It was like somebody dying of hunger suddenly in a warehouse full of food: 'Here you are. Eat it up.'" Immediately, Betsy understood the reason for those "strange rumblings" in her husband that had been so disturbing and baffling.

She says, "The important thing to me—I felt there were some things I really didn't like: that one isn't very good and that isn't hung perfectly. I wanted to rehang the show—and who the fuck is this woman? Boy, she looks tough as nails in that one—and she's soft as velvet in that one, and who is she and what's going on here?"

Wyeth remembers, "Oh, they shocked her. The fact that I'd done these things. She was thrilled. The bigness of Betsy is that when she saw those pictures, she knew the good ones. She didn't just say, 'Well, they're all crap.'"

Frolic Weymouth arrived, and Betsy told him, "If I hadn't liked them, I'd have killed him." Jamie telephoned Jimmy Lynch, saying, "The old man has lost his mind. Don't go near The Mill. You might get shot, or you might find the bodies." Jimmy came immediately and remembers, "Betsy was ear to ear grinning and just swooned because *that's* what she lives for. And he did it to her. For fifteen years he didn't show her these things that he had to have her approval for. He spited her for fifteen years."

The next day the Wyeths' friend and photographer, Peter Ralston, came by The Mill. He remembers, "When I walked in, the air was supercharged. It was palpable that something major was up." They sent him over to the

gristmill to see the work. Then James Duff telephoned Betsy on a museum matter and Betsy talked about the Helgas. He says, "That woman was *some* surprised."

Betsy called her curator, Mary Landa, the person who, next to her, best knew Wyeth's work. Betsy said, "You're not going to believe this. You should see what Andrew Wyeth has been working on. Get over here." Mary remembers, "I kept asking myself, When did he have time to do all this? Some of his greatest works had been coming out of the studio—*Night Sleeper, Flint*—never a lull that would make you think, What's he working on?"

The two women went through the piles of drawings and watercolors on the third floor. "Everything was brand-new to Betsy," Mary remembers, "and after the first thirty or forty, there was just silence, maybe an intake of breath, a gasp. It was almost a religious experience, these things so new yet connected to what we had already seen."

Turning over the watercolor of Helga's nude back as she lay in the Kuerner attic, Mary mouthed to Betsy, "*Barracoon.*" And there was a duplicate of Anna Kuerner on her porch, called *Easter Sunday*—except in this version it was Helga. "Looking at the subject, looking at Betsy," remembers Mary, "I was wondering, God, what is she thinking? How is she separating this from her life, seeing these paintings?"

In public, Betsy stifled almost all dismay. She knew Andrew's habit of using multiple models. She knew that his models did not exist as complete personalities, but as vessels for his fantasies. She knew that her true rival had always been the work, not other women.

Betsy put into gear her New England suppression. Pride and training forbade any behavior that might bring sympathy—which for Betsy smacks of pity and is deeply angering. In her mother's household, pain was not discussed. Emotionalism was self-indulgent. When Betsy's sister Louise wept over a death in her young world, Bess sternly said, "I want you to stop it this minute! You're only feeling sorry for yourself! None of that anymore!"

Something deemed shameful was to be buried. Louise remembers, "My father had an affair, and there was never a mention of it. Mother just went sailing along, no ruffled feathers, no tantrums, no big discussions. It

wasn't until a good many years afterward that I heard about it. In fact, I never knew that my grandmother committed suicide, ever, until some letters came out."

Betsy has always dealt with stress by absorbing herself in a project. Dolly Bruni remembers: "She wouldn't give me a moment to cry over some love affair that had gone wrong. She'd say, 'Okay, let's start vacuuming.' She'd have me cleaning the office, get me going with my life again. That's the way she is. Which I admire."

Now Betsy's project was the exhaustive preparation of the paintings for selling—which Wyeth wanted done immediately. Wyeth swept his hand toward the pictures and said to Betsy, "I want to sell them all!" She remembers, "He wanted them the hell out of the house. Never known him to do that before. Never. Someday we'll find out why."

At the time Wyeth said, "I just wanted to get them out of my life, and I thought, The least I can do for Betsy is get rid of the pictures. She felt I wanted to keep—that I was deeply in love with the girl and wanted to hold everything next to me. I told her, 'Do what you want with them.'"

But in December Betsy's right hand, Mary Landa, was in the hospital. And perhaps there was a kind of calm, a feeling of control, in subordinating the paintings to preparations for the elaborate Wyeth Christmas. In January Betsy began absorbing the 240 works into her archives. She says, "It was as if somebody dumped a pile of gravel in my front yard and I've got to put it in order."

Titles were conceived, paintings were reframed and rehung. On the back of each drawing and watercolor sketch, Betsy wrote a catalog number, which was recorded in her black book along with a handwritten description. Mary Landa and Peter Ray, the business manager, worked week after week cutting mats and backing the numbered works. All pictures were photographed. Tiny snapshots were mounted on Rolodex cards along with typed descriptions of the picture. Typed labels were glued to the back of the eight-by-ten-inch photographs that went into the files.

Within this meticulous record keeping was the central hurt—an *artistic* not a sexual betrayal. Wyeth had excluded Betsy from a prime episode in his career, as vital as those surrounding Christina Olson or Karl Kuerner.

He had denied her the mentor role fundamental to their marriage. As she said to Frolic Weymouth, "Where am I in all these?" Wyeth says, "Well, I wasn't thinking of her. That bothers Betsy. They're a portrait of me, absolutely."

Timothy Jayne, given just three weeks to do the needed restoration, was one outsider who sensed an agitation in Betsy. "I could feel the extent of her hurt," he remembers. "It was an unhappy time." Unwittingly, she voiced the dilemma at the core of her life. She asked, "Timothy, do you think painters must have their privacy?"

She said to Wyeth, "How could you do this for fifteen years when I've done everything for your work!" His painting had been *the* way she could feel connected to her husband—the only part of Wyeth that can be even semipossessed, the only truthful opening to his mind.

Her ignorance about the Helga paintings tormented Betsy, violated her obsession with order and exactitude. A segment of her records was wrong and would probably never be set straight. She banned everybody from the gristmill gallery and spread out on the floor the drawings and watercolor sketches. She struggled to match them with paintings and deduce the sequence and dates of pictures.

"Trying to get some idea of what was for what," she says, "was very confusing—when something was done—and I'd get Andy over there and we'd talk about it and he'd say, 'Well, you know this that and the other thing.'" Wyeth would tell her a set of years and then, driving her to distraction, reconsidered the dates the next day. "Andy was very impatient," she continues. "Antagonistic. Not cooperative at all. As if he wanted to shut it right out of his mind totally." She adds, "I had no idea what was bothering him."

Betsy studied every working drawing peripheral to Helga, reappraising them for clues to correct her records. She and Mary Landa found places where Wyeth had tried to hide Helga by erasing images from sketchbook drawings. There were drawings of Helga misidentified as Siri or Elaine Benner. Rolodex card #2248-R reads: "Very small composition of Anna (Kuerner) starting up the stairs, another pencil of a tree trunk and a tiny unfinished drawing of Anna's figure." On the card now is an asterisk beside

"tree trunk" and the notation, "Very brief pre-study for *Cape Coat* with figure of Helga Testorf."

She asked Wyeth more questions. Why had he done it? Why hadn't he given her Helgas for her book on the Kuerner pictures? His basic answer: "You never would have allowed me to paint her. You like *Night Shadow.* Well, it never would have existed." She asked him, "Did you have an affair?" He gave what, with variations, has been his sole answer: "Don't be ridiculous, Betsy. You know me better than that." He said privately, "I got so goddamn interested and excited by the subject, it's funny, I can't—Betsy should know my nature by now. Sex went out the window."

His physical relationship with Helga is a part of the Helga episode that Wyeth has never revealed. But he has spoken in general about the importance of sexual currents in the artist-model dynamic. "Rembrandt definitely felt that way," he says. "That's what makes him so earthy and powerful." He continues: "That's what it's all about—my urge to seduce that girl and get inside of her, not only with my penis but with my emotions. But *anticipation* is the thing. I want to keep them on this tense side of sex. It's tricky. If I go fuck, I've lost my energy and I can't paint. Delacroix in his journals says, 'I had a wonderful model here this morning, but damn it all, she walked off with all my energy.'"

Betsy once said, "In everything Andy's ever done, the most motivating force is sexual. It's very obvious in Picasso. It's very suppressed in Andrew Wyeth. He's *very* New England."

Wyeth himself presided over the sale of the collection, as he always does, despite Betsy's role as the business brain of the family. He knows exactly who buys each painting for how much and where it goes. In February 1986 he gave his son Nicholas an exclusive on the Helga collection for a month, stipulating that any buyer must guarantee to keep the collection intact. Wyeth wanted the impact, the synergism of all the pictures together—that single, evolving work he had been painting. Nicky did find a client, but he ultimately backed down. In March, Frank Fowler came up from Tennessee. Wyeth considered his offer too low. Betsy summoned their New York dealer, Fred Woolworth, and his partner in the Coe Kerr Gallery, Warren

Adelson. Woolworth, who planned to sell the pictures individually, handed Wyeth a check for four million dollars. Wyeth told him, "Put it back in your pocket." The figure was not high enough and Wyeth was emotional as he explained that the series must not be splintered into fragments.

During this period a potential buyer was personally studying the collection—the improbable man who would become the architect of the damaging public brouhaha over Helga. Leonard E. B. Andrews at sixty-one was a small, slender man on the edge of distinguished, with wavy, silver hair. Single and childless after two divorces, he was born in Nacogdoches, Texas. He grew up in Dallas, had a paper route, delivered laundry, pumped gas, clerked groceries, and worked his way through Southern Methodist University. Always a skilled salesman, he did marketing in Dallas for the soft drink Dr Pepper.

In the early 1960s he moved to New York City and was an executive in a credit card company. During a 1962 newspaper strike, the thirty-seven-year-old Andrews was the spark plug who raised the money and put together the staff to produce a successful interim newspaper, the *New York Standard.* He settled in Philadelphia as director of marketing for the Food Fair Corporation and formed an in-house advertising agency. Next he joined a securities firm. Constantly feverish with ways to make money, he urged the firm to promote itself by purchasing the *Queen Mary* as a Delaware River tourist attraction.

When the Penn Central Railroad went bankrupt in 1970, one of his ideas paid off brilliantly. He founded a weekly newsletter for Penn Central creditors throughout the country, copying on Xerox machines the court orders, decisions, lawyers' petitions, docket sheets, and so on. That newsletter led to the *Swine Flu Litigation Reporter,* then the *Asbestos Litigation Reporter.* Ultimately his Stockholders & Creditors News Service published twenty-three bimonthly special-interest reports costing from seven hundred to two thousand dollars a year. In addition he published two magazines in the field of electrical utilities.

After his second wife left him, taking her share of the furnishings, Andrews hired a local decorator named Kathleen Jamieson. She suggested that Andrews purchase Wyeth paintings through her friend Helen Valloti, Betsy's

best friend and the wife of the Wyeths' longtime family doctor. Andrews bought six Wyeths, qualifying him as a wealthy collector. Helen sent word of the Helga collection to Andrews, and personally took him to the gristmill.

Leonard Andrews, the shrewd marketer, the idea man, the public relations whiz, now had entrée into a very small and rarefied backwater, usually restricted to familiar people of proven loyalty. Wyeth has always treasured his innocence, always believed that the outside world corrupted his father's painting, believed that sophistication would dull his own sensitivity to his subject matter. Betsy, uncomfortable with strangers, has buffered their lives with her able, good-humored, devoted staff held together by affection for both Betsy and Andrew and by the magnetism of his personality and high seriousness.

Making up his mind, Leonard Andrews visited the collection several times. To float a loan, he took slides of the paintings to New York and projected them for the officers of U.S. Trust. One banker came down to Chadds Ford with Andrews's lawyer to view the paintings personally. Andrews met with Wyeth. Each working to spellbind the other, Wyeth was impressed that Andrews wanted to keep the pictures together, that he would "put his money where his mouth is."

In a Texas drawl Andrews talked grandly about the pictures as "a national treasure" that would go to the Leonard E. B. Andrews Foundation, which was essentially Leonard Andrews himself, no board of directors, and just one trustee, Kathleen Jamieson. The foundation financed exhibitions for indigenous artists, every submission accepted. Ultimately, said Andrews, the Helga collection would go to some great institution. Wyeth said, "He wants the very best, maybe the National Gallery." Later Andrews talked about buying *Christina's World* from the Museum of Modern Art. Wyeth remarked at the time, "He says he'll offer twenty million for it. I hope Leonard gets it."

Sherwood Cook, Wyeth's brother-in-law, once said, "Andy doesn't think logically. He thinks emotionally." Wyeth felt that Leonard Andrews "seems to *love* these pictures, just mad for them." Wyeth told him little about the circumstances: "I said, 'Don't ask.' I didn't want anybody with any

knowledge, don't you see? Except just looking at the pictures." Wyeth was especially impressed that "Leonard didn't ask anybody 'Well, do you think I ought—are they worth it?' He used his own judgment, and you know that's rare. You don't often get that kind of conviction."

Face-to-face, Wyeth looks for the hidden good in people. He liked Andrews, who caught his imagination. Andrews's tour as a navy pilot in Korea gave him a sheen of romance, a certain look that Wyeth found in his eyes. His position as an outsider in the art world appealed to Wyeth. Selling to this man had a quality of blaspheme, of rebellion. From the beginning, Betsy disliked Andrews, doubted his motives, thought he would resell the pictures.

This was Wyeth's second time around with a potent businessman. The movie producer Joseph E. Levine was also devoted to the work and used his own judgment. He bought paintings one by one, and during the accumulation, Wyeth gave him the reproduction rights. Levine talked about building a private museum for the pictures. To keep the Olson house from being torn down, he spent three hundred thousand dollars buying and restoring it under Betsy's supervision. She hung working drawings of Olson paintings, and it was an evocative, atmospheric museum for two years—until 1973, when it was closed because of local outcry over car traffic. In 1993 it was reopened by the Farnsworth Art Museum, but without the artwork.

In 1976 Levine partially paid for the exhibition of the Kuerner and Olson paintings at the Metropolitan Museum of Art. Wyeth was almost childlike in his gratitude. At Thomas Hoving's private dinner before the opening, Wyeth sat holding Levine's hand. Tacked onto the main show was a room containing the Joseph E. Levine collection—twenty-six pictures including *Weatherside* (page 145). This exposure substantially multiplied the value of the paintings. Levine sold them in 1979 for $3.1 million to Arthur Magill of South Carolina, retired head of one of the world's largest children's sleepwear manufacturers. They were hung in the Greenville County Museum of Art, which was promised the collection as a future bequest. In 1990, with Nicholas Wyeth acting as broker, Magill cashed in on the huge sums the Japanese were spending on well-known American artists, inflating prices worldwide. The Japanese Saisson Group, owners of the Seibu department store, paid Magill $48 million.

After three weeks and a brief negotiation with Wyeth, Leonard Andrews bought the Helga collection: 4 temperas, 10 drybrushes, 1 drybrush drawing, 29 watercolors, 32 watercolor drawings, and 164 pencil sketches—a total of 240 Helgas. The price is still a secret. The best guess is $6 million, the figure Mrs. Thomas Hoving heard at a party from a banker at U.S. Trust, which made the loan.

To sweeten the deal, Wyeth threw in the reproduction rights. Betsy was deeply dismayed: Now there were no contractual controls on Andrews's use of the paintings. Her consolation was the fact that she could choose three paintings from the collection. The choice was excruciating for Betsy. She picked *Night Shadow, Lovers,* and *Autumn,* which she considered technically one of her husband's finest watercolors. Wyeth himself would have chosen *Braids*—which she found unexciting. In general, she felt that the Helga nudes were "kind of languid, passive." She later told Wyeth, "You know, in a way I'm awfully sorry I didn't know about the Helga things because the viewpoint is *very* conservative, except for *Lovers* and *Night Shadow,* which is the only disturbing painting in the whole group."

The purchase papers were signed on April 1, 1986. Andrews and the Wyeths sat at the table at The Mill, drinking champagne and laughing about it being April Fool's Day and "wait till the art world hears about this."

21

Wyeth had been put above the fray, like the American flag, like a patrimony of the United States—the feeling of a royal family of American painting. He was by himself on a hill, vulnerable to attack by less advantaged artists struggling on the plain below. He was like a gunslinger who lords it over local cowboys and is open to challenge because local macho characters have to prove themselves. And then the Helga story happened—a tasteless, crass media event—basically disastrous.

PETER TATISTCHEFF, TATISTCHEFF GALLERY, NEW YORK CITY

No matter how much Leonard Andrews admired the Helga paintings, he was not borrowing millions just to hang the pictures on his walls. He was seeing them through the eyes of a marketer, an investment counselor, a newspaper publisher, and a risk taker. Once he had possession—along with the crucial reproduction rights—Andrews set about promoting his investment through the channels he knew.

In mid-April 1986 he mailed press releases about this "hidden, personal collection" to some seven hundred newspapers, magazines, TV stations—including *Time* and *Newsweek.* Because of the timing and the small-time, unimpressive source, the media took no notice. Only one local paper picked up the story. On April 23 the Delaware County *Daily Times* ran a story headlined WYETH'S COLLECTION OF NUDES SOLD FOR MULTI-MILLION FIGURE.

Andrews persisted. He hired Peter Ralston to shoot transparencies of the major works and asked him to use his connections with magazines to get the story out. Coincidentally, the day after he was hired by Andrews, April 27, Ralston was photographing a story for *Art & Antiques* on Frolic Weymouth's collection of antique carriages. With the Wyeths' permission,

Ralston took Jeffrey Schaire, the writer and executive editor, up to the second floor of the gristmill. Here were the pictures Wyeth had mentioned to Schaire in the 1985 interview. Schaire now arranged to publish a major article on the collection in September.

In May 1986, at the suggestion of an out-of-town salesman for his newsletters, Leonard Andrews showed the Helga transparencies to Robert Lewin in Florida. Lewin is a specialist in fine art reproductions at his Millport Press, and had done a book with Harry N. Abrams, Inc. He immediately called its editor in chief, Paul Gottlieb. Andrews flew directly from Florida to New York. Gottlieb remembers, "When Leonard opened up the box of transparencies, the hair stood up on my neck. That's only happened a few times in my life." Gottlieb immediately agreed to do a book on the collection—with an introductory essay by Leonard E. B. Andrews.

As Andrews was leaving the office, Gottlieb realized, "This guy doesn't know anybody." He asked if Andrews had thought about exhibiting the collection. Gottlieb telephoned museum directors throughout the country, and the man most interested was J. Carter Brown, director of the National Gallery of Art in Washington. When Carter Brown and Deputy Director John Wilmerding saw the transparencies, they were immediately excited and began arranging an exhibition. The Gallery rarely exhibits living artists, but the Helga collection could be inserted into a planned show of twentieth-century American drawings and watercolors.

Knowing that the show would greatly enhance the value of the collection, the Gallery worried that Andrews might sell the paintings after the tour, but felt reassured by his plans to make the collection the keystone of his foundation. Moreover, there was the impression that it would ultimately be donated to a museum. As is customary, Andrews was expected to donate a Wyeth painting to compensate for the expense of mounting the exhibition. He gave the drybrush watercolor *Field Hand*—Bill Loper's hook on a log overlooking "Little Africa."

With Gottlieb again on the telephone introducing Andrews, a national tour was set up at museums in Boston, Houston, Los Angeles, San Francisco, and Detroit. The Brooklyn Museum of Art made an independent arrangement with Andrews for the summer of 1989. Worried about

the debilitating effect of light on the works on paper, the Gallery wanted the collection rested during the six months between the Detroit and Brooklyn shows—which Andrews did not do, lending the collection for a tour in Japan.

In 1990 Andrews himself went to Japan. He sold the Helga collection to an unnamed individual, along with 290 drawings and sketches done at Olson's that Andrews had purchased in 1989 from Arthur Magill in Greenville, South Carolina. Arranged by Ann Richards Nitze, an American dealer experienced in Japanese sales, the price was estimated at forty to forty-five million dollars. Carter Brown reacted, "If we'd known going in that the whole thing was going into the market, it would put a very different coloration on it." At the Detroit Institute of Arts—which later exhibited the paintings—the director, Sam Sachs, was more succinct: "We were used." To the press and to Wyeth, Andrews expressed surprise and denied any mercenary manipulations.

Jeffrey Schaire pulled the publicity trigger in August 1986. The timing was perfect, August being the month when Congress is on vacation and national news is scarce. Schaire sent thirty media outlets a press release on his forthcoming *Art & Antiques* cover feature on the hidden Helgas. On August 6 the *New York Times* broke the story on its front page, reproducing *Braids* and announcing "240 Hidden Artworks by Andrew Wyeth Sold." On August 18 beside *Crown of Flowers,* the cover of *Newsweek* blared "Andrew Wyeth's Secret Obsession." *Time* used *Letting Her Hair Down,* and announced, "Andrew Wyeth's Stunning Secret."

In September *Art & Antiques* had *Braids* on its cover along with the words: "An American Treasure Revealed." Jeffrey Schaire's text ended with a deliciously suggestive moment that amplified the undertone of illicit sex. Schaire asked Betsy what the Helga paintings were all about. After a pause, she naively told the truth. She said, "Love."

She meant Wyeth's emotional involvement with every object and person Wyeth paints for an extended period, with Christina Olson for twenty years, Siri Erickson for ten, Anna Kuerner for thirty-four, Walt Anderson for fifty-one and Betsy herself, who has modeled through fifty-four years. He has said that the affection—the "love"—he summons for a

subject is so strong, he feels disloyal to Betsy. This love has a particular function. She once explained, "Everybody measures things in this world with a ruler. Or by years, by time. Andy doesn't comprehend figures— adding money. He doesn't have that part of his mind. It would take him an hour to measure a picture, trying over and over. He measures according to affection, the time distance that he has loved that thing, how many years does it go back."

To the press "love" meant "sex"—catnip from heaven. A battalion of reporters searched Chadds Ford for Helga. A helicopter landed on the lawn of Frolic Weymouth, who told the reporter he was the butler. Reporters staked out Helga's house, where a tearful, angry son guarded the door with two Doberman pinschers. In Germany reporters tried to interview Helga's mother. Carolyn talked to a reporter who later wrote that Helga was Wyeth's "Mona Lisa who did windows."

Now Helga, in turn, was caught in Wyeth's obsession that puts painting ahead of all relationships. She had to survive amid his contradictions, angers, loves, needs, self-justifications, compulsions. He himself once said, "My work is the only reason I should be forgiven and nothing else, because I'm terrible."

A couple of journalists prowled the N. C. Wyeth property and up behind NC's studio found Helga drawing. They confronted her. Till that moment she had known nothing—had no idea that Betsy had seen the pictures, that they had been sold, that she was now public property. She ran pell-mell down to Wyeth's studio and locked the door.

The words still jagged with hurt, she blurts, "I thought, It's not true. It's not possible. He'd promised the pictures were never going to be seen until he was dead. He had told me nothing. He hadn't told me one percent of what his thoughts were. When that hit me, I swear I could have taken a knife and ended it all there. Andy was in Maine, and I couldn't reach him by phone. What happened to our communication? I had put him as number one on everything, on every level. I was just nearly going crazy—the life I felt spiritually toward—my whole life was built on that—the pain in my chest—that lump in my throat."

Helga's withdrawal deepened. "I—I guess I removed myself from

anything that was happening. I just blocked it out. I pretended it didn't exist. I was numb. But the pain doesn't go away. Never will. I'd had to live the war of two people. Here they take the whole group of pictures and expose it without thinking of the people involved. If their life is based on emotions—well, their emotions must have been dead at that time."

Betsy, too, was devastated by the press frenzy. On a superficial level she and Wyeth briefly enjoyed the attention. Wyeth was both astonished and rather pleased that he could still create a furor. As Jamie said, "Daddy loves, like Douglas Fairbanks, going crash through the window and disappearing." A photographer in a helicopter buzzed their lighthouse home on Southern Island, and Wyeth remembers, "Betsy came in and said, 'Isn't this exciting?' Pretty soon, though, it was all like a cloud shadow moving over."

Betsy remembers that "Nothing bothered me—nothing bothered me until the press . . ." Then her suppressed resentments split open. She describes "a towering rage" that never did relax completely. She says with spirit: "Could you see me sitting on Southern Island or some place, saying, 'That's marvelous!'? I really wondered if our marriage would survive. I'm such a private person—it was months of just really agonizing, wondering."

Betsy was in the position she most loathes. Portrayed as the wronged wife, she was the object of journalistic winks and smirks, and, even worse, of public sympathy. Moreover, she *felt* like a classic deceived wife, always the last to hear. She repeatedly asked those around her, "Did you know?" She says, "As it turned out, a lot of people—everybody sort of knew and it was, 'Don't tell Betsy.' You know: 'This is something Betsy doesn't know anything about.' Which made me look like the worst kind of fool you could think of."

In early September 1987 a visitor to the house on Bradford Point found the air vibrating with tension. The white plaster walls were bare with empty nails where paintings usually hung—except for Wyeth's tempera *Dr. Syn*, a self-portrait as a skeleton in his War of 1812 navy officer's jacket. Like a child caught being naughty, Wyeth was jumping to placate Betsy. She was on the dagger point of her predicament—needing to control her environment while forever bonded to a man demanding complete freedom.

That evening Betsy stood for a moment at the kitchen window, gazing out along the St. George River toward the patchwork of islands, her face handsome, jaw strong, a powerful woman. Her eyes seeing the far distance, she spoke for a moment about the islands, about her longing to have something absolutely apart from everything—something that was hers and hers alone.

At that time Wyeth said, "Betsy's a remarkable person. I really adore her. I tell all my models that I would no more leave Betsy—no matter what. She may leave *me.* And I tell her to leave me, for her own good. She has a right to leave. But I'd be devastated if she did. She has a knowledge and understanding of my work that none of . . ."

At his core, however, Wyeth was unrepentant. He said then, "I'm getting the hell knocked out of me, as you can well imagine. Betsy gets a great kick out of the paintings, but she goes somewhere and somebody makes a comment, or a letter comes in—and it all starts up again. These shits are saying, 'How can you stand a man like that?' Which puts me in a great position." After a pause: "Betsy didn't leave me. I thought she would." Then, angry and defiant: "I'd do it again!"

He continued: "I told Betsy, 'I think it was a dastardly thing for me to do. If you think it's that important, you should leave me.' But this is where I put my painting ahead of my personal life. I told her, 'Maybe I'll never paint another nude, but I may do something even worse.' I told her, 'I did *Christina's World,* and then should I lie back and do nothing else but figures in the field?' Really! I've got to grow. I know it's tough, and I know it's been hard on her, but I will *not* have fences put around me. And I'm not going to be fenced in by my *models,* either. Because they want to do it. They get just as bad as Betsy."

Leonard Andrews was appearing on TV shows and sitting for press interviews. He seemed to enjoy his celebrity as proprietor of a media sensation. He described Wyeth as "so far ahead of any other living artist, it is hard to name the second best." He kept calling his purchase "a national treasure," and said that seeing the pictures "I thought of Ross Perot when he bought the Magna Carta."

Such hyperbole made him an irresistible target. Unimpressed by his National Arts Program, one story dubbed him "curator to the masses."

Another described him using "strings of nouns to describe himself—entrepreneur, publisher, raconteur, socialite, investor, collector, visionary." The magazine *Manhattan, Inc.* ridiculed the whole episode as a "coup-de-hype."

Wyeth remained vehemently loyal. "The hate for this man Andrews!" Wyeth exclaimed. "They're crucifying him. They think it's better that I never sold anything and that he didn't exist. I got an award from the Philadelphia Art Alliance and Walter Annenberg came to it—he would barely speak to Leonard—and they asked me to say something and I thought, Well, now, here's my chance. I said, 'Right across this room from where I'm standing, I had a show when I was nineteen and I had thirty watercolors and I didn't sell one picture. I didn't have Leonard Andrews at that time.' Those Philadelphia blokes wouldn't spend twenty dollars to buy a watercolor of mine. God, you so rarely get anyone that's interested in your work."

Wyeth continued: "Nobody but Leonard Andrews came forward. When someone offers you a number of millions of dollars, you wouldn't walk away. People are embarrassed by the pictures and won't look at them. He had the guts to do it. Yes, what he did was terrible, and the way he's handled it—but he went at it and he bought them and he certainly put them on exhibit in the top place. You can't berate that."

Before the opening at the National Gallery on May 24, 1987, Wyeth told the deputy director, John Wilmerding: "The only thing that interests me about this show is to see pictures so natural up on the walls of the National Gallery. I'll be fascinated." Typically, he was grateful to J. Carter Brown and Wilmerding, and pleased that the National Gallery had organized the show *before* the avalanche of publicity. "They had the guts to do it," he said. "They believed in me." He added a little wistfully, "I wish they'd put in some Kuerner pictures."

He was gratified, too, that the public seemed to "get" the work. Ticketron processed 10,000 ticket requests. In the first forty-three days, the attendance was 212,000, outdrawing the earlier Matisse show at 185,000, and second only to the *Treasure Houses of Britain*, which attracted 253,000. The lines for tickets routinely snaked through the west wing of the museum and down the stairs to the subterranean corridor.

The Abrams book, *Andrew Wyeth: The Helga Pictures,* was the exhibition catalog. As Paul Gottlieb had instantly predicted, it became a blockbuster. Also published in Britain, France, West Germany, the Netherlands, and Japan, it was a July 1987 main selection of the Book-of-the-Month Club, the first art book in the club's sixty-year history. Priced in the United States at $40.00 in hardcover and $19.95 for a softcover version, it ultimately sold 320,000 hardcover copies and 75,000 in softcover—something of a record for a single volume on a living artist.

However, the daily press coverage of the exhibition was often mocking, an obbligato that continued as the show toured the nation for two and a half years. Sample headlines: ANDREW AND HELGA, DID SHE? OR DIDN'T SHE?/CRITICS SPRAY GRAFFITI ON WYETH/AN ART EXHIBIT FOR THE COMMON PEOPLE/A HUGE BRUSH-OFF/WYETH'S LISTLESS HELGA EXHIBIT IS A BORE/HELGA, HYPE . . . AND HOPE/ANDREW WYETH: ILLUS-TRATOR OR GENIUS?

Even as the press itself fed the hype by writing about it, newspapers were determined not to be taken in—particularly if the details had been fabricated. Stories included the phrases: "Devalues the museum's purpose as a treasure house of aesthetic value"—"all the sentimentality and sensation-alism"—"the crass way promoted"—"the soft-core pornography of an afternoon soap." One writer called *On Her Knees* "your basic crotch shot," and found Helga lying under the Kuerner ceiling hooks "S&M tinged." Robert MacNeil on the *MacNeil/Lehrer NewsHour* voiced the opinion that "the most disturbing thing about the Helga show is that naked talent shows, and the early pencil studies of the Helga poses are labored and ten-tative." He ended with: "The Helga pictures are not going to change anyone's mind about Andrew Wyeth."

The media responses to the exhibition may have been affected not only by a backlash against the publicity but also by an inherent problem. Especially after all the hoopla, the show felt diluted and slim. Some of the prime Helgas were still in Betsy's possession, including the black *Barracoon* (opposite page 358) and *Autumn, Lovers,* and *Night Shadow* (opposite page 342). These were hanging across town at the Corcoran Gallery of Art in a

show called *An American Vision: Three Generations of Wyeth Art.* The 125 pictures at the National Gallery included no more than 16 substantial Helgas.

Hung in the graphics galleries in conjunction with an exhibition of twentieth-century drawings and watercolors, the show was designed to track the artist's creative process. In each room the few paintings of importance were surrounded by walls and walls of drawings and sketches, sometimes slight and repetitive, never intended to be more than notations. Deputy Director John Wilmerding explains that Andrews kept insisting that his entire purchase be hung in the show: "There was the implicit threat that if we didn't do it, he would pull out and go elsewhere. We had to battle to get it down to half. We were trapped into showing too much."

When Carolyn decided to go see the Helga show, Wyeth was astonished and extremely pleased. But he was concerned about her reaction. He wished he had culled through the drawings, leaving "just what worked." He told her, "This is not the kind of show you'll like. Half of the pictures are crap. They're thin. Tentative. Experimentation. It's a show of my thoughts, which was probably a damn fool thing to allow. But this is the way it is, and the critics don't understand it because they're not used to this kind of exhibition. They have a preconceived idea of the niceness of drawings."

Pushed in a wheelchair from picture to picture, treated like a queen, Carolyn announced to the world where each was painted, exulted over most, but sometimes said, "That doesn't make it." As she approached *Braids* (page 389), a man was studying it, very still. His wife came up beside him. Rubbing the small of his back with her left hand, she said softly, "It's wonderful, isn't it." He nodded.

During the press furor, Betsy avoided reporters, but when she relented, her words sometimes encouraged speculation about Helga and her husband. The *New York Times* quoted her: "To me the Helga paintings are very much like a ballet—erotic, beautiful but untouchable. And that's the whole fascination of dance. It's the erotic silence that's fascinating. In a great many pictures, she is sleeping, her arms are over her head. I've stood the paintings on end, and she becomes a dancer. So is she sleeping? Or are the eyes only

closed?" Then Betsy adds suggestively, "She's dancing alone, but who's her partner?"

Fueled by the previous release of certain Helgas, and by Betsy's accomplished facade of equanimity, which seemed too good to be true, the idea of a Helga hoax became common currency. One story said: "The revisionists started thinking the whole thing had been staged." Another reported, "Revelations . . . led some cynical observers to suggest that the Helga phenomenon was sensationalist hype prompted by the artist and [his] spouse." For years the computer network Prodigy carried a biography of Andrew Wyeth, written by the former curator of the Delaware Art Museum, which referred to "the Helga hoax."

In *Time* the art critic Robert Hughes wrote, "Like an avalanche of Styrofoam and saccharin, the Great Human Interest Saga of Andrew Wyeth and Helga Testorf, the German nymph of Chadds Ford, Pa., came roaring down the narrow defiles of silly-season journalism and obliterated the meager factual content of the story . . . the [purchaser] planned to reap vast profits from selling reproductions of Helga's pale and sturdy torso; and the whole thing had been cooked up among him, the Wyeths and the editors of *Art & Antiques*, a sort of cultural airline magazine."

After Wyeth read this, he was so shaken that a companion worried that he could not safely drive home. He told Betsy, "They'd only believe you if you walked out and left me."

A few respectful voices spoke out. In the *Christian Science Monitor*, Theodore Wolff wrote, "His work appears less private, romantic, and 'perfect,' and more overtly human and accepting than it was before. Which leads me to wonder if the 15 years devoted to this series weren't really all about a creative individual coming to grips with the awesome issues associated with human life."

In his collection of essays titled *Just Looking*, John Updike called *Black Velvet*, Helga levitated in blackness, "a triumph . . . an American Venus, with something touchingly gawky in her beautifully drawn big bare feet, bent elbow, and clenched hands. This is what Winslow Homer's maidens would have looked like beneath their calico." He concluded, "When all the hype

Braids, 1979

has faded . . . Wyeth's fifteen years of friendly interest in Helga should leave a treasurable residue."

Before the Brooklyn Museum of Art had signed up for the show, the *New York Times* took umbrage at the scornful reactions. It editorialized, "The city's curators think New York is too good for Helga . . . Philippe de Montebello, director of the Metropolitan Museum, sniffs that 'we quite pointedly and as a conscious decision declined' to participate in the show . . . Wyeth was plainly willing to commit his deepest feelings to his model and his work.

While adapting Helga's face and form to various roles in a fantasy drama extending through the entire series, Wyeth paused to paint *Braids*. Working on it periodically during two years, he was showing the actual Helga. "He enjoyed doing it," Helga says, "because he wanted an exact replica of the real thing—like putting an emblem in your pocket."

The investment inspires interest. It also commands respect . . . I resent the snobbery of museums that enjoy hefty tax exemptions and public contributions . . . shouldn't they also feel some obligation to show legitimate art that clearly interests the public?"

Wyeth told Carolyn, "I don't think anyone ever had worse reviews. Laugh at it. What's it matter?" He repeatedly quoted Lincoln Kirstein: "Why do you want approval from those horses' asses?" He said emphatically, "Everybody thinks I'm ready to commit suicide because my show has been beaten over the head. It's just what I needed. A good swift kick in the ass. I'm a grown-up. I believe in myself. I'm not sitting around waiting for critical approval. I'm too old for that crap. Jesus!"

He has often protested that he is sick of all the acclaim—"like too much candy, the nice old Wyeth with his barns and Robert Frost walking along." He once described himself as "toughened to criticism," and said, "I've taken a beating from Betsy and from the critics, but it doesn't concern me because a few of the pictures are a hell of a leap over what I *was* doing."

But as usual with Wyeth, opposite feelings were equally true. He told a friend, "They're sticking pins in me! I never thought little old me painting weeds in the field would end up in this position." He told Carolyn, "I'm a has-been." He was hurt that not one of his friends and supporters had publicly come to his defense. He said to a confidant, "The only thing I regret—maybe the pictures shouldn't have been brought out in my lifetime." At the peak of the Helga publicity, he said to Betsy, "I don't know how we're going to live through it." At his lowest point, he told her he had disgraced the National Gallery.

Betsy said at the time, "He must be so horrified that it took such a wrong turn—the sensationalism. And this is the one thing he really did alone. I feel that he is really, really alone now. He is *really* going underground this time. You'll never get him." Wyeth stopped releasing finished work from the studio and, a month after the National Gallery opening, he pulled all his work off the market.

22

The Helga exhibition, wrote Douglas McGill in the *New York Times*, "has stirred a more intense debate among art professionals than any other museum show in recent memory." The passion of the disagreement—the public delight and establishment disdain—was a classic demonstration of Wyeth's anomalous position in the art world. The territory of the disagreement is no less than those core conundrums: What is painting? What is art? What is truth? What is modern?

Wyeth's answer is his intensely personal brand of realism—pictures that are windows into a three-dimensional universe, the objects and textures minutely observed, the people portrayed as complex human beings. The avant-garde has answered those central aesthetic riddles by breaking through the nineteenth-century envelope of conventions, creating an art centered on freedom, excitement, innovation.

As a youthful prodigy in the 1940s Wyeth could still find a comfortable niche in the art world. The Museum of Modern Art in New York City exhibited him as a magic realist and purchased *Christina's World*. The magazine *Art News* called him "Watercolor's White Knight" and said, "His work is bold and adventurous. That puts him in right, with both conservatives and with radicals."

Those "conservatives" were such realists as Charles Burchfield and Edward Hopper, Reginald Marsh and Jack Levine, descendants of the Ashcan School, a turn-of-the-century group that rebelled against academic realism and painted a gritty, socially conscious vision of city life. The modernist "radicals," in their struggle to express underlying essences, were rooted in the 1913 Armory show, which introduced American artists to the European styles of postimpressionism, fauvism, and in particular cubism, which fractured subjects and perspectives into geometric planes, simultaneously showing all sides of a form, even elements of the rear.

By the 1950s, the dominant force in American art was the New York School and abstract expressionism, which produced such enduring masters as Willem de Kooning, Jackson Pollock, Mark Rothko, Franz Kline, Robert Motherwell. Image, story, and three-dimensionalism were jettisoned. The flatness of the surface—"the picture plane"—and the paint itself became part of the eloquence. The critic Arthur C. Danto once described abstract expressionism as "the drip, the dash, the splash, the sag of paint, the heavy brushstroke, the shallow space, the energetically churned and turned pigment, slurried like the mud of no-man's-land." "Action painting" became the label for brushstrokes lush with meaning, precisely *because* they were spontaneous and unmeditated.

In the early 1950s Wyeth was an independent but respected player in a still eclectic art scene. The semiabstract John Marin and the socially conscious Ben Shahn were important names, and both had retrospectives at Venice Biennales—as did the abstract expressionist Willem de Kooning—while de Kooning's artist wife, Elaine, wrote in *Art News* in 1950: "Wyeth's depictions of commonplace visual realities are always charged with high emotional content. Without tricks of technique, sentiment or obvious symbolism . . . he can make a prosperous farmhouse kitchen or a rolling pasture as bleak and haunting as a train whistle in the night . . . an overpowering sense of desolation conveyed in the clarity and economy of representation."

After another article in 1956, she wrote Wyeth, "I must add, as a tribute to you, that I found your work just as fresh and exciting a subject to write about this time as it was the first."

But the tide of abstract expressionism was rapidly engulfing figurative art. In a develop-or-die environment—in which "interesting" meant looking at the world in a new way—Wyeth was determined to remain *himself* and did not swerve. He explained at the time, "I went to Washington the other day, just to spend the night. I had something in my mind I'd been thinking over for a couple of months—and when I got back it was all dead. *That's* why I have to keep to myself. It might sound as though I'm scared, but I see so many men's work with influences in it, and I want to keep out influences and try to do what is true to me."

Time summarized Wyeth's position in a 1951 review of his show at the Currier Gallery of Art in Manchester, New Hampshire: "Ever since their turn-of-the-century brethren failed to gauge the force and direction of modern art, the critics, not to be caught again, have been resolutely seeking out new and strange varieties of painting to explain to the public. The modern art bandwagon may never stop rolling, but Wyeth rolls blithely in another direction. And his back road may lead to a new turnpike."

The one realist Wyeth admired and cultivated was Edward Hopper, visiting him in New York at 3 Washington Square North. Wyeth enjoys telling of the party after the opening of a mammoth survey of American art, extending back to 1754, at the Metropolitan Museum of Art. Both Wyeth and Hopper were invited to the penthouse of Robert Beverly Hale, the associate curator of paintings and sculpture. During cocktails on the terrace, the abstractionists Stuart Davis and Jackson Pollock were talking techniques and philosophies. Hopper, off to one side, suddenly tapped Davis on the shoulder and said, "Very interesting and I'm sure you're right. But can you boys deny that?" He gestured out at the glowing tones of the setting sun striking across a skyscraper. "Everybody was silent," remembers Wyeth. "That was it. There was nothing they could say."

Along with such artists as Jack Levine, Isabel Bishop, Raphael Soyer, Hopper was active in a group that put together three issues of *Reality: A Journal of Artists' Opinions,* defending themselves against abstraction. Hopper once wrote Wyeth to bewail the course of American art:

> In more than a decade the Whitney Museum has presumed to point out the road on which art should travel, as evidenced by its annual exhibitions. The last Annual, for example, features 145 paintings, of which 102 are non-objective, 17 abstract, 17 semi abstract, leaving only nine paintings in which the image had not receded or disappeared. I feel that this partisanship is very dangerous.

Wyeth replied:

> The current run of things in the art world is an ever-present threat. The company our paintings have within group exhibitions

isn't what you or I would wish, but it is a challenge to be up against a 6' × 6' non-objective and not have the forms and meanings of our realistic paintings fade into nothingness. I feel that abstract art and all its cousins is the toughest neighbor that realism has had to put up with for years.

Our ideals must search deeper and you will always stand with me as the greatest contemporary power of us all. Wherever one of your paintings hangs, all else fades into triviality. You could be the only one in a show of 4,000 non-objectives and be the victor. I do not feel we should make our cause by letters or protest but should strengthen it by better paintings. Could it be that realism has become paunchy from centuries of easy living? We must not forget our weapons, our paint brushes, not voices or public protests.

With greatest respect for your silent power.

In May 1967 Wyeth said, "I've been so moved today on hearing of Hopper's death. Even though Hopper wasn't painting much, the fact that he was alive and still thinking. . . . He never lost the large grasp, never got mixed up in a lot of picky young theories that don't mean anything." Then Wyeth reflected on the "strange dignity of Hopper's people," and the way he had "stripped everything away till there was nothing, till you are filling nothingness with emotion. He ended up painting a corner of a vacant room and a patch of sun. The whole world in a shaft of light."

By the mid-1950s abstraction and abstract expressionism in particular were the "official" art of the day. Unlike the nineteenth century, when the French Academy tried to quash the independent impressionists, the twentieth-century power centers of the art world promoted the avant-garde. This contemporary art "establishment" was once described by the critic Harold Rosenberg, himself a force in the New York School. "The texture of collaboration between dealers, collectors, and exhibitors has become increasingly dense, to the point where the artist is confronted by a solid wall of opinion and fashion forecasts constructed, essentially, out of the data of the art market." John Canaday, the former lead art critic of the *New York Times*, referred to this statement in 1976: "To 'dealers and collectors and exhibitors,' Rosenberg should have added critics as collaborators."

In the sixties and seventies the New York School reacted against abstract expressionism, and the acceleration of styles became so swift, Jackson Pollock and Willem de Kooning became academic in one generation and not to be imitated. There was pop art, op art, kinetic art, conceptual art, and minimalism. Reductionism banished the picture frame, and works were often painted on the wall itself. Photographs were projected onto canvas and copied. Realism became the real. Found objects were glued into boxes—three-dimensional collages. Installations arranged freestanding objects. Sculptures were cast from real people. The idea became the art; sociopolitical commentary became an aesthetic. Artists had ideas that metalworkers constructed. Finally, materials themselves were abandoned. Words alone—the ultimate flatness—became a visual experience.

During this fast-forward in art history, Wyeth still had scattered critical appreciation. *Time* magazine critic Robert Hughes later became a Wyeth debunker, but in 1973 he visited the artist in Maine and admired the 1973 exhibition at the de Young Museum—the first public showing of the Siri nudes. He wrote, "When the illusiveness at the core of his imagination reacts with his virtuoso power of rendering the soberest nuance of light, texture and weight, Wyeth becomes a formidable artist . . . Fact as poetry is becoming Wyeth's strength."

In 1980 Wyeth was the first living American artist exhibited at the Royal Academy of Arts in London. In 1978 he was elected to membership in the Soviet Academy of the Arts in Leningrad. He did not attend either, having made his one and only trip abroad in 1977, flying to London on the Concorde, sitting by coincidence with Tennessee Williams and Rudolf Nureyev. He found England too picturesque, but went on to Paris to be inducted into the Institut de France Académie des Beaux-Arts, the first American painter admitted since John Singer Sargent.

The French government was endlessly hospitable, and he was thrilled to explore the country of the Marquis de Lafayette, who had been wounded at the Battle of the Brandywine. One misty morning Wyeth imagined the hunchback, Quasimodo, looking down from the tower of Nôtre-Dame. During the induction ceremony at the academy—he was

escorted by guards in breastplates to the sound of bugles and drums—Wyeth sat on a little bench before the president of the academy, the presentation saber on the desk between them.

Toward the end of his extensive and admiring address the president said, "You have the soul of an artist, and filled with poetry as it is, its expression is clear, precise, like a mirror reflecting your feelings. And that is why you are linked to those masters of the past for whom acts of faith always depended on their professional conscience."

Nevertheless, "Andrew Wyeth" in the sixties and seventies was increasingly a name for everything that contemporary art in America wanted to leave behind. Art historian and critic Michael Brenson is a specialist on sculptor Alberto Giacometti and the son of an abstract artist. He explains: "I think that Wyeth and that style in some way have represented all the stuff out there that artists had been fighting against. The identification of the middle-class values as the enemy of true imagination, of true feelings, has been around since the beginning of modernism: the belief that there was something fundamentally inauthentic about a certain way of living and a certain kind of values, something repressive and self-deceived—a narrowness—an acceptance of the way things are rather than an attempt to rebuild or re-image a new world. This view has been very deep in artistic culture, and I think with some validity."

Over the years every aspect of Wyeth's painting has been rejected by important modernist writers. His technique has been called "bless-every-blade-of-grass realism." His "obsessive detail" is "a trick beside the point," a "quality admired by the uneducated." He cannot draw. His pictures are "just sort of colored drawings." The objects are "not felt," and "not physically present." "His desire to be taken seriously creates a patina of foreboding." His "plodding, rigid" images show "picturesque poverty and passive poor people" who are "hopeless loonies, drunks, and freaks." His content is a "vacuous message" that is a "rehearsal of painstaking nostalgia."

Katherine Kuh, a modernist pioneer and curator of modern art at the Art Institute of Chicago, has written that Wyeth's pictures are "like kindly little sermons at the village church. This artist's contrived compositions

shine with moral rectitude. He offers us first-rate illustrations of 'the good life,' but these vignettes never rise above illustrations."

Wanda Corn, a professor of art history at Stanford University, curated the 1973 Wyeth retrospective at the de Young Museum. Explaining the critics' attitude, she says, "The criticism of Wyeth was not just to marginalize him (where he was content to be), but also to center a kind of modern painting that was extremely different from his. The abstract artists and critics had everything to gain by denying him a place in the art universe—and they used him to position themselves as outside *his* universe and make art into a more rarefied and difficult endeavor. To critique Wyeth was to protect their own turf and promote their own aesthetic systems."

Brian O'Doherty is a former *New York Times* critic, a minimalist and conceptual artist exhibiting under the name Patrick Ireland, and a current administrator at the National Endowment for the Arts. In the early 1970s he was interested enough to visit Wyeth and write about him at length in *American Masters*, published in 1974. Though he concluded that Wyeth has painted great images, not great pictures, O'Doherty believes that city versus country sensibility is a basic factor in Wyeth's reception in the art world. He wrote in 1974, "Modernist art is urban art." Discussing the urban mind, he said: "While it accepts the urban view of the landscape (from Fairfield Porter's sunny idealizations to Hopper's bald realism), it will not accept the rural view, nor is it equipped to read it, or perceive in it anything more than clichés identified with forms of nationalism troubling to the liberal spirit. . . . Thus Wyeth, the only genuine rural artist of the slightest consequence, is attacked with a violence far beyond the usual etiquette of critical disagreement."

John Canaday thought that Wyeth's troubles began in 1959, when the Philadelphia Museum of Art spent $31,000 to buy *Ground Hog Day*— the plate and cup on Karl Kuerner's sunlit kitchen table. At the time this was the highest price ever paid by a museum for the work of a living American artist. "This," wrote Canaday, "was a slap in the face of the establishment backing abstract expressionism." Wyeth quickly broke his own records, selling *That Gentleman* in 1962 to the Dallas Museum of Fine Arts for $58,000. Then in the same year the Farnsworth Art Museum in

Maine purchased *Her Room* for $65,000. Progressively, the escalation and the slap continued. By the mid-1990s the going rate for temperas, set by the market in Japan, has been one to three and a half million dollars.

Betsy Wyeth thinks the anti-Wyeth momentum increased radically in 1966 and 1967, when his massive retrospective toured four of the nation's top museums. At the Pennsylvania Academy of the Fine Arts in Philadelphia, the attendance of 173,000 was a record. The Art Institute of Chicago attracted 253,727, and had the largest per diem of the four participating museums. At New York's Whitney Museum of American Art, lines of patient admirers stretched along Madison Avenue and halfway along Seventy-fifth Street. Inside was a hushed air of reverent concentration. The show was extended by a week, to fifty-five days, and the attendance of 263,302 was a record.

"It was just too successful, too appealing to the common man," says Betsy. "That was the kiss of death." In addition, there was the marketing of Wyeth's popularity—the huge sales of Wyeth books, the flow of reproductions—which was viscerally judged not "respectable" for an authentic artist. He had acquired the off-putting aura and fame of a movie idol, and, wrote Brian O'Doherty, "For most of us, his stardom had cannibalized his art to a degree unprecedented by any other artist with pretensions to seriousness."

In *The Many Masks of Modern Art*, a collection of Theodore Wolff's reviews from the *Christian Science Monitor*, he takes up the issue of Wyeth's popularity: "If there is one thing the elite of the art world cannot abide, it is the realization that an artist they might admire is also the particular favorite of plumbers and farmers. It threatens their claim to be 'special,' to have insights and sensitivities beyond those of 'ordinary' human beings. . . . Not surprisingly, it is important to these people that art be perceived in the most precious and progressive of terms, as something so subtle and innovative that only persons of unusual refinement and imagination could possibly understand and appreciate it."

The critical buzz has been so pervasive within the American art establishment that voicing respect for Wyeth is considered professionally haz-

ardous. Though the Museum of Modern Art owns *Christina's World*—and in 1991 used it to advertise its show *The Art of the Forties*—MoMA did not invite Wyeth to its fiftieth anniversary celebration. Critic and lecturer Wolff admits, "I always hedged my bets when I wrote about him, qualifying some of the more positive things. It is a risky thing for any critic or writer to come right out and say, 'I think Andrew Wyeth is a major artist.' It's the danger of not being taken seriously. It's like, 'Wolff is really sort of an idiot. He probably thinks Norman Rockwell is wonderful.'"

An extreme example is the background politics of the 1976 Metropolitan Museum of Art exhibition, *Two Worlds of Andrew Wyeth: Kuerners and Olsons.* Thomas Hoving, the director, received a surprising note from Henry Geldzahler, the museum's curator of twentieth-century art, described by John Canaday as "a card-carrying member of the highest flying echelon of the New York contemporary art establishment." The note read, "My reputation to the contrary not withstanding, I would like to be the curator in charge of the proposed Andrew Wyeth exhibition.... When the show becomes a reality, please think of me."

Selecting pictures in Chadds Ford, Geldzahler radiated charm and enthusiasm—and hinted that Wyeth should make him a personal gift of a prime watercolor called *River Valley.* Several weeks later, Geldzahler suddenly had second thoughts and quit the project. In his autobiography Hoving wrote: "The man was terrified about his reputation." When Hoving telephoned the news to Chadds Ford, Wyeth said, "The poor son-of-a-bitch."

Through the years, Wyeth's reaction to the critics' drizzle of dismissal has been typically complex and conflicted. Secure in his conviction—a form of freedom—he rather likes being misread by the establishment. Too much analysis and understanding might deflate the secrecy, might bring self-consciousness, which would compromise his delicate, fantasy-laden relationships with his subjects. He insists, too, that he is inured to his bad press, and says, "All these terrible criticisms really don't affect me because I've had it from Betsy for years. She's a very brutal woman when she gets going. Tears me to shreds."

However, the rejection has sometimes hooked into Wyeth's insecurity.

Ann McCoy once explained, "He armors himself. Anything that touches the center—the womb—it's excruciatingly painful." Wyeth once said, "I don't put myself on any pinnacle because I don't—I have the lowest opinion of myself at times. Most of what I've painted is shit." On another occasion he protested, "You can say you got near something, but if you know nature, know things well, you know how minuscule our abilities are. I'm only conceited about what I *might* be able to do."

Wyeth sees himself walking a precarious knife edge. On one side is the pitfall of being, as he says, "pure cornball." He once explained, "The greatest danger of any technical accomplishment—you can get awfully nice in your lovely drifts of melting snow—very delicate and pleasant. I detest the sweetness I see in a lot of realistic painting. Awful. I know because I've done hundreds of them and will probably do hundreds more. The abstractionists escape perfunctory picturesqueness by obliterating the object. Then it's easier because you don't have the goddamn thing of subject matter standing in your way. You've just got color and mood." But Wyeth considers any kind of fear a dangerous inhibition. He says, "My God, I can't go out in the landscape and paint with the fear that something may be sentimental. I've got to jump in with both feet. I can't be analyzing."

On the other side of the knife edge is the pitfall of a stiff, static realism, "carried so far it goes beyond the truth. If you get too accurate, it becomes dull as hell—a complacent nicety of execution. The realism is the weakest part of my work." Wyeth feels that "so much art shows starvation; it has no life." Photorealism, he thinks, "is like a man who gets up and speaks beautiful English but doesn't say anything, doesn't talk about how infinitesimal we are, how passing."

Wyeth's realism is *his* realism. "I want to get inside of reality," he once said. "I want to feel the bones beneath the flesh. I want to get beyond the enigma of paint, beyond

In his whitewashed studio on Bradford Point in Maine, Wyeth sits in an exhausted metal easy chair surrounded by utilitarian equipment dating back to his twenties. Though his temperas end up precise, he starts with the big brushes beside his jars of pigment. The eggs are on the iron stove. His doctor, Margaret Handy, once described his process: "Paint is all over everything. His fingers are a mess. He stirs the yolk and pigment and water with his finger, and pulls the brush out to a point with his thumb and forefinger. He lets the dogs eat the egg white."

technique." He has said, too, "I'm not at all interested in painting the object just as it is in nature. Certainly I'm much more interested in the mood of a thing than the truth of a thing."

Wyeth amplifies moods by removing what distracts from the emotion, by emphasizing objects, distorting perspectives, composing impossible optical effects and vantage points. Wanda Corn has written: "Windowsills, floorboards, and room lines lead us from the edges into the picture, giving us the beginning of a space that will never be completed. Somehow corners are always obscured, lines are blunted, back walls float forward to create what is less a physical chamber of space than a psychological chamber of privacy and loneliness."

Volumes and relationships are crucial. "He'll talk to me for hours," Betsy says, "about the white on top of that rock and its relationship to the light on that field—or in a portrait of me, the end of my eyelash in relationship to some little place down in the corner of the background. It's all *terribly* important to him."

Wyeth explains: "Intensity—painting emotion into objects—is the only thing I care about. There are people who like my work because they think they're seeing every blade of grass. They're not seeing the *tone.*" He continues: "People like to make me the American painter of the American scene. They try to tie me up with painters like Eakins and Homer. I'm no more like that than the man in the moon. Eakins was a *realist;* his figures actually breathe in the frame. He worked out distances mathematically. His realism is almost a preconceived realism." Says Theodore Wolff, "I think Wyeth picked up where Eakins left off, and gave realism an added dimension, a metaphoric level."

The Wyeth "look" comes in part from a tension between reserve and intensity, between the reality of the subject and the phantasms of the artist's dream world. In his most successful work, Wyeth's realism becomes a concealing scrim that allows a pregnant wondering. "My mood is hiding behind the mask of truth," he says. As in his life, Wyeth bases his painting on his belief in the power of concealment, of indication, the potency of limitation—simply *suggesting* a whole life lived in a space. Emotion cannot be painted overtly. It is most powerful when only sensed, illusive, an atmos-

phere, the evidence covered up. A body is buried, but a person walking over it knows it is there under the ground.

Wyeth says: "In this age of chattering, I think we need a pause for monotony—with something smoldering in the middle of it." He adds: "So much can be said by so little. I think great simplicity is complex. To my mind the master is the one who can give the effect of great simplicity and breadth and yet you can go right up to it and enjoy it."

Ironically, many of Wyeth's methods for communicating the invisible are those of the modernists. In fact, Wyeth himself could be considered a modernist in his narratives of alienation and aloneness, his projection of an interior self. He shares the conviction of the "action painters," that arm and hand can be a conduit for uncensored feelings pouring out onto the flat surface. "The brain must not interfere," Wyeth says. "You're painting so constantly that your brain disappears, and your subconscious goes into your fingers, and it just flows. If you think you're painting a good watercolor, you can be sure it's lousy. It is important to forget what you are doing—then a work of art may happen."

Giving an example, he explains: "You think of a mass of trees in the distance and what makes up that mass. It's all very well to put a mass down as mass, but only after you've *known* . . . that's why Rembrandt is so remarkable in his wash drawings that came later in life. He had painted these hundreds of portraits with the quality of decaying flesh, the hollow mouths, just cavities and bad teeth and watery eyes. Finally, when he did a wash of it, that was all in there."

Wyeth regards himself as "a pure abstractionist in my thought." He begins both watercolors and temperas as a covert abstract-expressionist. His underpainting, the emotional base, is scribbled lines, spatterings, streams of running paint, rough scratches with the wooden end of his brush—sometimes digging holes through the paper—broad swipes and pools of tones and textures (Helga watercolor, page 405). "I work with impulsiveness," he says. "I use eleven kinds of brushes, camel's hair or sable or an old house painter's brush. Sometimes a scrub brush. I've torn pictures in half trying to get into them, to get structure and weight and form and succulence and passion."

Wyeth continues, "People like Franz Kline and Jackson Pollock and de Kooning sometimes do get amazing qualities that give me a kick in the tail to really let go." But Wyeth says: "I think a painting is undigested if you leave it in the state of just chaos. I like that first, wild impulse to be there underneath, but pulled back into clarity. I want my impulsiveness, my chaos to have meaning. I want the primitive effect when you bring abstraction and the real together."

Comparing Kline and Wyeth, John Canaday wrote in 1962: "Kline is concerned with fragmentary forms and fragmentary meanings. The inference of his painting is that we can be certain of nothing in life except its energy. . . . But energy of this kind is a superficial manifestation to Wyeth. He senses deeper energies that have always existed in nature . . . and refuses to accept chaos as a stimulant inherent in our civilization. . . . It is easier to fail by Wyeth's standard. . . . A quiet revelation is more difficult to offer (and to recognize) than a brilliant one."

Wyeth sums up, "If my work has any importance at all, it will live *not* for its subject matter but on its tonal off-and-on quality, on its shapes, another core embellished with realism. The sense that there's something else there." Trying to see past the image to judge the abstraction in a new painting, he turns it upside down, he studies it in a mirror and in twilight. He says, "If it doesn't excite the imagination upside down, if it doesn't have an abstract element, then it lives just on its subject matter or being contemporary and it's dead wood."

When an emotion hits, Wyeth floods his excitement onto the watercolor paper with wild, spontaneous strokes—which may become the underpainting for a fully realized image. When he painted Helga supine on the forest floor in 1973, he moved with such violence, ripping the sheet off the pad, that he tore it almost in half.

Perhaps in part because he is still alive and producing, there has been no reassessment of Wyeth in an art world that is now more diverse, less oppositional, in which representational painters like Mark Tansey, Philip Pearlstein, Eric Fischl, Vincent Desiderio, Alex Katz, and George Tooker are flourishing side by side with abstractionists Brice Marden, Frank Stella, Agnes Martin, and Sol Lewitt.

There has been no winnowing process to

isolate the several dozen works by which Wyeth will stand or fall. To date, his pictures have been available to the establishment primarily in huge exhibitions cataloging his long productivity, room after room of paintings. John Canaday once wrote, "Wyeth suffers in a large exhibition. When he is not completely successful, he skirts the edge of genre. And when he is at his best, you are distracted by neighboring pictures from the pictures that can speak fully only alone and at length." Sometimes, too, the irresistible impulse to package his work by locale and subjects encourages a feel of storytelling, a kind of journalism.

One factor isolating Wyeth from the mainstream of the art world has been the insistence, spearheaded by Betsy, that they maintain a high degree of control over the marketing, exhibition, and reproduction of the work. For anybody who wishes to exhibit Wyeth paintings, Betsy's records have been virtually the only library of lists of his entire oeuvre and the whereabouts of pictures in private hands. Her own collection contains some of his choicest works, and the sale of a painting almost never includes the copyright. She is often the only source for color transparencies. Moreover, the force of *her* perceptions is often irresistible.

The uncompromising ways of the Wyeths have created resentment among museum professionals who feel brushed off or uncomfortably controlled. Moreover, the artwork is sold through private representatives, including Nicholas Wyeth. It is not part of the network of commercial galleries who offer the imprimatur of an establishment voice.

This removal from the art scene is exactly what the Wyeths wish. To them it keeps him from being one more painter in a vast stew of artists, and his exclusivity, his rarity, his remoteness, his prices, create a kind of dignity, an aura of eminence, both artistic and commercial. Their control ensures the highest possible standards of presentation, the prime environments they deeply believe the pictures deserve. Perhaps most important, remaining on the margins of the art network keeps Wyeth personally untouched, uninvaded, unbothered.

Relatively few in the art world have had reason or opportunity to absorb Wyeth's work in depth. One was Hoving, on the occasion of the 1976 exhibition at the Metropolitan Museum of Art. When he visited

River Cove, 1958 An edgy composition of abstract shapes, of disorienting ups and downs, reduces the sum to a few essential parts as Wyeth expresses his vision of seacoast nature, the horrible beneath the lyrical. *A* dark, placid tidal pool relentlessly drowns a sandbar where a heron has come and gone. He once said, "You know, powerful things are sometimes very slight. The explosion is very delicate."

Chadds Ford, he discovered "a complex artist . . . involved with the urgent and cruel reality surrounding him." When Hoving assembled the 135-piece exhibition for the *Chunichi Shimbun,* Wyeth's first major exhibition in two decades, only one U.S. venue, the Nelson-Atkins Museum of Art in Kansas City, Missouri, was interested in the show. Its director, Marc Wilson, says: "From the virtually random encounter with a painting or two, I thought Wyeth was a good artist, but not nearly as profound as I now believe him to be. I've come to a very different understanding of why Wyeth will last, why history will be kind to him even if his own generation is not."

From all across the United States, 82,758 people came to the two-month exhibition. As far as this audience was concerned, the show was an authentic art experience, crystallizing half-formed thoughts and feelings. Thousands wrote their reactions in a comment book—an inch thick, two columns a page—filled with words like "awesome," "fantastic," "inspiring," "beautiful," "thrilling," "moving," "cool."

Some found Wyeth an artist of simultaneous opposites, painting "emphasis through nonemphasis," so "simple and complex," a "mixture of joy and pain." Some reported that they wept: "tears and warmth all at the same time." Some found the work "drab and boring." One asked for "more nudes, less grass." Some discovered a new way to see, thought they "would never look out the window in the same way again," thought they had experienced "a whole different world that was part of my own."

Many reacted to the themes of death and madness. Some found the pictures "a little stressful." They thought that "the walls are closing in," that "Mr. Wyeth needs mental help." One liked "the way he deals with death, but I think he needs to focus on something more positive. He needs help." Others felt "he touches the soul," saw "darkness with hope," enjoyed the "reminder of mortality," the "darkness and depth," the "incredible solitude and passion (and passiveness)" that "creeps into you like a chill breeze over the Pennsylvania hills."

Discussing the appeal of Wyeth's paintings, *New York Times* critic John Russell said, "It is really rather odd that a nation which rightly prides itself on its buoyancy of spirit should identify so firmly with an artist whose spe-

cialty is the study of wounded or inarticulate natures in an unforgiving landscape."

But Wyeth's stark, unflinching contemplation is central to his attraction. Explaining the appeal of the exhibition in Japan, Nelson-Atkins director Marc Wilson said that the Japanese "sense that our existence is very temporary and man is subordinate to a nature that's much, much larger and more powerful than we understand—and is not necessarily caring or nurturing."

Wilson continued: "Wyeth is so accessible to people of other cultures because he does deal with constant human issues—the passage of time, decay, fleeting existence—that have been with us since we got down out of the trees. It's not the parochial U.S. issues of the moment—gender, race, sexual identity, the whole catalog. You don't have to be American to *get* Wyeth."

Wyeth's northern sensibility—the blackness of the fairy tales of the brothers Grimm—contains a timeless fatalism, very real to the mass of Americans who feel vulnerable, who know about anxiety and regret, who remember their only half-buried childhood terrors. Not unlike the poetry of Robert Frost, the interior darkness is potent *because* the mood inhabits what is familiar, often ordinary. Though Wyeth speaks in atmospheres, his voice is not complicated by intellectualism, does not need clarification. His major works speak of acceptance and quiet endurance, offer the reassurance that the worst can be faced and resolved with dignity and self-sufficiency. He offers a transmutation of fear into a cruel beauty—the redemption intrinsic in high art.

Wyeth himself takes a dour view of his popularity. "I am an example of publicity—a great deal of it. I'm grateful because it gives me the freedom to go and try to do better. But I never had any great idea that these people are understanding what I'm doing. And they don't. I think you get fastidious if you want every little brushstroke to be understood by the public. That's a bunch of crap. Very precious.

In 1975, under a full moon, Wyeth stood on the hill above the Kuerner house, listening to Anna chop kindling behind the lit window in the low shed. The abstract shapes of melting snow on the Kuerner hill gleamed, remembers Wyeth, "like an Indian's painted face." He hurried to his studio and painted *Wolf Moon* in half an hour.

"Let's be sensible about this. I put a lot of things into my work which are *very* personal to me. So how can the public feel these things? I think most people get to my work through the back door. They're attracted by the realism and they sense the emotion and the abstraction—and eventually, I hope, they get their *own* powerful emotion."

23

In 1996, at seventy-nine, Wyeth is an old lion, frail but still living for the hunt, ruthless as he prowls his shrinking turf, looking back over the winters of his past, reviewing, summing up. "Hate" more than ever fuels his diminished energy, mixing like gasoline with the air of "love." As Betsy once said, "I've seen Andy's rage grow and grow through the years. Early in our marriage, I had no indication of it at all. It's much more part of his personality now. But he thrives on it. It pushes him forward."

He is fierce in his determination. He is still experimenting with new techniques—using opaque white covered with a clear wash in drybrush, manipulating tempera-like watercolor. "You want to improve," he says, "and you do *know* more. So you think things will get a little easier. But it gets harder with age. You have all these emotions and you try to build them into a clear statement. It's all a terrible struggle with little beams of light now and then beckoning you on. You have to be tough and you have to work like hell. I'm not going to just sit here and turn out nice temperas— 'Oh, there's another Wyeth. He ought to get a medal for popularity.' Fuck that! Really!"

This demonic doggedness carried Wyeth through the emotional turmoil following the release of the Helga collection. Not only was he dealing with the static from the press and Betsy's distress, but Karl Kuerner was dead and Helga had ceased to be the single, fifteen-year painting that was an extension of Kuerner's. Except in memory Wyeth was disconnected from his sixty-year cycle of German fantasies, based on the contrast of grace and brutality, romance and madness. Except for Helga and Anna Kuerner— vanished in their own ways—he had now lost all the players in the drama set in that corner of Pennsylvania. Gone were the blacks around Mother Archie's, gone was his walk up the ridge, now dense with suburban homes.

"Andy has to have something he can count on to paint," Betsy says. "He's got to have that security."

In 1985 Wyeth began a long adjustment, a kind of grief period. After completing the Helga series with *Refuge*, he painted the bleak tempera *Ring Road*. He returned to a spot already significant, done twice before through the years. It is a deep cut just before Ring Road curves downward and Kuerner's comes into view. In this picture the road banks frame the distant, ruined relic of Mother Archie's church beside a skeletal beech tree. Beyond is Kuerner's Hill. All evidence of humanity is whited out by snow—except for a curving arrow on a startling yellow sign that directs a single set of car tracks, a symbol recurring in many pictures, perhaps of his own fleeting passage.

After seeing the picture, his sister Ann said, "That sign, a period—definite, ugly—and the road leads to death . . . everything in that neck of the woods. He's almost digging up old bones. He makes branches look like bones, look like something's in them . . . almost like people."

In July 1987, at the height of the reverberations from the Helga exhibition, Wyeth lost the last important member of his lifelong cast—Walt Anderson. In commemoration he painted the tempera *Battle Ensign*, the American flag from Walt's casket hanging backwards on a clothesline, the field of stars to the right. Now Wyeth was saying, "There's nothing left for me in Maine," and he suffered long, frightening periods of "blank brains." Carolyn, worrying, insisted: "He's not burned out. He just has no motivation."

Wyeth told a friend, "As I get older, ideas are a very scarce thing for me. You want more." He paused. "Something may break. But it may not. It's tough." One day Wyeth asked Betsy if they had enough money to live if he never sold another picture. She supportively agreed to sell off assets, if that was necessary.

In the fall of 1987 Wyeth was suffering extreme fatigue. He told people: "I'm washed up. I'm done. I'm exhausted. I may never paint again." Carolyn bewailed: "His stomach's gone. He gets colitis now and can't eat and gets sick and all that stuff. I told him, 'It's because you're so damn nervous and high-strung.' He's so jittery."

She guessed that his condition was caused by Betsy's anger at the Helga deception—exacerbated by Helga's continuing presence. Despite the medical and psychiatric help Wyeth arranged, Helga was still isolating herself in the schoolhouse. Occasionally he painted her just as herself, part of his existence, as he had once done with Willard Snowden. He did a watercolor called *Red Sweater* showing her mental state—Helga rigid, gaunt in a straight-backed chair, eyes fierce and frantic. When he needed privacy, he painted in Carolyn's studio.

Helga was still scorning medications, and Carolyn worried that she might kill herself there in the schoolhouse. Scheming how to trick her into taking antidepressant pills, Carolyn said, "I'm not drinking a goddamned thing, because I've got to think clear for Andy. If I could just get this girl on her feet, that will help him sure. Jesus Christ."

She also decided to intercede with Betsy. Tears in her eyes, Carolyn said, "I hate to do what's ahead to save Andy's life, because it could come to that. Poor boy." She telephoned Betsy, and Andrew was thrilled by her loyalty. He reported, "Carolyn was marvelous. Hit it on the head. She said 'Betsy, you blew it. You left him alone and deserted him. You got more interested in the business angle of his work, going off, having a lot of people working for you, not really living. . . . Of course, he's going to find somebody else. Not sex, Betsy. There's no sex in it. He just wanted the freedom of someone else who would pose well for him and was interested in what he was trying to do.'"

In January 1988 the pressures on Wyeth culminated in a temperature of 104 and an irregular heartbeat. Fearing a blood infection affecting his heart—potentially fatal—Dr. Valloti put him in the hospital. His blood was normal, but atrial fibrillation was diagnosed—a permanently irregular heartbeat. A blood-thinning drug was prescribed.

While he lay in the hospital, Betsy decided to get some answers, to see what was going on at the schoolhouse. She went with Betty Hammond, who has worked for the Wyeths for decades and cleaned for Andrew once a week. "The place was about a hundred degrees," Betsy tells. The studio door was open, which surprised her. She went inside. There was the familiar chaos, the

413

kitchen table with its tin top covered by brushes and paint-spattered jars of pigment. Along one wall was the low cupboard, the white enameled wood cabinet, the file drawers. All flat surfaces were littered with tin cans, jelly jars, mugs, drawing pads, jars, paper, cans of fluid, spray cans, jars with brushes sticking up like an Indian headdress. There was the four-legged stool, the couch covered with green plastic leather, and the six-foot, free-standing mirror. Leaning with their faces toward the wall were the panels and water-colors. On the walls, scabrous as Christina Olson's kitchen, were swords and a small picture of Betsy from the 1965 article in *Life* magazine.

Inside the studio, Betsy noticed that "the big easel was sort of at an angle and the whole place was like an unmade bed. And something moved. In the corner was a kind of bed and there's a lot of potato chips and boxes of Cheez Whiz and this figure is slowly pulling itself up. I said, 'My God, you must be Helga!' She doesn't say a word, just sort of stood, looking me up and down. I said, 'Ten million people wouldn't believe this.'"

Helga came forward. "There was a terrible sadness in her face," Betsy continues. "I was appalled. I felt sorry for her immediately. She was tragic. She was much shorter than I imagined; I'd expected a tall, slender girl, a raving beauty. I said, 'The paintings are beautiful.' I said, 'I want to explain why Andy isn't here.' I realized I was talking a lot, very fast. God! In my nervousness, I turned to go out, and there was a perfectly beautiful drybrush painting. I said, 'Oh, don't tell him that I saw it.' She said, 'I won't.' That's all she ever said."

In the hospital Wyeth was enraged when he learned that Betsy had entered his sanctum without permission. He berated Dr. Valloti for incar-cerating him in the hospital; otherwise this would not have happened. According to his recollection: "Betsy said, 'I don't know how you could . . .' I said, 'Listen, she did a lot for me and she can have that studio anytime she wants to. And don't you ever touch it.' I made the law quite clear. Betsy puts up with an awful lot from me, but she knows . . . I said, 'You can leave me!' Just like that. 'Go ahead.' That studio is the only place I have that's mine."

In the late spring of 1988, powered by "hate," Wyeth began pulling out of the semiparalysis in his painting. Helga says, "When he has the right sub-ject, you see a different Andy. It's the difference between feeling old and *not*

feeling old." That summer he painted *Maiden Voyage*, a portrait of a delicate, fine-tuned white racing yacht in the Thomaston shipyard. Looming behind it is a gigantic spruce tree, darkly menacing.

Talking about this picture, Wyeth mentions a toy sailboat given him on his fifth birthday, his youthful admiration for the swashbuckling, piratical Errol Flynn, his father's illustrations for *Captain Blood* and *The Sea Hawk*. But it also represented a moneyed Maine that repels Wyeth. "I've never fought a picture more," he said. "Betsy was going off to the islands. Building another house. I'd hear them out on that big damn dock, getting into the boat, wearing fancy hats, looking like Katharine Hepburn taking off. And I thought, What the fuck am I . . . Walt is dead and here I am painting a wealthy boat, going with the snobs, working on this picture when I really don't like Maine." He laughs. "I feel about Maine like the fighter who gets beat up for ten rounds and says, 'It was a great fight, Mom.'"

Then in 1989 Wyeth turned the corner into a new era in the arc of his work. He was finally down to the nub, increasingly painting his *own* life directly, not obliquely through Karl, Christina, or Helga. As Wyeth said, "What I'm painting now is the experiences and the moods I'm having at this time in my life. I'm not interested in going back to what I was 'cause you can't return. It's like being a virgin and not a virgin. It's like trying to concoct the old feeling for a woman you've lost your feeling for. You can never go back. It's hopeless."

The pivotal transition into this new incarnation—releasing him from his doldrums—was the tempera *Snow Hill*, called by Wyeth "this old man painting." To release himself into the future, he usually will put a period at the end of an episode, and this time he painted a curtain call that finished the long drama since his father's death. A maypole with a Christmas tree at its peak sits on the summit of Kuerner's Hill. Around the maypole at the end of colored ribbons dance Karl and Anna Kuerner, Bill Loper, and Helga holding onto his hook, and Allan Lynch and Adam Johnson. A white ribbon, the same color as Helga's, leads to a hidden figure, Wyeth himself. His models, he says, only half joking, are celebrating his impending death: "When I worked I raised hell with them mentally and emotionally. They wish I were dead, so they wouldn't have to pose anymore."

In the snow-covered landscape below—blending into a luminous sky heavy with impending snow—are in miniature the railroad tracks where NC died, a tiny Kuerner farm, a rebuilt Mother Archie's, Adam Johnson's pighouse, Bill Loper's stone house. "I don't think there's anything that I have a deeper love for," Wyeth says, "than that little section."

Wyeth began revisiting his heritage, painting Howard Pyle's summer mansion in *Widow's Walk* in 1990—the roof and cupola and, in the distance, Kuerner's Hill and then Delaware Bay, the area where Pyle and N. C. Wyeth and Andrew as a boy went to Rehoboth Beach and to Cape Henlopen. *Moonlight* in 1995 shows the mummified interior of the cupola, eerie in the full moon. Below is Lafayette's headquarters on the Brandywine battlefield. Along Route 1 into Chadds Ford comes change, the modern world, a stream of cars and headlights like an invading army.

As his eighties approach, change and death seem all around Wyeth. In 1995 he was immobilized by a hip operation, which felt like death. He painted *Night Nurse.* An ethereal female figure, almost lighter than air in a flowing nightgown, glides away from the house toward misty woods—death leaving behind an empty chair on the house porch. That fall when he returned to Chadds Ford, Wyeth found one of his painting sites, Othaniel Winfield's frame house, obliterated as though it had never existed—the ground seeded into grass like a little park. The last black home in town, it was his final link to the Chadds Ford blacks. He painted *Demolished,* a ghost house in moonlight, a white sheet draped over the porch railing, flapping like a phantom.

He fears that his body might give out, leaving him unable to paint up to his standards—or worse, unable to paint at all. He asked Peter Ralston, "If I ever start to slip, do you care enough about me to shoot me?" He once lay on a bed with his niece Robin McCoy, telling her that almost everybody he loved was dead, that he expected to die soon. They discussed how cold it must be in a coffin. He would say to people, "We better do that tomorrow because I may drop dead a week from now." He would say to Carolyn, "I'm ready for the grave anyway, so it doesn't matter to me." He once joked, "I'm shaky," and quoted Oliver Wendell Holmes's *The Wonderful One-Hoss Shay:* "First you shake, then you quake. Something like an earthquake."

There is, indeed, a sense that Wyeth is living on nervous energy and willpower. His hearing is slowly fading. After four hours of work, his energy is drained. Naps are frequent. Painting outdoors, an important, refreshing outlet for strong emotions, is harder, more taxing. With one lobe of his lungs removed and chronic sinus problems, pneumonia is a constant danger. Sometimes his boyhood bronchitis returns. Once when his niece Robin McCoy leaned her head affectionately against his chest, she was panicked by the sound of gurgling fluid in his lungs. The irregularity of his heart may cause a blood clot and a stroke.

However, since 1991 a reborn Helga has taken on a new role in Wyeth's life—nurse/caretaker. That year she suddenly emerged from what he called "her vacuum," coaxed out when David Alan Harvey came to photograph Wyeth for an article in *National Geographic*. The next day she cleaned Carolyn's house and would take no money. She made a call on Betsy Wyeth, who was a perfect lady and showed her the trove of photographs of Wyeth, assembled chronologically.

He painted his bemused amazement in a watercolor, *Helga's Back*, her now heavy figure, even bulkier in layers of clothes and an insulated vest, charging into the big schoolroom, a bundle of possessions under one arm, the painful varicose veins in her legs wrapped with wet cloths, making her look something like a World War I doughboy.

Though living at home, she spends most of her hours taking care of the details of Wyeth's daily life. He says, referring to Betsy's eleven-person full-time and seven-person part-time staff, "Betsy has all her servants; why shouldn't I have *one*?" Helga refuses money, but he has bought her two automobiles and helped the four Testorf children. A few times he has painted her in watercolor to catch her present quality. She is no longer a medium for imagination.

Wyeth feels safe with Helga. She drives him in the big GMC Suburban, picked out by Betsy. Helga always carries an emergency medicine kit. In her white outfits she rather resembles an army field nurse. She explains, "It's my fault if something slips in there that I could have prevented. He doesn't have that extra strength to fight for his health and paint, too. Andy doesn't think to

take care of himself. You have the day-to-day follow-up, keeping constant track of where he goes, what people he goes with, what he ate, what his level is on his pulse count, what vitamins and pills he takes and how it affects him, and then you have his allergy side. Got to give him penicillin for lung infections. You've got to keep track of the weather. You just have to live it, breathe it, eat it, sleep it. It's one circle. It's life."

Still in Wyeth's life, primarily as a caregiver and companion who oversees his fragile health, an older, heavier Helga comes often to the studio during the day. Here in 1991 she was photographed in the large schoolroom, while Wyeth gazes out the window past a toy military marching band.

At a dinner party Wyeth was desperately choking. In one blink Helga was behind him, doing the Heimlich maneuver. The piece of meat popped out. What might have been lethal was only a pause in the conversation. Helga tells of the day she took his pulse and found his heart wildly fibrillating. She asked, "What's going on?" He answered, "I'm thinking of a picture. Snow is coming." She massaged him until his heart calmed. Helga explains, "It was the excitement. He has an elemental sense for the

weather. Feels it in his bones. He anticipates so much—all built up in his mind—waiting for the right moment—being ready when it comes."

Wyeth once said, "Helga's kept me alive. I'd be dead." Then he turned to her. "I don't know why you're keeping me alive, Helga."

"Pure selfishness," she said, smiling.

Like Betsy, Helga works at being a curator, laying claim to Wyeth through the work. She digs through his studio file drawers and writes notes on paintings—where and when they were painted, the size, and a number. Like Walt Anderson in the early days, she has become an assistant painter, grinding his pigments, mixing his colors, cleaning off his palette. She lines up his brushes, large to small. Watercolor tubes she arranges by color. "He likes neatness," Helga says. "If the painting table is not like a surgical table, he is not induced to paint." While he paints she keeps his water clean and hands him brushes like a surgical nurse.

Pursuing her own art ambitions, she is like an apprentice in a medieval painter's workshop. She does her own paintings and drawings, all of them hidden away. She has learned to paint tempera and is an accomplished technician who has restored some early Wyeth paintings. She will even do repairs on a work-in-progress, scrapping an area where the tempera is crumbly because the pigment is piled too thick or has insufficient egg yolk. But when Wyeth is in a crucial creative moment, he must be alone and asks her to leave the room.

While Wyeth keeps the big schoolroom sparse, Helga has used the kitchen and anterooms as a packrat's attic. Bulging shopping bags are secreted under tables, in crannies. "I don't try to change her," he says. "It's the thing that appealed to me about Helga which horrifies everybody. She's like going into the barn with Karl Kuerner. She cuts the grease off all the wealth I've pulled around myself." He once told Betsy, "If I'm going to be kept up in that mill with clipped lawns, I'll just drift away into nothing, get picky and precise. I've got to have my earthy German side that's wild."

Allowing people to live in the schoolhouse, usually models, has been a lifelong pattern for Wyeth. Allan Lynch of *Winter 1946* moved into the basement. Another resident was Lester Stanley, a model for Jamie, who was using the schoolroom as a studio. Next came Willard Snowden, *The Drifter.*

Jimmy Lynch explains, "Andy would never like to admit it, but I think he really is a caregiver, and it's hard to be a caregiver to Betsy. It's like Helga's his person. He always has had a person, a pet person." Now, talking about Helga, shaking his head in disbelief, Wyeth says, "I'm living with Mrs. Kuerner. I've got two wives!" He told his sister Carolyn, "At my age I can do anything." She answered tartly, "You're doing it, all right!"

Though Wyeth dreads turmoil, he is also the small boy who feeds on tumult. Betsy marvels at her husband's ability to manage the complications he creates—comparing him to Frolic Weymouth, founder of the Brandywine River Museum, who drives his carriage horses, four-in-hand: "I've always thought Andy was like Frolic. How can he control all that complication, all those four horses running and those four different personalities and all those reins and how can he make them go the right way and bring them safely back?"

Wyeth comes home to Betsy at The Mill around five-thirty each afternoon. Nothing could be more opposite to his schoolhouse scene than Betsy's tightly managed precincts. Stimulated by contrast, he likes to leave environments and then return again, reexperiencing their quality in sharp focus. The pungent milieus in his life have always been played off against Betsy's ultra-refined taste, a daily restorative for the fastidious side in his nature. But in her domain—where her staff renders equal parts of respect, fear, and affection—Wyeth says, "I'm nothing, just a very nice old man limping around."

Virtually every corner of Wyeth's existence is somehow influenced by Betsy. She frees him from all responsibilities, administers the investments, the painting collection, the files and records, her staff, the properties, the business decisions—though he makes the final judgments on the sale of his work. She furnishes the protected, predictable, disciplined platform essential to his life. But when a friend mentioned how much people looked after him, he snapped, "Yes, and I don't like it." He explained, "I guess I was taken care of so much as a boy, I find it cloying. Too much sugar."

In return for this practical caretaking, Betsy has the independence she prizes. "I have been the most free female in the world, and I've never left home," she once said to Wyeth. "That's the great thing about being married to you. Never been tied up."

"I don't believe in doing that," said Wyeth.

Betsy continued, "Most of my life has been spent with women that are frustrated, women who don't know how to have total freedom under all the rules. Anything I want to do, I do it."

"And I do what I want to do," he said.

Their life together is pared down to the same simplicity that pervades Betsy's buildings. Betsy says, "I haven't joined Andy in a lot of things that . . . I can no longer go to openings. I just won't do it. And I know he's proud of me and loves me to go, and can't believe the things I've accomplished. He'd love it. I probably should have." On the rare occasions that she and Andrew do go to parties, she can be enchantingly vivacious, surrounded by men. Once she danced so exuberantly that she fell and injured her leg. Her own entertaining is mainly confined to intimates, invited on short notice for drinks and occasionally for dinner. Reinforcing the reclusive side of Andrew, she says, "I don't like anything pinned down, dates ahead."

Like her mother before her, she has a streak of creative domesticity. She can devote most of a day to baking. During the Siri era, she specialized in Finnish breads. She spends hours cooking complicated recipes, experimenting, inventing, preparing a dinner every night. She is a walker and knitter, making her own designs—sweaters, hats—knitting while she talks to visitors, knitting all morning with Mary Landa.

Most evenings are early and quiet. Betsy is a voracious reader, with a specialty in Thomas Jefferson, and sometimes reads aloud to Wyeth. Their telephone number is a secret, and they can be approached only by mail or through the office. Her penchant for islands, she explains, is because people can be seen coming from a long way off. And, she says, "The comings and goings are much more important occasions, and it's easy to say it's time to leave, the boat is coming." She continues, "Islands are self-contained, easy to understand. I like miniature things and paintings are really islands. The theater is an island. A book's an island."

Benner Island, her Maine retreat, is the ultimate fulfillment of Betsy's austere perfectionism. The centerpiece is her reproduction of a classic eighteenth-century Cape house with its central chimney and second floor under

the steeply patched roof. The interior is an exquisite assemblage of small compositions of objects, planes, and textures, done in the colors of her husband's spare palette. A visiting painter once said, "It looks just like an Andrew Wyeth." He remarked dryly, "I think it looks like a Betsy Wyeth, myself."

Indeed, she considers the house "my tempera." All the components—paneling, wainscoting, poured glass panes, flooring—were bought and saved through thirty-five years by the same Betsy who as a girl collected neighborhood castoffs on junk day. She is happy on Benner. "It's a pleasure," she says. "It's been a great pleasure." Andrew is awed by her accomplishments. "Take this uneven floor," he says. "It's an old barn floor that's been rubbed. It has the most amazing feel. Very strange."

The house presides over a little colony of structures, a former fish house, now a small fishing museum; a studio that looks more like a guest house; an actual guest house; a motor generator house; an enclosed vegetable garden; and a delicate, octagonal, glassed-in structure for Betsy's collection of old oceanographic charts. On the pointed peak of this structure is the lightning rod from Henry Teel's island house, the pale mustard yellow glass ball that appears in the 1950 tempera *Northern Point.* In the center of its floor, protected by a sheet of glass, is a square of slate from the portico of Mount Vernon, once tread upon by George Washington.

Betsy had hoped that Andrew would settle down on Benner each summer, but he feels alien. He says, "This island is *hers.* I don't feel any different than those workmen getting off that boat every day. She's making her own world out there, and I just can't fit in." He adds, "It's like going to Jerusalem for me to paint there. They're not rocks that I've known."

Betsy has never believed that an artist needs to stay on home ground. She left behind her upstate New York birthplace. She points out that N. C. Wyeth left his home in Needham, Massachusetts, and she says, "NC preached that the most treacherous thing you can do is to leave where you were born. I found that rule very rigid. And I know why he did it. He wanted to keep his children right under his thumb."

She believes that part of her wifely job is to challenge Andrew, keep him from slipping into comfortable, familiar grooves in his work. He

quotes her telling him, "You want things that have moss growing over them. I'm trying to jolt you out of that. This is just what you need at your age. A completely new environment."

Painting his own life, Wyeth did indeed fasten on island subjects. He saw Betsy's employee, the handsome blond Susan Miller, as an exotic creature of the sea. Moreover, surrounded by the habitat of his early watercolors, he was inevitably drawn back to painting the nature of island Maine.

Betsy designated a section of Benner Island as her husband's painting preserve, no intruders allowed. "I like a place no one goes," Wyeth says. "But I don't like it planned: This is where Andy paints and this path is made so he can walk there without falling down. Fuck that! I'm not that kind of man." Nevertheless, he drew on that headland, and when a wild northeaster hit, he was ready. Betsy watched him from the house. "You want to see my husband in heaven?" She laughs. "He was taking off with his watercolor box in one hand, and in the other this huge piece of cardboard with the paper taped on it, catching the wind like a sail. God, what a man!"

At the headland he did the watercolor *Whale Rib,* lying prostrate on his side, painting with one hand, holding down the paper with the other. Drops of rain spattered the sheet. Across the foreground arches the desiccated, lichen-spotted rib, "something thrown up from so deep down," Wyeth says. "Frighteningly deep." Beyond a passage of gray sand, embedded with shells and dark green trailing yew dotted with blueberries, is the contained power of the wind-flattened sea, gray in a haze of mist. Wyeth says, "Something happened on that spot—I can't tell about it— which finally made me paint there. Almost anger. I just put it down."

Storms raging behind lovely, peaceful foregrounds are a leitmotiv in Wyeth's island temperas—portaits of his relationship with Betsy. In 1986 he painted *Squall* on Southern Island. In the lighthouse Betsy's yellow slicker and binoculars hang on pegs. Through a window and a doorway is the dark and lowering sky of an approaching squall.

The long, horizontal *Heavy Sea* was painted in 1989 during Betsy's restorations on Allen Island. The grass foreground is confined on three sides by a picket fence. Across the low, bare hills, tire tracks lead toward a

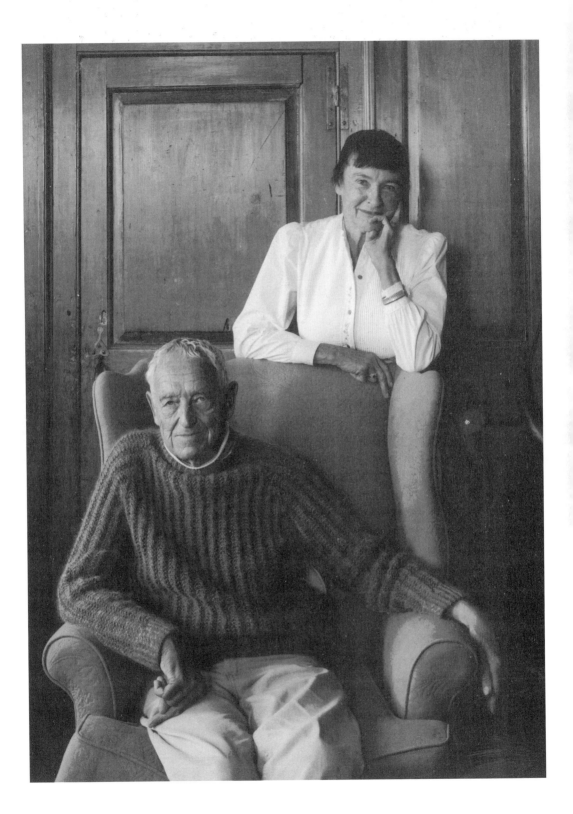

Two If by Sea, 1995

notch where ocean waves—just visible—crash against the rocks. He once told Betsy, "You're wonderful, but your interest in watching me fences me in. I have to break that fence line."

Wyeth painted *Jupiter* on Benner Island in 1994. In the foreground are the three freshwater ponds that Betsy caused to be dug on descending levels, their depths inscrutable beneath calm surfaces. In the night sky and reflected in one pond, is a crescent moon and the glittering dot of Jupiter. A radical departure, the tempera was done rapidly, in

On Benner Island, her small dominion, Betsy built a glass octagon to house a collection of antique charts. An echo of Mother Archie's church in Pennsylvania, and of all the lanterns Andrew has painted in barns and houses, the tempera is also a reverberation of the complex relationship between Betsy and Andrew: a mix of glowing light and storm.

only a few weeks. Certain areas are painted with the sweeping strokes of a wide brush, almost angrily, a return to his early work when he manipulated the tempera like watercolor. Wyeth said, "What worries me—everybody likes it."

Two If by Sea (page 425) is named after the lanterns hung in Boston's Old South Church to signal Paul Revere that the British were moving by water to march inland toward Lexington and Concord. In front of the wind-whipped sea is the octagonal glass "chart house" in the night, a huge lantern filled with eerie, spirit light, unearthly—the glow that might be inside a brilliant mind. With its jittery pattern of panes and mullions, it seems poised to levitate in the darkness, spinning like a bewitched merry-go-round. Within, restating the theme of *The Witching Hour* (page 312), are two candles, their flames fanned by the winds of conflict.

Henriette's daughter, Ann Carol, says, "Andy doesn't have a bad life. He has organized it more or less the way he wants it, and he's very productive. We all make our marriage partners act out a role for us. It's a two-way street. She is simply doing what he unconsciously requires her to do. She's a kind of guard dog, the mother protecting him. Everybody makes Betsy out to be the bad guy, and she very dutifully acts it out. And sometimes it makes him very angry and it seems to hurt—but don't think it doesn't hurt her, too, because if she were in a different situation, she might be quite a different person. She has a very sensitive side and a very tough side, and there's constant internal clashing."

In Maine, Wyeth repeats his Pennsylvania life of contrast and counterpoise. As he did a half century ago, rowing from the new house on Bradford Point to Olson's to paint *Christina's World*, Wyeth in the early morning boards the *Boston Whaler*, which delivers him in fifteen minutes to Port Clyde, where it picks up workmen headed back to the island. "This is a weird life," says Wyeth. "Very weird. Rushing across in a boat at dawn, pounding waves, with a hip that's not too hot. But it's good for me. Otherwise, I'd settle back into old age and be like every other old fart, trying to paint the same old thing."

Wyeth works in his father's studio at Eight Bells. The lawn is a weed field, deep in neglect. Inside the house, always a perching place, never a

dwelling, there are no *new* imprints since his youth. The warren of small rooms with their iron bedsteads, the long shed that NC converted into a simple living room—with its dining table at one end, its book-piled table under the windows, its two shabby chairs and short sofa before a fireplace flanked by NC's musty books (*The Adventures and Letters of Richard Harding Davis; The Works of Charles Dickens*)—all seem like compartments of the past, still filled with the original air. Fixed there is the remembrance, like a web of nerves, that Wyeth feels is crucial to his inspiration. Awaiting him is Helga, who spends each summer at Eight Bells, his daytime acolyte, ready each morning with a big bacon-and-egg breakfast.

Betsy has managed an uneasy internal truce with Helga. She has invited her out to Benner Island and taken an amused delight in the resulting shock waves within the Wyeth and James clans. On her seventy-third birthday in September of 1994, Betsy invited three of Andrew's female models to the party on Benner—Susan Miller, Pam Cowe, and Helga, who brought the cake. Betsy said, "It's sort of like a psychiatrist bringing his patients home."

Since she herself recoils from illness, she is relieved that Helga has taken over the health-care role. And she is able to say, "Andy needs a simpler personality than I am." Those around Betsy admire her pride, her dignity in the face of this unsolvable embarrassment.

In 1995 Betsy decided that the time had come to meet John Testorf. She went to the house, knocked on the door, and introduced herself. She found "a lovely man, beautifully dressed, tall, a big man, the son of an actor." He agreed to sit for a portrait, arriving at The Mill each day in a convertible, delighted to pose for Wyeth in the granary, a touch flamboyant in a lambs-wool–lined coat echoed by his long hair down to the collar, his bushy eyebrows, and a small smile on his lips.

During one session, he said, "I just wish Helga would spend more time at home." Wyeth answered, "I wish so, too. But I can't control her. I leave the studio open, and if she wants to come there, that's her decision. I can't get into it, John." He replied, "I understand." Telling the story, Wyeth adds, "I think I settled a lot of things." At the end of each session, Testorf shook Wyeth's hand.

Speaking of the Helga series, Wyeth says, "My only regret is that it caused all the furor and it's a sadness to Betsy. It's tough on her. She's still feeling it and she'll carry it to her grave." In 1992 Betsy found her way to even the score with Andrew. As a joke she had color copies made of a watercolor sketch of Helga from the waist down, nude and kneeling. She had the pubic hair painted with an odoriferous liquid of a type used in advertisements. On the pictures was written "Scratch and Sniff! Merry Christmas!" She sent these to selected friends. Further enraging him, she took a copy in an envelope to be publicly opened at the annual Christmas party given by the Sipalas at the old Howard Pyle summer mansion. But George Sipala quietly suppressed it.

"In many ways Betsy's an energetic thinker," Wyeth once said, "and maybe that combating is just what I need. I'm too wrapped up in it to know whether it's good or bad for me, but that's the way it stands, and she certainly has been a remarkable companion—but it's not easy. I wouldn't call it falling off a log. It's made me a little more ruthless and a little freer, I think, than if she hadn't been that way. But I need strong people. Yes I do. We have great bonds. Great bonds."

Each afternoon when Wyeth comes in the door of The Mill, calling to "Suzy" or "Betts," his pet names for Betsy, the room leaps to life. There is her vitality of mind and throaty laugh. His boyish, infectious energy is still present, the jokes, the bright eyes, clicking his teeth as he laughs. After posing for twenty-three paintings, Betsy, too, knows what it is to be one of his models. In 1993 he painted the latest portrait, *Tundra*, Betsy in the snow in a fur hat, formidable and beautiful at seventy-two, the light reflecting up into youthful eyes. During this painting they were almost romantic together, seen holding hands, Betsy alive, glowing in the warmth of Andrew's full attention.

She once said, looking fondly at her husband, "Don't we have fun, Andy. We're still having a lot of fun." She became reflective. "I've laughed until I've ached. It's been a great life! Lot of sadness; lot of tears; a hell of a lot of laughter." As of 1996 Andrew has been with Betsy fifty-seven years,

twenty-nine more than he knew his father. Says Betsy, laughing ruefully, "A marriage that lasts as long as ours is an old beat-up ship."

Wyeth telephones her several times a day, asking, "What's happening?" He signs off: "I love you." As Wyeth once said, "Let's face it, when I'm away from Betsy, I miss the highs, the understanding, you know, beyond words." They are, as a friend said, "like skeleton and flesh," held together by those powerful twin intimacies, anger and love. "It's an intense loyalty and an amazing love," says Jimmy Lynch, who has watched them close-up through most of his life. "They just tantalize each other and torment and tease each other to a degree of almost destruction. But it's not. It's productive. Their romance has a lot of fire."

The complex and convoluted strands of Wyeth's life are ultimately the paths to a single overriding end. The work *is* Wyeth, as a rock is a rock. Though drained by age, shadowed by mortality, churned by troubles, he still believes in the perfectibility of his painting, believes it can be better, fresher tomorrow than it is today. In the marrow of his mind, he is competing not against his contemporaries but for a high place in the history of American art, up against Thomas Eakins and Winslow Homer.

"When I die," Wyeth says, "don't ever worry about me. I don't believe in being there for the funeral. Remember that. I'll be flying far away, off on a new tack. Something new that's twice as good."

EPILOGUE

Nowadays Wyeth often stops by the house of his sister Ann in Chadds Ford. Since John McCoy died of pneumonia in 1989, after four years of Alzheimer's, Ann has lived alone, busy with her music, her painting, her walk-in dollhouse. She and Andrew are the last functioning Wyeth siblings. Her house, full of their father's paintings, is the one place where Andrew is still the family's adored and indulged youngest child, any behavior expected—and forgiven. For both Ann and Andrew, nothing will ever be as wonderful—or as important—as those childhood years they shared so intimately. If she is absent, he leaves a note signed "Robin Hood."

Henriette, on the San Patricio ranch in New Mexico, suffers from senile dementia—her decline speeded by a series of small strokes and a hip broken in a fall. In 1992, taken to the hospital for observation, she fell out of the bed when nurses failed to raise the bed rails. She needed seventeen stitches in her head and never painted again. "It was like erasing a computer," says Ann Carol Hurd.

In 1995 Henriette made what was almost certainly her last trip to Chadds Ford, journeying there to be present at Ann's eightieth birthday. A frail, papery vestige of herself, she moved on a walker or in a wheelchair, her attention floating on the surface, murmuring in the midst of the loud, exuberant talk, almost girlish, beaming at Andrew and Ann, patting their faces. When Andrew drove her to the Big House and NC's studio, much of the time she stared vacantly ahead or at her wizened hands in her lap. Andrew reported that "she's not the sister I knew," his voice reflecting both annoyance and impatience.

But when Henriette listened to Ann play the piano, she wept. She twice toured Andrew's exhibition room at the Brandywine River Museum, studying each picture. At a restaurant lunch he gestured toward a hideous still life hanging on the wall. "Did you paint that, Henriette?" From out of the embers still in the depths of her being, she exclaimed, "Never!"

At eighty, Ann McCoy is still composing at her piano under the watchful eye of Beethoven.

430

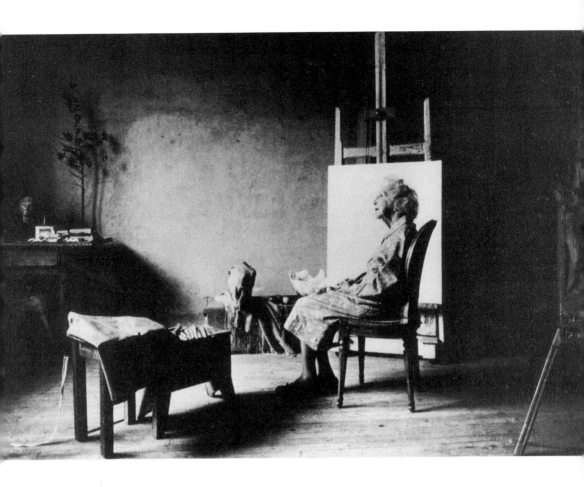

The first breach in the charmed circle was Nathaniel, the mechanical engineer, who often referred to himself as "the other Wyeth." Nat's wife, Caroline, died in 1973 in an auto accident, and he

ABOVE: In 1991, at age eighty-three, Henriette Hurd sat in her studio in New Mexico among her Southwestern artifacts. A year later her mind faded and she could no longer paint.

OPPOSITE: In 1983 Nathaniel Wyeth posed with forms used in his process for manufacturing plastic bottles capable of holding carbonated beverages.

married the divorced Jean Krum Grady from Berwyn, Pennsylvania. In 1989 he suffered a stroke. On the Fourth of July 1990, when Nat was seventy-eight, the clan gathered at Ann McCoy's house in Tenants Harbor, Maine, for the annual fireworks display put on by Nicky Wyeth. After the final crescendo fusillade, Nat said goodnight and walked out the door onto the lawn. He fell and lay still.

His niece, Robin McCoy, a nurse, rushed to her uncle and began mouth-to-mouth resuscitation. She recalls, "I kept counting for him: one, two, three. I knew he was dead. I told myself, Okay, Robin, no heart rate. No heart. But I kept going, on and on." Finally an ambulance arrived. As Nat was taken away, a last rocket suddenly ignited, and a white star arched through the sky.

Carolyn died of a stroke at age eighty-four on March 1, 1994. That morning Andrew and Ann and Jamie stood by her bed. Her jaw was tied closed with a red scarf—like Mrs. Sanderson in *Christmas Morning*. The funeral took place outdoors at the Big House.

The air was still, life barely ticking beneath the ground. In the silence of earliest April, the occasional bird call, the *rat-ta-tat-tat* of a woodpecker,

rang clear in the leafless woods. The mourners gathered around the oval of grass at the center of the driveway circle—Andrew and Betsy Wyeth, Ann McCoy, Jean Wyeth, their children, and the innermost circle of supporters.

Watching, too, was the house, one eye patched where the shade was closed in the rear room where Carolyn had died. The white paint on the wood trim was peeling and green with mildew. Through dead leaves on the ragged grass, a swatch of tiny white spring flowers bloomed. Traces of Carolyn were still present. By the kitchen door the air was slightly rancid with the dog urine in the earth of her dog run, now removed. Cat litter, put down during the last snow storm, coated her kitchen steps. On a table on the porch was an ashtray containing two bent, broken cigarettes, violently stubbed out.

Inside the Big House were the relics of the idyllic childhoods: Andrew's little blue sailor suit; preserved in labeled envelopes, locks of each child's baby hair—including that of the first baby, who died; Christmas tree ornaments; the children's Christmas stockings; the sleigh bells N. C. Wyeth rang on the roof. In a paper bag in a closet was Carol Wyeth's diamond engagement ring; in a bureau drawer the worn wallet NC carried the day he died.

A subtle gaiety filled the group gathered at the oval because Carolyn would so have appreciated what was about to happen—and also a poignancy because it would be so much Carolyn. And without a Wyeth in that house, without her force of nature, a core was gone from the family.

On the grass of the oval was a card table, near the overgrown rock where Ann and Andrew as children played pirate ship. Beside the table stood a retired Episcopal clergyman, George Peabody, a stole around his neck. He read a short service from the Book of Common Prayer, punctuated by a silver bell. "For I reckon that the sufferings of this present time are not worthy to be compared with the glory which shall be revealed to us."

Next a man in a leisure suit, the opposite extreme of the Reverend Peabody, stationed himself behind the table. He announced that he was following an ancient Chinese ritual brought to the West by Marco Polo.

One by one the mourners advanced to the table. Each spooned a bit of Carolyn's ashes from an inlaid wooden box into one half of a plastic sphere, using a tiny silver ladle, a souvenir from Betsy Wyeth's high school sorority, now used at home sometimes to serve whipped cream. With elaborate care the man taped the two halves of the sphere together.

He disappeared down the drive. Signaled by a shout, Ann and Andrew together pressed a button on the card table. *Whooosh! Bang!* The sphere rocketed out of the muzzle of a pipe into the sky above the pasture. In a burst of blue and white stars, the pale haze of Carolyn's remains sifted down onto the field. To the south, set off by the reverberations, the burglar alarm in Margaret Handy's former house echoed off the hills like the whistle of a train traveling through the valley.

ACKNOWLEDGMENTS

In 1964 when I arrived to interview Andrew Wyeth, he looked at my large leather-cased Uher and announced, "No tape recorder." Since the article was going to consist of a monologue in his words, this was saying, "No story." I laid the machine on the floor and surreptitiously turned it on.

A half hour later, Betsy Wyeth came into the room. With her usual acumen, she said, "Something's on." My skin went cold. Then, protecting me, she said, "It must be the refrigerator." A half hour later Wyeth said, anxiously, "I'll never be able to say these things again." Then I confessed. He was mightily relieved—and in the thirty ensuing years has been unfailingly warm and generous.

Ever since that first encounter, Betsy has been leading me through the labyrinths of her husband's thinking and creative process, giving me crucial hints and leads. In this biography, I am again in debt to Betsy for the shrewd and insightful interviews she gave during the three years of its writing, and for the remarkable cataloging and organization of Andrew's work, which allowed me to survey the full reach of his creative output and come to my own understandings.

The quality of the reproductions in this volume would be distinctly poorer without the care, persistence, and good humor of Mary Landa, the curator of the Wyeth Collection, who provided the finest quality transparencies and black-and-white prints. On Betsy's staff, Deb Sneddon and her computerized library of Andrew's paintings were essential. Peter Ray and his Rolodex saved me many hours of detective work. Diane Packer was a helpful presence and Dolly Bruni Parker was a sensitive and delightful interpreter keeping me on course.

The entire Wyeth clan through the years has enriched my life and by extension this book. In particular: Ann McCoy and her daughters, Robin and Anna Brelsford; Henriette Hurd and her daughter, Ann Carol Hurd; Nicholas and Jane Wyeth; Jamie and Phyllis Wyeth. And there was Carolyn Wyeth, whom I sadly miss.

I am most grateful, too, for the trust given me by Andrew Wyeth's models: Helga Testorf, Pam Cowe, Jimmy Lynch, Helen Sipala. I have drawn liberally from Thomas Hoving's interviews with Wyeth, which discussed his temperas and watercolors. I have also quoted from David McCullough's interviews with the extended Wyeth family during the shooting of the Smithsonian film *The Wyeths: A Father and His Family*. My thanks to Wentworth Films, Inc., for supplying the text. I am obliged to Gene Logsdon for his vital portrait of Adam Johnson. I admire Karl Kuerner's children—Louise, Clara, Lydia, Elizabeth, and Karl, Jr.—for their candor while recollecting their complex father. At the Brandywine Museum, James Duff and Vicky Clark were most generous.

Special gratitude goes to Theodore Wolff, Wanda Corn, and Chris Crossman for their generosity, giving me important amounts of time in the midst of busy lives and allowing me to tap years of accumulated expertise. I needed, too, the perspective of Michael Brenson. The enthusiasm of Buz Wyeth was essential. Laurie Winfrey repeatedly rode to my rescue in the world of picture research. Two people helped far beyond the call of friendship: the documentary filmmaker James Lipscomb and Ralph Graves, my mentor at *Life* magazine. Both read the entire manuscript and unhesitatingly applied their pencils, forcing a rigor and clarity that I could not have found alone.

During the span of this project, I was supported by an indispensable corps of patient helpers. Suzy Hubbell Jaeckel, Johanna Roberts, Alfred Fariello, and Susan Lyman—souls of toleration—transcribed sometimes barely audible tapes. The isolation of writing was mitigated through the course of the book by the intelligence of Grai Rice, who helped process my research material and handled the exacting details of procuring paintings and photographs. In the final push to completion, she was joined by Mary Beth Aberlin and Joanne Pawlowski, all meticulously checking hundreds of facts and telling me when my flights of eloquence made no sense.

Allen, Douglas; and Douglas Allen, Jr. *N. C. Wyeth: The Collected Paintings, Illustrations and Murals.* Crown Publishers, Inc., 1972.

Corn, Wanda M. *The Art of Andrew Wyeth.* The Fine Arts Museums of San Francisco, 1973.

Duff, James; Andrew Wyeth; Thomas Hoving; and Lincoln Kirstein. *Three Generations of Wyeth Art.* Brandywine River Museum, 1987.

Hoving, Thomas. *Andrew Wyeth.* Little, Brown & Co., 1995.

————*Two Worlds of Andrew Wyeth: Kuerners and Olsons.* Metropolitan Museum of Art, 1976.

Logsdon, Gene. *Wyeth People: A Portrait of Andrew Wyeth as He Is Seen by His Friends and Neighbors.* Doubleday & Co., 1971.

O'Doherty, Brian. *American Masters: The Voice and the Myth.* Universe Books, 1988.

Wilmerding, John. *The Helga Pictures.* Harry N. Abrams, Inc., 1987.

Wolff, Theodore F. *The Many Masks of Modern Art.* The Christian Science Publishing Society, 1989.

Wyeth, Betsy James. *Christina's World.* Houghton Mifflin Co., 1982.

————*Wyeth at Kuerner's.* Houghton Mifflin Co., 1976.

————*The Wyeths: Letters of N. C. Wyeth, 1901–1945.* Gambit, 1971.

CREDITS

INDEX OF TITLES